MW01122063

BEYOND METHOD

BEYOND METHOD

Stella Adler and the Male Actor

Scott Balcerzak

WAYNE STATE UNIVERSITY PRESS
DETROIT

Library of Cataloging Control Number: 2017953892

ISBN 978-0-8143-4291-6 (paperback)
ISBN 978-0-8143-4489-7 (hardcover)
ISBN 978-0-8143-4292-3 (ebook)

Wayne State University Press
Leonard N. Simons Building
4809 Woodward Avenue
Detroit, Michigan 48201–1309

Visit us online at wsupress.wayne.edu

Contents

Acknowledgments

This book would not have been possible without the generous support of the Dorot Foundation Postdoctoral Research Fellowship in Jewish Studies. I wish to thank that organization, which funded my research in the Stella Adler and Harold Clurman Papers at the Harry Ransom Center at the University of Texas at Austin. I want to also thank Chelsea Weathers, Eric Colleary, Steven Wilson, Bridget Gayle Ground, Richard Watson, Suzanne Krause, Michael Gilmore, and the rest of the wonderful staff at the Ransom Center who made my time there so fruitful and enjoyable. I wish to also acknowledge all those who digitized the Adler studio recordings long before my visit. Without the dedicated work of digital archivists, this sort of book would not be possible.

My gratitude to Ellen Adler Oppenheim, who graciously made her mother's materials available to researchers, and her son Tom Oppenheim, artistic director of the Stella Adler Studio of Acting in New York City, for his support of the project. Also, thanks to Robert De Niro, for giving access to his screenplays, and Corey Parker, for use of his rare photos of Adler.

Many scholars warrant thanks as well, including Cynthia Baron, Steven Cohan, Susan Hegeman, Robert Lang, Justin Rawlins, R. Colin Tait, Maureen Turim, Lucy Fisher, Mark Gallagher, Celestino Deleyto, Tiffany Christian, Heike Steinhoff, Jimmy Draper, Brian Brems, Nathan Koob, Matthew Morris, and my fellow summer 2015 Ransom researchers. In their own way, each helped this project develop through manuscript or proposal review, letters of support, sharing conference panels, or simply listening to me blabber as the project developed. Also, this book would not have been possible without the studies of film masculinity by Steven Cohan and film acting by Cynthia Baron, Sharon Marie Carnicke, and James Naremore. Their research laid the conceptual foundation for much of this book.

I also wish to acknowledge my supportive colleagues in the Department of English at Northern Illinois University—in particular, Timothy Ryan, Joe Bonomo, Robert T. Self, Melissa Adams-Campbell, Lara Crowley, Timothy Crowley, Diana Swanson, Kathleen Renk, and Amy Levin. I also want to recognize my current and former students. Writing a book about a teacher makes you consider your role as an educator and mentor. I thereby wish to show appreciation to my graduate students, who inspire me to grow as a researcher and writer, and my undergraduates, who, every semester, inspire me to challenge my preconceived notions.

Also, special thanks to Barry Keith Grant, whose continual interest in my research has allowed me to find a home at Wayne State University Press. Thank you, editors Annie Martin and Carrie Downes Teefey, who have been enthusiastic supporters of this project and wonderful guides through the publication process. I also want to acknowledge design director Rachel Ross and copyeditor Dawn Hall as well as Kristina Stonehill and Emily Nowak for their splendid work during the final stages of the publication process.

I need to express gratitude to my family—Mark, Kyle, Lisa, Emily, Matthew, and Abby. I particularly want to acknowledge my mother, Katie, who instilled in me a love of learning. Thank you for your lifetime of love and support and for your amazing ability to locate information online.

Also, thanks Torga, for being a lovely writing companion. I miss you, buddy.

And, of course, I wish to thank Stella Adler, whose recorded class sessions were as entertaining and enlightening as one could hope. My appreciation also to all those who worked at her studio during her lifetime. Thank you for having the foresight to push record.

Introduction

Stella Adler and the Male Actor

In 1943 Marlon Brando studied with Stella Adler. It is certain that what Ms. Adler taught in her class was the technique she had evolved. Marlon Brando never took acting classes again and so the interesting question is why Stella Adler's student [has] been put forth in Mr. Gussow's article as the very embodiment of Lee Strasberg's "Method" and as a product of the Actors Studio. Even more puzzling is why this myth persists decade after decade despite anything Brando or anybody else has said.

<div align="right">

Ellen Adler, letter to the editor,
New York Times, May 30, 1997

</div>

The training of Marlon Brando, perhaps the most influential American film actor of the twentieth century, was for the most part misrepresented by the press throughout his career. The above letter was written to the *New York Times* five years after the death of the actor's actual teacher, Stella Adler (1901–1992) and fifteen years after the death of the man most routinely misidentified as his teacher, Lee Strasberg (1901–1982). As the daughter of the former, Ellen Adler's frustration is understandable as the criticized article by Mel Gussow references the October 5, 1947, founding of the Actors Studio as corresponding with the Broadway premiere of *A Streetcar Named Desire* later that year on December 3, suggesting the famous production launched the career of Brando and the "actor and his performance came to signify the essence of the Method."[1] The article presents Strasberg as the most important name in developing a style of more realistic acting for the American stage and

screen through embracing the techniques of Constantin Stanislavski[2] and the Moscow Art Theatre—with no mention of major teachers from the same period not associated with the Actors Studio such as Adler, Uta Hagen, or Sanford Meisner. Through the Studio alone, the article implies, "Method actors like Mr. Brando probed deeply into their characters, and uncovered a greater psychological truth."[3] This misidentification was nothing new as Brando had been mentioned in press on Strasberg and the Studio for decades. As early as 1951, a *New York Times* story on the relatively new studio mentions Brando as an alumnus while various art section profiles of Strasberg in the following decades listed the actor as among his pupils.[4] By the time Strasberg died, the obituary in the *Los Angeles Times* mentioned Brando twice and stressed the iconic performance of Stanley Kowalski in *Streetcar* as "a part that catapulted his student, Brando, to fame."[5]

Despite decades of articles stating otherwise, Ellen Adler's 1997 correction is the actual story, and the actor himself was always quick to credit her mother as his true teacher. In his autobiography, he snidely remarks, "After I had some success, Lee Strasberg tried to take credit for teaching me how to act. He never taught me anything. He would have claimed credit for the sun and the moon if he believed he could get away with it. . . . I sometimes went to the Actors Studio on Saturday morning because Elia Kazan was teaching, and there were usually a lot of good-looking girls."[6] The mischaracterization of his training was something Brando routinely corrected, lauding Adler as instrumental to not only his development as an actor but to the entirety of twentieth-century acting, making a point to stress her influence on screen acting in particular. As he contends, "Virtually all acting in motion pictures today stems from her, and she had an extraordinary effect on the culture of her time."[7]

As Brando's statements suggest, the question Ellen Adler poses in her letter, why this myth of the actor's training persisted for decades, speaks to something larger than simply giving credit where credit is due. If Brando can be classified as one of (if not the) most influential male actors in Hollywood history, the question of what he represents as a performer has profound implications. In terms of the public imagination, he was a *Method* actor, easily the highest profile standard-bearer of that label. Brando states in his autobiography that "'Method acting' was a term popularized, bastardized and misused by Lee Strasberg, a man for whom I had little respect, and therefore

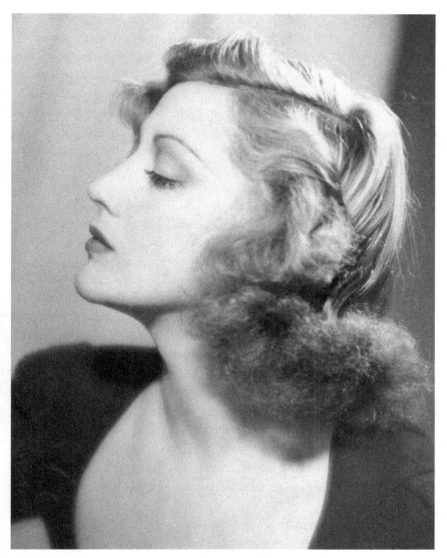

Stella Adler. Harry Ransom Center, the University of Texas at Austin.

I hesitate to use."[8] Yet regardless of his self-classification, the actor came to represent whatever became understood as Method acting by the public during the mid-twentieth century and, at least initially, the most respectable variation of that label. The popular press of the 1950s showed a growing fascination with a new type of on-screen movie actor characterized by the Method, which, at least partly, was initiated by Brando's performance in the film adaptation of *Streetcar* in 1951.

The consistent misidentification of Brando's actual training exposes the sexism inherent in many public narratives of American acting. As Cynthia Baron writes, patriarchy has "an influence on popular accounts of American acting, for these too tend to be gendered all the way down, tacitly conveying the idea that what matters is men's creative labor as actors and acting teachers." As such, "accounts of mid-twentieth-century acting generally feature male names like Lee Strasberg, Harold Clurman, and Elia Kazan."[9] The name of Stella Adler certainly is well known within American theater studies, yet even there, she is often presented as Strasberg's most vocal critic. In many ways, this association is understandable since her professional history as a teacher famously began with her contentious break from Strasberg's instruction. After training with Stanislavski for five weeks in 1934, Adler openly challenged Strasberg's psychological interpretation of the Russian practitioner's System at the influential Group Theatre. From this initial split, other teachers, such as Sanford Meisner and Robert Lewis, also challenged Strasberg's focus on the actor's psychology over concerns like script analysis. In terms of theater history, Adler is routinely associated with Strasberg as an adversary—representing movements in training outside the Actors Studio, a challenge to that program's introspective and psychological approach to acting.

In a written statement for Stella Adler's memorial service in 1992, Marlon Brando took a thinly veiled swipe at Lee Strasberg by criticizing the popularity of his approach: "It seems clear to me that her [Adler's] talents and her dedication to the theater has largely gone unappreciated. There are others who with diligent application of exploitive techniques benefited themselves at Stella's expense."[10] While Brando was perhaps the most vocal in criticizing Strasberg, many of the major male stars associated with the Method were either trained exclusively or partly by Adler. This list includes Robert De Niro, Warren Beatty, Karl Malden, Harvey Keitel, James Coburn, Martin

Stella Adler teaching at Yale University in 1966. Harry Ransom Center, the University of Texas at Austin.

Sheen, Roy Scheider, Benicio del Toro, and Mark Ruffalo. In the 1950s and '60s, the teacher's association with Brando likely contributed to her being sought out by young male actors with knowledge of his actual training. For example, as Suzanne Finstad suggests, like many young male actors of the 1950s, Beatty probably saw "Brando's trajectory to fame as a blueprint for his own," which meant he actively pursued Adler as a teacher.[11] Calling Adler "the greatest teacher of them all," Beatty would later reflect on his training as an empowering experience for young male actors, relating it to Brando's earlier training, suggesting she "convinced me that I couldn't make a mistake. She seemed to convince Brando of that too . . . but she was very good for a young male ego and enabled me to start."[12]

Of course, attempting to link an actor's style to a specific teacher can be a tenuous proposition, since many trained with other teachers at some point and, as artists, developed their own variations on acting methodology. With that in mind, the real significance of Adler is found in what she represents to the history of twentieth-century acting—a profound philosophical alternative to Strasberg's Method, a narrative that forces us to reconsider the cultural significance of the male actor. Adler's approach provides a continuation as well as a recontextualization of acting lessons taught throughout the

first half of the twentieth century. Her persistence as a counter to Strasberg through most of his public reign as the "guru of the Method" illustrates how the foundations of Modern acting—established before the rise of the Actors Studio—developed in the second half of the century. Despite the public obsession with psychology during the period, Adler's approach fosters an understanding of performance as based in behaviorism and sociological observation. If Brando's zealous proclamation in his autobiography that "all acting in motion pictures today stems from her" is even partly true, critical questions emerge.[13] What does Stella Adler mean to the history of cinematic acting? How does her approach challenge our understanding of white masculinity on screen—a classification that routinely defines Hollywood's conception of the Method movie star?

Admittedly, white masculinity is a dubious classification but a necessary one for understanding male actors as a cultural force during the twentieth century. In the simplest terms, white maleness signifies "normalcy" in the ideology of Hollywood; The Method actor's challenging performance of this "norm" signifies disruptions in white hegemony. As Gwendolyn Audrey Foster writes, whiteness, regardless of gender identification, "is a master narrative that is increasingly being questioned and marked. . . . White performances are simulacra, falsely stabilized by master narratives that themselves are suspect and whiteness itself is a construct that needs constant upkeep."[14] Stella Adler's rise to prominence as a teacher from the mid-1940s onward occurs at a fascinating time when such "upkeep" defined postwar culture. The 1950s have been described as the second "masculinity crisis" for whites in American history. Of course, the concept of a hegemonic class like white males having any actual "crisis" is problematic. But the phrase speaks more to the status quo trying to maintain dominance than to any true existential or identity crisis. The first supposed "crisis of masculinity" in American culture occurred as a result of industrialization from the 1890s to the 1910s as a response to changing gender roles in the rising middle class.[15] Various other historical considerations would also factor into the perceptions of "crisis" for hegemonic maleness at this time, with changing gender and racial dynamics in workplaces and a rising awareness of psychological discussions of sexuality. If the 1950s were another perceived "crisis" for white maleness, it must be considered that these two eras were not mutually exclusive and, instead, display a history of masculine identity that could

be consistently challenged. This would be especially true from the Industrial Revolution onward since the first half of the twentieth century saw radical technological modernizations reducing the need for certain forms of labor, two world wars, economic collapse, racial migrations, the influx of immigrant populations, and a growing awareness of gender and sexual identities that challenged traditional binaries.[16]

As James Gilbert writes, "Throughout the twentieth century, at repeated intervals, the remaining pockets in which older concepts of masculinity still prevailed were further undercut, particularly in the 1940s and 1950s with the rise of the companionate, nuclear family, the entrance of women in large numbers into the workforce, and finally by the feminist movements beginning in the 1960s." These challenges often meant white males would reinforce concepts of masculinity "around ideals of difference (a racially, gendered, or sexually oriented other), and in ways that, if only vicarious as in the emulation of celebrities or sports and war heroes, still reasserted some sort of male social dominance."[17] The 1950s prove particularly challenging not only for professional or political reasons but also because the public became more aware of gender and sexual diversity. The popular press was fascinated by a diversified sexual and gender reality analytically designated by Sigmund Freud, whose theories flourished in postwar America, and well documented as social reality by Alfred Kinsey's *Sexual Behavior in the Human Male*, which created a groundswell of controversy on its release in 1948.[18] This cultural moment facilitated a changing perception toward white maleness during the mid-twentieth century, and nowhere does this appear more evident than in the evolution of the movie star.

Analyzing American white maleness through movie stardom is far from a new concept in film studies. The star persona—carried over, to some degree, from film to film—is central to understanding masculinity on screen. As Dennis Bingham writes in his study of James Stewart, Jack Nicholson, and Clint Eastwood, such star personas "have indeed addressed the consequences of white male privilege before a mass audience, deliberately, passionately, as if unable to keep from doing so." While white male stars are representations of hegemony, they can also expose the "undermining of masculinism and the revelation of 'femininities' that conventional masculinities work to contain," as such "subversions take place in cycles—and in different corners of an increasingly fragmented movie industry in different eras."[19] Studies of film masculinity therefore often focus on star personas

during specific eras, as seen in the work of Susan Jeffords on Reagan-era maleness (1994), Gaylyn Studlar on 1920s Jazz Age masculinity (1996), Steven Cohan on 1950s Hollywood masculinity (1997), and my own work on 1930s male film comedians (2013).[20] Collectively, these and other star studies analyze a complex amalgam of maleness on screen that engages their respective historical moments through not only the cinema of the period but also in other media like industry and fan publications. As Cohan maintains, a respective era's stars are "highly charged and conflicted social constructions." The Hollywood star system, which included fan publications in the 1950s, "brings out numerous contradictions arising from the positions of actors as gender models and sexual objects, all underscoring the comparable performativity of masculinity and femininity."[21]

As implied by Cohan's suggestion of a "comparable performativity," the gendered performances studied when looking at male actors are best understood through the foundational theories of Judith Butler—who described gender characteristics as something neither natural nor innate but a self-perpetuating social construct that serves individual purposes and institutions. Working primarily from Foucauldian conceptions as opposed to a psychoanalytic framework, Butler contends gender acts and gestures "are *performative* in the sense that the essence or identity that they otherwise purport to express are *fabrications* manufactured and sustained through corporeal signs and other discursive means."[22] Such fabrications can be considered through social definitions and attitudes more than biology or psychology. As Raewyn Connell writes in *Masculinities*:

> To grapple with the full range of issues about masculinity we need ways of talking about relationships of other kinds too: about gendered places in production and consumption, places in institution and in natural environments, places in social and military struggles. . . . 'Masculinity,' to the extent the term can be briefly defined at all, is simultaneously a place in gender relations, the practices through which men and women engage that place in gender, and the effects of these practices in bodily experience, personality and culture.[23]

This removal of masculinity from a biological or even psychological essential provides a framework for understanding maleness that proves truly

culturally directed. Maleness, in all its forms, is a matrix of social practices and allows for a manner of examining male stardom as representational of social constructs that are fluid in nature.

While such theoretical paradigms offer expansive ways to consider male movie stars, this book wishes to position on-screen maleness away from the label of *star*. While star persona will be a significant consideration throughout, my primary concern is the *actor* behind the image—the performer as a technician defining the body, voice, and movements we see on screen. Undeniably, the distinction between studying the star and studying the actor can be vague, primarily because a performer's acting abilities can, in some cases, define his stardom. Christine Geraghty contends that a star's acting talent can undercut other potent conceptions of stardom—like off-screen reputation, an on-screen persona from film to film, and an association with certain genres, like action or cowboy films. But this distinction does not mean a reputation as a talented actor lessens a performer's position as star. In fact, as other mediums like music and television create more celebrities, for film, "there has been quite a profound shift towards performance as a mark of stardom and the concept of star-as-performer has become a way of re-establishing film-star status through a route that makes its claim through the film text rather than appearances in the newspapers."[24] When film scholarship specifically focuses on "acting" on screen, it thereby does not shy away from analyzing major movie stars. This is certainly seen in two of the most significant studies of cinematic acting, James Naremore's *Acting in the Cinema* (1988) and Cynthia Baron and Sharon Marie Carnicke's *Reframing Screen Performance* (2008)[25]—which cover, among others, Charlie Chaplin, Marlene Dietrich, James Cagney, Katharine Hepburn, Marlon Brando, Robert De Niro, Anjelica Huston, and Denzel Washington.

With masculinity studies in film, the role of acting has been discussed in some notable ways. For example, specific acting choices are deconstructed to comprehend masculinity as performative in the work of Cohan and Bingham, who both reference Butler in relation to on-screen performance. Perhaps masculinity study's most focused examination of on-screen acting is Donna Peberdy's *Masculinity and Film Performance: Male Angst in Contemporary American Cinema* (2011), which examines "the mechanics of masculine performance" of aging movie stars of the 1990s and 2000s, such as Michael Douglas, Bill Murray, and Jack Nicholson. Employing "the specific 'sign

vehicles' that comprise those performances, and the ways in which these sign
vehicles have been read in popular culture," Peberdy addresses "the notion of
masculinity as performance as it is constructed in socio-cultural discourse."[26]
Her study significantly sets some foundations for linking previous scholar-
ship in cinematic acting to masculinity studies with the expressed goal of
understanding the relationship between "the performance of masculinity on
screen (playing a character) and the performance of masculinity off screen
(social roles, gender discourse, and popular culture)."[27] While this statement
encompasses many of my goals, *Beyond Method* expands on this approach by
considering this relationship within a larger history of acting. This book pro-
vides a deeper exploration of acting choices as based in a long-standing the-
atrical history encompassing cultural narratives with their own complicated
gendered discourses. By examining the influence of Stella Adler on popular
male actors, *Beyond Method* provides a documented link between traditions
of acting instruction and the changing image of white maleness on screen.

This book employs the acting instruction of Stella Adler to examine gen-
der practices as they appear on screen within some of the most popular male
actors of their generation. Logically, it is difficult to consider how much any
of an actor's performance can be attributed to a single teacher. But what I
propose in employing Adler as a lens to reconsidering white masculinity
on screen is not that her teaching exists as necessarily a direct influence
on what we see in a single performance. Instead, Adler represents an al-
ternative way to consider the male as not defined by Lee Strasberg or, in
a larger sense, Freudian conceptions of "self"—which privileges a biolog-
ically and psychologically determined gender identity. Strasberg's Method
is a critical component to considering a shift in performance style in the
mid-twentieth century, but it is not the only component. As a complica-
tion on that public narrative, Adler's approaches and philosophies pro-
vide a clearer understanding of how these male actors' performances do
not exist within a vacuum of acting rhetoric (Strasberg, Adler, or even
Stanislavski) or Hollywood production (the marketing of male movie
stars). Adler's promotion of sociological observation and social engage-
ment invites a consideration of how actors could and do engage discourses
of gender both inherent to the text and beyond. Building on the previous
decades' traditions of Modern acting, her approach removes the actor
from the "self" and forces us to consider the performances as matrixes of

social determinants rather than a form of psychological determinism. Her acting instruction provides a clearer path for understanding performance on screen in correspondence to postessentialist conceptions of maleness— gender as theorized by Butler but also examined in a sociological context by Connell.

Approaching Adler's theories to better comprehend male performance on screen does present a challenge in that she saw herself more as an active teacher than a theorist. By most accounts, she viewed her contribution to acting as defined by her face-to-face interactions with students, and those were an extension of her theatrical personality. Being approached about writing a book on acting in 1980, Adler wrote a publisher that she would have to decline: "My work, or what sustains me, is that my work is in depth and I have gotten used to this 'larger than life' means of communication. So I'm stuck. I'm sure you will understand exactly what I am talking about."[28] It was only late in life, with an eye toward her legacy, that she considered the endeavor. She produced only one slender work, *The Technique of Acting*, in 1988, which she wrote with the assistance of Irene Gilbert and Mel Gordon.[29] The text is primarily a step-by-step textbook, with various exercises she employed in her classrooms mapped out for readers in noncomplex terms. Other works, compiled after her death, include *The Art of Acting* (2000), edited by Howard Kissel, which reproduced some of her lectures, and *Acting with Adler* (2000), where her former student Joanna Rotté employs selective lesson plans and her own class notes in recounting Adler's techniques.[30] Barry Paris edited two volumes, also published posthumously though planned during her lifetime, of her insightful analyses of major playwrights, *Stella Adler on Ibsen, Strindberg, and Chekhov* (1999) and *Stella Adler on America's Master Playwrights* (2012).[31] My book references all these works but will make greater use of Adler's archived studio materials, which cover a period from the 1950s to the 1990s. These include audio and video recordings and typed notes, activities, and transcripts. The archived items are especially important since they illustrate how she employed her approach to actual classroom situations and to an expansive social context.

Beyond Method examines male actors who studied with Adler through the lens of her instruction to reconsider on-screen masculine performance as culturally directed. My first chapter sets up this discussion by exploring the mythos of the Method male through the popular press of the 1950s as

an extension of the Actors Studio and Lee Strasberg's rise in celebrity. In this narrative, which suggests the psychology of the actor as instrumental in creating the performance, Strasberg's reputation aided the economic imperatives behind midcentury film stardom. The chapter then provides an overview of Stella Adler's role in the history of acting instruction and many of the foundational Stanislavskian concepts defining her approach, considering her influence as challenging the Method as a legitimate classification for much of Modern acting. In total, Adler's methodology allows us to analyze performance on screen as a form of social engagement rather than just personal expression.

The second chapter explores Adler's foundational lessons on *technique*, which were the focus of first-year classes at her studio, to understand the appeal of the male body on screen. During his early days as a matinee idol in Hollywood, Marlon Brando had a physicality viewed as revolutionary in its sexual appeal. This bodily expression can be understood as an extension of the Stanislavskian techniques championed by Adler, as evidenced by studio materials and recordings, where the concept of the doable action is privileged over the mental "self." Through understanding this privileging of the performing body in relation to Judith Butler's theories of regulatory gender practices, Brando's performances give us new insight into how the actor can incorporate social determinism by observing distinct variations on maleness. By analyzing the gestures and object work of Brando's iconic portrayal of Stanley Kowalski in *A Streetcar Named Desire*, this chapter deconstructs performance choices that determined a version of the body that both celebrated and critiqued sadomasochism's role in constructing a male ideal in post–World War II America.

The third chapter examines Adler's approaches to *characterization*, a topic she taught after technique. She promotes understanding characterization as expressions of both slanted and realistic performance styles. These two classifications relate to traditions of character found in both her background in the Yiddish theater and her training in Stanislavski's System. The approaches allow for a reconsideration of the career of Marlon Brando in the 1970s, which adopted socially determined behaviorism more than psychology as a directive, allowing us to recognize the actor's choices in relation to sociologist Raewyn Connell's theories of masculinities. As Vito Corleone in *The Godfather* (1972), Brando provides a heavily mannered slanted performance based in altering

his appearance and voice. As Paul in *Last Tango in Paris* (1972), he portrays a grief-stricken widower performing violent sexual dominance on a young actress, a sadistic yet realistic portrayal. Most intriguingly, in *The Missouri Breaks* (1976), Brando's queer killer Robert E. Lee Clayton acts out various types in a darkly comic and self-aware exercise, reworking Adler's lessons on characterization into a form of subversive postmodern performance.

Throughout her career, some of Adler's most popular classes were devoted to *script analysis*, which is the focus of the fourth chapter. In records of these classes, she demonstrates an intellectualized process for considering a text's thematic concerns as well as a character's social psychology. In doing so, the text itself, as a predetermined expression of gender, is privileged over the instinctual or improvisational. Another student of Adler, Robert De Niro, is famous for his meticulous preparation for roles, including close analysis of screenplays. As such, his archived script for *Taxi Driver* (1976) provides an insightful example of his preparation through a record of his extensive analytical notes, giving us insight into how a Modern actor engages given circumstances through intellectual exercises. This script analysis illustrates the mechanics of performance from its early stages—showing how De Niro considered gender in creating his volatile depiction of post-Vietnam-War-era maleness. Here, the quintessential male actor of the 1970s displays how much of his performed aggression was not necessarily instinctual but carefully determined by a meticulous understanding of societal context.

The next chapter considers television sitcom performance. In creating the character of Arthur "Fonzie" Fonzarelli on *Happy Days* (1974–84), Henry Winkler credits Adler in helping him to develop an understanding of the stylistics of sitcom acting—demonstrating what Brett Mills identifies as a commedia dell'arte–derived style of comedic performance. Through this, the actor repurposes the motorcycle greaser type that gained popularity with Marlon Brando in *The Wild One* (1953). Fonzie serves not so much as a parody of that performance but a post-Watergate culture's requalifying of pre–Vietnam War era icons of maleness. Winkler's performance can be deconstructed as, in the parlance of Fredric Jameson, a pastiche of the cultural undercurrents defining the popularity of the Method males of the 1950s. By examining episodes from the third season of *Happy Days*, when the series took steps to domesticate Fonzie, this chapter demonstrates how Adler's methodologies and its resulting depictions of maleness are repeated,

recontextualized, and reconsumed for both a different era and medium of mass entertainment.

For the sixth chapter, the book brings Adler's methodologies into the digital age by considering one of her last notable male students, Mark Ruffalo, and his performance as Bruce Banner and the Hulk in the Marvel Cinematic Universe (2012–present). In these blockbuster films, the physicality and externality of Adler's approach correspond with new technological developments in film acting—where, due to motion capture (mocap) CGI technology, the body is removed but the movements remain. Using Sharon Marie Carnicke's employment of Stanislavski's Active Analysis in understanding mocap performance, this chapter considers Adler's own action-based methodology to identify her impact on a new era of cinematic acting. By examining *Avengers: Age of Ultron* (2015), the chapter considers how Ruffalo's performance is motion captured, showing advancements in the technology that allow for more nuanced expression and gesture while privileging an understanding of the character's size in both a physical and emotional sense. Through this, Ruffalo explores fantastical ways to perform the damaging effects of white male rage within the repressed male.

In the conclusion, I consider Stella Adler's approach in relation to women through class materials and recordings focused on female performance. While it is revisionist to classify Adler as a feminist in modern terms, the conclusion considers her notable female graduates as well as her tendency to mentor a teaching staff of women. In relation to these topics, the conclusion also questions how the presence as a strong female voice altered the trajectory of on-screen maleness through a promotion of a relatively complex view of gender identity not found in other classrooms.

1

Strasberg and Adler

Reconsidering the Method Male

They are all gone or going, the film heroes of my youth—the strong, silent types, the fast-talking wiseacre, the sophisticated man of the world. All are going to pasture to make way for the movie hero of the 1950s, and he seems to be a cross between Peck's Bad Boy and Rebecca of Sunnybrook Farm.

Gerald Weales, "The Crazy Kids Take Over,"
The Reporter, December 13, 1956

In this article, Gerald Weales laments the changing nature of on-screen masculinity during the 1950s, crediting Marlon Brando and James Dean as its standard-bearers. The critique playfully associates this new generation of leading men with immaturity and femininity—referencing both George Wilbur Peck's series of books (1883–1904) about a young prankster and Kate Douglas Wiggin's 1903 novel of a young woman coming of age.[1] Weales continues, "The new hero is an adolescent. Whether he is twenty or thirty or forty, he is fifteen and excessively sorry for himself."[2] The piece is responding to the "most grotesque form of the new hero" found in Elvis Presley's debut performance in the supporting role of Clint Reno in *Love Me Tender* (1956), a tragic character who jealously cannot live up to his older brother and ultimately dies.[3] While the music icon's sensitive supporting role is hardly on the same level as the groundbreaking performances of Brando in *A Streetcar Named Desire* (1951) or *On the Waterfront* (1954), Weales notices the dramatic debut of the King of Rock 'n' Roll for what it is—a lackluster attempt to turn Presley into a dramatic star of the same

Method ilk, albeit one lacking the dramatic training of a Brando. While somewhat tongue in cheek, the piece does an insightful job linking together multiple popular culture phenomena and noting a changing perception toward maleness in the culture of post–World War II America.[4] The crux of the argument revolves around dramatic film roles, which the author characterizes as being overwhelmed by "miniature Brandos and Deans" going through "their adolescent tricks."[5]

This image of the new male actor as an immature figure (whether he was playing an adolescent or not) was typical of the period. As Steven Cohan writes in *Masked Men: Masculinity and the Movies of the Fifties*, the emerging Method class of stardom, as it was often covered in the press, positioned the male actors as signifying "the performative elements of their youth: the uniform of black leather jacket, T-shirt, and jeans; the mumbling diction emphasizing inarticulate (and uneducated) speech and deeply rooted (and unresolved) emotionality; an association with New York theater, particularly the style of the Method acting learned at the Actors Studio; an irreverent attitude toward a studio career."[6] The true implications of these figures prove confounding in that they are men without the fully formed implications of a hegemonic adult maleness, existing as somewhat floating signifiers. Method stars like Brando, Dean, and Montgomery Clift can, as Cohan suggests, fall into the "rhetoric of feminization" commonly associated with some of their performances in popular films like *On the Waterfront*, *Rebel without a Cause* (1955), and *A Place in the Sun* (1951). In discussing this dynamic group of young actors and their star vehicles, Cohan contends:

> In his personification of the boy who is not a man, as the new male star of the fifties likewise passes between binarized categories (masculine/feminine, straight/gay, young/mature), he disturbs the ease with which Hollywood's representation of masculinity collapses sexuality into gender. . . . Drawing on Oedipal narratives of generational conflict, the melodramas of this period dramatized the category crisis that results from the displacement of sexuality onto gender.[7]

While older more established non-Method stars of the period like Gary Cooper, James Stewart, Robert Mitchum, and Gregory Peck might have starred in melodramas encompassing Oedipal themes of generational

conflict, it was the Method actors who emerged with personae identified with this genre, playing restless and unstable males central to the narrative.

This chapter reconsiders the cinematic image of the Method male by examining the legacies of two acting teachers routinely associated with this variation of on-screen gender—Lee Strasberg and Stella Adler. Employing the popular press of the 1950s through the 1970s, I examine how Method maleness developed in the public imagination as an extension of the Actors Studio and Strasberg's own rise in celebrity. In this narrative, which suggests the psychology of the actor as instrumental in creating the performance on screen, the mythos of the Method aided the economic imperatives driving popular stardom when a changing landscape of post–World War II maleness needed new icons of psychological vulnerability. Yet this correspondence promotes a limited understanding of acting instruction at the time. The popular perception of Method training promoted by Strasberg did not match the actual training of many of the most famous stars labeled as Method. This chapter then profiles Stella Adler's history as a challenge to the Method, questioning if the label itself fits for many Modern actors. In covering this history, I outline essential concepts to understanding Adler's role as a teacher and a thinker, highlighting how her approach disrupts the notion of a psychologically unified "self" promoted by Strasberg and allows us to comprehend performance on screen as a form of social engagement.

Lee Strasberg and the Method Male

Like most popular press on the Method, George Weales's column misidentifies Marlon Brando's training and highlights Lee Strasberg's influence by complaining too many young actors are copying "mannerisms, by Brando out of the Actors Studio."[8] In general, the new techniques of acting prevalent during the era were largely attributed to Strasberg, often dubbed the "guru of the Method," as they were debated, criticized, or mocked in the industry and popular press. For example, a sprawling *Saturday Evening Post* article on the Studio from May 18, 1957, is filled with excitement over Strasberg and plenty of celebrity name dropping. Here, the Method's controversial position in the industry is characterized as creating possibly too much autonomy for the actor since "enemies of The Actors Studio—and they are many—believe

Stella Adler speaking as Lee Strasberg looks on, 1963. Harry Ransom Center, the University of Texas at Austin.

it spoils actors by encouraging them to imitate life so truthfully that they are not audible, intelligible, amusing or theatrically exciting. Rehearsals of Broadway shows, television plays and films have sometimes been disrupted by Method actors differing violently with a director over an interpretation of a line of dialogue."[9] Interviewed for the article, director Billy Wilder takes the charge even further, suggesting a wide range of immature behaviors for the Method actor that disrupts Hollywood's production and aesthetics: "They are being taught acting by the kind of people who don't believe in under-arm deodorants. They are the types that believe in sitting on the floor, although there are six comfortable chairs in the room. They want to make every actress ugly and dirty. This they think is being true to life; this they think is realistic."[10]

The idea that the Method actor is an unwashed brat who strives for realism to ridiculous degrees appears in other critiques from the period. Cary Grant, perhaps the poster child for a suave and antinaturalistic variation of motion picture stardom, is quoted in the May 8, 1957, *Variety* as highly dismissive of the Method "boys," stating, "I don't quite understand all the fuss over this so-called realism. . . . No, I shall wait until they learn to be clever again."[11] This conception of the disruptive and adolescent Method actor was something fought against by some of the Actors Studio's most successful students, such as Rod Steiger, who notably was not cast as adolescent characters. A few months after *Variety* printed Grant's lament, it reported on August 21, 1957 that the gruff stocky thirty-something Steiger wanted everybody to know that "not everybody that belongs to the [Actors] studio wears dungarees."[12] As such press suggests, while the Actors Studio trained plenty of talented and well-known actresses (including Marilyn Monroe, who brought much attention to the school), the Method actor was often discussed as a "mumbling" and "slouching" *male* figure—something aligned with a rising tide of postwar obsessions over youth and adolescent sexuality. As Cynthia Baron contends, references to the Method in popular culture usually call to mind "portrayals of tough, moody, sexually potent male characters." With Brando and Dean as its early exemplars, "Method acting has become associated with a handful of male stars, whose singular, florid performances stand out from the ensemble."[13]

This popular image of the psychologically vulnerable and immature male actor—a stereotypical product of Strasberg—tellingly emerges at a time

corresponding to the public's fascination with developmental psychology through Sigmund Freud. As James Naremore writes in *Acting in the Cinema*, Method acting as routinely associated with Strasberg is notably different from Constantin Stanislavski's original System, as the American teacher's appropriation "consisted of a series of quasi-theatrical exercises, often resembling psychological therapy, designed to 'unblock' the actor and put him or her in touch with sensations and emotions." The most famous technique with the Strasbergian Method would be the actor developing "an 'affective' or 'emotional memory' that functioned rather like an onion concealed in a handkerchief, producing real rather than artificial tears."[14] Strasberg was introduced to the Russian System primarily through Richard Boleslavski at the American Laboratory in the fall of 1924. In their original Stanislavskian contexts, concepts such as "affective memory" (sometimes translated as "emotional memory") and "sense memory" were not so much about "unblocking" an actor's true emotions as creating an understanding of the characters' responses to the "given circumstances"—the situations as defined by the play text. These types of activities were primarily experimented with in Stanislavski's First Studio of the Moscow Art Theatre, created in 1912 to research and develop his System during its early stages, where his pupils included Boleslavski.[15] In a term borrowed from French experimental psychologist Théodule-Armand Ribot, Stanislavski saw "affective memory" as consisting of revisiting personal emotions and sensations that might be analogous to your character's circumstances. While exploring this technique, Stanislavski also reminded actors that "empathy" toward a character could be as powerful as one's own emotions. Related to "affective memory," in Stanislavski's approach, "sense memory" more directly deals with recalling sights, sounds, tastes, touches, and smells. Often, these exercises would mirror pantomime and aided in creating believable actions in performance.[16]

When Stanislavski's ideas began to dissipate into America in the 1920s and '30s, as Sharon Marie Carnicke writes, listeners "actively filtered Russian ideas through their own social expectations and backgrounds, with cultural contexts sometimes transcending individual interpretations." During this period, a growing interest in Freudian psychoanalysis made "the subconscious and introspective aspects of Stanislavsky's work most intriguing."[17] In this sense, the American Method is a hallmark of the midcentury Americanization and dispersion of Sigmund Freud's theories into popular culture. As

Naremore summarizes, Strasberg's Method was essentially a psychological contextualization of the original Stanislavski school, the latter being more a "distillation of commonplaces that governed Western theater since the seventeenth century, combined with strictures against pantomime and a series of training aids adapted from behaviorist psychology." Reborn in an era of increased psychotherapy, Strasberg's focus on sense and affective memory was Stanislavski "narrowed down to a quasi-Freudian 'inner working' fueled by an obsession with the '*self*.'"[18]

This movement toward psychoanalysis meant Strasberg's Method was less interested in character building and more focused on "realistic" emotional expressiveness. Through privileging the actor's "self" more than the character, "affective memory" and "sense memory" were conflated into *emotional memory* exercises.[19] As Strasberg explains in *A Dream of Passion: The Development of the Method*:

> In the emotional-memory exercise, the actor is asked to recreate an experience from the past that affected him strongly. The experience should have happened at least seven years prior to the time that the exercise is attempted. I ask the student to pick the strongest thing that ever happened to him, whether it aroused anger, fear, or excitement. The student tries to recreate the sensations and emotions of the situation in full sensory terms. . . . I tell the actor "Do not pick a recent experience; not that the recent thing won't work. But the older the experience is, the better it is. If it works, it's going to last for the rest of your life."[20]

With this new focus, Strasberg reformulates Stanislavski through a stricter Freudian lens that, in a sense, rejects the behaviorism and situational text-focused approach found in the original System. Now a long-ago memory is privileged, suggesting a developmental moment from childhood (or a type of "primary scene").[21] As Shonni Enelow contends, with such approaches, Strasberg's Method reproduced key structures and tropes of psychoanalysis, such as:

> Freud's topography of the unconscious, with repressed memories that inhibit free behavior, and the talking cure, in which patients reconstruct their past experiences, leading to a cathartic breakthrough, with the goal

of controlling their psychic and emotional lives. For Strasberg, as for Freud, all action referred back to psychic life; psychical manifestations were secondary. Like Freud, Strasberg insisted that discharge of emotion had a powerful cathartic effect.[22]

As expressed in *A Dream of Passion*, Strasberg saw the true problem of the actor as based in the fact that "almost all human beings have areas of inhibitions, self-consciousness, and embarrassment which made it difficult for them to express as fully on stage as they express in private."[23] While Strasberg would develop other exercises in his career, emotional memory would remain the lynchpin of his Method, described in detail twice in *A Dream of Passion*, where he maintains it is "central to many of the greatest moments in performance."[24]

In the era of popular psychology, an acting technique supposedly presenting psychological realism though quasi-therapeutic exercises truly captured the public's imagination. By the mid-1950s, the mythology of the Method actor was clearly established as the press helped to spread its tantalizing allure. For example, an extensive piece in the *New York Times* from May 6, 1956, called "The Temple of the Method: Tomorrow's Stars—and Quite a Few," gave the reader a peek into the Studio as a trendy and highly desirable school, famous for locating major talent like Brando (once again tied to Strasberg), Clift, Dean, Steiger, Julie Harris, Eva Marie Saint, Paul Newman, Eli Wallach, and others. In the article, Elia Kazan, most likely aware of the need to legitimize the artistic credibility of the school, is quick to credit Strasberg as the "heart, he's the soul of the Studio."[25] Indeed, Strasberg proves the person most interviewed as he stresses the concept of performance as the actor's search for a personal and emotional breakthrough: "We deal with the actor's inner life. . . . Our emphasis is laid on thought, imagination, emotion, which is the basic ingredients of any human being."[26] As described by *Times* reporter Seymour Peck, Strasberg's role has a clear parallel: "In his concern with the actor's deepest, most private emotions, Strasberg seems to resemble the psychoanalyst in modern medicine."[27] The piece goes through the studio techniques of Strasberg and directly relates them to Freudian psychotherapy. Listing the psychoanalyst's techniques of helping the patient move beyond "confusion and inhibitions" to find "the truth about himself through the endless exploration of his past life," Peck then suggests Strasberg promotes

similar techniques so "the actor will be carried through the scene by his true, sensitive, almost unconscious, human, awareness of how the character he is portraying will behave."[28] This publicity establishes a new form of acting as realism directly related to a process of psychological personal discovery by the actor, facilitated by the analyst/teacher Strasberg.

This image of a more "realistic" performer created a new manner of stardom for the male actor that had a long-lasting effect. As Christine Geraghty writes, "whereas in 1950's cinema the Method was associated with the youthful naturalness and rebellion of James Dean or Marlon Brando, cinematic method acting is now a way of marking performance as work and thus claiming cultural value."[29] The early press on the Method, whether negative or positive, highlighted stars as heavily trained actors. In a contrast to earlier versions of movie stars, "Method acting directs attention to the body of the star but shifts it away from the body as spectacle . . . to the body as site for performance, worked over by the actor." With a recognition of there being some sort of methodology driving the appeal, in "a quite conscious way, the audience is invited to recognise what the actor is doing with his face and body" as performance.[30] The label of Method exists as a product or a manner of stardom, related to, as much as any other aspect of marketing a film, the economics of the industry. As Barry King writes, "stardom developed as a response to the intersection of three areas of discursive practice"—which he refers to as "economics—systems of control that mobolise discursive resources in order to achieve specifiable effects." These would consist of the following: "the cultural economy of the human body as a sign; the economy of signification in film; and the economy of the labour market for actors."[31] Despite any idealizations or criticisms associated with the actual techniques of performance, the Method actor clearly fits into King's classifications as much as the major studio star commodities of the 1930s.

Illustrating King's "economics" of stardom, the popularity of the Method star emerges as a direct response to a changing labor market for cinematic actors. The establishment of the Actors Studio as a premiere training ground for film stars post–World War II is very much associated with the labor market and political landscape of Hollywood. As noted by Cynthia Baron and Beckett Warren, the Studio's quick rise to prominence was a "by-product of the anticommunists' success in using allegations of communist influence to control postwar labor unrest in Hollywood," since the Studio filled the

vacuum created by the closing of the Actors' Laboratory on the West Coast, which was discredited for its supposed communist ties.[32] The rise of the Method actor in Hollywood needs to be considered as a phenomenon just as much dictated by economic, political, and cultural factors as any other Hollywood trend.

Admittedly, stardom itself, as the viewer registers it, has a complicated relationship with the actual process of acting, since critics and audiences often characterize the appeal of a personality on screen in mysterious terms. While acting talent has its place in helping to define stardom, we often talk of stars as possessing an elusive "it factor" or "charisma." As Richard Dyer writes, despite its often-uncertain origins, "charisma" is not something to be understood as removed from the cultural-historical aspects related to the commercial appeals of cinema. To understand one of the Actors Studio's most famous students, Marilyn Monroe, who entered the program after finding major success as a sex symbol and comedic actress, the "charisma" of her personality can be discussed as representing a very appropriate postwar appeal. As Dyer writes, Monroe's "image has to be situated in the flux of ideas about morality and sexuality that characterized the fifties in America."[33] We can see her appeal as rooted in the spread of Freudian ideas in postwar culture, the popularity of the Kinsey Reports, the relaxation of cinema censorship in response to competition from television, and the rise of sexually volatile male stars such as Brando, Dean, and Presley.[34]

Along with understanding stardom through such cultural dynamics, it is important to recognize the elements of all screen personalities that register as "performance." As Dyer writes in *Stars*, there are "signs" of performances related to the choices of the actor, which are: "facial expressions; voice; gesture (principally of hands and arms, but also of any limb, e.g. neck, leg); body posture (how someone is standing or sitting); body movement (movement of the whole body, including how someone stands up or sits down, how they walk, run, etc.)."[35] With film performance, these external expressions of movement and voice continue from film to film as the defining attributes of a screen persona.[36] While initially seen as unconventional, the Method star fits into these conceptions of recognizable signs. As Naremore offers, the Method actor as a celebrity image can be understood as a star who was, supposedly, "exposed to ideas of the Group Theater and the Actors' Studio during the late forties and fifties." More precisely, for the consuming viewer, the star exhibited a

combination of "nonconformist 'patterns'" that were noticeable and helped to classify the screen star as Method. These would include a star like Brando appearing in a "naturalistic setting" (that is, a socially realistic drama), acting out "the 'existential paradigm'" (seen through performed "intensity of emotion" perhaps fueled by the actor's use of "affective memory"), and, most notable for audiences of the time, how he "deviates from the norms of classical rhetoric." With this final performance sign, Naremore writes, "Looked at today, Brando hardly seems unusual, but at the time of [On the] Waterfront, he was known for his 'slouch' and 'mumble.' . . . At the same time, his body was almost self-consciously loose."[37] As this suggests, in its seeking of realism in performance through mental and physical work, Strasberg's Method, to the public, supposedly created for males on screen a series of identifiable signs with vocal and physical differences from classical male stars.

While the press of the time could present this new class of performer as problematic for the industry, in truth, they were not all that disruptive to the essential nature of the star system or even film production. It can be argued that the process of filmmaking is defined by fragmentation, never allowing for a complete approximation of any acting technique to manifest on screen. After all, for an actor, making a film proves notably different from acting on the stage where the performance is relatively self-contained and, usually, has a clearer emotional and psychological progression defined by a temporality analogous to both the actor's and the character's performed experience. For example, Marlon Brando performed Stanley in A Streetcar Named Desire nightly on stage in a clear progression without retakes or out-of-sequence moments. But with film, the production process makes such a closed temporal space and prolonged psychological journey impossible for the actor. The realities of production, with its reliance on assembling a performance from various takes, undeniably creates a less unified process of performance.

The differentiation between stage and screen is something that has long been noted by actors and teachers alike. Writing for a 1957 Encyclopedia Britannica entry on acting, Strasberg himself contended, "It is possible to put strips of film together and create a performance that never was actually given."[38] This is not to say film actors have no agency in creating the performance that eventually appears on screen. As Cynthia Baron and Sharon Marie Carnicke maintain in Reframing Film Performance, "Film audiences do encounter performances that have been mediated and modified by the work

of directors, cinematographers, editors, and others. What has been obscured by traditional views about stage-screen opposition, however, is how film mediates and modifies *some thing*, namely discernible performance details with specific qualitative features that carry a delimited range of meanings and connotation." In this sense, directors and editors might select and assemble out-of-sequence takes to create the illusion of temporal unity but, as Baron and Carnicke contend, this is a "selection and combination of recognizable human gestures and expressions that carry dense and often highly charged connotations that can be variously interpreted."[39] Film production might be a more fragmented process than stage but the actor can still dictate the meaning of those fragments of performance, directing the emotional and psychological significance imbued in performed actions and dialogue.

Sharon Marie Carnicke makes a case that Strasberg fits the process of cinematic acting better than other schools, not necessarily because he promoted psychological realism but because he empowered the director in constructing a performance. As Carnicke writes, he positioned the director as the clear auteur helping the actor to access the performance: "Strasberg, in contrast [to Stanislavski], shifts responsibility for the interpretive shaping of performance to the director, a shift clearly sympathetic to film. In the Method, the actor may be central, for the actor is the object of the audience's attention, but the director is 'auteur,' sculpting the role's dynamics from the actor's credible, 'real,' emotional life as if from living clay."[40] In this often overlooked aspect of Method training, Strasberg insisted on the authority of the director, considering the "problem of acting solved" when the actor "is capable of giving to the director anything that he wants."[41] Also, other elements of Strasberg's Method would correlate well to film production. Two of his most famous techniques for keeping a scene psychologically realistic lend themselves nicely to out-of-sequence filming: emotional memory and the private moment (where one performs in public an action as private). In using such exercises to create a "logic" or "reality" for a scene, the actual larger narrative context or consecutive order of circumstances is less necessary. As Carnicke posits, "Personal, 'private' logic can be created without a script or partner, in the absence of a consecutive flow of story, in the absence of sound effects and atmosphere. The techniques of affective memory and private moments allow actors to maintain emotional continuity under the fragmented experience of film work." In commercial terms, "while Stanislavsky proposed

an ideal for artistic creation, Strasberg transformed it into practical tools for the contemporary business of film acting."[42]

All these points suggest the rise of Strasberg's Method as a logical convergence of societal and industrial factors that facilitated a new type of male stardom. The psychological introspection of emotional memory could capture the public imagination and only aid in the selling of a star personality. The fragmented nature of film production could be served by an acting process that focused on the personal and private to unlock realistic moments. The changing landscape of postwar maleness resulted in new masculine types in storylines that depicted psychological vulnerability and often privileged developing male psyches. These factors fit neatly into the public fascination with new stars that were products of Strasberg's tutelage, with its quasi-Freudian focus on "self." But, in many ways, all these corresponding industrial, cultural, and psychological components fit too neatly together to create a narrative of phallocentric artistic exploration. They leave little room for engaging the performances of these Method males as something more complex and deconstructive of gender in a manner that challenges Freudian developmental narratives. More concretely, a major complication arises in the fact that Strasberg might have been the public face of the Method but, behind the scenes, his role as "guru" can easily be contested. In fact, the very concept that his Method defines Modern acting—specifically, the style of many of the male stars of the mid-twentieth century—itself is a dubious claim. What Strasberg represents, a Freudian focus on the actor's "self," was consistently challenged by other influential teachers. The most public of which was the woman who challenged his authority directly at the Group Theatre.

Stella Adler and the Thinking Actor

To grasp the development of the male actor from the 1950s onward, the complex history of Constantin Stanislavski's influence on American theater must be understood as a constantly evolving and heavily contested theatrical practice. And Stella Adler has a crucial role in defining its core debates. As Sharon Marie Carnicke writes in her history of the Russian teacher's enormous influence, in New York City, this history originally started under the direct influence of teachers trained by Stanislavski, Richard Boleslawski and Maria

Ouspenskaya at the American Laboratory Theatre, only to be reconfigured by Strasberg at the Group Theatre, founded in 1931 and disbanded in 1941, and then later, more notably, the Actors Studio, founded in 1947 and still active today. As stated in my overview of Strasberg's influence, this evolution was one toward more of an overt Freudian-psychological introspection: "In the United States, conditioned by a Freudian-based, individually oriented ethos, actors privileged the psychological techniques of Stanislavsky's System over those of the physical. The Method, as it became known in New York, defined itself primarily through this one aspect of the multivariant, holistic System."[43] As Carnicke suggests, "Stanislavsky's influence in the United States was far from cohesive or coherent. In the theatre world, obsession with his System has led to a seemingly endless hostility, like religious fanatics, turning dynamic ideas into rigid dogma."[44] While in the popular culture of the second half of the twentieth century, Strasberg became the public face of a new type of acting and the mouthpiece for Stanislavskian "realism," behind the scenes, his prominence was hotly contested and, perhaps, his most vocal critic was Stella Adler.

Unlike Strasberg, born Israel Strasberg in Austria-Hungary, the son of a garment presser, Adler was born into the theater.[45] The youngest daughter of Jacob and Sara Adler, her family was widely known as the Jewish American Adler acting dynasty, major immigrant stars of the Yiddish theater. While often forgotten today, located on the Lower East Side, the American Yiddish theater of the late nineteenth and early twentieth century was crucial to the New York City theater scene and served as a forerunner to the movements of realism found later in the American theater through the Group Theatre and playwrights such as Eugene O'Neill and Clifford Odets. Jacob and Sara Adler were instrumental in developing the immigrant theater beyond the *shtick* or *shund* ("trash" art) of burlesque and operetta farces, performing not only Shakespearean classics in Yiddish but also the works of modern playwrights like Henrik Ibsen and Anton Chekhov.[46] The theater where Adler grew up was never afraid to address social issues, something the other popular theater of the era eschewed. As Stella Adler biographer Sheana Ochoa writes, "During the Yiddish theater's heyday, while Broadway was still showcasing farcical operettas and Victorian melodrama, the plays downtown highlighted current events," including new works that addressed issues of religious persecution, poverty, women's rights, and even birth control.[47] In this atmosphere, Jacob,

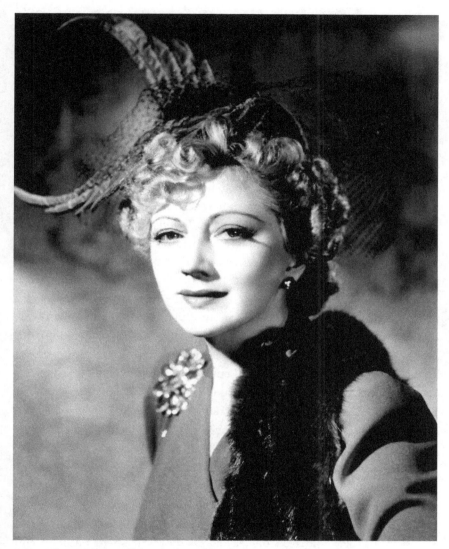

Stella Adler, publicity still for *Shadow of the Thin Man* (1941).

the patriarch, established a reputation for him and his family so respected that when the Moscow Art Theatre troupe toured America in the early 1920s, Stanislavski rushed down from his hotel room in this robe and slippers to greet the "Great Adler," who was too ill at that time to make the trip upstairs.[48]

Outside of Jacob Adler, unquestionably the most important figure in Stella Adler's life in terms of professional development would be Constantin Stanislavski. She spent five weeks training with the Russian practitioner in 1934, something Adler referenced throughout her lifetime, making it a centerpiece of her professional identity as a teacher. Since none of her American contemporaries could make the claim to have actually studied with the father of Modern acting, Adler consistently referenced the experience in interviews and, more significantly, in her studio. In *The Technique of Acting*, she includes a recollection of the meeting as the final chapter, ending the remembrance with, "I had worked with the master teacher of the world, the man whose words were going to flood the world with truth."[49] During her final interview with Barry Paris in 1992, Adler focuses heavily on her memories of Stanislavski and proceeds to retell the story, suggesting that the account in *Technique* was "diminished."[50] The meeting was facilitated by Adler's frustration with Strasberg's employment of Stanislavski, as she grew increasingly disheartened by the Group Theatre's psychological emotional memory approaches and by Strasberg's lack of interest in the actual techniques used by the Moscow Art Theatre. Adler, Strasberg, and director Harold Clurman had traveled to Moscow to view the Art Theatre's performances, which failed to impress Strasberg, who later told his biographer, "It was so bad I couldn't believe what I saw."[51] Adler was dismayed by his disrespect and lack of understanding, telling Paris in 1992, "He [Strasberg] and I went to meet the head of the Moscow Art Theatre or somebody that was important . . . He [Strasberg] said, 'We do it better than you.' . . . He was a man of great arrogance."[52] When the chance to meet Stanislavski in Paris arrived on leaving Moscow, Strasberg declined and Clurman and Adler went on to meet the Russian master. As the story goes, Adler stood quietly during most of the initial meeting and, when finally engaged directly, said, "Mr. Stanislavski, I loved the theatre until you came along and now I hate it!"[53] In response, Stanislavski agreed to train her in the ways of his System in his Paris hotel room for five weeks.

While his response to Adler's outburst might seem surprising, in truth, Stanislavski was aware that the beautiful and outspoken actress, from a

world-renowned acting family, presented him with an opportunity to reinforce his System stateside with a charismatic American. As Adler suggests, "I was a very pretty girl. And the Russians are not unaware of the theatrical personality and I have that. . . . And what he wanted, I think, in talking, is that he wanted his theories, his philosophies, to be taken over by a beautiful American girl who understood him."[54] Ironically, despite Adler's later influence on American acting, Stanislavski would recall his meeting with her, though never mentioning her by name, as somewhat wasted time since Adler had learned most of the System's basics from Boleslawski and Ouspenskaya's program at the Laboratory Theatre, even if those lessons had been heavily muddled by Strasberg at the Group. He wrote, "I had to take her on, if only to restore the reputation of my system. I wasted a whole month on it. It turned out that she had learnt it right. She had been shown and had studied everything in the school [Laboratory Theatre]."[55] While Stanislavski was probably right in his assessment that Adler learned much of the total System beforehand, she certainly found her time with him enlightening and clarifying in a manner that did inspire her to become an acting teacher. These lessons with Stanislavski can also be viewed as a strategic move by Adler, giving her instant credibility to challenge Strasberg's authority as a facilitator of the System in the Group Theatre.

Later in 1934, Adler returned to New York City with her notes and a complete chart of the System in hand, proceeding to lecture the Group actors on what she learned. As Carnicke writes, "When Adler spoke to the Group Theatre that summer about then unfamiliar aspects of the System, she split the Group into camps and challenged Strasberg's sole authority."[56] In direct defiance of Strasberg's teaching, she opposed his take on emotional memory with new information on how the play's *given circumstances* shape characterization. In essence, personal emotional experience might be used as a reference point to remember behavior but only selectively since plays usually have different historical and situational contexts than an actor's personal history. Adler's "new" knowledge of the System stressed the power of the actor's *imagination* and what would later be labeled as "the Method of Physical Action" by those who study Stanislavski. Strasberg dismissed this suggestion and declared that he taught not Stanislavski but an interpretation that could be understood as the "Strasberg method," and "that we used the practice of affective memory in our own way, for our own results," which essentially

would develop into "the Method" in the popular vernacular.[57] As Carnicke posits, by making this declaration, Strasberg "described both the gulf that had opened between the American and Russian evolutionary branches of Stanislavsky's work, and a rift in the American theatre that exists today."[58]

In the Group Theatre, Adler's challenge to Strasberg split its members in ways that influenced decades of acting instruction, defining many of the American techniques that emerged during the second half of the twentieth century. Group member Sanford Meisner had also grown dissatisfied with the emotional memory focus and, when hearing of Adler's new instruction, championed her methodology over Strasberg's. Eventually, he wrote to Adler's brother, Luther, that she "be given an executive position with complete authority over the artistic problems of the theatre," as she "is eminently capable of working in the only way I would consider as being the right 'common method' for the Group. She alone in the entire company understands and practices the Stanislavsky system."[59] Meisner would go on to develop his own "Meisner Technique," which rejects Strasbergian emotional memory to focus more on the interaction with other actors, embracing an important component of Stanislavski's "given circumstance" as it appeared in his later incarnations of the System.[60] Also a key figure in the Group Theatre, Robert Lewis went on to cofound the Actors Studio in 1947 and break away within a year due to, among other things, conflicts with Elia Kazan. Along with heading up Yale's drama school for many years, he published the highly read *Method—or Madness* in 1958 to clarify Stanislavski at the height of the press's obsession with the Studio and Strasberg. In the book, he included the actual detailed chart Adler brought back with her from Paris in 1934, correctly crediting her as clarifying Stanislavski for the Group.[61]

Despite these conflicts, it can be suggested that both Alder and Strasberg simply embraced different evolutionary steps in Stanislavski's System, which, unlike the two American teachers' approaches, significantly evolved throughout the Russian's lifetime. Strasberg focused on elements that had been of concern early in Stanislavski's career, which the American teacher had learned from Boleslawski, a member of Stanislavski's First Studio where sense and affective memory, while used in a different manner than Strasberg's later Freudian reappropriations, were studied. By 1934, the Russian teacher had begun to question his earlier techniques and created what would be dubbed "the Method of Physical Action," the planned basis of his final book in his

trilogy on acting, which was assembled by others and published in translation in America as *Creating a Role* in 1961, long after his death.[62] Here, the external physicality of performance was stressed more than the interior mental preparation since it could lead to a logical way to embrace the circumstances of the play and, in turn, create a characterization aligned with the text. As he writes in *Creating*, "An actor on the stage need only sense the smallest modicum of organic physical truth in his action or general state and instantly his emotions will respond to his inner faith in the genuineness of what his body is doing. In our case it is incomparably easier to call forth real truth and faith in it in the region of our physical than of our spiritual nature."[63] This focus on the physical privileges the "given circumstance" of the play's narrative (the "doing" of the scene) more than the interior psychology. In this regard, as Carnicke writes, Strasberg and Adler "do not represent a radical change in the System as is often assumed, but rather a cross-section of the master's continuing experiments."[64]

The split between Strasberg and Adler takes on different connotations when removed from a history of twentieth-century acting as singularly derived from the lineage of Stanislavski, which is admittedly a limited purview. In *Modern Acting: The Lost Chapter of American Film and Theatre*, Cynthia Baron explores the underexamined histories of actor training that existed in the manuals, theater programs, acting schools, and studio back lots during the 1930s and '40s, before the rise of the Actors Studio in 1950s. To Baron, "Method" was a term mainly devised by Strasberg, a master of self-promotion, and does not properly characterize the crucial developments in performance styles occurring well before the Actors Studio. Instead, she proposes the term "Modern" to explore a multifarious history of twentieth-century American acting as that term regularly appeared in lessons from the era that privileged detailed script analysis and character building to adapt to new forms of stage and screen entertainment. Not discounting the undeniable influence of Stanislavski on world theater, Baron contends that during the first half of the twentieth century there existed a more general sense of "Modern acting techniques" that represented "one set of strategies American acting teachers formulated to facilitate performances keyed to the aesthetic priorities of modern drama and stagecraft, which emerged in the late nineteenth century, gained influence in the early twentieth century, and influenced American film and theatre in the 1930s and 1940s."[65]

Baron's description of the 1934 split between Strasberg and Adler shows Adler as more attuned to these Modern methodologies, as they were already permeating the theater landscape: "Adler's interest in circulating Stanislavsky's ideas illuminates a period on the timeline of American acting history, one distinguished by the articulation of Modern acting principles. Her involvement in the study and teaching of acting strategies is noteworthy not for its singularity, but because it is indicative of the era."[66] Many of the foundations of Adler's lessons actually reflect much of what was already viewed as Modern in the acting manuals of Sophie Rosenstein (author of 1936's *Modern Acting: A Manual*), Josephine Dillon (1940's *Modern Acting: A Guide for Stage, Screen, and Radio*), and Lillian Albertson (1947's *Motion Picture Acting*) as well as in the acting instruction found during the period at the American Academy of Dramatic Arts in New York City (1884–present), the Pasadena Playhouse in Pasadena, California (1924–present), and the Actors' Laboratory in Hollywood, California (1941–50).[67] Baron characterizes Adler's teaching career more as a continuation of Modern techniques during the rise of Strasberg rather than a counterversion of the Method. Understanding many of the discourses already used in Modern acting as well as understanding theater history, due to her upbringing on the Yiddish stage, Adler represents a broader spectrum of theatrical traditions beyond the Russian school. As a distinct facilitator of Modern acting, which should be viewed as "both affiliated with *and* distinct from Stanislavsky," Adler existed during the second half of the twentieth century as a powerful voice continuing many traditions of acting that Strasberg dismissed.[68]

Despite this expanded knowledge of approaches and traditions, unlike Strasberg or Meisner, Adler never claimed to develop her own technique or method as much as serve as an ambassador of Stanislavski's ideas. This embracement of her time with the Russian teacher often tended to place her career in the shadow of Strasberg. Baron writes, "While that move [promoting her Stanislavski training] gave her credibility, it also failed to distinguish her approach from Strasberg's—because he too presented his work as building on Stanislavsky."[69] As Strasberg gained more press coverage, Adler grew increasingly frustrated that his approach was viewed as solely representing the Russian System. In November 1964, at the height of the Cold War, Adler was instrumental in organizing a Soviet-American summit on acting hosted by the Institute of International Education. She arranged from the Moscow Art Theatre the inclusion of its director, two actors who studied with Stanislavski,

and a historian of Soviet theater.[70] In addressing those in attendance, Adler gave the basic history of the System's introduction to America, correctly crediting Boleslawski and Ouspenskaya and diplomatically calling Strasberg "a brilliant director and a very nice man." Although she was also quick to dismiss the "emotional memory" approach as "insane" and, in recalling her time with the Group, "that insanity took the form of working very much with the memory of the actor's past." In contrast, Stanislavski taught her "it was mostly the truth of the circumstances, where as in America the influence was to take your own circumstances and go back to while you were here."[71]

By 1964, as evidence in transcripts of the summit, Adler was aware that much of the popularity of Strasberg grew in correspondence with a rise in popular Freudianism, suggesting, "Stanislavski and Freud have been placed together. This has been a major influence: self-analysis through acting."[72] A Moscow delegate seems perplexed by her mention of Freud and, in general, the split represented by her and Strasberg, suggesting, "To us Stanislavsky and the basis of his theory is really so sound and so healthy and so far divorced from Freud." Adler clarifies:

> Mr. Strasberg emphasizes that the actor can do what he wants, without regard to the idea of the play or the character. This creates the personality actor in America. That is, the actor that does not play the character, does not play the play, does not play the idea of the play. The soul of the actor. The first point is that it is Freudian and the second it is the emphasis of the actor's personality rather than the play's idea.[73]

In some ways, Adler is providing a critique that is often directed at Strasberg, that he fueled an obsession with "self" as realism and, in turn, diminished the theater by promoting personal expression over theatrical performance. As Naremore writes, "a case could be made that they [Strasberg's approaches] impoverished the theater—feeding the star system, promoting conventional realism at the expense of the avant-garde, and giving American drama a less forceful social purpose."[74] Significantly, Adler is also quick to clarify that the emphasis on "personality" is not exactly stardom in the traditional way we consider the term but an appeal to the individual "selfness" behind a constructed persona. She goes on, "It is not so much two schools. The American system has wanted to buy the person, not the character. . . . It is not quite

the star system. It is a system of everybody being a star if he is himself." In this view, "self" on screen or on stage would be the apex of realism and the standard of quality. In Adler's counterview, this approach proves problematic since stardom might be achieved simply through a successful transmittal of one's "self" as opposed to the ability to craft a characterization. As she suggests to those in attendance, if we strictly follow Strasberg's thinking, "The dog is a big star because nobody can be a dog."[75]

While Adler's career as a teacher began at the Group Theatre in 1934, it flourished as her own stardom on stage (and briefly, less so, on screen) began to wane.[76] During the 1940s, she immersed herself more in the training of actors, teaching at Erwin Piscator's Dramatic Workshop at the New School for Social Research, New York City, before founding her own studio in 1949. While running her studio from the 1950s to the 1970s, Adler also taught classes and, for limited periods, headed up the acting programs at Yale University and New York University. Her New York City studio grew throughout the 1970s and, eventually, a branch opened in Los Angeles in 1985. Both the New York City and Los Angeles studios are still in operation today.[77] Throughout the later period of her life, in contrast to the 1950s and '60s, Adler's reputation grew in the popular press as an awareness emerged that she represented a vocal criticism of Strasberg. An October 7, 1979, *New York Times* piece titled "Can the Method Survive the Madness?" outlined the differences in the two teachers' approaches and showed how their professional rivalry had grown increasingly vicious over the years, with both not holding their tongues in criticizing the other. Adler tells the reporter, "Strasberg uses a great gimmick of intimidating through the psychoanalytic. . . . He produces this neurotic actor. His teaching is painful and dangerous."[78] As her criticism of Strasberg made for good press, Adler's reputation grew and her approach to acting started to find some validation, especially since her most famous pupils, Marlon Brando, Robert De Niro, and Warren Beatty, by the 1970s, represented to cinephiles thoroughly Modern actors.

Despite this growth in celebrity as a teacher and the expansion of her studios, the early and more modest days of her studio best illustrate her primary concerns in interpreting elements of Stanislavski and promoting pre-Strasbergian Modern acting techniques. A 1958 brochure for the "Stella Adler Theatre Studio" promotes how the "two year course leads the actor through specific exercises dealing with his inner means that are designed

Stella Adler (*left*) teaching at the New School for Social Research, 1940. Courtesy of Corey Parker.

to prepare him to analyze the script, create the character, and do the play."[79] Programs of study are listed as the following, for the first year:

Principles of Acting—Beginning Miss. Adler
(1 term, 15 weeks per term; three times per week, 4 1/2 hours, Fee $250.00)

Principles of Acting—Advanced Miss. Adler
(1 term; 15 weeks, three times per week, 4 1/2 hours, Fee: $250.00)

And for the second year:

Characterization Miss. Adler
(1 term; 15 weeks, three times per week, 4 1/2 hours, Fee: $250.00)

Analysis of Plays Miss. Adler
(1 term; 15 weeks, three times per week, 4 1/2 hours, Fee: $250.00)[80]

"Principles of Acting" would later be labeled in her archived materials as "Technique" or "Techniques," and those class activities serve as much of the basis of her 1988 book, *The Technique of Acting*. These are based very much in late-career Stanislavski and "given circumstance" as a means to approach performance. Characterization was taught after technique to build a fuller performance based off scene analysis, and the culmination of these ideas would serve in the analysis of whole plays. Elements of scene analysis were taught in correspondence with scene work that aided in the teaching of both technique and characterization. Clearly, these three areas—*technique, characterization*, and *script analysis*—were considered fundamental to Adler. She solely taught them at her studio for years—with other classes listed as electives, featuring multiple teachers covering vocalization, mime, dancing, staging, and so on. Later in her career, the studios on both coasts grew to include a more expansive faculty and course offerings. Yet the core of her two-year program would always consist of technique, characterization, and script analysis, often taught by her disciples under the guidance of Adler. These three classifications also dictated how her classroom materials were archived.

Variations of these approaches had been taught in other acting programs during the 1930s and '40s. As Baron discusses, documents left by the teachers of that period "reveal that the era's acting experts carefully outline a preparation process that entails identifying characters' given circumstances, objectives, and intention-laden actions, and a performance process that involves maintaining a focus on the characters' problems and actions scene by scene."[81] In her lessons, Adler took many of these earlier directives of Modern acting and steeped them in a Stanislavskian present-tense approach to performance, highlighting a central tenet of the Russian teacher, *experiencing*. As Sharon Marie Carnicke defines it, "experiencing" represented to Stanislavski the "ideal kind of acting, nurtured by the System, in which the actor creates the role anew at every performance in full view of the audience; the actor's creative process itself. Such acting, however well planned and well rehearsed, maintains an essentially active and improvisatory nature." The System "generates a synonym for 'experiencing' in 'I am,' . . . which stresses the actor's immediacy and presence on stage."[82] Reflecting this general tenet, Adler conveys in *The Technique of Acting* that the "aim of your approach to acting is to find the actions in a scene or play. The actions must be do-able, and they can be expressed by using the verb form."[83] In contrast to emotional memory or,

more generally, an actor's psychological deconstruction of a character, Adler's approach emphasizes the present and immediate sensation of experiencing the circumstances—which, however debatable the labels, could be considered a more *external* approach in contrast to Strasberg's *interior* approach, which taps into past moments to create "realistic" emotions.[84]

Stanislavski's focus on "given circumstance" would also be of interest to Adler since he stressed textual analysis. In *Creating a Role*, while not dismissing searching "in the actor's own soul for emotions common to the role," Stanislavski promotes practicality in script analysis: "Analysis dissects, discovers, examines, studies, weighs, recognizes, rejects, confirms; it uncovers the basic direction and thought of the play and part, the superobjective and the through line of action. This is the material it feeds to imagination, feelings, thoughts, and will."[85] Adler, though, stressed script analysis as not only a means to a more physical (or behavioral) approach to realistic performance but also as instrumental to performing modern drama since, unlike classical drama, the moderns facilitated ideas more than emotions. In *Technique*, she stresses: "The discussion of ideas is at the center of the modern theatre. . . . The modern theatre is the theatre of ideas, a theatre whose purpose it is to make an audience think and learn about the larger questions of life."[86] The *ideas* of theater became a centerpiece of her approach to teaching acting, since she saw the work of Henrik Ibsen, George Bernard Shaw, Eugene O'Neill, Clifford Odets, Arthur Miller, Tennessee Williams, and Edward Albee as necessitating Modern acting and, in turn, Modern acting meant "one must recognize the difference between issues of varying weight and importance, and judge between the larger and the smaller ones."[87]

In the upcoming chapters, I will examine male actors through the lens of Adler's three primary concerns as a teacher—*technique, characterization,* and *script analysis*. These three areas of training, as documented in the teacher's archived studio materials, provide a foundation for understanding the male actor on screen beyond the focus on "self" found in Strasberg's embracing of psychological introspection. While Adler never proclaimed to have her own technique or method, in truth, like Strasberg or Meisner, she highlighted elements of Stanislavski as well as other Modern techniques that corresponded to her own preoccupations in the theater. And these ideas reflect a clear philosophical purpose. In presenting her approach as a counter to Strasberg, she focused and refitted elements of the System to promote social context over

psychology. Adler privileged late-career Stanislavski, yet this approach was appealing to her due to her belief in a *thinking* actor as opposed to simply a *feeling* actor. From a gender perspective, as suggested by Rosemary Malague, this approach proves radically different from Strasberg as teacher/analyst: "The fact that Adler trains actors via political debate presents new prospects for thinking actors—and for feminists. Any actor who understands a play and can debate its meaning can also imbue a performance with her own perspective."[88] While Adler rarely addressed feminism in the classroom (at least not in terms of the gender dynamics of the students), the self-empowerment of an actor was a consistent goal. In her teaching, she saw a social awareness beyond "self" as almost a spiritual aim for the actor. In *The Art of Acting*, she stresses a point that runs throughout class recordings: "There is one rule to be learned. Life is not you. Life is outside you. If it is outside, you must go toward it. . . . You may have been corrupted into thinking that you are important. If so you are a lost creature waiting for the world to come to you."[89] In the next two chapters, we will see how this philosophy informs the performances of Adler's most famous student, Marlon Brando, as he employs Adler's lessons in technique and characterization to create unique images of on-screen masculinity.

2

Technique and Doable Actions

Marlon Brando in
A Streetcar Named Desire (1951)

MARLON BRANDO—He beat up Vivien Leigh in *A Streetcar Named Desire*, and led a troupe of younger actors into imitating his torn shirt, sullen body-building acting.

Vogue, May 15, 1953

This description of Marlon Brando appears in a bizarre item titled "Beefcake for Cheesecake" from a 1953 issue of *Vogue*. The two-page photo spread combines publicity photos of three of the era's most popular male stars in revealing poses: Kirk Douglas is shirtless as a trapeze artist from *The Story of Three Loves* (1953), John Wayne is captured mid-action with his shirt open from *Big Jim McClain* (1952), while Brando stands sullenly with his ripped tank-top tee from *A Streetcar Named Desire* (1951), hair mussed and muscled arms exposed. Cheekily eroticizing the bodies of these male stars as "beefcake" in a manner more commonly used for female bodies (or "cheesecake") might seem queerly progressive. Yet the piece negates such subversion by reminding the reader that these bodies are aggressive and abusive of women: "These three healthy beaters of women in the movies are male pin-ups, virile, half-naked, and deliriously in demand."[1]

Similar to the sentence on Brando, each star's abusive performance is outlined next to the partially nude body: Douglas "threw Lana Turner, dressed, into a swimming pool in *The Bad and the Beautiful* [1952]," and Wayne

Vogue, May 15, 1953.

"dragged" Maureen O'Hara "several Irish miles, mostly by her red hair" in *The Quiet Man* (1952).[2] The photo spread directly correlates the desirable male body with acts of violence against women, providing an illustration of the conflicted nature of eroticizing the male body in Hollywood. The essentials of Laura Mulvey's well-known assertion that in "a world ordered by sexual imbalance, pleasure in looking has been split between active/male and passive/female" are apparent as *Vogue* negates the male bodies' gaze-worthy desirability with "action" as opposed to a passive "to-be-look-at-ness."[3] Instead of what is usually just a subtextual violence, the actions appear here as the overt physical and sexual abuse of women.[4]

The spread challenges us with an intriguing question about the appeal of the male body on screen. What role does violence, sexual or otherwise, play in its eroticization? After all, even the most violent of male stars on screen can alternate between sexual dominance and something more passive, creating an appeal in correspondence with a desirable sadomasochistic sexuality (to which the photo spread seems to be attempting, yet failing, to appeal toward). As Miriam Hansen writes in her reading of a foundational male star in Hollywood history, Rudolph Valentino, hetero-male desirability on screen can have

clear sadomasochistic dynamics alternatively cruel and sensitive in actions: "The vulnerability Valentino displays in his films, the traces of feminine masochism in his persona, may partly account for the threat he posed to prevalent standards of masculinity—the sublimation of masochistic inclinations after being the token of the male subject's sexual mastery, his control over pleasure."[5] Displaying such control, most males do not necessarily fear being eroticized and desired. As Peter Lehman writes, a male is "driven to look at, and talk, and write, and joke about his 'exhibitionist like.'"[6] The erotization of the male body can hold a power through the performance of the "active," which encompasses both implied and overt violence as a desirable trait.

The sadomasochistic appeal of the eroticized male body on screen becomes of particular interest when considering Marlon Brando's rise to stardom as it invites questions concerning the role of acting itself. In discussing her famous pupil in 1955, Stella Adler commented on his "great physical beauty—not just in good looks, but that rarer thing that can only be called beauty," which she acknowledges, along with his acting talent and charisma, as defining his appeal.[7] He was truly a "beefcake," more muscular than other male stars of the era. As Kenneth Krauss writes in *Male Beauty*, "The young Brando was a beautiful looking man. Sometimes his roles demanded that he change his appearance, but with most of his characters, audiences could still catch glimpses of the handsome face and muscled body."[8] As conveyed in the *Vogue* photo spread, his "torn shirt" and "body building" constitute a manner of "beauty," though one that could also be an aggressive sexualized image that arose after the popularity of *Streetcar*. Yet it must also be noted that here and elsewhere his appeal was routinely sold as something new and exciting in acting.[9] This conception of him as a new kind of actor was not in addition to his desirable muscular and youthful body but viewed as an extension of it. In early press, his body was celebrated as an actor's instrument while his voice was initially viewed as bizarre in contrast to his impressive physicality. For example, a 1952 article titled "Marlon Brando: Actor on Impulse" suggests, "Hollywood technicians say he has picked up the different screen techniques faster than any stage actor they've known," yet "diction is Brando's one big acting fault. His voice is Midwestern, flat. He reads lines in a monotone, and is striving to correct this."[10]

Stories on Brando from the period label him as a curiosity, a star whose masculinity did not conform to previous generations of stardom or maleness.

As Krauss notes, "What made Marlon Brando so emblematic of masculinity during the postwar era was his consciousness of and discomfort with who and what he was." This was an appeal very much corresponding with how the actor performed roles, "Brando demonstrated that he was perfectly capable of playing a 'man' in contemporary terms, made it possible for spectators to recognize that performing masculinity might not be as restrictive an activity as society at large decreed it was."[11] Similar to Montgomery Clift and other transgressive young actors of the era, as Steven Cohan suggests, this appeal was defined by a manner of "masculine masquerade," with "implications of performativity and bisexuality" born out of "his early star status as a transgressive boy."[12] The press would relate Brando's youthful sexual allure directly to his performance choices as well as to his wild-child anti-Hollywood image. Such a view appears in a 1953 *Saturday Evening Post* profile, which paints the star as emotional and contemptuous of Hollywood, "difficult to pigeonhole."[13] When discussing his sexual allure, the article highlights his performances over his off-screen persona. Similar to the sadomasochistic sexuality encompassed by Valentino, Brando is discussed with a focus on both a sadistic "masculine" and a sensitive off-screen "feminine" persona, with the latter described as a "four-handkerchief sentimentalist" that "wept copiously at the touching spots" of *The Yearling* (1946) and *The Wizard of Oz* (1939).[14] The article quotes film producer George Glass in characterizing the sexual allure of Brando's breakthrough stage role as Stanley in *Streetcar*: "Dames breathe heavy in his wake. . . . They say there is a large shot of masochism in every dame. I wouldn't know. I do know they shivered and wriggled at the way he talked." The producer is quick to state that this brutish appeal is all performance and constructed, something Brando can turn off and on: "But don't get the idea he's an inarticulate mumbler. He can talk straight out of a pear tree if he wants to. I hear he is talking that way now as Marc Anthony in *Julius Caesar* [1953]."[15]

Glass speaks to something rarely considered when discussing sex symbols on screen—the performance choices themselves, which are fundamental to defining the allure of an actor. With Brando, we are presented with Stella Adler's most famous student and, for this book, a performer who serves as a standard-bearer to her acting methodology. While it is difficult to suggest Brando derived all his techniques from Adler, his consistent crediting of her positions him as not truly a Method actor, at least not

in the vein of Lee Strasberg's approach of privileging emotional memory. Instead, Brando developed Modern acting techniques on screen as an extension of Adler's lessons, through stressing what she defined as "do-able actions," externalizations of performance motivated not by Freudian psychology but by sociological observation. To consider Brando as performing a culturally fluid masculinity, this chapter examines his iconic performance in Tennessee Williams's *A Streetcar Named Desire*. Williams, one of the era's most astute observers of modern maleness, was a writer who fascinated both Adler and Brando. By understanding the film adaptation as a performance showcase, the bodily appeal of Brando emerges as a clear gender construction that exists in correspondence to theories of Modern acting. Through these, the actor deconstructs the violence inherent in postwar conceptions of desirable maleness. Using Adler's lessons on *technique* as a lens, the performance choices of Brando illustrate how dominant physical and sexual aggression correlate to an image of the white masculine body on screen as desirable. Brando's iconic performance exists as an amalgam of performed cultural considerations popularly defining the postwar white male.

When Brando Met Adler: Teacher and Technique

In *Brando's Smile*, Susan L. Mizruchi characterizes Brando as the consummate thinking actor: "Even the most astute analysts overlook the conscious observant mind behind the work. . . . As the actor and idol who made it all right for men to be tongue-tied or incoherent, he became so synonymous with an inarticulate masculinity that it was impossible for audiences to accept that the physique was inseparable from an equally formidable mind."[16] With such an intellectualism evident through his extensive library and recorded thoughts, Mizruchi characterizes him as, in many ways, quintessentially an Adler actor in his approach and even his career, as he remained more interested in engaging the world than selling himself as a star: "Brando was sparing in his use of personal experience for affect in his performances. In this way, among others, he followed Stella Adler. The complexity of Brando's approach to the world, his deep grasp of his own motivations and those of others, makes him a perilous subject for biographers."[17]

The meeting of teacher and student can be seen as fortuitous in the fall of 1943, when Adler was teaching at the New School for Social Research in New York City.[18] She was early in her career as a teacher. At age forty-two, it was less than ten years after she studied with Stanislavski in Paris. Arriving in the city four years before the birth of the Actors Studio, which quickly rose to prominence in the early 1950s, Brando avoided the widespread embracement of Strasberg, who, at this time, was viewed more as a theater director than teacher. Mizruchi suggests Brando's avoidance of the Method as fortunate, since Adler provided the young actor a safer way to create emotions in performance:

> Since emotional intensity would be Brando's stock-in-trade as an actor, it was a stroke of luck that Adler was teaching the class in which he enrolled at the New School. By avoiding personalization, and emphasizing script analysis, historical research, and action, Adler saved Brando from excavating his past. A childhood of neglect and loneliness provided plenty of Sturm and Drang, but he might have been unable to handle his emotions had he been pushed to reenact them while a vulnerable student. What Brando *did* have was imagination, loads of it, and what Adler called "a sense of truth." That sense of truth afforded a deep and subtle understanding of how emotions were expressed.[19]

This sort of biographical speculation can be called into question since we do not know the type of actor (or person) that might have emerged under the tutelage of Strasberg. But, suffice to say, Brando himself expressed the belief that Adler possessed an intimate understanding of what personal qualities benefited his professional growth. He writes in his autobiography, "Once she told a reporter that she thought one of the assets I brought to acting was a high degree of curiosity about people. It's true that I have always had an unwavering curiosity about people—what they feel, what they think, how they're motivated—and I have always made it my business to find out."[20]

The first lessons Brando probably took from Adler at the New School would have been in "technique" or, as they are sometimes called in her archived materials, "principles." These lessons would be foundational courses for any young actor and, in the two-year sequence at her studio, made up the bulk of the first year, before students were taught fuller lessons on

Stella Adler (*left*) teaching at the New School for Social Research, 1940. Courtesy of Corey Parker.

"characterization" and "analysis of plays" during the second year. Some of the earliest of archived class materials from Adler's studio show the teacher had very particular goals in her technique classes, which audio recordings confirm were filled with new students just starting the program. A transcript of an introduction to the class from the early 1960s shows Adler stressing actors should work to adapt their personal "outer" physicality, telling them: "As an acting teacher, you have to come to me with a normal body, a normal voice. I have to have that. I work with that."[21] More importantly, she proposes the purpose of the course would not be to comprehend personal or even necessarily the character's inner "self," "You act with your body and your voice. You don't act with your soul. Everybody has a soul. . . . Everybody can act from the inside." In other words, "Now if the outside is false it makes the inside false."[22]

The earliest records of her classes on technique are typical of acting programs, covering, as typed lecture notes from 1950–51 convey, "body; voice;

diction; habits; difficulties (Be glad); assets (leave them alone)."[23] Notably, the class activities deal not with psychological motivation or really any form of proclaimed "inner" work, instead existing in the context of the "exterior." For example, classes have the students perform actions where they are presented "obstacles" both "physical" and "inner." The physical obstacles are meant to change one's handling of an object—such as "putting on glasses—wet nail polish," "opening a window that's stuck," or "to open a drawer with broken finger."[24] Inner obstacles focus on attitude, yet these are based on situations and circumstances rather than psychological barriers: "To say goodbye to the baby (for the last time)," "to pay the landlord (haven't got the money)," "to leave (no place to go)."[25] As evident, even the most basic of movement and object work for beginning students was meant to forgo the "inner" in psychological terms and focus on the situational and present.

Many of the most famous on-screen moments of Brando are related to such techniques, the specific moment-by-moment choices that create the performance. For example, Brando and Eva Marie Saint walk through a playground early in *On the Waterfront* (1954), where, famously, a simple yet revealing use of an object occurs. Saint drops one of her gloves and Brando picks it up as he sits on a swing. He then casually slips on the glove over his hand as they speak, providing Saint with an obstacle to her actions. While the moment can be read as improvisation in that it was not mentioned in the original script, it does seem something that was worked out and, perhaps, discussed with director Elia Kazan beforehand as a performance choice.[26] The subtext can be read as tied to character psychology, yet there is no true indication Brando was embodying those emotions as much as making a logical performance choice about a presented object. As James Naremore writes, "There is, in fact, good reason to doubt that the action was purely spontaneous; the whiteness of the garment and Brando's position at the exact center of the composition seem calculated to make his gestures especially visible."[27] Naremore suggests that the significance of the glove proves different from other important objects in film, like George Raft flipping a coin in *Scarface* (1932), a motif of the character, or narratively significant objects like Cary Grant's matchbook in *North by Northwest* (1958). The "glove in *Waterfront* also has a purpose, but one that seems relatively unmotivated, more like an actor's than a writer's choice."[28] In this context, Brando's training, his understanding of motivation and action, is significant since he imbues the object

with meaning. More directly, he gives his action a purpose that fits the scene's given circumstance, something that existed as the cornerstone of Adler's technique classes.

In these classes, Adler privileges physical action—or, as she refers to it in many classes, the *doable*. While the actions could be based on one's personal memories, Adler keeps the focus squarely on physicalizing rather than psychoanalyzing or assessing personal emotions. In *The Technique of Acting*, she writes, "When I ask an actor to physicalize his actions, and use his circumstances, the purpose is to take the burden off the actor. . . . In life, as on the stage, not 'who I am' but 'what I do' is the measure of my worth and the secret of success. All the rest is showiness, arrogance, and conceit. Anything you do is physicalizing. Doing means physicalizing."[29] The difference between this concept and Strasberg's emotional memory becomes clear in a transcript from 1963, where in discussing the creation of realistic action, Adler informs the class, "You can go back to the circumstances, but you cannot use them. You can only use your action, what you did at the time." A student asks if this is affective memory (misidentified in the transcript as "effective memory"). Adler responds, "No, effective memory brings back the emotion. I only want to bring back the action. You do not go to emotion. You go to circumstances and find out what you did, formulate what you did in terms of an action."[30] Later, she elaborates on how personal experience would work in this approach by further dismissing Strasberg (though, typical to her classes, she never mentions him by name):

> Effective or emotional memory is dangerous for the actor, as well as cruel. You only use "memory" to find out what you did. You do not remember the emotion. You cannot do emotion. You can only do an action if you are having an extremely difficult time finding the do-able part of your action, then you may have to remember your emotions but only if it helps you to find out what you did in a like situation. Once you find the *do-able* part, throw out everything else. Otherwise you are trying to be in two places at once—your own experiences of five years before and the present situation of your play.[31]

Adler's dismissal of emotional memory—Strasberg's Freudian revamping of Stanislavski's affective memory—here proves insightful as it encompasses

three core principles central to her classroom: (1) the protection and empowerment of the actor, (2) the significance of physical expression in performance, and (3) the necessity to remain in the present circumstances of the narrative—experiencing as understood by Stanislavski.

A clear illustration of these three principles appears in a recording of a March 21, 1973, Technique I class as Adler works with a female student doing scene work as a character reminiscing about past loves. While the larger circumstances and motivations of the scene would be of concern in later courses, here, the focus is simply on the student recognizing remembrance itself as an action—as in, "to remember." Adler could be demanding of young actors, and here she calmly but forcefully reprimands her for not "doing the homework" on the scene and missing a previous class.[32] Yet she also proves equally protective and even respectful of the student's private life and emotions. After the reading, Adler is unhappy with the performance and tells her to leave the text and focus simply on the action: "Let's take another past then. Take your own past." The student responds with, "You mean now?" Adler gathers the student thinks this requires remembering a past romance, a private memory she might not want to share, so she moves away from this idea. Also, in keeping with her philosophy of acting, the student's personal emotional experience is of little concern to Adler. Instead, she wants her to simply reminisce to understand the action of reminiscence as a present activity. Adler responds, "Yes. I just want you to say, oh not about men, but where you lived, just recall your life." The student proceeds to tell about her life in Texas, in a town surrounded by mountains. Adler continues to push the student not to simply describe or necessarily feel the past but realize the action, saying, "OK, instead of telling me about it, the difference between remembering, recalling, reminiscing, and talking is that you're telling me something. Now, I would like you to just go to it. And when we go to actions, you'll see there is a difference between 'I'm going to tell you something that happened' and 'I am going to recall something that happened.'"[33] As this illustrates, Adler stresses the present-tense action of the scene even when it is a mental action. Before understanding the past of the character or even her emotional state, the student must recognize remembering as a present doable action.

This concept of the doable was of enormous importance to Adler and keeps with Stanislavski's late-career focus on physical action and the given

circumstance. In *The Art of Acting*, she explains the fundamental necessity to understanding circumstance in relation to all performance: "You will hear me say very often what Stanislavski said—truth in art is truth in circumstances, and the first circumstance, the circumstance that governs everything, Where am I?"[34] Unlike Strasberg's focus on the personal moment, *imagination* proves central to her approach to circumstance. As she writes in *Technique*, "Every circumstance you find yourself in [when acting] will be an imaginary one. And so, every word, every action, must originate in the actor's imagination."[35] To Adler, the imagination is not a flight of fancy but a developed intellectual process to be honed through research and close observation of the human condition. In her chapter on imagination, she writes, "Actors must exercise their powers of observation. You must be continually aware of the ongoing changes in your social world. Keep a journal filled with lists of observations."[36] These observations can be developed through a variety of factors, from personal experience though more often through research and social observation. To Adler, these parameters are not meant to limit but expand a consciousness that will aid the imagination, which is particularly important for young American actors who often have limited worldviews. As she writes, "If you confine yourself only to the social moment of your generation, if you are bound within the limits of your street corner, separated from every object or period that does not contain your own experiences, then the result is a disrespect for the world in general and an alienation from anything that is not immediately recognizable as part of your everyday habits."[37]

This approach might seem like an actor could be in danger of depersonalizing a character, distancing the performance away from "self" to perform an approximation based on an outsider's observations. But quite the opposite occurs in Adler's studio, where she routinely is shown stressing *empathy* with characters through an understanding of their social circumstances. In scene work from March 21, 1973, she is dissatisfied with a young actor's interpretation of George Gibbs from Thornton Wilder's *Our Town* (1938). The young man plays the part as immature and almost childlike, which Adler quickly recognizes as displaying a problematic judgment of the character: "Don't patronize him. Don't play that he's younger than you are. Don't look down on him. He has the same problem that any human being has. He has a problem of going away and facing a new life. Now he is not younger than you. He's not older than you. He's human. And you're patronizing him."[38] The student

suggests he sees the character as "boyish." Adler scolds, "You can't play that. Therefore, we see you feel bigger than he is. Don't do that." She stresses that there must be some form of identification with the character. "He is in you. He is not outside of you." Yet this identification is not one developed through mining one's past in search of similar emotional states or even circumstance. Instead, it is based in an empathetic identification, an understanding of the universal human condition. She tells the class, "He [the character] doesn't want to face the world. Now you have to understand it is hard to face the world. Is it?" The students, many living away from home for the first time in New York City, reply with a resounding "Yes!"[39]

As illustrated by the above exchange, developing a broader sense of empathy is important to initially approaching a character. The primary problem Adler has with the student's performance is not necessarily his lack of sympathy toward Gibbs as much as his lack of understanding of the character's social circumstances as suggested in the script. In Adler's studio, quick and uniformed assessments of a character were dissuaded in scene work, as such simplifications could dismiss broader considerations about situation, approaches that will later become central to script analysis classes. These would be key in developing an *attitude*, a word Adler employed often in her technique classes. As former student Joanna Rotté writes, attitude in this sense encompasses how the "qualities with which the actor endows the circumstances spark his responses to them. Broadly speaking, the actor's character likes or dislikes the place and the partner."[40] Creating a character's attitude requires acknowledging how humans develop opinions in everyday life, through "experience and acculturation," using social observation to see how "human beings constantly exhibit these opinions on the street, at home, in shops, in restaurants, etc."[41] While analyzing the script is key to honing a character's attitude, that does not mean a playwright gives easy directives on the page; the actor's personal interpretation is crucial. As Rotté suggests, "The actor consults the script to find the attitudes," yet the "attitudes are only indicated, usually not spelled out, in the script."[42] The process of developing an attitude from scene to scene as it "is carried over from situation to situation" is central to understanding *inner justification*. In general, justification is the motivation the actor ascribes to an action in a performance—which can be externally or internally motivated.[43] As Adler states in *The Technique of Acting*, "Inner Justification" would be the most difficult to develop because

it is not based in obvious immediate reasoning or given plot details: "Inner justification is what the actor contributes to the lines of the playwright. The author gives you the lines. He does not give you the justification behind them. That's the actor's contribution."[44] The choices made here are what we as viewers perceive as the individuality of a performance since it drives the character's attitude behind an action or line reading. As Rotté conveys, "According to Adler, justification is the 'heart of acting.' It pumps the action into circulation, getting it going."[45]

In her technique classes, Adler developed exercises to teach attitude by having students deconstruct their own opinions as not universal truths but socially dictated constructs. Removed from script analysis, which was taught later in the course sequence, such exercises provided hypothetical situations that encompass circumstances related to social categories, such as gender and economic class. For example, in an exercise from a February 15, 1973, course, Adler describes a "friend" who is "very wealthy. She's inherited a lot of money and her husband died. . . . She spends about five–six hundred dollars a night by inviting people to dinner."[46] She then asks the students to develop an opinion that would dictate their attitude toward this woman. A male student suggests "her values are distorted," another male dismissively sneers, "I think she must be very boring by the way you're telling the story." When a female student sympathizes with Stella's "friend," suggesting the widow is "lonely," a male student disagrees with this assessment. Adler stops his attempt to debate, "I don't want this to be a discussion . . . Now everybody's attitude comes from what they are in terms of themselves. It will not be the same attitude." Adler then takes this exercise further, suggesting this rich widow, with no theater experience, approached her to direct a play featuring her students. To the amusement of the class, she suggests she agreed to this proposition. The students all express different viewpoints about the widow, some sympathetic others contemptuous, and have a lively debate. Afterward, Adler tells them to describe their own and their classmate's attitudes, pointing out: "The attitude came from her [the widow's] life and the situation. You had an attitude toward her before she came in to direct you." At the end of this exercise, she explains its purpose, which is to have students recognize the social constructionism behind their opinions. This helps them recognize the actor's job as justifying and understanding different attitudes for, eventually, different characters: "What I'd like you to do, very soon, is to say, I can change

parts. I can play, through justification, say, 'Well, she's lonely and won't do us any harm. If we care about her and like her, we can let her talk to us. We can really handle her.' Or you play the other part. Or you play both parts by then justifying the attitude."[47]

This exercise demonstrates how adept Adler was at pulling in her beginning students through a scenario encompassing issues of economic class and gender, all made relatable through an imaginary circumstance. Many of Adler's exercises in technique classes went even further in developing an understanding of social context and theme to address circumstances beyond the imaginary. For example, in an April 3, 1950, class for beginners, students are asked to "put myself behind" and explain "my 'liking' and 'not liking'" of public personalities: "1; Mary Martin 2; President Roosevelt 3; President Truman 4; Mrs. Roosevelt 5; Mrs. Truman."[48] Another common exercise in Technique I had students bring in newspaper stories and restate them in their own words and then discuss the content with partners or in groups. These exercises were not about fostering any sort of political debate, but about having students display an understanding of the significance of their words (often, a social significance). While major news events were discussed, Adler welcomed smaller news stories as well. In an October 16, 1972, class, while many students bring in news items on Richard Nixon and George McGovern, Adler spends a considerable amount of time with a female student who summarizes a relatively minor local news story on business owners calling for more street lights in their neighborhood. The student breaks down the events into three simple points, which impresses Adler, who then has the class partner-up and discuss these essential concepts. She tells them, "Go through that and see if it affects you. If you can see it. Then, it will help you if you can see the dimly lit stores and the dimly lit streets. And the people were afraid to walk."[49] The point of this exercise is to have students deconstruct circumstances point by point to recognize each one's significance: "This is the rehearsing of a theme. And the technique is not to take the whole thing but to take one sequence after another. Whenever you have a speech to make or a lot of words, divide it up into this sequence." In having students break down the sequence of events of this local news item, she asks them to differentiate between larger themes, like "universal love," and smaller themes, like public safety or fear of crime, which characterize the story. Here, she stresses the specifics of social context as circumstance, telling them, "You must place

your idea in circumstances. The circumstances here are New York and the time is 1972."[50]

As this all suggests, the technique classes dealt much with social observation and acknowledging differences in characters' attitudes as dictated by situation. In terms of understanding period parts, this would require research for the Modern actor. As Rotté writes, in discussing preparing for classical roles, students were to "research historical life" by recognizing "that history was on display for us to examine in museums and books."[51] For modern plays, which would be more aligned to the films that define much of Brando's early success, such research might be necessary, but social observation could be as, if not more, important. Rotté recalls that "our job was to look and to see. Alder encouraged us, for example, to discern different ways of walking: the parading on Fifth Avenue, the slouching on Ninth, the reticent walk of Chinatown, or the shuffle in Harlem."[52] In New York City in particular, different social groups could easily be studied by students to help them understand different physicality and behaviors: "Also, by looking into various neighborhoods, we could see how a particular environment demanded particular behavior."[53] Such assignments are more than simple ways to develop gesture, voice, and walks. They relate to Adler's overall philosophy of a socially observant as opposed to introspective process. As she tells her students in a Technique I class in 1973, "What you have to learn is that things feed you. You don't feed things. You don't feed the world. The world feeds you. And the world awakens you. That is a tremendous knowledge, that the world awakens you to react to it. People awaken you. The columns awaken you. You're all a body of material that has to be awaken to life."[54]

Admittedly, it is difficult to know which specific lessons Marlon Brando learned or continued to employ from Adler's courses on technique. Yet identifying his technique as Adler-derived provides a way to understand a constant throughout a career that encompassed multiple roles with various voices (as he improved with accents as he grew older) and bodies (as the actor gained much weight during the last decades of his life). As Mizruchi writes, "What is continuous from role to role is technique, as in Brando's exemplary use of objects,"[55] as already discussed briefly with his famous use of the glove in *On the Waterfront*. Sometimes, this technical brilliance was mistaken by critics as effortless, since "Brando had a knack for making whatever he learned appear instinctive."[56] In analyzing his performances, central elements of Adler's

lessons in technique are of interest since we see them in practice. The *doable action* proves fundamental to Brando's approach as his physical movements and employment of objects are as (if not more) significant than his voice, especially in his early film work. *Attitude* is a word routinely identified with his iconic early roles—be it the brutishly violent misogyny of *Streetcar*, the unfocused rebelliousness of *The Wild One* (1953), or the blue-collar sensitivity of *Waterfront*. But Adler's employment of attitude, as situationally driven and feeding inner justification, opens a new way to understand his performance choices. In total, Brando was a socially observant actor taking to heart Adler's charge to observe and engage the human condition. He writes in his autobiography about how he wandered New York City, looking at pedestrians and studying "their faces, the way they carried their heads and swung their arms; I tried to absorb who they were—their history, their job, whether they were married, troubled, or in love."[57] Through understanding Adler's techniques, Brando's early screen performances provide new insights into how an actor can incorporate and engage sociological determinants of gender. His performances are an amalgam of doable actions, crafted through observations on the masculine body and the postwar male.

A Streetcar Named Desire (1951): Body and Text

Approaching early Brando in the context of gender, performance, and body encompasses questions of gender identity central to post–Judith Butler debates. As "body" remains central to both the actor's appeal and performances, the materiality of the physical form must not be divorced from behaviorism. In *Bodies That Matter* (1993), Butler engages a central critique of her groundbreaking *Gender Trouble* (1990), the notion that "gender performativity" would be "constructivist" in nature and not apply to the material reality of the body, which defines the perceived biological sex of a person. As she clarifies in *Bodies*, gender performativity exists not as an act or choice "but, rather, as the reiterative and citational practice by which discourse produced the effects it names."[58] Butler proposes, "if gender is constructed, it is not necessarily constructed by an 'I' or a 'we' who stands before that construction in any spatial or temporal sense of 'before.' Indeed, it is unclear that there can be an 'I' or a 'we' who has not been submitted, subjected to gender, where gendering is, among

other things, the differentiating relations by which speaking subjects come into being."[59] There is not an essential gendered subject—a biologically or psychologically determined "self" existing beforehand. This means the regulatory practices that determine gendered behavior also define our conception of the sexed body: "'Sex' is, thus, not simply what one has, or a static description of what one is: it will be one of the norms by which the 'one' becomes viable at all, that which qualifies a body for life within the domain of cultural intelligibility."[60] The sexed body is not a given where gender is "artificially imposed," but rather a "cultural norm which governs the materialization of bodies."[61]

In understanding gender and the gendered body through Butler, Adler's approach to actor performance becomes of interest since, unlike Strasberg, it greatly diminishes notions of "self" in the actor. Adler, while relatively gender inclusive in her classes, does not have a postmodernist let alone even progressively feminist view of gender. As Rosemary Malague writes in her feminist reading of Adler's teaching, it is difficult to argue Adler was a "self-avowed (or even a secret) feminist" or even that her technique "is an inherently feminist approach to acting." From a feminist perspective, though, she finds Adler significant since "Adler's investments were these: to inspire actors to stretch themselves beyond the realm of their personal experience though the use of imagination; to teach them to read and analyze plays; to encourage them to *think*—and to think for themselves."[62] Expanding the actor beyond "the realm of personal experience" means Adler's approach to performance welcomes an analysis of performed gender identity that takes into account the role cultural determinants play in regulating gender. True to Butler's points on the discursive nature of the sexed body, these determinants prove significant in relation to the perceived realities of the performing body. As Raewyn Connell writes, the body "is inescapable in the construction of masculinity; but what is inescapable is not fixed. The bodily process, entering into the social process, becomes part of history (both personal and collective) and a possible object of politics."[63] Adler's process of performance engages with the social moment, which is central to questioning why Brando feels so culturally relevant as a movie star in not only behavior but also body.

Marlon Brando's stardom initially was associated with *A Streetcar Named Desire* and Tennessee Williams, a writer fascinated by social definitions of maleness. Williams's own status as a homosexual playwright whose work subversively deals with sexuality and conflicted gender relations welcomes

performances confronting and even queering gendered "norms."[64] *Streetcar's* characters all encompass attributes that can be considered types defined by their gendered roles: Stanley, the brutish lout; Blanche, the fading Southern beauty; Stella, the blindly devoted wife; and Mitch, the mama's boy. All these characters, defined by Williams's flare for stylized realism, encompass subversive gender and sexual definitions particular to the era. In *Communists, Cowboys, and Queers*, David Savran writes, "Tennessee Williams offers an urgent challenge to the stubborn antitheses between the political and the sexual, and between the public and the private, binarisms so crucial for normative constructions of gender during the 1940s and 1950s."[65] The playwright is both a culturally and politically subversive artist, one with thematic preoccupations attuned to issues of gendered power:

> Williams's destabilization of mid-century notions of masculinity and femininity is accomplished, in part, by his ability both to expose the often murderous violence that accompanies the exercise of male authority and to valorize female power and female sexual desire. In the same gesture, his work undermines the hegemonic and hierarchical structure of masculinity itself by disclosing the contradictions on which its normative formulation is based and by celebrating various subjugated masculinities. Finally, and perhaps most important, his plays redefine and reconfigure resistance so that it is less the prerogative of rebellious individuals than a potential always already at play within both social organization and dramatic structure.[66]

As Savran positions these texts, Williams's plays of the 1940s and '50s are inherently deconstructive of masculinity through character, situation, and setting. The narratives often have elements undermining structures of masculinity, yet those in themselves can be defined by complex contradictions, especially when considering Stanley.

The character of Stanley remains one of the most challenging in mid-century theater and film, as critical and audience responses displayed both a repulsion and sexual attraction. The part, as written, explores the problematic dynamics of sadomasochism inherent to social definitions of the sexually desirable masculine body. As Williams writes in *Streetcar's* stage directions, Kowalski is "strongly, compactly built," and since "earliest manhood the center

of his life has been pleasure with women, the giving and taking of it, not with weak indulgence, dependently, but with the power and pride of a richly feathered male bird among hens."[67] By the play's end, this "power and pride" destroys the fragile Blanche through sexual assault and emotionally scars Stella, who sobs with "inhuman abandon" as her sister is hauled away to the mental institution. In terms of gender, the play is about a tragic reestablishment of masculine dominance, one defined through sexual violence—as implied by the ironic ending line by Steve, one of the male poker players who now overtake the Kowalski home, "The game is seven-card stud," which is spoken while Stanley gropes the sobbing, emotionally devastated Stella.[68] The play and the film position Blanche as the clear protagonist with Stanley as antagonist, since the director of both productions, Elia Kazan, followed Williams's view that the play was linked to "classical tragedy."[69] Yet despite the classical narrative arc, Kazan's background with the Group Theatre, where he studied and directed with Alder and Strasberg, meant such dynamics would be muddled by social complexities. As Philip C. Kolin writes, "Kazan read any Aristotelean notion of tragedy through his Stanislavskian, naturalistic perspective. Privileging the swelling undercurrents of naturalism he detected in *Streetcar*, Kazan portrayed Williams' characters in behavioral terms as social types translated for the stage."[70]

While Stanley is a villain in a traditional narrative sense, the character has often been discussed in complex sometimes even alluring or sympathetic terms. This response has as much to do with Brando's association with the role as it does with the character as he appears in the play text. Williams himself, ever the modern playwright, worried in 1947 that the role of Stanley could be simplistically interpreted as a "black-dyed villain" by an actor overlooking the fact that the play dealt with social psychology: "Nobody sees anybody truly, but only through the sense of their own ego. That is the way we all see each other in life."[71] In producing the play, Williams had a say in casting the character of Stanley, leaving the selection of the rest of the Broadway cast to Kazan. Brando, in his early twenties at the time, was originally viewed as too young for the role. But on seeing his reading, Williams was ecstatic, stating in a letter, "It humanizes the character of Stanley in that it becomes the brutality or callousness of youth rather than a vicious older man."[72] The casting of the youthfully sexy and muscular Brando certainly had much to do with the perception of Stanley as an appealing sexual dominator.[73] As Kolin writes,

the actor's physique and good looks "transformed Stanley into a sexual icon, a new male sexual hero arousing women in the audience as no actor on the American stage had done before."[74]

In his autobiography, Brando suggests that much of his performance as Stanley came not from traditional research but through more of an engagement with Williams's writing. True to Adler's views on technique, the actor did not attempt to identify with the role through personal experience but through starting with the given circumstances of the text, building on them with his imagination: "I was the antithesis of Stanley. I was sensitive by nature and he was coarse with unerring animal instincts and intuition. Later in my acting career I did a lot of research before playing a part, but I didn't do any on him. He was a compendium of my imagination, based on the lines of the play. I created him from Tennessee's words."[75] It is important to note here that Brando, likely, is meaning research in the form of "book research," a staple of his later preparation. Most of Brando's recorded insights on Stanley stress a broader sense of social research through observation, some of which encouraged anything but a close adherence to the play text. About his famous mumbling vocal choices, which could obscure and even alter the specific wording of dialogue, Brando told Kazan the choice was based on social types he witnessed: "Guys like Stanley [are] so muscle bound they can hardly talk. Stan doesn't give a damn how he says a thing. His purpose is to convey his idea. He has no awareness of himself at all."[76] As Mizruchi writes, much of the critical response to Brando's Stanley stresses the performance as an extension of the actor's natural charisma, implying instinct over preparation. This simplification overlooks "Brando's knowledge of technique," which was based in his close social observations. Even if the actor found much of the foundation directly from the play text, the performance was calibrated from his observations of people's behaviors and expressions: "From childhood, he recognized them as specific to the various stations people occupied even in a democratic society. . . . The ways people revealed themselves in the smallest movement fascinated Brando."[77]

The doable action, the cornerstone of Adler's technique lessons, defines much of the performance, both its mental and bodily dimensions. The film's version of the end of scene one presents the audience with Stanley, who is seen only briefly fighting in the distance at the bowling alley before this scene. Typical to Williams, the play's stage directions are detailed, giving a paragraph-length description of Stanley with some mention of action

("glance," "smile") and motivation: "He sizes up women at a glance, with sexual classifications, crude images flashing into his mind and determining the way he smiles at them."[78] The remainder of the scene features other descriptions of specific actions for Stanley: "He has crossed to the closet and removed the whiskey bottle"; "He holds the bottle to the light to observe its depletion"; "He starts to remove the shirt"; "He grins at Blanche."[79] On screen, Brando does perform many of these directions yet also imbues the scene with a dominating and consistent sense of actions as a fluid display exposing what is most significant in the character. The performed actions give us more insight into Stanley than the written dialogue.

In the film, Brando enters the scene smacking gum, an addition highlighting both an immaturity and an oral fixation that becomes a motif in the performance. In meeting Blanche, Brando takes Williams's character description to heart and has his eyes drift downward to look over her body. When asking, "Where is the little woman?" he tears open his jacket buttons as he begins to walk out of frame toward Blanche, foreshadowing the assault in scene ten. These actions quickly establish the sexual dominance of the character from the restless youthful libido implied by the smacking gum to the leering objectifying glances to the aggression suggested by unbuttoning his jacket. Now donning his sweaty tight tee, he walks by Blanche and asks where she's from. Here, Brando scratches his pectoral muscles, presenting his developed chest to her as a bodily display. The actor's actual changing of his shirt remains a remarkable moment of erotic spectacle that inverts the gendered on-screen space in that it privileges Blanche's gaze. Kazan's camera keeps Vivian Leigh in the foreground and the shirtless Brando behind her, framed by a wide doorway.

Yet far from displaying passivity, the performed actions of the actor remind us that Stanley is in charge of the spectacle, finding power in his bodily command. As Brando walks to Leigh, he is quick to pull the new tee shirt under his armpits to tighten the garment around his muscles, folding his arms in a manner to have his hands rest under his biceps, making the muscles protrude. Talking in close proximity to the nervous Blanche, Brando has his eyes glance at her body once again. When the high-strung Blanche is frightened by a stray cat, the play conveys that Stanley responds, "Cat . . . Hey Stella!"[80] Leigh adds to the scene by touching Stanley's arm when startled, which Brando responds to by glancing at her touch. He changes the line to, "Oh those cats," which he follows with a loud feline-like screech. While this

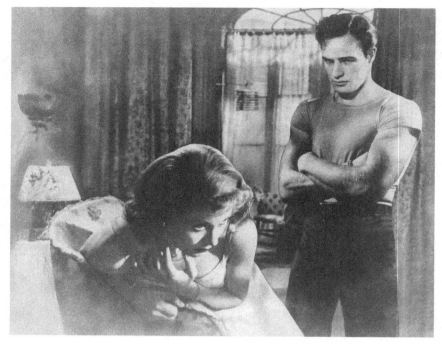

Vivien Leigh and Marlon Brando in *A Streetcar Named Desire* (1951).

is an improvisation, much like the moment with the glove in *On the Water-front*, it proves an acting choice not at all impulsive. The startling cat-like noise made by Stanley is consistent with other attributes of the character, his immaturity and animalistic primal sexuality, already established through the other actions in the scene. All these performance choices ascribe to the given circumstances provided by the play text, the uncomfortableness of Blanche and the sexual dominance of Stanley.

In terms of the given circumstance, the scene exists as a sequence of do-able actions all related to the text's provocative gender subversions. Stanley remains the most desired sexual object within the world of the play as opposed to any of the women. Stella's sexual desire for Stanley is the primary motivation for that character's devotion toward her husband, which is the reason why the physical attractiveness of the actor playing him is often a casting criterion. Ironically, while Blanche is the character most vocally obsessed with being physically desirable, it remains Stanley who projects the

most sexual appeal. As noted by Carla McDonough, Brando's "posturing" in the performance serves as a link to Blanche's less successful gendered displays: "Like Blanche, Stanley has his own costumes, particularly the sweaty T-shirt and the gaudy silk pajamas. Like her, too, he performs his sexuality in gesture and movement."[81] In his performance, Brando is acutely aware of the significance of wardrobe, which only gives the illusion of a lack of care or immaturity. As Kenneth Krauss suggests, throughout the play, "He [Stanley] is, no less than his sister-in-law, a creature acutely aware of living in the gaze of others—of other women and other men."[82] The clothing choices are as significant as Blanche's Southern belle dresses and cheap jewelry. Steven Cohan observes that Brando's wardrobe "veils and exposes the male body with the kind of attention conventionally given to costuming a female star." The changes of costumes in *Streetcar* "keep modifying Brando's appearance in the film to underscore the performativity of his body as the setting for Stanley's masculine masquerade."[83] The series of actions Brando performs in the above scene all suggest a character fully aware of the significance of clothing in relation to his sexual allure. Outside of the actual changing of the shirt, which is given as stage direction, other choices such as the timing of the unbuttoning of his coat, the touching of his pecs, and the tightening of the tee illustrate the character's awareness of physical presentation. Brando's Stanley performs actions that promote a sexual confidence meant to counter Leigh's neurotic fidgeting with presentational gestures.[84] The scene is about the erotic body as spectacle but, in the diegesis, it is a display in the manner of a male peacock, suggesting power as opposed to passivity.

A Streetcar Named Desire (1951): Performing the Postwar Male

By most accounts, Brando's opinion of Stanley did not necessarily reflect the sympathy found in some of the audience responses. In his autobiography, he acknowledges *Streetcar* as "one of the best-written plays ever produced," yet characterizes Kowalski as "insensitive and brutish."[85] He suggests his performance was inspired by social types, men of which he did not have a high opinion: "I've run into a few Stanley Kowalskis in my life—muscled, inarticulate, aggressive animals who go through life responding to nothing but their

urges and never doubting themselves, men brawny in body and manner of speech who act only on instinct, with little awareness of themselves."[86] While suggesting he understood Williams's concern to not make Stanley a "black-dyed villain," Brando embraces the idea that his character was the antagonist and "represented the dark side of the human condition."[87] Interestingly, he suggests both he and the original Broadway version's Blanche, Jessica Tandy, were miscast precisely because the audience sympathized too much with Stanley. He primarily blames Tandy's Blanche for much of this response, since, in his view, she performed the character "too shrill to elicit the sympathy and pity the woman deserved." Thus, "my character got a more sympathetic reaction than Tennessee intended," resulting in moments of laughter in response to Stanley's interactions with Blanche. Brando suggests this frustrated Tandy though the audience response was unintentional since "the laughter surprised me too."[88]

In scene two, when Stanley learns of the loss of Belle Reve from Stella and proceeds to tear through Blanche's luggage, significant actions that grow increasingly violent are provided in the stage directions: "He pulls open the wardrobe trunk standing in the middle of room and jerks out an armful of dresses"; "He hurls the furs to the daybed"; "He kicks the trunk partly closed."[89] In the film version, this volatile nature is captured, and Brando's performance of actions implies a view toward the character that is far from sympathetic. The performed actions suggest Stanley as truly "insensitive and brutish" with a near comical lack of self-awareness defining his attitude—a version of buffoonish male bravado that can illicit laughter from an audience even if unintentional.[90] Unlike the play, Kazan stages the scene to have Brando walk over to the refrigerator and take out a cold plate of dinner prepared by Stella for Stanley. A clear symbol of a disrupted domestic routine, since Stella and Blanche are going out to eat before Stanley's poker game, the meal is merely mentioned, not shown, in the play text, with Stanley responding with a disappointed, "Well, isn't that just dandy!"[91] In the film, Brando employs the cold plate and a nearby apple as objects, stuffing his mouth when he learns from Stella that "we've—lost Belle Reve!"[92] Kim Hunter places her arms around and kisses her costar as she tries to coax him to "try to understand her [Blanche] and be nice to her."[93] Brando's response highlights the character's immature oral fixation and single-mindedness, ignoring his wife's affections and continuing to eat as he appears to be processing the information he just received.

As Brando and Hunter move to the trunk, Brando continues to eat as his character begins to realize that the loss of Belle Reve means the loss of an inheritance. Hunter then performs the action of unpacking Blanche's clothing while Stanley tries to explain to her Louisiana's "Napoleonic code according to which what belongs to the wife belongs to the husband."[94] As Stanley attempts to display his intelligence to a disinterested Stella, Brando interrupts Hunter's action of putting away clothing with a frustrated line addition of "Will you listen?" Giving up on his wife, like a pouting child, he returns to the plate and places a piece of cold chicken in his mouth, suggesting he will confront Blanche after her bath. As Hunter hurriedly finishes putting on her dress, Brando finally takes a forceful pose, right hand on the trunk and left on his hip, asking, "Where's the money if the place was sold?"[95] Stella attempts to leave the bedroom, and Brando pulls her forcefully by the left arm. Hunter responds by holding her arm to suggest pain. When performing the "unpacking" of Blanche's things, the scene becomes an interplay of actions between Brando and Hunter as she attempts to stop him and he throws items on the floor. Ultimately, the actions read less angry than the stage directions and more childish. Displaying the character's inability to truly focus, as Stella storms out of the room, Brando notices a small feather floating before him and playfully tries to snatch it. When Hunter attempts to have him leave before Blanche enters, Brando, now standing by the fireplace mantle, places one cigarette in his mouth and another behind his ear. Stella asks, "Are you going to stay here and insult her?" Brando takes a match, strikes it on his thigh, and lights his cigarette—defiantly stating, "You bet your life I'm going to stay here."[96]

While the previous scene features Brando in, once again, a tight tee hugging his muscles, the purpose of his movements here is no longer for erotic display. The interactions between Brando and Hunter certainly imply the dynamics of the relationship as written by Williams, with telling additions, such as when Stella attempts to woo Stanley through physical affection, an implied promise of sex. Yet the dominance of the masculine character is now not a sexual aggression as much as a mental and physical one. The addition of violence, Brando's grabbing of Hunter's arm, shows the character's attitude to be, to use Brando's word, "brutish" by nature. The "insensitivity" manifests in the actor's lack of response to Hunter's display of pain, as he completely ignores it and continues his dialogue.[97] While all these actions might make it surprising to think Stanley could provoke laughter, there are notable performance

choices that highlight a comical lack of self-awareness. As performed in the film, with the punctuations of a mouth full of chicken, the repeated phrase of "Napoleonic Code" becomes increasingly absurd since the character's impulsive physicality and mumbling vocalizations do not match his feeble attempts at understanding something as complex as law. The oral fixation, moving from the food to the cigarettes, offsets the implied dominance with a silly immaturity—showing his authority to be unwarranted.

In terms of Adler's approach, Brando's understanding of the character as brutish does not mean he could not, in the strictest sense, empathize with Stanley—recognize the reasoning and vulnerabilities inherent in the character. This process meant engaging the social significance of the play text, an analysis that could influence the tone of the performance. In further discussions of justification, Adler asks her students to fully understand the character's attitude as divergent from their own and to justify and identify with it. This would be especially important in working with a partner, like Brando is with Hunter and Leigh, since adjusting the character's attitude would, as Rotté summarizes, "set the level or mood of the action, whether it is light (comedic) or dark (serious)."[98] Many of Brando's choices relate to his character's attitude toward others, yet they also expose Stanley's weaknesses. This dual purpose is especially apparent early in the play, which accounts for the comedic coexisting with the dark in tone. Notably, this manifests in his distinctive manner of speaking, which renders his points on the "Napoleonic Code" humorous. Mizruchi characterizes Brando's vocalizations as Stanley as "a low snarl at times, occasionally raised to a frightening pitch," yet "for the most part soft and modulated by anxiety." The most memorable aspect of the voice, especially in scenes between him and Hunter, is how it often whines in a childlike manner: "The whine perfected by Brando was critical to his reorientation of maleness, for it pinpointed weakness as a motivating factor in Stanley's need to dominate."[99] While often viewed as the epitome of primal sexuality, such a vocal contradiction characterizes Brando's iconic yelling of "Stella!"—which occurs after his pregnant wife flees their apartment when he drunkenly assaults her. As Mizruchi posits, the performance of the yell highlights "the disparate aspects of human sexuality, Brando conflates the infant's cry for its mother . . . with the brutal mate's demand that his desire be satisfied."[100] The yell is equally as pathetic as it is dominant, suggesting the vulnerability of the character. While Hunter's performance of the trance-like return to her husband implies her sexual attraction,

it also corresponds with her role as caretaker, her duty as a postwar wife and mother to Stanley as man-child.

Such moments speak to Brando's awareness that Stanley exists not as simply an archetype of brutality and childish aggression but very much as a cultural subject. While the actor worked closest with Kazan on the production, Adler's own words on the play show how Brando could have incorporated the historical moment into his performance of both desirable sexuality and undesirable aggressive immaturity. In lectures from 1982 on Tennessee Williams, Adler discusses the universal (that is, classically tragic) themes of the play but focuses on them as filtered through historical context. She opens the lecture on the issue of "social situation," telling students, "There are things happening in society that affects us all, which are not all conscious things. Most people live by habits—such as, 'That's your father. You must obey your father.'"[101] She reads *Streetcar* as primarily an examination of "the mix-up of class in society," which means the play examines a "historical change."[102] Adler recognizes Kowalski as a social type encompassing the conflicted nature of masculinity in postwar society, something the playwright himself both criticized and desired: "When he [Williams] writes Kowalski, the whole world knew Kowalski. . . . He is destructive, but, he is powerful and he does reveal what Tennessee wants. He wants the virile, the penis-driven."[103] She also speaks to the sadomasochistic appeals of the character, which she routinely conflates with Brando's performance in her lecture; yet notably, she does so as a cultural-historical consideration. To her, Stanley represents the inherently fascist nature of the aggressively sexual yet desired hetero-male: "the symbol of Stanley is the power drive of fascism. Of the fantastic thing that man wants. 'I'm going to tell you what I want.'"[104]

Unlike *The Glass Menagerie* (1944), which was his first success on Broadway, Williams wrote a more contemporary play with *Streetcar*, setting it in a modern New Orleans, then populated with a working class of returning veterans starting families. On seeing an initial reading by Brando, Williams was euphoric not only because of the actor's charisma but also because he displayed an understanding of the character as a social type defined by the historical moment. In an August 29, 1947, letter, the playwright notes how this interpretation creates something the original casting choice of John Garfield could not have captured: "He [Brando] seemed to have already created a dimensional character, of the sort that the war has produced among young veterans."[105]

As Kaja Silverman writes in *Male Subjectivity at the Margins*, World War II was a significant "historical trauma," which she defines as "any historical event, whether socially engineered or of natural occurrence, which brings a large group of male subjects into such an intimate relation with lack that they are at least for the moment unable to sustain an imaginary relation with the phallus, and so withdraw their belief from the dominant fiction."[106] In her reading of a trio of Hollywood films about, in some manner, the returning veteran, *The Best Years of Our Lives* (1946), *It's a Wonderful Life* (1946), and *The Guilt of Janet Ames* (1946), Silverman explores how the films "enact a range of responses to the historical trauma of World War II, and to the difficult reentry of the veteran soldier into the postwar American society," which in acknowledging the effects of historical trauma isolates it as "a force capable of unbinding the coherence of the male ego, and exposing the abyss that it conceals."[107] In a similar manner, *Streetcar* encompass such an understanding of national trauma as the text is also coded with gendered dynamics attuned to the postwar moment.[108]

John L. Gronbeck-Tedesco suggests America's wartime victories informed the public response to Stanley/Brando's desirable physique as it fed "upon the audience's recent cultural memory," such as found in photos of shirtless GIs that appeared in reporting on the American victory: "Stanley's body-shape comes into focus as a product of the American bootcamp. Only the dogtags are missing. His connection to an entire genre of World War II iconography is intensified in the film version of the play which frames Brando's upper body in medium shots that capture the entire torso."[109] In this context, the eroticization of Stanley, which Brando accentuates through his performed actions of erotic display, imply a character acutely aware of his body as desirable on multiple fronts—domestically (as postwar husband and provider), sexually (as potent male pinup), and nationally (as a symbol of American wartime victories). The contradictions found in the character's masculine performativity are attuned to this historic moment. The displacing power of national trauma defines the vulnerability—Stanley's fear of losing his phallic dominance—performed by Brando through mumbled vocalizations and childlike attachments to Stella. Along with this, his overcompensation of dominant physical and sexual aggression correlates to an image of the white masculine body as victorious and desired. Brando's Stanley is best understood as an amalgam of performed cultural considerations defining the masculine body of the returning veteran.

These aspects of the performance appear throughout some of the film's most significant moments. As established, Brando in scenes with the female characters of Blanche (prompting Stanley's aggression) and Stella (his childlike whining and domestic dominance) performs actions relating to the play's given circumstance as well as the social observations of the actor. As the film continues and the interactions become more emotional, these performed actions continue to present Stanley as a contradictory postwar male subject. For example, in the film's depiction of scene seven, when Stanley informs Stella of the dirt he dug up on Blanche's past, the fragility of his domestic position materializes through Brando's actions. Firstly, the actor picks up a bottle of liquor only to pour it into a dainty teacup, which he holds as he explains Blanche's sexual activities at the Hotel Flamingo. The mixing of props, "masculine" hard liquor with a "feminine" cup, illustrates the character's clumsy attempt at domestication, his difficulty truly coexisting with the female subject on returning to the home front. When he informs her of the most shocking news, Blanche's sexual relationship with a teenage student, he attempts to comfort the distraught Stella by placing his hand on her shoulder. Yet Brando disrupts this seemingly caring action by picking a piece of lint off her back, reminding the viewer of the character's impulsive and easily distracted mind. Stanley, through such performed behaviors, exists as a restless and out-of-place figure in this newly established postwar domestic space.

Despite the vulnerabilities the character displays as a returning veteran, the text of the play still suggests Stanley's phallic dominance as a destructive force, a narrative arc driving Brando's performance. In adapting scene ten, the lead-up to the off-screen rape, Brando begins once again performing the erotic displays of his body that characterized Blanche and Stanley's first meeting. He enters the scene rolling up his sleeves and times the dropping of his suspenders slowly, like a striptease. The removal of his shirt (part of the original play's stage directions) occurs as he walks past Leigh, to now expose a tank-top tee that highlights his muscles. When she asks him to close the curtain if he is undressing, he points to his chest saying, "This is all I'm going to undress right now."[110] The spectacle of the actor's body is eventually disrupted once the scene moves closer to the actual rape, which Kazan makes sure not to eroticize. Reflecting mostly Blanche's subjectivity, the camera races along with her nervous realization that a sexual assault might occur. Once Stanley reenters, the bodily spectacle is negated and the actions of the actor are purely

animalistic, denoting danger more than titillation. Donned in his "brilliant silk pajamas,"[111] fully covering his body since they are absurdly oversized, Brando makes the choice to return to the restless oral fixation established earlier. Approaching Blanche, he chews on food (which we never see him bite), creating the effect of a hungry animal closing in on its prey. The scene returns Stanley to the restless libido and lion-like sexual dominance found in other scenes yet obscures the desired body. Now the actions only exist in the realm of dominance and violence, communicating the character's destructive drive. Kazan's cut to a water hose cleaning the filthy street further stresses what Brando's performance choices already established, as the hose spews out like an ejaculating penis—driving home the idea that, despite earlier displays of insecurity, Stanley the returning solider endures as a conquering phallus.

In total, Marlon Brando's iconic portrayal of Stanley Kowalski illustrates many of the core lessons Stella Adler taught in her technique classes, which were early courses in the sequence meant to give a foundation for young actors. Appropriate for a teacher who trained with Stanislavski during his late-career focus on the "Method of Physical Action," the techniques are based very much in the external more than the internal in the sense that psychological motivation, while certainly a factor (as seen with the development of Stanley's oral fixation) was less of a concern than the development of doable actions (determined by the external). These motivations are determined by the given circumstances of the play. Brando incorporates an amalgam of these techniques to create a unified sense of character. The doable actions he performs as Stanley are in correspondence to an understanding of the masculine body as a manifestation of not the actor or, really, the character's sense of "self" but, in the words of Judith Butler, physicality as a "cultural norm which governs the materialization of bodies."[112] The impact of this star-making turn was based in how different it felt from previous film performances yet, somehow, was also "of its time." Brando's Stanley Kowalski exists as a game changer in film performance because Stella Adler's techniques allow for a more socially engaged form of acting.

3
Characterization and Types

Marlon Brando in
The Missouri Breaks (1976)

> If there wasn't the Yiddish theater, there wouldn't have been Stella. And if there hadn't been Stella, there wouldn't have been all these actors who studied with her and changed the face of theater—not only acting, but directing and writing.
>
> Marlon Brando, *The Forward*, July 30, 1999[1]

In 1999, seven years after Stella Adler's death, her New York City studio was facing an uncertain future. The studio had been given short notice by the landlord to vacate its Manhattan headquarters. At age seventy-five, the normally press-shy Marlon Brando made a rare call to *The Forward*, the Jewish American publication, to make an appeal to Jewish history to save its location. The front-page story, titled "Stel-la! Brando's Geshrei for Yiddish Theater," has the actor—along with Adler's daughter Ellen and grandson, studio artistic director Tom Oppenheim—speaking about the significance of the teacher and her roots in Yiddish theater. The goal was to appeal to Jewish readers, some of whom might be involved in charitable foundations. Brando, a gentile, unsurprisingly is the primary focus, with the iconic image of him as *A Streetcar Named Desire*'s Stanley Kowalski accompanying the story. The actor tells the reporter, "I would hate to see Stella and the entire tradition of Yiddish Theater go down the drain."[2]

The article makes the astute observation that "when it comes to the theater, the people Mr. Brando seems to mean when he speaks of 'the Jews' are the Adlers."[3] The actor's admiration for Stella Adler and, by extension, the tradition of Yiddish theater she represented to him, was something he held on to throughout his life. At its core, this respect was born out of his early experiences in New York City when the Adlers, including matriarch Sara Adler, served as a surrogate family for the young actor. As Ellen Adler conveys, "I think he feels he's been formed more by Jewish life more than by his own family."[4] Along with this familial bond, Brando's exposure to traditions of Modern acting was initiated by politically involved Jews during the period of the Holocaust and its direct aftermath. Stella Adler herself, during the years directly following World War II, would risk her safety working for the cause of Israel, helping to smuggle people out of Europe.[5] As Brando characterizes this period, "I was there [New York City] when I came from Nebraska and having no sense of culture and hardly any education, I went to the New School for Social Research and went to see Stella. I was educated by Harold Clurman. . . . I was introduced to Jewish culture and Jewish traditions."[6] Among the most significant of the actor's pre-*Streetcar* roles, Brando appeared on stage in Ben Hecht's *A Flag Is Born* (1946), which advocated for the creation of Israel, where the actor played a young Holocaust survivor opposite onetime Yiddish theater stalwarts Celia Adler and Paul Muni. The experience would be instrumental in forming Brando into a socially conscious actor, as the play toured synagogues around the country in situations that mirrored Yiddish theater in that he performed to Jewish audiences who were emotional and would call out to the players.[7]

Undoubtedly, Jewish culture and a tradition of Yiddish theater made an impact on Brando the individual. But what of Brando the actor? How did this heritage affect his approach to performance? This influence is more difficult to trace. When he arrived in New York City in 1943, that form of theater was largely gone. While he had interactions with many of Yiddish theater's biggest names, his theatrical experiences would be heavily defined by the then current turns toward realism on stage, many born out of the Group Theatre. In multiple instances, Brando is quick to credit Jewish American culture (and, as an extension of it, Stella Adler) as instrumental to the history of American acting. In his autobiography, he relates Adler's Jewishness with her education by Stanislavski and her role as an ambassador

of his methodologies: "I don't think audiences realize how much we are in debt to her, to other Jews, and to the Russian theater for most performances we see now."[8] Brando's equation of Modern acting with a Jewish identity is understandable since not only Adler but also Clurman, Strasberg, and Meisner, some of the most significant names associated with the movement in the mid-twentieth century, were Jewish. Modern acting during Brando's rise in popularity was facilitated by prominent Jewish Americans. Along with this fact, Stella Adler's identity as a teacher, while heavily influenced by Stanislavski, cannot be divorced from the Yiddish stage she witnessed at her father Jacob Adler's theater, a venue that was a notable precursor to movements toward realism in later American theater.

Such an amalgam of influence appears in Stella Adler's courses on *characterization*. In her creation of a two-year program for training actors, after a year's worth of coursework in technique, the beginning of the second year would build on this Stanislavskian physical methodology to consider a larger sense of character. These classes taught students to consider *types*, social constructions of personalities. While still having a basis in Stanislavski, her lessons in these classes encompass approaches that flourished in the American Yiddish theater. Adler teaches her students to consider modern roles as *realistic* and *slanted* types—classifications based in the social commentary driving the characterization, as some performances (slanted) are dependent on preconceived notions of identity while others necessitate more nuanced social deconstruction (realistic). With this, many of Brando's performances warrant reconsideration as Adler's lessons in characterization illustrate a confluence of acting traditions affecting the actor's overall approach to a role.

To provide a fuller sense of Brando's characterizations as realistic and slanted types, I will consider the movie star beyond his influential roles of the 1950s and examine him in middle age. The 1970s found Brando reaching new heights of acclaim due to two noteworthy portrayals that can be classified by the slanted and realistic labels. As Vito Corleone in *The Godfather* (1972), he provides a heavily mannered performance based in altering his appearance and voice to extreme degrees. As Paul in *Last Tango in Paris* (1972), Brando portrays a grief-stricken widower attempting to create a consequence-free "stage" to perform violent sexual dominance on a young actress, a sadistic yet realistic reconsideration of the sadomasochistic star image he developed in the 1950s. While both these roles can be read through an understanding

of socially determined masculine types, as designated by Raewyn Connell, a more confounding consideration of this approach can be found in a less-celebrated performance following those Academy Award–winning and nominated roles. In *The Missouri Breaks* (1976), Brando's queer killer Robert E. Lee Clayton exists as a darkly comic exercise, reworking Adler's lessons on characterization into a form of postmodern theatricality. In this film, Brando performs "performance" and, as such, the characterization fails to conform to the slanted and realist dichotomy. Yet the *postmodern characterization* still proves effective in how it encompasses a flamboyant theatricality that parodically subverts the masculine types found in the Hollywood western.

Traditions of Characterization: Adler(s) and Stanislavski

Interest in Russian theatrical practices began in the United States and grew exponentially from the 1890s to the 1930s. As Valleri J. Hohman writes, this influence "was largely due to the movement of people between Russia and the United States," many Jewish immigrants, "the advent of modernism in the American arts, and the growing interest in Russian politics."[9] While the influences of Constantin Stanislavski and Jacob Adler on American theater are both parts of this influx, it must also be understood that the Moscow Art Theatre and Yiddish theater represent two separate traditions. While he greatly admired late nineteenth-century stage innovations in his native Russia, Jacob Adler had to leave Odessa for London and eventually New York City when Yiddish theater was banned in his homeland in 1882.[10] By the 1920s and '30s, the Moscow Art Theatre was viewed as the official state theater of the Union of Soviet Socialist Republics (USSR), and Constantin Stanislavski, a gentile from an upper-class family, did not represent an ethnicity on the world stage as much as a nationality. In other words, the Bolsheviks won the Revolution and the official theater would more reflect that ideology (that of nonreligious educated Jews) rather than the older Yiddish traditions.[11] When Stella Adler and the rest of the Group Theatre embraced a more "realistic" form of acting, it was understood in theater circles to be a new Americanized variation of the Russian school. In terms of American stage history, the Modern style of the Group emerged as the Yiddish theater was dying.

Stanislavski's former students, Richard Boleslavski and Maria Ouspenskaya, began teaching Russian acting techniques in New York City from 1923 to 1930 at the American Laboratory Theatre. When Stella Adler took their classes in 1925, this experience marked a shift away from her Yiddish theater roots toward something more evolutionary in its design. The concept of actor training itself was relatively new and ran counter to the traditions of Yiddish theater.[12] But Stella Adler recognized the future of acting would have to innovate and solidify itself as not only an art but also a science with established methodologies. She came from a background where a "studio" for experimentation—a preoccupation with Stanislavski—would have been dismissed since Yiddish actors, like Adler's family, learned on the stage in troupes. On enrolling in the Laboratory, as biographer Sheana Ochoa writes, "She [Stella] remembered the family gathered around the dinner table, laughing and joking. This day Stella became the brunt of their jokes. An Adler going to acting school?"[13]

Stanislavski had become well known in American theater during 1923 and 1924, when he and the Moscow Art Theatre toured the country as part of a larger cultural exchange with the newly formed USSR. While the true history of Russian theatrical practice in America, especially on the Yiddish stage, started well before his visit, the impact of Stanislavski's tour cannot be underestimated. As Hohman writes, the cultural exchange's press agent, Oliver M. Sayler, "worked very hard to ensure Stanislavsky became the star in America," and, as such, many Russian artists, "looking to capitalize on the fame and association with Stanislavsky or the Moscow Art Theatre," associated themselves with his name. Discussion of Russian theatrical practice in America from the mid-1920s onward thus focused heavily on Stanislavski, and this "narrative and practice was sustained at the Group Theatre, founded in 1931," which "rose to prominence in artistic and academic circles."[14] As such, in America the "Russian school" was popularly sold as defining a new philosophy of performance. While she had not seen any Moscow Art Theatre productions, through reputation, as Ochoa writes, Adler "learned that its [the Theatre's] director, Stanislavski, had developed a system for acting. The idea of an actual acting technique fascinated the scholar in Stella." In the Yiddish theater, she had "been reared to study her characters, observe people, and challenge herself," but by 1925, as she considered how to move off the Yiddish stage, "she was keen to learn more about the current acting theory."[15]

The reasoning behind this interest was, as least partly, personal, as it was a chance to define herself outside the shadow of her revered father. While the stage of her youth inspired her, this interest in training and methodology was a deliberate move away from this tradition. As Adler writes in her introduction of the republishing of her father's autobiography, "When the time came for me to spread my wings, to find my own way, it was perhaps this memory [of her father's theater] that made me hesitate, unsure of my path." The appeal of a Russian technique was that it could be defined by transferable methodologies: "I wanted to know more about this new approach, this idea that, like a painter or a musician, there was a *course of action* for the actor, a *process* by which he could learn and develop his craft."[16]

Yet it would be problematic to divorce Stella Adler's acting instruction from her Yiddish theatrical background. She witnessed her father's role in bringing a more serious theater to America at a time when New York City mostly staged comedies and musicals. This had an undeniable impact on her view of theater and performance. Jacob Adler's Yiddish theater staged the classics, moderns, and acclaimed original productions written by another Russian Jewish immigrant, Jacob Gordin.[17] As Hohman suggests, the production of Gordin's plays at Adler's Union Theatre was a significant step toward establishing a more realistic form of theater in America decades before Stanislavski's tour: "While his [Gordin's] plays may not always achieve the ideals of Russian realism, many of them depict the everyday struggles of Russian and American Jews. . . . He was especially interested in training actors in a more realistic style to suit his plays and those he translated."[18] The creative output at Adler's Union Theatre had a major impact on Jewish American culture and the turn-of-the-century American theater scene. As Stella Adler writes, "Overnight a mass audience was created, an audience of workers, intellectuals, Socialists, Zionists, men and women of every class, every shade of political opinion—a true theater of the people."[19] In this regard, at least in Stella's view, much of Jacob Adler's Yiddish theater "derived its style from the school of the new Russian realism."[20] Yet this turn did not mean a complete rejection of older flamboyant traditions of the Yiddish stage. Jacob Adler's appeal as an actor could be defined by a Yiddish flare for expressionistic theatricality: "But though he espoused it [Russian realism], there was in [Jacob] Adler a life force too strong to be contained in any school, even a great one. There was no truth for Adler in the ordinary, in what he calls the

'flat imitation of reality.' There was always something larger than life in his conception of the character, always something mysterious, something of the unknown, in the image he created on the stage."[21]

Although he died in 1926, long before Marlon Brando's foray into acting, Jacob Adler's reputation would have been well understood by the actor during his early years in New York City as he became a protégé of Stella and was welcomed into her family. The Adler household was a vibrant Jewish home filled with artists and intellectuals, and Brando would spend hours listening to family matriarch Sara Adler as she recounted stories of the Yiddish stage. After seeing him perform, she would pay him the greatest of compliments, telling him, "If you want, you can change your name to Adler."[22] As Susan L. Mizruchi writes, accounts of Jacob Adler often mirror later accounts of Brando: "Key elements of Brando's acting glimmer through Stella's account of her father's acting. Both men identified with loners—outsiders isolated from the citizenry—whose dignity is based on their embrace of exclusion and embodiment of suffering."[23] Empathy would be a defining element of both their styles—in their empathy for characters and their ability to create similar empathy in the audience. Brando's performances of outsiders, like Terry Malloy in *On the Waterfront* (1954), were similar to the manner in which Jacob Adler performed characters—such as, most famously, his Shylock in *The Merchant of Venice*, where he maintained a profound dignity during his final humiliation in the courtroom through a decisive selection of gestures. Both actors were celebrated as masters of prop and gesture work, inviting "the audience into their thoughts, the action beneath the words, in part by exploiting every prop and piece of scenery."[24]

While his role in *Truckline Café* (1946) introduced Brando to the Broadway community as a vibrant talent to watch, it was acting in *A Flag Is Born* that most directly had the imprint of Yiddish theater. The subject matter, dealing with modern Jewish characters trying to maintain their existence in the aftermath of the Holocaust, created passionate responses in audiences that were akin to the performances of Jacob Gordin's works during Jacob Adler's heyday. More directly, the experience allowed Brando to perform with Yiddish theater master Paul Muni, who was the most successful actor to cross over from Yiddish to English productions. Muni was fifty-one at the time and had performed over three hundred roles in the Yiddish theater before moving to Broadway and Hollywood.[25] As evident from what is seen in his

Jacob Adler as Shylock in *The Merchant of Venice* during the late nineteenth or early twentieth century. Folger Shakespeare Library.

performances in such films as *Scarface* (1932), *I Am a Fugitive from a Chain Gang* (1932), *Bordertown* (1935), and *The Good Earth* (1937), Muni was an actor committed to creative characterizations through either research or social observation. He would alter his physical manner to portray real people in acclaimed biopics, such as *The Story of Louis Pasteur* (1936), for which he won the Oscar, and *The Life of Emile Zola* (1937). Muni was an actor Brando greatly admired, with him later reflecting, "His performance was magical and affected me deeply. He was the only actor who ever moved me to leave my

dressing room to watch him from the wings."[26] Performing with Muni and Stella's half sister Celia Adler, also a Yiddish theater vet, as one of the three leads in *Flag*, Brando held his own and gained the respect of his veteran co-stars, both of whom marveled that somebody from his goyish background could grasp the themes and emotions of the play. As Muni would ask, "How the hell can an actor like that come from Omaha, Nebraska?"[27]

While Jacob Adler's American Yiddish theater appreciated and incorporated elements of Russian realism, his stage tradition harkens to older conceptions of theater and performance. Nahma Sandrow suggests, "Yiddish theatre was the last of the Western theatre—perhaps even the last art form—in the grand nineteenth-century Romantic tradition." This is not to suggest that the theater focused only on plays that were Romantic but that it "exemplified the Romantic movement in both its development and its philosophy"—since its early history paralleled the spread of the Romantic movement, as "Romanticism appeared in Germany in the 1770s [with Johann Wolfgang Goethe and Friedrich Schiller] and radiated outward to other regions and languages."[28] At the same time, Germany saw the wellspring of "Haskalah, the Jewish Enlightenment movement, which then expanded to influence Yiddish-speaking Jews of Eastern Europe and Russia." All these helped to open "secular Yiddish culture" and birthed a "professional Yiddish theatre," which eventually spread to America, where Jacob Gordin and Jacob Adler would incorporate realist concepts of drama from Russia.[29] As Sandrow writes, the Romantic aesthetic in Yiddish theater required the actor to emotionally charge a performance through expressionism with the goal of captivating the audience with one's own energy more than achieving a sense of realism: "Romantic actors were known for the immediacy of their emotionalism and the intensity of their temperament. . . . The ability to tear raw emotion out of oneself makes acting of this type a quintessentially Romantic profession, and Yiddish actors were noted for their emotionalism and temperament."[30]

Ironically, while she was instrumental in creating our image of the Modern realistic performance, Stella Adler would often disparage the American theater scene of the twentieth century. In *The Art of Acting*, she tells her students, "The first thing you must learn to become an actor is what the theatre can mean. And how much it can mean. I'm not referring to the debased idea of theatre as it exists today, but the theatre as it has existed for over

2,000 years."[31] In many of her discussions both in and outside the classroom, Adler acknowledges Modern acting—the Moscow Art Theatre–influenced approach placed under the umbrella of "Method" by the mid-twentieth century—as simply one style of many developed primarily to perform modern or realist subject matter. In a 1964 television interview, she reflects on how realism has become too much of a focus in discussions of acting: "Now this misunderstanding of reality or realness is something that has gotten into the country and the public thinks of the actor today as being some kind of maniac or nut. . . . But it is absolutely false that the basic idea of the Method is one is to achieve a technique for acting and then to use that technique in every possible style." She then states that actors must have the ability to act multiple styles, such as "the Elizabethan style or the Romantic style or the Heroic style or the Poetic style." In other words, an actor "must be able as a technician to have means at his disposal which would permit him to both wear blue jeans when necessary but to also have the size and the stature of man as man is known."[32] In her instruction, Adler does not focus only on a Modern style of acting because actors are not called on to only act a modern style of drama. This goal also explains her preoccupation with young actors understanding a grander significance of a play's theme that usually exists beyond their personal experience and their view of "realism." As she states in *The Technique of Acting*, "When the playwright's ideas are universal and epic, the [American] actor withdraws. He is afraid of overdoing it. He pulls the playwright's ideas down to their simplest level, which he calls being real on stage."[33]

Adler's classes on characterization often had a more philosophical focus than those on technique in that the significance of these traditions of theater is often incorporated into the class exercises. The character course builds off her previous lessons on technique, but now the context of a performance relates to, especially, the whole of the character as it corresponds with the writer's intentions. Adler writes at the start of her chapter on character in *Technique*: "The actor must discover the important ideas that the playwright reveals through his characters."[34] Once again, this can be considered a movement away from the psychological, since relating personally to the character is not always the goal. For example, in studio recordings, she often tells students that their personal experiences and social observations cannot work for honing technique for older plays. As she lectures her November 6, 1958,

class: "If you are working on a character in Shakespeare or in Restoration you have to do it differently. . . . You can't use your own thing." In the same class, she has students perform research in the form of visiting museums to prepare for classroom performances: "All style, Greek, Renaissance, Restoration, Shakespeare, all those plays you have to get from the outside. Is that clear? You cannot do them from the inside."[35]

The primary way Adler has students consider a broader view of characterization beyond a sense of the actor's "self" is through an understanding of *types*. In classical theater, this might be related to standard characterizations such as a king or queen or fairy or devil.[36] But in the realm of modern social realism, the conception of a type takes on a different connotation as she relates it directly to social determinism—in that categorizations of people are highly derived from specific sociohistorical determinants. In *The Technique of Acting*, she refers to this as the *social situation*, factors that can include religion, education, family life, ethics, morality, money, sex, political situation, and other considerations.[37] These determinants are largely dictated by the script and, indeed, the "social situation" reappears as a term in her lessons on script analysis. As Joanna Rotté writes, to Adler, society and its types drive the initial impression of a character early in the acting process as "the actor first catches the framework of the type," since no "matter how unique the character, onstage he must be recognizable as belonging to some type or group of humanity."[38] An actor recognizes that "a spectrum of types make up a society." Within the various subsocieties making up the larger society, an individual "takes a social, an economic, a political, and a moral viewpoint."[39] As established in Adler's technique classes, this socially constructed viewpoint determines the character's *attitude*, driving the way an actor justifies his choices scene to scene—which, in the broadest sense can mean if the "actor's character likes or dislikes the place and the partner."[40]

In a January 5, 1959, character class, Adler partakes in an illuminating discussion that incorporates the topic of racial prejudice to discuss types as determined by socially constructed viewpoints. Adler opens the class telling her students, "When you say a social character, it's a character recognized from a point of view. For instance, when we say, I don't know how you can identify, it's always from a point of view, from another country's point of view or from another sect of society's point of view."[41] She then directs students to remember the then-recent past of World War II–era America by asking,

"Who was the Japanese soldier? Is he a nice man?" The students then proceed to respond with various racial stereotypes with Adler's encouragement, yelling: "little," "cruel," "sadistic," "a sneak," "thick glasses," "flat face," "bowlegged." Adler then asks, "Is he that way? Is a Japanese soldier automatically a sneak?" The students respond with, "No." Adler then elaborates that this is an extreme manner of "social type," one "angled" through our socially determined perceptions: "But when he is angled, when you angle him, you give birth to the social type, don't you?" One student asks if all types are stereotypes, as in this case. Adler concurs that sometimes the type can be one: "It can become very stereotyped. Very recognizable. And that's not against him. Do you understand? You do not need very much to try to take him out of that. That's good for him. It gives him very clear lines. . . . I would say that one of the most important things in acting is to make the character graphic."[42] Fascinatingly, through this example, Adler employs the distance of over ten years from the war to have students recognize the social construction involved in a racist image, the creation of a caricatured type informed by a biased viewpoint.

When considering the social situation and modern types, Adler provides a detailed differentiation between *slanted* and *realistic* characterizations. While one can consider all characters as types in a sense, some offer a clearer conception of social commentary and can be played more essentially as a standard social type and classifiable as *slanted*. As Adler states in a January 1959 class, "There is the social slanted character which is a character with comment. The society gives them the comment." In contrast, a *realistic* type would require a more meticulous deconstruction of social determinants, requiring different considerations from the actor than the less complex slanted character. As Adler continues, "The social [slanted] type has already got the comment in him, so you don't really have to make the comment. It's there. The comment is there. You must be sure that it's there. Otherwise it is a realistic type."[43] She has students discuss the type of the capitalist, asking how and where he vacations and how he behaves when he gets there. Although she is quick to suggest this heightened social type is "not caricature. It has only to do with reality." She clarifies, "If it were caricature, it could have a mountain of cigars which were smoking themselves with his face in it. . . . It has reality. It is not an unreal man. It has a certain comment."[44] Adler stresses social determinism as essential to even heightened or stylized Modern performances,

slanted characterizations that differ from more multicolored and complex realistic performances. Even a characterization bordering on stereotype that is meant to make a comment, if in a modern play, must have a basis in observable social reality.

In her teaching of slanted characterizations, Adler's conceptions of types have telling associations with the Yiddish stage, which employed expressive makeup and celebrated altering oneself to create easily recognizable social types. While Jacob Adler's Union Theatre was groundbreaking in its movement away from "lower" forms of immigrant theater, it did maintain a profound sense of being an inclusive theater for Jewish Americans. The most important Yiddish playwright of the Union, Jacob Gordin, created modern and socially conscious plays that were an important step toward dramatic realism; yet, as Sandrow writes, such works also could eschew realism through sentimental moralizing as "his characters become almost allegorical figures," encompassing clearly defined good and evil positions.[45] A prominent Yiddish writer of the period, Yitskhok Leyb Peretz, went so far as to call Gordin's plays "partway between art and *shund*."[46] Here, "shund" characterizes a form of Yiddish immigrant theater viewed as "lower art" by Jewish intellectuals. To be a dramatic (as in noncomedic/nonmusical) theater for the masses, Jacob Adler's theater had to embrace some of the spirit of the shund, which, as Sandrow states, "was the first art form to express the distinctively American Yiddish community." With that, the plays offered a series of recognizable types that fostered a sense of community in the immigrant population. Sandrow continues, "when the butcher, the rabbi, the market woman, the pants presser, and the tenement landlady made their entrances, a shock of recognition expanded the audience's delighted sense of self."[47] Many of the modern types of Jacob Adler's Yiddish stage—based in Jacob Gordin's social observations of the Jewish immigrant experience—could be classifiable as slanted. They were characterizations meant to produce quick recognition in the audience to create a sense of community. As Hohman writes, American Yiddish theater "recreated familiar, if sentimentalized, versions of life in the old country and presented romanticized or comedic representations of life in the new."[48]

In contrast to slanted characterizations, performances of realistic types would have to encompass more complex behaviors less based in an overt social commentary. In a move showing Stella Adler's impressive skills as a

teacher, multiple records of her character classes show her beginning the term easing students into the preparation for realistic types by having them perform a shy type of person. This, of course, would be a realistic characteristic that is observable in the acting classroom, where many new students might be shy. In a May 1, 1950, class, she, once again, stresses the doable action as significant to performance in a manner that considers the characterization as a unified type, not a collection of actions: "In acting you characterize. You say he's a nice boy, a cruel boy, a shy boy. It's important for you to know how you work for character elements. Now, if you were to say, 'I'm shy' or, 'I'm sensitive' it might remain in your head or you may show it. I feel it's important for you to know what you do in circumstances with character elements. You must always find the doable part of the element."[49] The type is an approach to character as, at least initially, essentialized to core components that could be enacted through a generalized sense of action. As she states in a variation of the same lesson in a 1958 class, "Let us work on one character element. Shy. What does 'shy' do? The action of shy is to pull away." This general conception of a shy type (one who pulls away) does not mean the significance of circumstances is diminished as all the actions are still situational in that they depend on the narrative of the play. As Adler clarifies, "The character element must be specific. The character will be shy about certain things but not shy about all things. For example, a babysitter will be quite confident with singing a song to a small child, bouncing a child on her knee. But she would be shy with a policeman."[50]

With its foundation still based in a technique of doable action, Stella Adler's approach to types remains Stanislavskian in its embracing of behavioral over psychological motivations. While simplifying the matter, the popular view of the midcentury has the Soviet school of acting favoring Russian Ivan Pavlov in contrast to the Sigmund Freud–based American school of Strasberg's Method. Pavlov, who famously investigated the behavioral conditioning of canines, was the promoted science of the Russian Revolution, and many Soviet intellectuals used his findings to claim human beings are essentially socially engineered machines with behavior learned from environment.[51] As Rose Whyman summarizes, the Soviets hoped this "would establish principles by which people, and society, would change for the better and by which a communist society, based on ideals of Karl Marx, would eventually come about. This meant the ideas of

spirituality and emotion, which could not be defined in materialistic terms, were therefore suspect."[52] Post-Revolution, it generally pleased Soviets that Stanislavski would focus more on the "Method of Physical Action" over affective memory since that would correlate with Pavlov's science—even though Stanislavski's earlier focus on memory was based in Théodule-Armand Ribot, the French psychologist who coined the term *affective memory*.[53] Suggesting Stanislavski focused on physical action late in his career to celebrate a Pavlovian encoding of behaviors as an outright rejection of psychology is highly problematic since, as Sharon Marie Carnicke writes, this "interpretation encodes Soviet expectations as surely as Strasberg's emphasis on affective memory encodes a therapeutic point of view." In total, such a "linear interpretation coopts and distorts the System as certainly as popular Freudian attitudes do."[54]

Yet this more behaviorist approach to types is not far removed from Stella Adler's focus on "doing" over "feeling" as established in her technique lessons. In a December 1958 class, where she is discussing the type of the "young artist," she tells her students: "In working on characterization, it is what the character does most that you base your performance on, not what he does least."[55] She acknowledges performing behaviors can be based on deeply rooted motivations like emotions but those must be based in something tangible to create expressible behaviors: "Now in what he [the actor] does most, he is responsible for his characterization, to an understanding of it. If it's inner characterization, a deep understanding of it through himself. Not a mental understanding, but an understanding [of that] which he experiences, which gives you what you call the key to the behavior."[56] True to what was established in her technique classes, Adler's approach to character celebrates expressible behavior as opposed to what is felt.

A fitting example of this approach appears in an October 30, 1958, class, where Adler has the students discuss Lieutenant Commander Queeg's courtroom speech from Herman Wouk's *The Caine Mutiny Court-Martial* (1953). The character is obsessive-compulsive and, after a poor performance of the scene in the previous meeting, Adler sees that many of the students are not clear on the behaviorism inherent to being compulsive. She first asks students to define "compulsive" in a general sense as an action. After some confusing answers, one student finally answers, "You have to push out everything else." Adler exclaims, "Bravo! Give him a hand! That's it."[57] She then asks them to

get more specific and provide her with individual actions that are compulsive: "I want you to tell me where you've seen a compulsive action on the outside." Some students continue to misidentify the behaviors mentioning nervous ticks. Adler clarifies that those behaviors do not match this realistic type: "That's not a compulsive person." Another student gets it right ("counting the lights on the subway as they pass"), which she compliments. When some students confuse compulsive with impulsive, she takes a different route and mentions animals, particularly a moth flying toward a light, as compulsive in its behaviors—though not in its motivations, which interest her less. When a student correctly states a moth's behavior is motivated by instinct, Adler is quick to add, "In the moth, it is instinct. In you [indicating it is compulsion]."[58] As this shows, behavior trumps motivation in this discussion, or, to put it more accurately, behavior defines motivation. Compulsion constitutes both the action and motivation for Lieutenant Queeg in the courtroom just as instinct defines the action and motivation for a moth flying toward a lightbulb.

Adler's classes on characterization were an amalgam of influence from both the Yiddish stage and Stanislavski. Her discussion of slanted characterizations reflects her experience witnessing the performances of Jacob Gordin's plays of Jewish life at her father's theater. Yet this experience did not counter her understanding of realistic characterization fostered through her time at the Group Theatre and with Stanislavski. As a teacher, Adler did not necessarily make a distinction between these two traditions. To appreciate this confluence, it is important to recognize the Yiddish theater as significant to the history of American theater and acting. As Hohman writes, "Gordin and [Jacob] Adler's interest in creating a performance style more suitable for realistic plays had an impact on the great interest among second-generation Russian-Jewish Americans such as Stella Adler and other members of the Group Theatre in Stanislavsky's approach to acting and the work of the Moscow Art Theatre," so much so that the Group, after Stella's departure, even presented a selection of Gordin's plays in 1941.[59] Hence, despite her gravitation toward Stanislavski's techniques in 1925 and studying with the Russian teacher in 1934, separating the influence of Jacob Adler from the influence of Constantin Stanislavski on Stella Adler mischaracterizes her actual intellectual growth and misrepresents a fuller history of modern American theater.

Reconsidering Marlon Brando: Slanted and Realistic Characterizations

Understanding Stella Adler's approach to characterization as derived from both Stanislavskian and Yiddish traditions provides a way to reconsider the performances of her most famous student. Marlon Brando, as suggested in the last chapter, was a desirable movie star in the 1950s who had an appeal defined by a performed bodily and behavioral sexual allure. And while many of his performances might have promoted "realism" in their perceived spontaneity, such conceptions have more to do with the mythology of the Method than his actual performance choices. As Susan White suggests, "The arrival of the Method as the new realism, the new reflection of authenticity within the studio context, is as much a postwar ideological phenomenon as a new style of expression in cinema."[60] Even though Brando's most acclaimed characterizations, like Kowalski in *Streetcar* or Terry Malloy in *On the Waterfront*, are perceived as comparatively realistic in contrast to other film performances, the label itself is problematic. White writes, "'Realism' in acting comes burdened with the double sins of essentialism (assuming that there is an essential reality to be captured by actors) and empiricism (assuming that the 'authentic' emotions called forth by certain actors can be scientifically measured and verified by means of semiotic analysis)." With these star-establishing performances, we can only discuss "what makes certain forms of acting seem 'realistic' to critics and audiences."[61] To relate this back to Adler's terms, Brando's performances of Kowalski and Malloy are characterizations definable as realistic types, culled together by more minute observable behaviors that seem realistic due to their relatability to a valid outside social context. Yet they are still types in the sense that they are understandable through their social situation—that is, the returning veteran and blue-collar dock worker, each with their own identifiable subsociety within the larger American society.

But the Brando of the 1950s also played slanted characterizations imbued with a simple social comment. Here, heavy accents and mannered gestures feel inspired by his admiration of Yiddish actor Paul Muni, who similarly altered himself to play character roles in the 1930s. Brando's desire to immerse himself under makeup and accents can be seen early on in his titular role of the Mexican revolutionary in Elia Kazan's *Viva Zapata!* (1952).

By the second half of the 1950s, his desire to play overt character parts had him experimenting even more with accents to portray clearly defined slanted types: a Japanese man in *The Teahouse of the August Moon* (1956), an American southerner in *Sayonara* (1957), and a German officer in *The Young Lions* (1958). White dubs these films as an unfortunate late-decade slide into "excess" or "the era of the accent."[62] Certainly, age has not been too kind to these films, especially *Teahouse*, which despite being a sympathetic characterization, contains an undeniably offensive conception of the racial Other. As White writes, the actor's "frenetic miming, the urge to disappear beneath the skin of an 'other,' pays a dubious tribute, perhaps unintended homage, to the stereotypical cleverness of 'Orientals.'"[63] Here, the essentialized lessons promoted in Adler's classes on slanted characterization could produce cringe-worthy results, as the point of view defining the performance is hegemonic whiteness. But to truly understand the gendered dynamics of Brando as a character actor (as well as a movie star), it is best to consider the decade where he fully encompasses that role, the 1970s.

Adler's approach to characterization provides an enlightening way to consider perhaps Brando's most iconic performance in Francis Ford Coppola's *The Godfather*. As the aging Sicilian crime lord Don Vito Corleone, Brando created a character that cemented itself in the public imagination and was lampooned for decades, including by Brando himself in *The Freshman* (1990). His Corleone is a prototypical Adler performance in that it adopts many of the lessons of her technique and characterization classes. Brando externalizes the performance in a manner typical of his admiration for Muni and Yiddish theater, embracing the makeup lessons he would have learned over the years and creating the famous nasal mumbling voice. As Mizruchi writes, when meeting with Coppola initially about the part in 1970, the actor performed a quick physical transformation that stunned the director: "Brando took out the makeup case he had drawn on for years, blackened his hair, adding a thin mustache, and stuffing Kleenex in his cheeks for jowls. Wordlessly, with an occasional grimace, a cup of expresso in hand, he became the Don."[64] Brando's characterization can be read as an exercise in externality, as he had to age his mannerisms, beginning as a vital but older man in his sixties, who Brando described in animalistic terms as an "old bulldog," and transitioning into a seventy-something weaker, bulkier man of limited movement.[65] In the terminology of Adler, Vito Corleone is the meticulous creation of a slanted

type, an aging Italian patriarch—based in a social reality but still very much a stylized amalgam of accent and gestures.

Brando's other highly acclaimed role during the decade, as Paul in Bernardo Bertolucci's *Last Tango in Paris*, proves a more complicated characterization. As a middle-aged widower having a sexually dominant affair with a young Parisian woman, Jeanne (Maria Schneider), the character was developed by Bertolucci very much with Brando's on-screen and off-screen personae in mind. For example, when a maid (Catherine Allégret) cleans the bloody aftermath of the suicide of Rosa, Paul's wife, the character's background is conveyed as a composite of Brando's former roles and well-reported personal life, stating he was once a "boxer," "an actor, then a racketeer on the waterfront in New York," "played bongo drums," a "revolutionary in South America," and "one day he lands in Tahiti."[66] Brando also gives a recollection of Paul's past in one scene through an improvisation that mirrors his own upbringing, ending with the sad line, "I can't remember very many good things." These elements of the characterization along with the fact Brando's actual physical appearance and voice were employed, helped the film grow a reputation as being about Brando himself. With the heavy (simulated) sexual content, as Linda Williams writes, it was this perception that helped the movie truly shock audiences in America: "His aging but still magnetic masculine presence did not allow American audiences to place the film's sexual scenes in the context of a foreign, supposedly Old World decadence," as was the case with other European film exports of the era.[67] As Pauline Kael writes in her glowing review of the film as "the most powerfully erotic movie ever made," the first on-screen sex act "had the audience gasping and the gasp was caused—in part—by our awareness that this was Marlon Brando doing it, not an unknown actor."[68]

No matter how tantalizing the idea might be to the mythology of the Method, it is difficult to contend that Brando is really playing himself in *Tango* as much as playing a character that dovetails with the mythology of the actor. As Susan L. Mizruchi writes, "Brando invests Paul with traces of his movie history, embellished by personal history related over the years in interviews. It is a canned past served up repeatedly to audiences craving access to the private life of a celebrity."[69] In this context, the characterization is still a type, though one noticeably more layered and complex than Corleone. If we were to whittle down Paul into something essential (a possible starting point for Brando's performance choices), the characterization

feels to be about acting. As Mizruchi suggests, "The most obvious evidence that we are not watching Brando *himself* on screen" is that so much of the performance "is about acting." The actor's "characterization of Paul is another variation of the Brando claim that humans spend most of their time, at least socially, acting."[70]

Paul's story arc shows this thematic thread in the screenplay (or, in Adler's parlance, the given circumstances). Faced with an existential crisis after his wife's suicide, a tragedy that only disempowers him further as a cuckold husband, Paul rents a Paris apartment and has an extended sexual relationship where no personal details are revealed, a stipulation necessary for properly embodying a "role" removed from himself. Facing a symbolic castration in the real world, only exasperated by interactions with his wife's mother and lover, Paul role-plays sexual aggression to increasingly extreme degrees, eventually performing taboo sex acts by anally raping Jeanne and then having her thrust her finger in his anus as he verbally assaults her. In many ways, the characterization exists as a dark parody of the sadomasochistic sexual appeal that originally helped define Brando's stardom in *A Streetcar Named Desire*. Yet, in middle age, the social acting that made Stanley a sex symbol is no longer matched with the muscular young body and now is juxtaposed with Paul's actual pathetic maleness outside the apartment. In the end, when he exposes his actual life story to Jeanne, she rejects the man behind the role and kills him. The character of Paul exists as a realistic type—focused in its deconstruction of a deeply rooted theme (social acting) yet still complex in its layers of intricate social observations, some of which derive from Brando's own public and private personae.

With its references to the personal, the performance is, perhaps, the closest Brando ever got to employing the psychological techniques promoted by Lee Strasberg. His performance in *Last Tango* is, as Mizruchi suggests, certainly not the actor playing himself. Yet it was well-reported that Bertolucci pushed the actor to confront personally experienced emotions for the role. While not necessarily a strict emotional memory approach, the director was, at the time, deep in analysis and used the experience to guide his interaction with the actor: "I thought it [analysis] could be a fantastic way to reach very secret places in the mind and the soul of the actor. So I was using it to stimulate and provoke." Although he is quick to contend there was no specific school to his approach: "It's not that I decided to have a method, it was just a

Marlon Brando on the set of *Last Tango in Paris* (1972) with Bernardo Bertolucci.

way of approaching things, of reading between the lines, of looking behind the mask."[71] In the film, it is difficult to see where this approach might appear in scenes when Paul is role-playing in the apartment with Jeanne—where he often obscures himself as he playfully adopts different accents. Such provocations by the director are most likely responsible for the effect created when Brando is alone on screen and emotionally exposed, which finds the actor reaching levels of raw emotionalism. The most potent example is a sequence where Paul breaks down before the displayed corpse of his wife—as he confronts his inability to understand women and, in turn, his fundamental lack in the face of Rosa's ultimate declaration of agency. Gazing at her expressionless face, Brando has Paul unable to maintain his angry facade as his actual deeply rooted pain rushes to the surface and tears stream down his cheeks. Collapsing on her body, Brando's raw emotionalism is startling as he begs for her forgiveness.

Whatever the techniques Bertolucci employed to access such emotions, Brando conveys in his autobiography that, after the film, he "decided that I wasn't ever again going to destroy myself emotionally to make a movie. . . .

In subsequent pictures, I stopped trying to experience the emotions of my characters as I had always done before and simply [tried] to act the part in a technical way. The audience doesn't know the difference."[72] This summation by Brando is, of course, debatable, as moments in *Tango*, especially the scene with Rosa's corpse, have an emotional impact never found in the performances to follow. Yet it would be difficult to categorize the performance as Strasberg's Method as opposed to Adler's approach since emotionalism was never dismissed in Adler's studio. Generally, in Stanislavski-derived Modern acting, experiencing the character's emotions in the moment is a goal, whether that experience is initiated through one's imagination (Adler) or one's personal emotional memory (Strasberg). Brando's choice here to experience Paul's emotions of mourning is keeping with Adler's training and, in truth, most training derived from Stanislavski. As Adler writes in *The Technique of Acting*, an actor "has to be reminded that his emotional range must be extended to the maximum. One cannot hold back on anything and be an actor. All this begins with self-awareness."[73]

A reconsideration of Brando's performances as types (whether they are slanted or realistic) opens the question of how do we consider them as *masculine types*. Much of what Adler promoted in her characterization classes—a detailed examination of social situation when considering a character—corresponds well with Raewyn Connell's definitions of masculinities. Connell acknowledges that there are different "masculinities" in society, which might be construed as types, but these are presented by her not as universals but as dependent on social relations, determined by gender as a practice rather than a biological or psychogenic reality. As she writes, "A focus on the gender relations among men is necessary to keep the analysis dynamic, to prevent the acknowledgement of multiple masculinities collapsing into character typology."[74] In this, Connell presents the following "guidelines" to consider practices and relations: *Hegemony*, "the configuration of gender practice which embodies the currently accepted answer to the problem of the legitimacy of patriarchy, which guarantees (or is taken to guarantee) the dominant position of men and the subordination of women."[75] *Subordination* constitutes the "dominance and subordination between groups of men."[76] *Complicity* exists as a categorization encompassing the inherent privilege of maleness as the "number of men rigorously practising the hegemonic pattern in its entirety may be quite small. Yet

the majority of men gain from its hegemony."[77] *Marginalization* takes into account other factors external to how we view a gendered identity, though these highly affect power relations. Hence, the "interplay of gender with other structures such as class and race creates further relationships between masculinities," which have to be considered.[78] All these relationships provide a basic "framework in which we can analyse specific masculinities." To approach this system realistically as an analytical tool is to "recognize gender as a social pattern" as both "a product of history" and a "*producer* of history." This breakdown is not about identifying or defining "fixed character types but configurations of practice generated in particular situations in a changing structure of relationships"[79]

Brando's performances in *The Godfather* and *Last Tango* can be read as existing in correspondence with Connell's configurations. As slanted, Vito Corleone is quintessentially hegemonic, at least within the crime world of the film, as he represents a clear patriarchal figure to the other male and female characters. As a more complex realistic characterization, Paul, in *Last Tango*, exhibits relationships with gender that serve as commentaries on multiple aspects of the classifications. The world of Paul outside the apartment displays a complicity and subordination as he operates a cheap flophouse and remains perplexed by the motivations of his now dead wife as he faces her mother and lover. Yet the film also shows the character attempting to establish hegemonic control through sexual domination. This informs one of the most notorious uses of object work in film history, what is now known as "the butter scene," Brando's reported on-set idea to have his character use butter as lubrication when he forcibly sodomizes Jeanne.[80] The choices displayed in this scene exist as an extreme version of the types of doable actions discussed through the employment of objects in *Streetcar*. There, Stanley's preoccupation with food allowed the actor to consistently convey his inner motivation through a restless oral fixation. Here, playing an embittered middle-age misogynist, the character's preoccupation with hegemonic control serves as a counter to the weak domestic facade Paul could not maintain with his wife. Unlike the sexual violence of Stanley, which suggested a restless animal aggression through the oral, this is an act of self-loathing and transference as the character forces Jeanne to repeat blasphemies against God and family as he anally rapes her. As Linda Williams writes, "he acts out his existential despair" in this act.[81] In this sense, Brando's choice of butter, an everyday condiment

found in a kitchen, as object shows a mockery of the domestic situation exposed to the viewer as deteriorated even before the suicide of Paul's wife. The object choice remains within the character's obsession to role-play the part of hegemonic control he lost but still desires in the outside world.

The Missouri Breaks (1976): Theatricality and Postmodern Characterization

After the near universal acclaim of his performances as Corleone and Paul, one of Brando's most perplexing character roles occurred after a four-year hiatus from acting, when he made the bizarre dark comedic western *The Missouri Breaks* in 1976. Jack Nicholson, fresh off his Oscar-winning role in *One Flew Over the Cuckoo's Nest* (1975), plays the film's protagonist, Tom Logan, a likable horse rustler who runs afoul of David Braxton (John McLiam) a powerful horse baron, and falls in love with his daughter Jane (Kathleen Lloyd). Brando makes his first appearance over a quarter of the way through the film as hired assassin Robert E. Lee Clayton, a character that was underwritten in the original screenplay. Paired with the actor for a second time, after *The Chase* (1966), director Arthur Penn gave Brando enormous freedom to do with Clayton what he pleased, which created one of the actor's most off-the-wall characterizations. As such, the film long held a reputation as more of a curiosity—most interesting not as any unified characterization but as an example of what occurs when a Method actor, living up to the reputation of being spoiled, is given too much freedom.[82] The characterization has largely been viewed as a highly self-aware performance rather than realistic character work. As Mizruchi writes, Clayton is "one of Brando's most self-consciously theatrical incarnations of evil" as the role embodies Brando's own credo that the best acting is "unpredictable."[83] While certainly not a realistic characterization, Clayton is not a slanted type either as he never conforms to a simple social commentary. With this performance, the dichotomy of slanted and realistic is challenged by a postmodern approach, an exercise in self-aware theatricality.

If Adler's lessons in characterization prove especially applicable to modernist theater, a postmodern performance means subverting the styles promoting "realism" that serve as the foundation of those lessons. As Nick Kaye

writes, in the most basic sense, postmodernity "is a turning against modernity in a questioning of legitimacy which refuses to supplant that which is called into question with the *newly legitimate*." Without providing necessarily a cohesive new model of aesthetics in return, "the postmodern becomes complicated and multiple, occurring as phenomena which define, limit and subvert the cultural products, attitudes and assumptions of modernity."[84] Parodying past conceptions of art exists as a goal of postmodern artists. Linda Hutcheon suggests, "post-modernism's main interest might seem to be in the processes of its own production and reception, as well as in its own parodic relation to the art of the past," yet, as an aesthetic, it is "precisely parody— that seemingly introverted formalism—" that defines the artistic processes of postmodern artists.[85] As Kaye writes, "performance may be thought of as a primary postmodern mode," since the parodic disruption located in "the postmodern might be conceived of as something that *happens*."[86] A postmodern performer often creates an effect of overt *theatricality* meant to call attention to the performance as a constructed performance: " 'Theatricality,' in this sense is not some*thing*, but is an effect, and an ephemeral one at that." This effect can create moments on stage or on screen defined by disruption and instability with "this *excess* produced by the figures in play."[87]

Brando's Robert E. Lee Clayton exists as a postmodern performance in that it encompasses a knowing theatricality, an excessiveness meant to disrupt. If Brando's Paul in *Tango* shows him portraying a complex realistic type as an examination of "social acting" as a theme, *Breaks* presents a disjointed characterization also focused on the theme of "acting," yet in a much more parodic manner. Before Brando's entrance, the audience is introduced to two distinct classes of males typically found in the cinematic western, the hegemonic order of the horse barons, represented by Braxton, and the marginalized horse rustlers, represented by Logan.[88] Each of these have their own social structures, with Braxton as a classic patriarch within his household and among the rich men of the territory. While separated from the legitimate social order, Logan's marginalized rustlers have their own familial structure with a patriarchal figure in Cal (Harry Dean Stanton), Logan as a second-in-command, and subordinate power relegated to the rest of the men, representing various degrees of maturity. Brando's introduction is an overt act of theatricality that disrupts these orders, which are genre norms. As Jane stands in the foreground on her father's porch, she spots in the distance what

appears to be a white horse and a jackass without a rider. Brando makes his first appearance thrusting his head into frame from behind the horse, having hidden himself from her (and our) view, and exclaiming, "Lee Clayton!" When she responds that he gave her "a scare" since all she could see was "his horse," Clayton states, "That was all you were meant to see." With this introduction, the character is shown to be a trickster—yet a trickster with a central purpose to control his image and obscure himself, which corresponds with Brando's own goals as an actor. While the other males are introduced as essential components of the western masculine order, clear genre types, Brando's character is quickly established as a subversion of this order. Ironically, while the character is hired to be a "regulator" by Braxton, his essential action (or, as Adler might suggest, what Clayton *does*) is "disrupt," both the lives of the characters and the diegetic unity of the film with its, thus far, easily identifiable classifications of on-screen western maleness.

Here, as in most scenes, Brando adopts a thick and excessive Irish accent he originally developed for *The Nightcomers* (1971), a voice that quickly establishes Clayton as removed from the surrounding characters. As the scene progresses, the assassin asks to be introduced to Braxton and then enters the home in a comical manner by, again, jutting his head into the frame. Once inside, the actor makes the choice to give the character a toothache, taping his face in a disarming manner in a playful variation on the oral fixations seen in other performances. Now, the focus on his mouth is about agitation, which serves as a defining attribute of the characterization, as his motivation in most scenes with other characters is to agitate by subverting accepted social practices. When he notices the wake for Braxton's overseer in the parlor, attended by the powerful barons and their wives, he enters by giving a respectful bow. He then turns to Braxton and chides him for hanging a rustler without finding out about the rest of the gang. When those in attendance protest, Brando proclaims, "You pampered the man and the result is the loss of this poor man's life," lifting the body and allowing it to crash down into the ice meant to preserve it. After loudly criticizing those in attendance for not securing his services sooner, Brando make the choice to stress the concept of agitation again, further disrespecting the solemn occasion by wrapping a piece of ice from the casket into a handkerchief and placing it on his cheek, turning to say, "Ladies and gentlemen excuse me, but I am under a severe attack from a tooth."

Clayton is marginalized as the men in attendance are quick to realize he is something usually unseen within the western genre, queer—a character that embodies through his dress, here a white rawhide coat with fringe, and behavior many attributes that would be considered feminine by the masculine order. After he leaves the room, they laughingly mock him: "He has no wife, but he sure does keep himself spruced up." "Many of a rustler said his prayers when he got a whiff of them lavender bath salts in the sagebrush." Although queer, the character is never implied to be homosexual or bisexual as much as an excessive performance of asexuality, seemingly interested in a solitary existence without any male or female companionship. Here, the characterization feels to be parodying the rugged individuality of the stereotypically solitary male often found in westerns. Following a scene where Jane successfully convinces Logan to take her virginity, the film juxtaposes this heterosexual copulation with Clayton as he enjoys one of his solitary hobbies, bird-watching. This choice was based on the actor's own interest in birds, yet the addition of this hobby is telling in that it is a solitary activity (as well as, of course, implies Clayton as a "bird of prey" in his pursuit of rustlers).[89] The character is presented as a queer subversion in his refusal to partake in not only heterosexual copulation but in any semblance of romantic love. His only relationship is with his horse, Jess, whom, late in the film, he talks to in a manner parodying hetero-romance: "You have the lips of Salome and the eyes of Cleopatra." In a telling choice of object, Brando places a carrot in his mouth and feeds it to the horse, combining his past focus on oral fixations with an overt phallic vegetable. He then dedicates a song on harmonica to Jess, "the only woman I ever loved," parodying the heterosexual love found in most mainstream film, as he chides his other horse with "I don't love you, you harlot."

Overall, Brando presents Clayton as a character embracing theatricality as he is bemused by his perceived queerness, which he uses to agitate and disarm other males. This attribute of the character appears in the scenes highlighting the film's major selling point—the pairing of Brando with Nicholson. The scenes where the two movie stars interact are limited to only three, with each showing an increasing self-awareness in Clayton's queer performance as Brando indulges in his Irish accent to set himself as apart from this quintessentially American setting. The first has Logan, posing as a small-time rancher, meeting the regulator for the first time as he removes a young horse

from a muddy gulch. Clayton, dressed again in his white fringe, and Braxton ride up in an official capacity, highlighting their position as the law and order of the territory by sitting well above Nicholson, who is covered in mud. With his birding book in one hand, Brando largely maintains his distance, accentuating himself as a calm observer of people, refusing to get upset by Logan's contention that regulators are without conscience since they shoot men from a distance.

Clayton continues to observe Logan and surmises he is a rustler. Visiting his rundown ranch to antagonize him, he performs his queer attributes to sinister ends—now dressed in darker colors but still with "feminine" accoutrements, such as a silky scarf, embroidered cuffs, and a light brown soft hat with a colorful band. Once again stressing the Irish accent to nearly absurd degrees, the actor takes a disarmingly dominant position by grasping his hand around a post as he relays what he learned about the Logan family. Typical to the western genre, Brando then employs the phallic pistol in his object work, though in a manner keeping with the character's queer predilection for the ornate. As he shows off his firearm, he gently rubs his palm and fingers over it, telling how it is "all hand done. Etched, you know. Scratched in silver. Oh, she's a beauty." Clayton then gives an impressive display of target shooting. In essence, the gunplay exists as an extension of the character himself, based on maintaining a disarming perception of flashiness while proving deadly skilled, even if the phallic symbol itself might be perceived as absurd in it garishness.

The final scene between Brando and Nicholson shows Clayton at his most subversive, expressed through a series of fascinating performance choices. After the death of Tod (Randy Quaid), Logan rides to Clayton. Bursting into Braxton's home, the rustler locates the assassin bathing in his lavender bath salts without any of his guns. As Nicholson enters the room, Brando places his hands on the sides of the tub, insinuating the lack of guns, as he states: "You know the old man [Braxton] built this tub for the old lady and she ran out on him." This statement aligns Clayton with the feminine, as he now takes the position of a new bride, which throws Logan off before he quickly checks the bathroom for a firearm. As Nicholson confronts him, Brando remains deadly calm, lamenting he has not eaten his dinner yet. Then, in response to a direct threat, Brando heightens the inherent homoeroticism of the scene by leaning forward to expose more of his nude body, calmly stating, "It just

Marlon Brando and Jack Nicholson in *The Missouri Breaks* (1976).

ain't in the cards, angel." Logan gets more frustrated by Clayton's lack of anger and demands, "Get up." In response, Brando simply leans back and passively exposes more of his body, bemoaning, "I want to lie here and lose. No dinner. No nothing." Brando turns his back to Nicholson mockingly welcoming the gunshot or, in another sense, penetration since he is role-playing as the bathtub's intended bride. As Brando stares off into the distance, a view unseen by Logan, he conveys a slight worry in his eyes, flinching, as the gun goes off into the side of the tub, missing his body and draining the water. Thrown by his disarmingly passive behavior, Nicholson throws suds onto Brando's face before leaving the bathroom, declaring, "My God. You ain't even there."

On one level, Brando's performance in *The Missouri Breaks* can be read as parody, embracing a queer subversion of hetero-masculinity as it traditionally appears in westerns. With this in mind, the question can be posed if the characterization itself is really "there." Robert E. Lee Clayton is performed as a perplexing figure in that he fails to really exist as a realistic type since he takes on a nearly mythical quality as a trickster with an almost superhuman ability to murder. On the other hand, a slanted type implies an essential core

to the characterization, something Brando gleefully eschews in a performance precisely about the ethereal nature of performance. Instead, if Brando approached Clayton as any sort of type, it is a postmodern characterization very much aware of types. He appears to be not "there" because he willfully obscures himself through acts of role-playing, which results in the viewer questioning the legitimacy of the characterization itself as "real."

The disruptive theatricality of the performance becomes apparent when the Irish brogue Brando adopts is exposed to be a possible act as we see Clayton interact with Tod before murdering him. Here, the assassin now adopts the persona of Jim Ferguson with a comical American southern accent. As a performance within a performance, Ferguson is a fully formed characterization worthy of his own motion picture. Strumming a mandolin, Brando adopts a wholly different physicality from the Irish Clayton, with his mouth consistently stuffed with rabbit meat, hair disheveled as he slouches his body. Despite his misleading preacher's collar, he tells Tod he is "about a quarter ass horse thief. Anything to get some grits in my stomach. Not doing too good at it neither. Otherwise, I wouldn't be eating hare. I'd be in Dodge City playing with them big asses, drinking champagne." Here, Clayton performs a slanted type—creating Ferguson as a comically marginalized figure desiring for increased power and heterosexual fulfillment. He adopts the type of the horse rustler. In this moment, the viewer is confronted with multiple levels of performance—Brando as Clayton, Clayton as Ferguson, Brando as Clayton/Ferguson—that challenges the legitimacy of the disjointed characterization.

The Missouri Breaks contains an overt and disruptive theatricality in its presentation of Clayton, as Brando embodies a character that role-plays in a manner that throws the viewer. In one of the film's most absurd images, Brando has Clayton dress in a frontier woman's bonnet and dress as he violently murders the rustler's patriarch, Cal. No explanation is given for the character's bizarre choice of dress. Since the assassin sneaks up on Cal's cabin under the cover of darkness, the dress is not motivated by a need to disguise. Instead, the absurd image of Brando in the costume is simply presented as a queer subversion of the tropes of the western since an assassin character would usually be presented as hypermasculine. The performance choice is an act of pure theatricality, displaying an understanding and subversion of the audience's expectations for the western genre.

In total, Robert E. Lee Clayton in *The Missouri Breaks* was a sign of things to come as late-career Brando embraced a more playful manner of performance, where often subversion seemed to be the goal. At their worse, some performances do not have the appealing subversive attributes of Clayton, which can be read as an effective postmodern performance, and simply appear cartoonish. Most notoriously, such choices appear in his titular performance in *The Island of Dr. Moreau* (1996), where the actor paints his face white and wraps himself in white cloth in a manner resembling Kabuki theater. While, true to his Adler training, Brando gives these bizarre flourishes some semblance of motivation (his character's fear of sunlight), the theatricality now veers into burlesque within a production the actor felt comfortable undermining.[90] His veering toward broad, sometimes subversive, theatricality could be due to the fact he grew increasingly disdainful of the celebrity that came along with his acting talent, a stardom he saw as foolish in contrast to real-world social issues—famously rejecting his 1973 Oscar for *The Godfather* to call attention to Native American rights and often focusing on environmental concerns in late-career interviews.

In truth, Brando never rejected acting and stayed true to the spirit of Adler in his view of it as largely a noble pursuit. In 2001, nine years after Adler's death, the seventy-eight-year-old Brando even followed in her footsteps by conducting a ten-day workshop called "Lying for a Living," a strange gathering where he oversaw a group of young acting students as well as established stars—including Sean Penn, Nick Nolte, Edward James Olmos, Whoopi Goldberg, Robin Williams, and even Michael Jackson, who stopped by for a single class. The sessions, videotaped but never released, are the stuff of Hollywood legend as strange impromptu exercises with unknowns and megastars resulted in odd spectacles all under the guidance of a largely freewheeling Brando. As Olmos remembers, it was an unstructured affair with the acting legend often handing over the proceedings to others: "Nothing was scripted. . . . When Brando says, 'OK, you teach a class,' what the hell are you going to do? I just talked about how I work and the feelings that I get from acting?"[91] While the stories of the classes veer toward celebrity sideshow, the intentions at least initially were sincere, as Mizruchi writes, "Brando had global ambitions for these classes, which he planned to film and distribute worldwide."[92] Reportedly, Brando opened the seminars in an act of theater, not teaching. He walked into the studio space not as himself but

role-playing a familiar figure from his past. On the opening day, the doors reportedly flung open and the three-hundred-pound Brando entered wearing a blond wig, blue mascara, and a black gown with an orange scarf. In a matronly voice, as if to scold the students, he exclaimed, "I am furious! Furious!"[93] With this act of theatrical burlesque, he performed the type of the acting teacher. In perhaps his most playful tribute to his former teacher, in a comically slanted style, he performed the type of Stella Adler.

4

Given Circumstances

Robert De Niro's Script Analysis
for *Taxi Driver* (1976)

Tucked away in the archived materials of Robert De Niro is a single sheet of paper with a speech titled "I'm a Capitalist." The typed contents are short and express the thoughts of a nameless owner of a shipping yard as he addresses and belittles labor representatives, referring to them as "masters at the art of deconstruction. Like a cancer you multiply and spread, and like a cancer you kill from within." The piece ends with a warning, "But while you're doing all this rebel-rousing and crying 'red-baiters,' when we fight back, remember, America doesn't start wars but neither does she lose them."[1] On the page, the paragraph is split into four sections by lines of blue ink, divided according to the motivations behind the words, as the speech moves from the character's introduction to insulting labor to countering their beliefs to overtly threatening them. On the back of the sheet, De Niro writes his analysis of the short script in multiple lines that provide almost as much text as the original speech. Focusing on the inherent privilege and power of the male capitalist, he writes, "except my side is better than yours. You can see for yourself because we have the better things in life," and "my country depends upon me. You are too small and unimportant to bother with."

The analysis is based in defining essential doable actions, with De Niro even writing, "Remember: action is only an action in a specific situation. . . . That is why my action has to be as specific as possible." He defines the motivation behind the action as simply "to let them know I am superior and if they want trouble they are going to get it."[2] De Niro breaks down the speech in a manner reflecting the social type of the character—the inherent privilege of the capitalist male. He then employs that social context to determine the motivation

in relation to specific circumstance, the essential action defined as a need to express the speaker's self-perceived superiority and to threaten those he perceives as lower. In *The Technique of Acting*, Stella Adler stresses the fundamental goal of analyzing a script: "In the beginning, the script is outside you—a body of material that is external—but as you study, breaking it down into actions so that you can understand the growth of the playwright's idea, you begin to take it inside of you."[3] The written notes on the speech provide insights into the process of De Niro as a young student of acting, working to understand "the playwright's idea" by breaking down the motivations driving the capitalist and internalizing them.

Analyzing this speech was a common activity in Adler's studio and, indeed, the document comes from De Niro's time studying with her. Unlike Marlon Brando, De Niro never developed a close relationship with Adler that can be defined as that of mentor and mentee. He was eighteen years old when he came to study at her studio in 1960 but already had some instruction with other acting classrooms beforehand, studying at the Dramatic Workshop at age sixteen and attending a public school for the arts in New York City.[4] He stayed at Adler's studio for an extended period, until 1963, though also studied at other programs as a young actor, including the Herbert Berghof Studio and the Actors Studio. While a committed student, De Niro was not a star pupil like Brando. As the actor summarizes the experience, "I wasn't anybody who made an impression on her [Adler] when I studied there."[5] Adler favored demonstrative personalities in her studio, which did not mesh particularly with the young De Niro, who was quieter and introspective. In short, reflecting a common critique of her, during his time there, he was often put off by her theatrical personality.[6]

Despite a lack of a close mentorship, De Niro is an actor of the Adler school, at least in contrast to other popular methodologies of the era. Between 1960 and 1963, the young actor continued to study with her primarily because she stressed the research and analysis of a role as existing outside of "self": "[Stella Adler] would be inspirational as a teacher for me. . . . There was a lot of pomp and splendor . . . with her, but she was a good teacher. Very good. I always give her credit for having a big effect on me." Marking a notable difference from the Strasberg Method, De Niro states Adler's approach shows acting "is not about neurosis; playing on your neurosis. It's about the character, and about doing that first: the tasks of the character. Not going

on about it as if it was all about you and how you would do it. It was more about the character, being faithful to the text, the script."[7] As this suggests, to De Niro, Adler's Modern approach to script analysis defined her primary difference from other schools of acting, especially Strasberg, as it moved from the external (the play's directives) to the internal (the actor's approach). Also, the primary goal always remained to convey the grander ideas of the playwright—the themes of the play. As De Niro reflects on his training with Adler, she taught him how a character "represents an attitude of the world, or this part of humanity, if you will. Stella gave me that sense when you're reading these characters they represent more than just themselves but they are themselves in a very real way. That made an impression on me; she taught how acting applies to a bigger vision."[8]

The privileging of the script was of paramount concern to Adler and, in many ways, would cement her reputation as a teacher of acting during her lifetime. Her classes devoted to script analysis—especially later with her series of lectures specifically on famous playwrights in the 1980s—proved the most popular as they did not exist at other programs, at least not in the careful and detailed manner of Adler's instruction. As Rosemary Malague suggests, in these courses, Adler's "approach is highly specific; she studies the differences between and among Anton Chekhov, Henrik Ibsen, Arthur Miller, August Strindberg, and Tennessee Williams, to name a few of the writers whose work she taught. . . . by giving lectures on how to read and understand a play, she was unique among her contemporaries."[9] Equipped with an encyclopedic knowledge of modern theater, Adler employed intelligent literary and cultural analysis.[10] Her students often commented on her approach to script analysis as among the most impressive aspects of her instruction, as it dealt with the concrete tools for first approaching a character with only the written word—a professional reality that actors consistently face before auditions, rehearsals, and performances. Broadway and Hollywood character actor John Randolph recalled how Adler promoted a "knowledge of the craft I could use on stage or in film, in auditions and readings. It was a knowledge that bred confidence. Not only that, she was a sheer genius when it came to breaking down a script or building a character. It was not academic, it was 'doing.'"[11]

Adler's privileging of the script provides an illuminating framework to consider the film actor's relationship with the screenplay as an interplay

between the written and performed. Her classes on the subject illustrate how script interpretation existed as the culmination of her other lessons on technique and characterization, helping to situate the performance into a larger social context. Her lessons demonstrate an intellectualized process for considering a text's thematic concerns as well as a character's social psychology. In doing so, the text is privileged over the instinctual or improvisational. By examining the actor often considered in American film as Brando's successor, Robert De Niro, this chapter dissects how the actor's dynamic relationship with the screenplay reveals a wide array of complex process-oriented engagements. As R. Colin Tait writes in his examination of De Niro's archived screenplays, the actor's script analyses show "an extremely complex author-figure himself, whose intellect, artistic sensibilities, words, and ideas make their way onto the screen."[12] This process becomes especially apparent in his early film work with Martin Scorsese, which cemented the actor as an icon of post-Vietnam-War-era maleness. As seen in the annotations on the archived screenplay for *Mean Streets* (1973), De Niro's collaborations with Scorsese exhibit a foundation for performance very much based on the techniques and philosophies covered in Adler's studio. This process laid the framework for the actor's iconic portrayal of Travis Bickle in *Taxi Driver* (1976), which became a prototype of volatile post-Vietnam-War-era white male aggression and explored a new manner of disturbing on-screen masculinity. By examining his process of script analysis, the mechanics of performance from its early stages show how De Niro considered gender in creating Bickle. Here, the quintessential male actor of the 1970s displays how much of his performed aggression was not instinctual but carefully determined by a meticulous understanding of psychosexual and societal context. In doing so, even as the actor famously improvised elements of the performance, the roots of the character are proven to have sprung from De Niro's interplay with written text and its scripted gendered dynamics.

The Script and Performance: Adler and the Text

As it is listed on the 1958 brochure, two years before De Niro enrolled, the program at Stella Adler's studio cumulated with the "Analysis of Plays," where young actors employed the skills developed through technique (or, as listed

here "principles") and characterization classes. The brochure states about the entirety of the studio program, "This two-year course leads the actor through specific exercises dealing with his inner means that are designed to prepare him to analyze the script, create the character, and do the play."[13] As suggested by this summary, the learned techniques existed as the building blocks of performances and were meant to aid in an actor's interpretation and comprehension of a play—conceivably a final step in the training process (though, in truth, plenty of actors continued to train beyond this course). Adler would often open her term on script analysis by suggesting that an intellectual engagement with the written text was paramount in defining the actor as a creative individual. In fact, she even challenged the students to rethink their roles as creative artists with such a distinction in mind. In a 1983 seminar, she states, "If you say 'I am an actor,' people think you're an idiot. . . . The term 'script interpretation' is a profession; it's *your* profession. From now on, instead of saying 'I am an actor,' it would be a better idea for you to say 'My profession is to interpret a script.'"[14]

In Adler's instruction, there is a sense of the script being the most significant determinant of a performance—more important than the director or even the actor's personal feelings toward the character. The meaning of any written work is, of course, subjective, nevertheless, the script remained defined by Adler as a text onto itself with a singular authorship possessing a distinctive vision: "Once the playwright has written the play and the play is here, he's done his job. It's closed. It lies there. Then it hangs around for people to see or read or study or act in."[15] Adler then defines the play as having two levels of significance:

A play has two aspects/essences: it is divided into the *literary* side (the playwright's) and the *histrionic* side (the actor's). The histrionic side belongs to the actor and to what he puts into it, how he thinks, what he says and understands through it in his mind, his soul, his background, his culture, his personality, his whole being. That histrionic side of the actor is what he is and what he adds to the play. The play is dead. It lies there. The other side is the side that people fool around with.[16]

When Adler states that the play is "dead," it is not meant to disempower it, as her courses fully illustrate her appreciation of the text as a vital artifact.

Instead, she is suggesting the written essence of the script has an eternal quality based in a past-ness. In contrast, the actor's interpretation exists as something more fluid, encompassed by a present-ness—the performed. Neither of these two aspects are overshadowed by the other. Instead, they exist in correspondence as an *interplay* between the performer and the written idea that creates the characterization.

In her classes, Adler contextualizes this understanding of past-ness and present-ness as significant in acknowledging both the limits and potentials of performing slanted and, in particular, realistic characterizations. In a 1980 scene analysis class, after hearing a series of monologues, she addresses the issue of realism by asking, "How many people are afraid to act a little bit differently than they think is real?"[17] The students acknowledge this and Adler elaborates, "Now, real ought to be defined by you. Real is leaning in your particular style of reality. . . . Real means, theatrically, that you live with reality in circumstances." Adler tells the students, some of whom had been professing a desire to master "realistic" acting, the concept of a script's past-ness is central to performing in a manner that appears truthful. She states, "if you are saying goodbye to somebody who is going to jail [in a scene], to say goodbye and to suffer is not real. To say goodbye is to say goodbye to somebody you knew before the scene; and if you know him and you know it, then you know how to be in these circumstances saying goodbye."[18] The past-ness of the written text is what defines the collective experience of the character: "So real means the past. Living truthfully in the circumstances." Adler sees establishing a version of truth in performance as embracing the past-ness of the play text and the present-ness of performed actions. A sense of reality can only be established "through living the past of a character, to understanding the truth that the author wants you to understand, to understand the truth of a clean napkin and a dirty napkin, to understand the truth of a piece of cake that is clear and wrapped and secured and a piece of cake that's got rotten and dirt on it." Such understanding begins in the written text and then is elaborated on by the actor, developed through a process of interplay: "Therefore to have really the truth it has to become the created rather than common. Who understands? It must go through the creative process."[19]

By the end of her studio's course sequence, students would have understood Adler's approach to acting as very much defined by a clear dichotomy—an appreciation of the literary (the written text) and the histrionic (the actor's

interpretation). Existing as an interplay that defines an actor's preparatory process, this dichotomy promotes the idea that a performance is a failure if it is only about self-expression. The professional goal of any actor is to have a performance be for public consumption. While the histrionics of a text are significant since audiences want individualistic performances, one cannot dismiss the literary as the narrative and themes also define the appeal for an audience. As Adler suggests, "The audience is interested not just in acting but in the literary side of the playwright; that has to come through. There are statements in every play. Get to know how they work. Every play is external. It isn't internal. It isn't in you and it's not going to be—not if *I'm* around!"[20] Throughout all her classes, Adler's general disposition to dissuade incorporating too much "self"—the internal—in performance serves as preparation for script analysis, which is about understanding circumstances outside of "self"—the external. From a teacher's standpoint, this approach makes sense as Alder saw how the play text often deals with ideas challenging to young actors, who, if interpreting a role solely through personal experience, could misunderstand essential elements of the narrative.[21]

Adler's script-focused approach to crafting a performance can be read as empowering to actors as it privileges their interpretation as much as (if not more than) the director's. As Rosemary Malague writes, "An intellectually engaged actor, who understands the ideology of the script, is empowered to create a nuanced, *embodied* reading that can resist, critique, or contextualize the play." Suggesting Adler promotes radical reinterpretations of scripts is problematic, as Malague acknowledges: "Strictly speaking, Adler would never endorse disagreeing with the playwright in one's performance. She does not intend to train actors to subvert the author's ideas."[22] Yet acknowledging Adler as a teacher who does give students more power to create their performances opens the potential that her techniques allow for readings not overtly present in the original written text. As Malague writes, "By teaching actors to understand scripts, to critically engage with them, and to debate their ideas, Adler implicitly equips them with skills that could be applied with political (and feminist) consequence."[23]

Former student Joanna Rotté gives a breakdown of her teacher's approach to script analysis that illustrates how the practice encompasses an understanding of larger societal concerns. After students summarize the basic sequence of action of a script, they consider general impressions about

character and setting. Their personal insights (their opinions of the character), though, were not enough for Adler. They had to also practice a detailed consideration of a broader *social situation* by concerning themselves with what "the society of the play thinks" about the following issues:

- Politics, or the distribution and use of power.
- Economics, of the distribution and use of money.
- Sociology, or the class structure and acceptable behavior in public (including attitudes toward minorities).
- Domesticity, or the family structure and acceptable behavior in the home (including the attitude toward women).
- Religion, or the system of beliefs, morals, and practices.[24]

Keeping with their teacher's focus on the present circumstance and the doable, students discuss the play and its society in the "present tense." Yet they never do so in a manner obscured by an actor's personal sense of lived experience. Instead, the exercises externalize through immediacy, giving the actor "a springboard into studying, thinking about, and imagining the way of life of the society that determined the play's social situation."[25]

As Rotté summarizes, this approach encompasses methods first considered in technique and developed further in characterization, recontextualizing them into a broader and cumulative process of analysis:

> Referring to the text and using imagination, the actor gradually develops this background, giving it body. He seeks out literature and works of art from the time period and locale where the play is set. He immerses himself in images typical of the play's social class. Thus rich with a wealth of attitudes appropriate to the social situation of the play, he fulfills one job of the actor: figure out how to live and react within the given code.[26]

The key to engaging the script would be the cultural code driving not only the gender depiction but also all the aspects of any performed identity. According to Adler's philosophy, the play "is essentially the social situation and its inherent conflict. In the modern theatre, the play is contained within the place and may be acted because of the place."[27] The analysis of a script for a modern realistic text might encompass a psychological journey, yet the aim

of a character, the impetus of the mental state, would be circumstantial and related to a larger cultural code.

In a February 27, 1961, class, Adler explores how social situation is critical to analyzing the whole of the text as the culmination of her lessons on technique (doable actions) and characterization (social types). Referencing the terminology established in previous classes, she explains how an initial response to a scene is based on the in-the-moment actions. She states, after what seems to be a first reading of a text, "What is the action? What is happening? What is being done? . . . And always take it from a one character point of view. What is the character doing?"[28] Adler situates the students in the essentials of technique, the present do-ability of the action. She then states, "Now a few things came [with the first reading]. Either the action comes first or a sense of character comes." These initial responses to the written text might also facilitate something beyond the immediate actions—characterization, which can be determined as a type through external social factors. With characterization, a type is likely to emerge with an initial reading since first impressions are based on quick social generalization. For example, "A man [in a play] that has six children around him, all over him, you would say is a family man. He always has many things around. Family, bills, obligation, things like that. So you know he's a family man. Now that may come first; a sense of character."[29] Adler also suggests these initial considerations for a performance cannot exist without a larger sense of the play, not only its story and themes but also its "culture." She states, "What you need mostly to know, immediately, when you approach a play, what produced it. What culture is it in?" To Adler, the culture defining the storyline and, often, the writing of the play is critical to understanding not only the narrative and characters but also the text's entire essence as meaningful art: "Now, how do you get the culture? You get it for the actor through its [the play's] morality. What is its morality? You get it through its social forces. . . . The social situation is the thing that produces the play."[30]

This philosophy dictates her requirement that her students discuss plays in the present tense, a requisite stressed in her class notes on scene analysis. For example, a typed card labeled "Fact," with a margin note for "Class Nationality," states, "Underline each fact in very minute detail using present tense," which is an exercise where students look for clues (or "facts") in a scene to recognize the cultural realities of the narrative and characterizations.[31] The

card then lists basic ways to connect to (or make present) the past-ness of the written artifact:

A. Always in present tense.
B. The past of the role comes from the present tense.
C. The facts give you some kind of life—a social situation.
D. This social situation pushes down to a deeper level of thinking.
E. It shows you the way of life.
F. It makes you go to the literature concerning period.
G. Goes from thought to experience.[32]

The bottom of the card gives the reasoning for this activity, as it relates to Adler's overall philosophy of performance: "How to put life into external circumstance; Go from the facts to artistic imagination; The facts make you create thoughts," and most provocatively, "People live factually every day."[33] With this final point, Adler acknowledges how in real life, behavior is determined by these "facts"—or cultural determinants that all human beings live out day to day in the "present tense."

In Adler's lectures on major playwrights, culture exists as a primary focus as it frames her insights on many key modern works. For example, when discussing Arthur Miller's *Death of a Salesman* (1949) in a class from the 1980s, she is quick to have the students understand the midcentury period as distinct from their own: "The historical moment is America in 1949. You have to know when and where you are in the play's present time, but also the background."[34] She then states, "From the social circumstances we go to the larger historical circumstances. What is the country at large thinking and doing then? You must know this in order to understand the play." Here, the employment situation is explained to the students, "In 1946, the men started to return [from the war] at the rate of 650 an hour, twenty-four hours a day, every day. By 1947, 350,000 men were discharged. In '48 and '49, thousands more came home and flooded the job market."[35] As posited by Adler, this influx of people, both in the workplace and in communities, challenges the masculine autonomy of Willy Lohman: "That is the industrial scene behind Miller's salesman—the scene in New York, in Chicago, in all the big over-populated cities. You have to know this because you have to know why, the moment Willy Lohman comes in, he is *lost*, and why the life around him is

lost." These cultural determinants, what was perceived by some as the rebirth of a crisis of masculinity, drive the characterization.[36] To Adler, these cultural drives must be considered to develop the performance. Yet they also speak to the larger significance of the play as an artistic creation, "It's the beginning of a whole new way of American life, which is why Willy feels so 'dismissed' from the play's outset."[37]

In the studio, Adler found fascinating ways to explain culture and a larger sense of literary themes that could relate to the student's personal experience. For example, in a 1980 scene analysis class, two students perform Biff and Happy's dialogue from Act II Scene 7 of *Salesman*, where Biff tells his brother how he stole a fountain pen off the loan officer's desk in a feeble act of rebellion. After hearing the performance, which she largely responds to positively, Adler places the action in the context of changing institutions—primarily the crumbling myth of American exceptionalism and the dismissal of religion: "We have swallowed the myth. We have taken the myth, which is the biggest need for a man, the myth of nationalism. That is the biggest myth in the world."[38] She then contextualizes this concept in reference to Biff's motivations, "So what we have now is the breakdown of 'Where are they going to go?' if they don't have the myth. . . . What is going to help them? Religion isn't going to give them anything; So, there is the generation that inherited, 'I am wonderful. I am a great athlete. I'm a great this. I'm a great that. And without that I am a dollar an hour.' "[39] She then personalizes Biff's feelings for the students, asking, "Now has it been easy for all of you to break away from your parents?" They reply with an exuberant, "No." While promoting this sense of empathy, Adler is quick to differentiate the character's experience from their own, stating, "Now imagine how much stronger it was forty years ago when there was a family." She then relates this all back to the larger sense of literary context: "And now let me tell you one more thing, which is biblical. . . . The father looks to the son to carry on the tradition and that is the son's primary motive is to carry on the tradition of the father. And that is historical from the Bible on. The oldest son stays at home to carry on the tradition."[40] Through this exercise, Adler directly relates the character's motivation to both the cultural significance and larger literary significance of the play in a manner still promoting an actor's empathy, the understanding of the universality inherent to family relationships.

With such analysis, Adler could address very specific cultural codes related to gender and sexuality in her classes. For example, her insights on William Inge's *Come Back, Little Sheba* (1950) are particularly geared toward the cultural with a focus on gender relations. In a late-career lecture, Adler is most interested in Inge's first play as it explores mid-twentieth-century, middle-American sexual codes, discussing region and era-specific considerations with her students. She states, "So you start with the fact it takes place in the Midwest. He wrote his plays in the fifties and sixties. That was his time. He makes you understand that in the Midwest, the life and the lifestyle revolve around the family."[41] Through the lens of this culture, removed from the cosmopolitan concerns of New York City or Los Angeles, she challenges the students to rethink their supposedly more progressive conceptions of gender: "The most important thing he [Inge] says about the male-female relationship is that men think because they have the muscle that they're important. Muscle and power."[42] She then suggests that Inge recognizes the drive for phallic power as masking a wider sense of cultural lack, "Inge discovers in every play that men who want to be boss, who want to be the head of the family, have in them a universal emotional sickness. They don't truly believe in themselves."[43] Adler presents these observations as derived through social determinants, a prism defined by a white middle-American culture as distinctly different from the students' current cosmopolitan existence: "You will see that through these kinds of relationships, especially in the Midwest, America had a whole life that consisted only of kids and family problems—not the war, not Nazism, not the ghetto we made for blacks."[44]

In another lecture on *Come Back, Little Sheba*, Adler goes even further to position the play for the students in a moment of changing sexual mores and gender roles. In a January 14, 1980, class, she states, "There were sex rules— sex rules were established and maintained."[45] She stresses these binaries of gender as seemingly rigid: "The male was the aggressive partner; the female was expected to remain passive. Lovemaking was heterosexual between married partners. She had to be a good girl and a virgin on her wedding night." Yet she also suggests an underlying atmosphere of challenged gender and sex codes, documented by the public response to the Kinsey Reports,[46] as seen in the character of the lustful young college student Marie in the play: "The Kinsey report talks about the white people in America. Sex roles were established in the '50s. It's more interesting if a girl is passive. It invested

the wife with ideals. A wife could enjoy sex if she obediently catered to the man. There was a sense of propriety in the relationship—role playing in bed. Kinsey reported that one didn't have to play so much the part of a fine girl."[47] Adler emphasizes that students need to realize the complex social currents defining the gendered characters they portray: "It was a confused moment—confused because you have to grow up, political awareness, maturity [was] needed to be a man. The message was divided and the kids didn't know what to accept—the old ways and the new ways were there."[48] As seen in these examples, Adler's approach to script analysis embraces the culture surrounding the text, providing a developed and specific contextualization concerning gender classifications and codes. Characters were the product of their time and place—their social situation—and this would remain a central consideration that helped to determine actorly choices related to both technique and characterization as one analyzed the script.

Analyzing the Screenplay: De Niro and Scorsese

In film studies, the screenplay has long been a difficult consideration as it exists outside of the cinematic experience as a type of pre-text. The script can be an awkward fit with film analysis because of its position as a "before," a foundation that is interpreted by another creative force in the form of a director (or in the case of a writer-director, written then interpreted by a filmmaker at different points of the creative process).[49] When film studies examines a screenplay, it is fundamentally different from how a written text might be viewed in literary studies, as the two disciplines have different views of authorship defined by an understanding of pre- and postproduction. As Kevin Alexander Boon writes, "screenplay studies posit the writer (or writers) as the author of the work (i.e., the screenplay), and at least, *an* author of the film. . . . The dynamic interplay between a screenwriter's vision and a director's vision are ultimately what we see on a screen, and the interaction between writing and filming are worthy of critical inquiry."[50] When considering a film or a screenplay, there is accordingly always an implicit second text to consider—that is, the script that preceded the film or the film that will proceed the script. It is a view of authorship that is based on an interplay of pre- and post—as opposed to a singular creative force. In a manner

resembling Adler's lessons on an actor's relationship to the script, this view of film production privileges a fluid interplay of creative forces.

For the actor, there remains fundamental similarities between a printed play and screenplay as texts in that they are meant for limited audiences with an eye on production. As Boon writes, "The primary function of a screenplay is to facilitate production of the film in the same way that a stage play's primary function is to facilitate the stage production."[51] Adler understood that all scripts, even the great plays, primarily function to facilitate a production. In welcoming students to her script analysis class in 1983, she stresses that the script has a function beyond guiding a single performance, and the actor needs a full sense of all the aspects of production: "To interpret means to interpret stage design, lighting, scenery. All this is part of acting. The actor has to train himself as soon as possible, as soon as he's smart enough to understand directing; to understand the other characters; to understand sets, lighting, costumes. Don't come just to show yourself on the stage 'cause you're special. You're not. You're a dime a dozen."[52] In her typically colorful way, Adler informs her students of the most significant aspect of all scripts—plays or screenplays—that they promote collaboration. To see how Adler's approach can help us understand the actor as "script interpreter," let us examine one of the most famous actor-filmmaker collaborations in film history.

Martin Scorsese directed Robert De Niro in *Mean Streets*, *Taxi Driver*, *New York, New York* (1977), *Raging Bull* (1980), *King of Comedy* (1982), *Goodfellas* (1990), *Cape Fear* (1991), and *Casino* (1995).[53] To cinephiles, Scorsese's work with De Niro stands as paramount in defining the director's vision of manhood and, in return, the actor's gendered persona. As Gretchen Schwartz writes, "For more than thirty-five years, De Niro has remained pejoratively defined by Scorsese's aesthetic vision of the Italian American male as an tormented urban animal of sorts, rendering the public perception of De Niro as a man deemed awkward in civil society, but effective in his rage."[54] As the film initiating this professional relationship, *Mean Streets* is a personal work for Scorsese, who cowrote the screenplay with Mardik Martin.[55] The filmmaker presents a story based in the Little Italy neighborhood of his upbringing, following protagonist Charlie (Harvey Keitel), whose Catholic morality pits him against his spiritual yearnings and worldly ambitions, specifically his role as a small-time collector for his Mafia uncle's loan shark operation. While an impressive work, one establishing many of the motifs

cinephiles came to expect from the auteur, the film proves most fascinating in the history of cinematic acting due to its initial pairing of Scorsese with De Niro, here cast in the supporting role of the volatile Johnny Boy, whose friendship with Charlie tests the bounds of homosocial loyalty.

De Niro's archived materials, showing his preparation for *Mean Streets*, illustrate a process for the actor aligned with the general belief of the more "exterior" approach championed in Adler's studio. Notebook paper lists "<u>Clothes (+ what to get)</u>," which includes the numbered items: "1. Handkerchief, 2. Knit shirt, 3. three quarter jacket, 4. hat (look at new ones), 5. pointed shoes (wing tips) see what they're wearing now, 6. a St. Christopher medal, 7. rub shoes on back of pants."[56] As R. Colin Tait suggests, such preparatory materials show how the actor recognized the autobiographical nature of the material as marking a different upbringing from his own: "Although De Niro grew up and lived a short distance between New York's Little Italy and Greenwich Village, the director's and the actor's childhoods could not have been more different." Hence the actor "still needed to immerse himself in the distinctiveness of a somewhat foreign ethnic culture, particularly as he was not raised as an Italian-American."[57] For example, another page lists "<u>Things to do</u>," which displays an understanding of a specific social setting. These notes include, "Haircut (after decide with Marty [Scorsese])," "Look at Hairstyles in neighborhood since it's mine now," and "Walk around with attitude + see styles, shoes, hair, clothing, etc."[58]

De Niro leans heavily on his director in his notes on the screenplay itself to recognize the cultural code necessary for building the character. On the script, the actor reminds himself to ask Scorsese about codes of behavior inherent to the neighborhood. For example, in one scene, a fight breaks out in a poolroom between Charlie's group of friends and the owner's crew, which results in the arrival of the police. Despite the animosity between all the men, they all cover for each other in the face of the cops' questions. De Niro writes in the margins of the script, "Find out the <u>real</u> meaning of this," indicating he recognizes the behavior as related to specific cultural codes found in the relationships between men within this society.[59] As the author and, essentially, gateway into this world, Scorsese was a primary source to decode the characters' behaviors.

Overall, the handwritten notes show multiple instances where De Niro fully recognizes Johnny Boy as removed from the "self," as he often adopts

the culturally specific language of Little Italy to understand interior motivation. For example, in perhaps the film's most dated scene, after fleeing the scene of a shooting at a bar, Charlie and his friends find themselves riding in a car with two stereotypically flamboyant homosexuals. After some typical hetero-panic, the friends throw the gay men out onto the street. On the back of a page for this scene, De Niro writes a numbered list that breaks down the direct motivations for his behavior, listed under "<u>What transpired?</u>":

1. Saw the guy from neighborhood shoot another guy from neighborhood.
2. I was drinking a few
3. I hurt in a few spots from the fight
4. Walk out with my coat on arm
5. 2 fags are gonna get into the car
6. Had a little scuffle with Tony about a game. He called me a scumbag.
7. We're in the neighborhood driving with these fags.[60]

In correspondence with Adler's lessons, this list demonstrates motivations based in direct situational justification (witnessing violence, drinking, and anger from a previous scuffle with Tony). De Niro presents this list with the culturally coded language of Little Italy; hence, the shooter was a "guy from neighborhood," the scuffle with Tony was particularly vexing since he called Johnny Boy "a scumbag." With the slurs against the homosexuals, De Niro continues this pattern that defines Johnny as a cultural subject.[61] The language of his notes is in the present tense of the scene in a manner reflecting the heterosexual panic of young Catholic males as they worry more about the perception of their peers than the actual gay men: "We're in the neighborhood driving with these fags." The actor dissects the scene as an interplay between given circumstances and their cultural specificity, which facilitates the hyper-heterosexual performativity of the young males. While De Niro's first collaboration with Scorsese illustrates a relationship with the script that encompasses many of the general philosophies promoted in Adler's classroom, his second film with the director was a more complex interplay between actor and written text. This time, De Niro would be the protagonist

in a film embracing a perplexing first-person subjectivity, creating one of cinema's most disturbing deconstructions of white masculinity.

Taxi Driver (1976): Script Analysis and the Psychosexual

Taxi Driver tells the story of the unstable Travis Bickle, a former marine who takes a job as a cabbie in New York City and grows increasingly angry over what he perceives as the degradation of modern society. From his cab, he twistedly assumes a self-perceived privileged position over the "filth" of the city and obsesses over the beautiful Betsy (Cybill Shepherd), a campaign worker for presidential candidate Charles Palantine (Leonard Harris). Eventually rejected by her, Bickle grows more violent in his fantasies and actions as he plans to assassinate Palantine. Eventually, he redirects his rage into rescuing the underage prostitute Iris (Jodie Foster) from her pimp (Harvey Keitel), assuming a self-destructive vigilante role and, ironically, ending up a folk hero in the media. In a manner that challenges Adler's respect of the written text, the production history of *Taxi Driver*, with its screenplay written by Paul Schrader, is one that encouraged script alterations from the actor. In fact, when examining the archived screenplay, the heavy amount of handwritten marginalia reveals a process that challenges a perception of sole authorship for the character of Bickle. As R. Colin Tait writes, one of De Niro's most significant contributions to the production was his substantive changing of dialogue and dictating of blocking:

> De Niro's rewriting here (as in *Mean Streets*) conforms to his sense of his character's rhythms of speech and his larger impression of how all of this is rooted in his [the character's] individual truth. This approach derived from his work with Stella Adler and his subsequent development of his own method, particularly regarding how De Niro's characters interact with the world and how the actor's choices are rooted in the socioeconomic moment that they live in. Scorsese provided De Niro a great deal of creative license, particularly with improvisation before and during the production.[62]

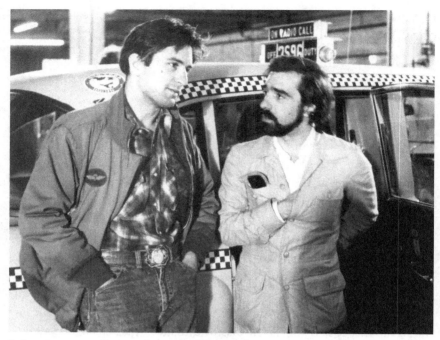

Robert De Niro and Martin Scorsese on the set of *Taxi Driver* (1976).

While Schrader completed the screenplay in roughly ten days, "the screen-writer's work was in constant revision once De Niro and Scorsese got in-volved."[63] The archived screenplay reveals a "triangulated authorship" between Schrader, De Niro, and Scorsese for the characterization of Bickle we eventually see on screen.[64] De Niro engages the script in the full spirit of collaboration and, as such, adds "depth and complexity to the character," writing a series of notes in conversation with "Schrader's focus on existential alienation and Scorsese's concern with dysfunctional, violent masculinity."[65]

For example, such an authorial influence by the actor includes the addi-tion of one of the most famous sequences in 1970s American cinema. The iconic moment of De Niro as Bickle standing before the mirror in his dingy apartment pulling his gun resulted in the actor improvising the often-quoted lines, "You talkin' to me? You talkin' to me? You talkin' to me? Then who the hell else are you talking to. You talkin' to me? Well I'm the only one here. Who the fuck do you think you're talking to?" Much like the improvisations seen with Brando's early performances, these were reportedly not instinctual

in-the-moment additions, but were worked out with the director and the screenwriter beforehand. As Schrader states, "In the script it just says, 'Travis speaks to himself in the mirror.' Bobby [De Niro] asked me what he would say and I said, well, he's a little kid playing with guns and acting tough. So De Niro used this rap that an underground New York comedian had been using at the time as the basis for his lines."[66]

Much like with Brando as Stanley Kowalski in *A Streetcar Named Desire* (1951), De Niro's performance as Bickle was a depiction of masculinity that was a jarring departure from previous on-screen characterizations. The film's release came at a time when Hollywood was embracing the vigilante hero in a blatant appeal to the "silent majority" white male population, which was feeling threatened by what they perceived as an unstable post–Vietnam War, post–women's liberation, and post–civil rights America. Films like *Dirty Harry* (1971), *Walking Tall* (1973), and *Death Wish* (1974) presented the vigilante as an avenging force in an unstable and racially diverse American landscape.[67] The prevalence of the white vigilante subgenre of action cinema partly explains the critical backlash against *Taxi Driver*, with critics labeling the film simply as an artier expression of such white male fantasies. For example, Jonathan Rosenbaum loathes the film, suggesting, "The audience is invited to identify with a violently Calvinist, racist, sexist, apocalyptic wish-fulfillment fantasy, complete with an extended bloodbath, that is given all the allure of expressionist art and involves very few moral consequences for most members of the audience."[68] Despite such criticism, *Taxi Driver* actually serves as something more profound in contrast to other vigilante cinema of the era because it deconstructs the masculinist drives that make those fantasies marketable. The film repositions the vigilante "hero" as an unfocused, selfish, and even pathetic subject. In some sense, Bickle resembles Stanley Kowalski in that his potential for violence is portrayed as a grappling with lack—a desperate plea to reestablish (or in Bickle's case, perhaps, initially establish) a phallic dominance. These two iconic characterizations exist as portraits of white maleness desperately seeking self-definition, expressing themselves through a consistent string of proclamations of self-importance that the audience is meant to question.

As with Kowalski's characterization in Tennessee Williams's original play, the characterization of Bickle has its foundations in the written word. As it was sold, Schrader's original screenplay still follows the basic narrative

and character development seen in the finished film, even though there are notable differences that were developed in the working relationship between the writer, Scorsese, and De Niro. In discussing the screenplay, Schrader suggests it came from a deeply personal place as he was dealing with his own sense of loneliness and depression after his divorce, which resulted in insomnia: "At the time I wrote it I was very enamored of guns, I was very suicidal, I was drinking heavily, I was obsessed with pornography in the way a lonely person is, and all those elements are upfront in the script."[69] Yet the screenwriter also positioned the character beyond these personal introspections to make Bickle more overtly racist and sexist, heightening a sense that the character's rage is in correspondence with the white male paranoia of the era: "Obviously some aspects are heightened—the racism of the character, the sexism. Like every kind of underdog, Travis takes out his anger on the guy below him rather than the guy above." Such misguided rage is essential in defining the character: "When they edited the film for TV I didn't so much mind having to lose the violence, but they had to remove huge sections of narration because of the virulent anti-black and anti-women characterizations. He appeared a very silly kind of guy because there was no edge to his anger."[70]

As this suggests, De Niro was presented with a screenplay that was a compilation of culturally specific extremes found in the white male psyche, existing in response to the changing racial and gender codes of the 1970s. Yet it is also important to recognize that the script deals with a broader sense of existentialism, the very type of larger thematic concerns Adler explored in her classes on script analysis. As Schrader suggests, "Travis is not a socially imposed loneliness or rage, it's an existential kind of rage. The book I reread just before sitting down to write the script was [Jean-Paul] Sartre's *Nausea*, and if anything is the model for *Taxi Driver*, that would be it."[71] It is thereby difficult to locate easily defined motivations for Bickle's behavior in the screenplay. For example, while it might seem appropriate to suggest his actions as caused by mental disorders related to traumatic combat experience, very little in the script points to that as an actual trigger for his behaviors. Instead, the narrative positions his psyche as something more universally American in its violent maleness, something the Vietnam War, at the most, only facilitated. As Amy Taubin contends:

It's not Vietnam alone that produced him. He is the product, rather, of the repetitive cycles of violence that made the United State number one. What's most brilliant about *Taxi Driver* is that it locates, in Travis' pathology, the intersection of the individual psyche with history. Critical to this history is a particularly American strain of apocalyptic Christianity that sees, for example, the Alamo dead as Christian martyrs who will rise again. *Taxi Driver* is even more evasive about Travis's religious background than his military service, but there's no doubt he fantasizes himself as some kind of avenging angel.[72]

In this regard, some have read the character as an ironic inversion of depictions of supposed "heroic" isolated maleness that existed in previous cinema. The clearest example is found in the film's narrative parallels to John Ford's *The Searchers* (1956), a western that complicates the lone hero myth by having its protagonist Ethan Edwards (John Wayne) express disturbingly racist thoughts.[73] Yet even this parallelism feels subverted by Schrader's script. As Lawrence S. Friedman writes, "*Taxi Driver* shadows *The Searchers* in its external form more than in its internal dynamics. What is missing from *Taxi Driver* that is present—though hardly idealized—in *The Searchers* is any sense of viable community."[74] Schrader's screenplay subverts all forms of idealization for its loner hero by having him exist in a closed-off world without any sense of community—a completely subjective viewpoint that presents social isolation as selfish as much as tragic.

These classifications suggest Travis Bickle is defined by a psychology attuned to an American white male identity culturally specific to the 1970s yet also determined by larger mythic associations. As David Greven contends, the character is fragmentary and prone to contradictions:

Taxi Driver broods over certain key themes, chief among them the contemporary condition of American male identity. It depicts identity as fundamentally split, essentially multiple and fragmentary. The various untethered parts of the self each actively spy on each other and on themselves as a whole. Travis's subjectivity consists of a number of warring components, each equally paranoid and disconnected. What united all of these different selves within Travis is fundamental bewilderment over his

own male identity, especially its gendered, sexual, and raced aspects. *Taxi Driver* depicts American manhood as a stranger to itself.[75]

With this disturbing complexity of character, encompassing all the fragmentary insecurities of American white maleness, Bickle would be a challenge for any actor. When preparing, in correspondence with his Adler training, De Niro privileged a research-driven approach by locating external examples of the character's social pathology as well as a cultural context for his actions. While filming Bernardo Bertolucci's *1900* (1976), he spoke with American Vietnam War veterans stationed in Italy. With Schrader, he read aloud into a tape recorder from the diaries of Arthur Bremer to understand the thoughts of the fame-obsessed would-be assassin of politician George Wallace. The actor also got a cab driver's license for a short period and picked up passengers around New York City to witness the professional environment and the dangerous nighttime cityscape explored in the script.[76]

Other preparations for the role show De Niro examining ways to differentiate his physicality from Bickle by considering animal behavior, a common activity seen in Adler's technique and characterization classes. One of the earliest exercises performed during the studio's two-year course sequence were basic "animal exercises." For early classes, this activity, as Adler writes in *The Technique of Acting*, is designed "to rid the actor of his social mask and to free him of his inhibitions."[77] As students moved into more advanced classes in characterization, the point of using animals as inspiration took on a much more complicated purpose, meant to create new approaches to behavior and physicality to differentiate one's "self" from character. Numerous exercises in archived materials ask students to associate characterizations with animal behaviors. A 1950 class has the students finding the "character element" of animals to understand a broader sense of character. Individual students analyze an animal to realize how its physicality suggests basic actions: "Leopard. Action . . . Reaching out; Monkey. . . . Action: to investigate and amuse." The exercise removes the development of a characterization away from heavy psychological introspection and privileges externality, which Adler sees as crucial when first approaching a role. The class notes state: "This is the beginning of broad characterization, this helps break the human inhibition, and locating the characteristic gesture outside, this is the main element inside of a character or animal."[78]

Among the archived items for his *Taxi Driver* preparation is a sheet of notebook paper listing De Niro's observations on wolves, a fitting choice of animal since Bickle grows increasingly predatory throughout the film and can be classified as a "lone wolf." Showing Adler's classroom activities in practice, the actor writes:

1. Walk similar to what I do
2. head (chin) resting—good. Maybe for when looking at her from cab.
3. way pick up head + peak to side when hear something. Certain regality to it.
4. Certain way of stealthily walking which is good.
5. Way they curl up to sleep resting on chin good.
6. Way wrist goes in good when resting
7. lick myself, my wounds[79]

As this list shows, the exercise is primarily employed to consider new ways to approach Bickle's physicality. Specific doable actions, such as resting the chin while "looking at her" [probably Betsy], are direct associations of animal behavior to human actions. More interestingly, though, is how he employs the exercise to consider a larger sense of "broad characterization," ending the list with the provocative statement, "lick myself, my wounds." With this final item, he employs the animal exercise to consider a duel significance behind the predatory mindset. While the earlier items stress the concept of hunting—"way pick up head + peak to side when hear something" and "stealthily walking"—this final observation considers the vulnerability (physical injury but also to the psyche) that defines a predatory person.

De Niro's screenplay for *Taxi Driver*, archived with different colored pages suggesting changes, or "new pages," during the production process, is substantially more commented on than his *Mean Streets* screenplay. In correspondence with Adler's lessons of script analysis, the comments are mostly written in the present tense. Even when considering the past of the character, De Niro keeps his notes focused on Bickle's present state of mind—identifying points that define the direct external circumstances. This approach appears in a paragraph written on the back of the second page, in reference to when Travis enters the garage for the first time looking for work. Here, De Niro creates a short backstory for Bickle:

I'm in here for work. can't sleep. Just got out of Marines. Just went home for about a month but couldn't take that. There was nothing there. So I decided to come to N.Y. cause I know a girl here. But she turned out to just be writing me. So now I'm here alone. Don't have any special skills. Have not much $ left. Had a job as a delivery boy for a message service but couldn't do it anymore. It was the lowest. Got some pills from dealer on the lower east side. So I've been spending my money on that, what little I have. But I can't make friends easily. I don't know why.[80]

Since this is backstory, much of this is written in past tense, yet notably the history only goes back a few months. While a Strasbergian Method approach might warrant a deeper psychological profile based in Freudian motivations related to, for example, childhood relationships, De Niro eschews such considerations to keep the backstory focused on his present state of mind while entering the garage—a disposition of loneliness within the city. Even more surprisingly, despite his reported research with combat veterans, the actor does not particularly seem interested in understanding Bickle as a former solider, simply stating he "just got out of the Marines." His screenplay notes in general rarely mention military service, instead focusing on present circumstantial motivations. With this, De Niro recognizes Travis as defined by gendered relationships (or, more precisely, the lack thereof). Tellingly, he adds a detail in his character's backstory of Bickle coming to New York City to see a girl with whom he had been corresponding, most likely through a pen pal program with soldiers, only to find she was not interested in a romantic relationship. Here, De Niro suggests Travis's present mindset as disconnected from other human beings—in particular women, which means there is no emotional or sexual release. This is coupled with an immature lack of self-awareness in relation to his inability to "make friends easily," ending with the childlike statement, "I don't know why."

Throughout the screenplay, De Niro writes notes specifically related to doable actions that accentuate this feeling of disconnect from others, including men. Despite his military background, the character proves unable to establish homosocial bonds with his professional peers. As Greven suggests, the camaraderie between cabbies in the film shows the "homosocial is a priori; it exists before Travis attempts, always with great awkwardness, to insert himself within it."[81] The uncomfortable interactions with other men exemplify

the narrative's gendered social dynamics, therefore Travis's "brooding, disconnected, isolate manhood, his intense loneliness, is repeatedly contrasted against different styles of masculinity"[82]—not only the congenial nature of his fellow cabbies, personified by Wizard (Peter Boyle), but also Iris's pimp, the smug campaign worker, Tom (Albert Brooks), the gun salesman, Andy (Steven Prince), the homicidal jealous husband (Martin Scorsese), and various other male figures. As such, through "depicting Travis' social estrangement as a specifically gendered one, the film makes a powerful political point about the failures and constrictive demands of male socialization."[83]

His inability to establish homosocial bonds is most evident in the only scene where Bickle attempts to reach out to another male for understanding. At a late-night diner that serves as a cabbie hangout, Wizard asks Travis, "What's the action around?" Travis responds with only, "Slow." In the script, De Niro writes the simple direction "in pain" next to this dialogue and then contemplates the character's isolation from these men: "Good to <u>know</u> their lingo but not be part of it—outside."[84] The script then has him leave the diner with Wizard, where Bickle confesses, "Sometimes it gets so crazy so I just don't know what I'm gonna do. I get some real crazy ideas, you know? Just go out and do something." Wizard responds, "The taxi life, you mean." Travis: "Yeah." De Niro's notes the failure of this homosocial interaction as Wizard misunderstands his meaning, writing, "Not looking at him cause that isn't really what I mean."[85] Wizard then feebly attempts to relate to Travis by simply placing his problems in professional terms, "Look, a person does a certain thing and that's all there is to it. It becomes what he is. Why fight it? What do you know? How long you been a hack, a couple months?" Bickle responds with, "That's just about the dumbest thing I've ever heard, Wizard." For this scene, De Niro writes doable actions that accentuate the failure of homosocial connection, either by not looking at his scene partner or writing in his notes, to stress disconnect, "*just* stare at him."[86]

In total, the narrative of *Taxi Driver* is a psychosexual character study as much as a study of violence (not that violence and sex are mutually exclusive subjects). The screenplay opens with a description of Travis stating, "He has the smell of sex about him: Sick sex, repressed sex, lonely sex, but sex nonetheless."[87] In his analysis of *Taxi Driver*, which compares it to various Alfred Hitchcock psychosexual narratives,[88] Greven suggests the film does not offer a clear map to comprehending Travis's sexual drives, which alternatively

seem voyeuristically pornographic (as suggested by his obsession with pornography) and judgmentally moralistic (his misogynistic disgust toward female sexual agency). As Greven writes, "Travis's sexuality remains an elusive, maddening blank, one the film offers us very little help in decoding."[89] The character's sexual impulses feel contradictory in contrast to other screen depictions of hetero-male desire: "Travis pursues and inhabits scenes of heterosexual intercourse without ever seeming to be directly involved in them. He does not 'satisfy' either himself or the normative sexual expectations of audience."[90] Bickle exists as a deconstruction of the white male gaze—examining its limitations through a character who spends much of the film gazing at the world through his cab window and reaching no form of sexual release, only finding "climax" though its masculinist stepchild, violence.

With the psychosexual firmly established in the narrative as the primary motivation of the character, the most extensive notes on De Niro's script are in reference to Travis's thoughts concerning Betsy and Iris. As Schrader suggests, these two relationships are central to the character's psychology and, as such, the plot itself: "*Taxi Driver*'s plot structure is fairly simple. You have this pathologically lonely man confronted with two examples of femininity, one of which he desires but cannot have [Betsy], the other of which he can have but does not desire [Iris]." In keeping with Greven's points that the film is about the character's lack of sexual completion, the screenwriter suggests, "Now obviously he's chosen objects which will exacerbate his own pathology—he doesn't really want a girl who will accept him, and when it seems as if the Cybill Shepherd character may, then in that unconsciously destructive way he takes her into an environment [a porno theater] that will show her his real ugliness so that she will have to reject him."[91]

As such, Bickle's thoughts concerning Betsy are of paramount concern to De Niro in his script notes. On the back of a page facing the scene introducing Betsy, where she talks to Tom in the Palantine Campaign Headquarters, De Niro scribbles an extensive litany of thoughts concerning Travis's obsession toward her and how it will play out in the upcoming scenes: "he'd do anything. She'd never have to leave. he would cook, shop, walk the dog, we don't need anyone else. I'd go rot with the sewer to make $. I don't want her to be contaminated."[92] Other notes on this page continue to concentrate on Travis's initial idealization of Betsy in contrast to his surroundings, "Flower living in a sewer; too beautiful to be living in this sewer; you're a special

person. You're dif[ferent] from everybody else." More writing considers Travis's insecurities in facing Betsy as this idealized vision, "I've seen you many times + you haven't seen me; Remember have to be afraid to be rejected; try approaching Betsy in then dif[ferent] ways." De Niro also considers the character's eventual ability to overcome those feelings through, perhaps, misguided confidence, "undivided attention, charming, not or doesn't seem nervous, smooth + confident flow; talks about self all the time." By the second column on the page, De Niro starts to scribble the seeds of Travis's misogyny and selfishness, "she's like everybody else; you're afraid of what I have to offer," yet does so through rooting it in the character's insecurities, "I'm really trying to talk to her to make her understand me. I'm trying to get her to understand me. What's wrong with me[?] (verge of tears)."[93] As such a litany of thoughts toward Betsy illustrates, De Niro is fully aware of his character's conflicted sexual desires and inability to view Betsy in anything but selfish terms. The notes express either a desire to keep his unrealistic view of her uncontaminated or a disappointment in her failure to live up to his warped ideal.

This litany of thoughts for Travis—or, in terms of Adler's instruction, inner motivations—features many points that define De Niro's marginalia in later scenes. For example, heavy notation appears when Bickle enters the campaign headquarters and convinces Betsy to have coffee with him. Here, a new list of notes on the opposite page has the actor reconciling the character's idealization of Betsy with his display of an arrogant confidence (yet also consistently veering back to the previously established feelings toward her): "Walk in brisk. No slouch. Hostile. arrogant, better than everyone else. Perfect posture. I'm suspicious. Could stand patiently, waiting to talk. I've seen you many times but you haven't seen me. Undivided attention, charming, not or doesn't seem nervous. Smooth + confident flow. Talk about self all the time (only thing know what to talk about, or need to, wants to, talk about)."[94] De Niro then returns to the idealizations of Betsy, "Flower living in the sewer, too beautiful to be living in the sewer, Your [sp] a special person, your [sp] dif[ferent] from everyone else. Everyone else is closed. You're open."[95] As such notes suggest, De Niro relates Travis's arrogance and idealizations directly to the given circumstances, bridging the immediate "past-ness" of the character, his stalking of Betsy, to his present situation, the confidence he needed to muster to march into the campaign headquarters. As the scene goes on, De Niro's notes are very detailed as he fluctuates in motivation to

convey both confidence ("Charm her? I think so, to add color")[96] and inse-
curity ("I'm talking personally to her for the 1st time; Nervous here; get up
nerve to go thru with this").[97] In the script, Travis makes a joke to charm her,
suggesting that the date will occur "in broad daytime. Nothing can happen.
I'll be there to protect you." This causes Betsy to smile, though, to the viewer,
it has a layer of irony since Bickle is the threat. De Niro notes Betsy's favor-
able response to the joke might cause a moment of slight panic in Travis: "Do
I mean seriously? Or sense of humor? Or at least trying for a sense of humor?
I'm connected with her. The first step is done. Now for the hard part when I
see her again."[98]

Throughout De Niro's notes concerning Betsy, he conveys an understand-
ing that all his thoughts, even the positive ones toward her, are based in the
character's selfishness and misogyny. When Betsy and Bickle have coffee, in
a disturbing note, De Niro writes, "Most women are tramps. All they do is
take advantage of a man. That's all they know to do. But you're innocent, your
[sp] a flower. All they do is give their sexuality to get them to want them. All
they think of is how they look."[99] Throughout this scene, De Niro rewrites
some of Schrader's original dialogue, displaying the collaborative nature of the
production. While the original screenplay does not contain any dialogue con-
cerning Travis's view of Tom, De Niro suggests that such thoughts should be
expressed, writing some of his notes in quotations marks, suggesting them as
possible additions of dialogue: "I didn't like him [Tom]"; "He's an idiot"; "He
acts jealous + all that but if he really understood you he'd never act like that. If
he really respected you. He doesn't really know what a treasure you are. Other-
wise he wouldn't be so insensitive."[100] In the finish film, such additional lines,
concerning Travis's hatred of Tom, do appear in the scene. While the origi-
nal screenplay keeps the scene very much about the male-female dynamic,
De Niro recognizes Bickle's definitions of self as based in comparisons with
other versions of masculinity in his environment. Sensing Tom as a threat to
his predatory claim on Betsy, he needs to dismiss his maleness as phony.

De Niro keeps his notes concerning Betsy consistent. Even when Travis
dooms the relationship by taking her to see a porno movie, the actor is careful
to approach the darkly comedic scene as anything but absurd, writing, "this is
for real, nothing intentionally funny about it, played for real."[101] In the script,
Betsy leaves the theater and yells, "If you wanted to fuck, why didn't you just
come out and say it?" In the margins, De Niro writes his response as calm,

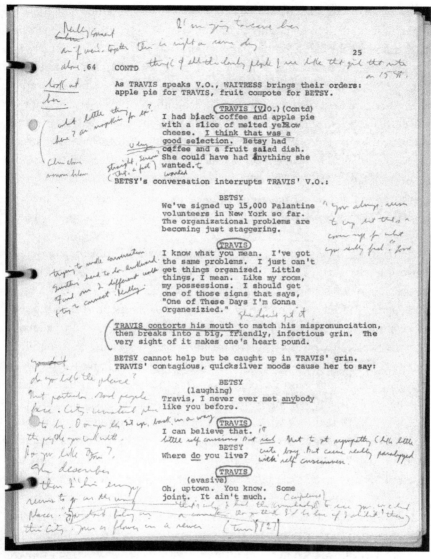

Handwritten notes (margins, partially legible):

I'm going to leave her

as if we're together then it might rain some day

think of all the lonely people I see like that girl that wrote on 15 St.

64 CONTD

25

As TRAVIS speaks V.O., WAITRESS brings their orders:
apple pie for TRAVIS, fruit compote for BETSY.

 TRAVIS (V.O.)(Contd)
 I had black coffee and apple pie
 with a slice of melted yellow
 cheese. I think that was a
 good selection. Betsy had
 coffee and a fruit salad dish.
 She could have had anything she
 wanted.
 BETSY's conversation interrupts TRAVIS' V.O.:

 BETSY
 We've signed up 15,000 Palantine
 volunteers in New York so far.
 The organizational problems are
 becoming just staggering.

 TRAVIS
 I know what you mean. I've got
 the same problems. I just can't
 get things organized. Little
 things, I mean. Like my room,
 my possessions. I should get
 one of those signs that says,
 "One of These Days I'm Gonna
 Organizizied."

 TRAVIS contorts his mouth to match his mispronunciation,
 then breaks into a big, friendly, infectious grin. The
 very sight of it makes one's heart pound.

 BETSY cannot help but be caught up in TRAVIS' grin.
 TRAVIS' contagious, quicksilver moods cause her to say:

 BETSY
 (laughing)
 Travis, I never ever met anybody
 like you before.

 TRAVIS
 I can believe that.

 BETSY
 Where do you live?

 TRAVIS
 (evasive)
 Oh, uptown. You know. Some
 joint. It ain't much.

Handwritten marginal notes include: "do you like the place?", "Not particular. Good people. Faces. City. Uninterested...", "Do you like them?", "where do you live?", and other partially legible annotations.

yet unnervingly so, "Maybe just be still like a stick of dynamite. Still, looking at her." Then, tellingly, he has his character, even in his attempt to salvage the date, still place the blame on her: "no matter if she's strange" and "I'm always straight + totally, believably, seriously in it. In other words, I react as if she's right."[102] Notably, the motivation suggests Travis's response as being based in seeing her offense as "strange," with no recognition of his own behavior as self-destructive. He reacts only "as if" her response is warranted. By the time Betsy completely rejects him and Travis attempts to confront her on the street, De Niro returns to the laments established earlier in his notes on the overall arc of the relationship: "Why are you afraid of what I have to offer?"[103] During every step of this pseudo-relationship, the actor demonstrates the character's obsession over Betsy as stemming from a selfish misogyny rooted in his own insecurities.

In contrast, Bickle's other major relationship with a female, the underage prostitute Iris, features De Niro exploring different elements of the character's psychology. This time, the actor keeps his notes focused on Travis's moralistic side. The marginalia convey no major deconstructions of a thought process toward Iris and, as opposed to showing the deeper psychosexual obsessions explored with Betsy, focus on immediate responses that highlight social positioning. In the second half of the script, Travis's mindset has been established as erratic, and De Niro embraces this trait when the character searches out Iris, after she had attempted to jump in his cab. The screenplay reads, "TRAVIS takes a swig of peach brandy and continues his stakeout." De Niro writes, "pills before, to get courage (why am I here?) to kill the pimp if I have to?"[104] By phrasing these immediate motivations as questions, still based in his insecurity as he takes the pills for "courage," the actor highlights the character's indecisiveness. As the scene goes on, Travis is instructed to talk to Iris's pimp, a scene that was heavily altered by De Niro and his screen partner, Harvey Keitel, for the finished film.[105] Next to this interaction, De Niro writes, "Maybe here act little like with secret service man though little more confident here,"[106] a reference to an earlier scene where Bickle has a tense encounter at the Palantine rally. As this shows, the actor realizes much of Travis's behaviors will be identifiable through interactions with the other versions of masculinity he encounters.

The improvisations with Keitel, where it is suggested Iris is only twelve years old, carries into the scene when De Niro is alone with the young

prostitute, with him writing the dialogue addition of, "You really 12 1/2?"[107] While the screenplay suggests Iris as young, about fourteen or fifteen, the even younger age of the prostitute was established through the casting of Jodie Foster, only twelve at the time of production. In his notes, De Niro seems aware that the scene cannot be played in any erotic manner, given the youth of the scene partner and the possibility of exploitation. When the script suggests, "(IRIS works on TRAVIS'S crotch off camera. He bats her hand away)," De Niro provides a rare note in reference to an actor other than himself: "She should be somewhat professional. She really has to do."[108] As these notes convey, he wants the tone of the scene to stress the exploitation of Iris in her role as sex worker rather than the sexual act. De Niro bases many of his notes on his character's established moral disgust more than any psychosexual impulses. Early in the encounter, he notes that this is a different side to Bickle, largely unseen with Betsy, writing, "Actually let this scene (sit) affect me what it really does. We could say that in this scene we have never seen me like this before. Another side where can be kind of gentle + understanding."[109] Yet De Niro is also aware that the character's deeper impulses are not fatherly and understands the irony distinguishing his choice of doable actions: "maybe take her hand. Also might be good cause unexpected + in a strange weird way, romantic, esp[ecially], cause coming from me."[110] Despite this consideration of ironic subtext, De Niro still embraces the moralistic motivations established early in the screenplay: "This whole scene + my saving her ties in with all the scum of this city. It's filth."[111] By the end of this scene, De Niro provides a note on a major change in character motivation in simple terms: "I decided maybe it's not such a good idea to kill Palantine. Maybe to let it go a little bit. Or do it tomorrow. I'll help her first."[112] As this shows, the actor keeps the motivations impulsive and relates the shift to the larger thrust of social disgust expressed through Travis's narrations.

When Iris and Travis have breakfast together, the screenplay accentuates the fact that she represents a lost youth, a type of girlhood Bickle is unable to comprehend. While certainly exploited by her pimp, Iris attempts to assert her independence in her dialogue by asking, "Didn't you ever hear of women's lib?" and rejecting his suggestion she go back to her parents. Bickle is perplexed by Iris—who, while open to the idea of leaving her pimp, does not seem all that enamored by the prospect of being rescued.[113] In his notes, De Niro establishes this inability to recognize Iris's agency through basic

doable actions, implying a lack of understanding or even focus: "Squinting, confused somewhere. Here or in earlier scene but somewhere. Also with kind of distraction."[114] With this established, the actor provides minor alterations to the dialogue that stress a lack of understanding of Iris as an individual removed from his limited purview of the world. When the screenplay has Travis state, "But you can't live like this. It's hell. Girls should live at home," and "Young girls are supposed to dress up, go to school, play with boys, you know, that kinda' stuff," De Niro tweaks the lines to read, "A young girl is supposed to live at home," and "A young girl is supposed to dress up . . ."[115] As this suggests, the actor is most interested in Travis's lack of understanding of Iris as an individual, an independent subject as opposed to a collective view of femininity. Throughout the interaction, De Niro considers his character's attitude toward Iris as an expression of Travis's intense narcissism. In the margins, he writes, "logic I use (attitude) is that I see them for I see myself. Key to my attitude." Yet he recognizes the moral superiority his character expresses as absurdly misguided. When Travis expresses uncertainty over Iris's suggestion of moving to a commune in Vermont, the character states, "I saw pictures in a magazine, and it didn't look very clean to me." In response, De Niro writes, "a paradox here—I'm clean yet not clean."[116] Noting his character is likely referencing one of his porno magazines, the actor recognizes the instability of his moral high ground, the paradox of him proclaiming a moral superiority when, in reality, he wallows in a pornographic obsession with sex as masculinist spectacle.

De Niro's screenplay notes for *Taxi Driver* reveal an actor employing many of the lessons on technique and character established at Adler's studio—as he dissects the scenes to comprehend his character's actions he displays a larger understanding of the social situation defining Bickle as a realistic, albeit disturbing, type. The annotated screenplay exists as a testament of the actor's heavy preparation through Adler-style script analysis in a manner that both deconstructs the direct given circumstances and recognizes their larger cultural contexts, especially regarding Travis as a gendered subject. The actor acknowledges the psychosexual pathology of the character as a product of a culture of paranoia and misogyny, a bleak theme that runs throughout the screenplay and final film. While Travis is ironically heralded as a "hero" by the press and his fellow cabbies due to his violent act of vigilantism, De Niro understands the ending of the film must reflect the nihilism

that runs throughout the rest of the script. In the screenplay, after reading about his "heroism," Betsy gets into his cab and acts pleasantly toward him, eventually stating, "Maybe I'll see you again sometime, huh?" The screenplay simply reads: "TRAVIS: (thin smile) Sure," then, eventually, "BETSY steps away from the curb and TRAVIS drives off. She watches his taxi. CAMERA FOLLOWS TRAVIS' taxi as it slowly disappears down 56th Street. SUPER-IMPOSSED TITLES: THE END." On this page, De Niro writes, "Should be ambiguous that's the real truth of it. That nothing matters + life goes on + we're all lonely, from the start again . . . What we did before which means nothing now in my case it was almost killing Palantine + then really killing the others + for what."[117] As this script note suggests, the actor sees the nature of Travis as a never-ending cycle of anxiety and hatred—asking the question one must always ask when deconstructing masculine violence: "For what?"

5

Characterization
as Pastiche

Henry Winkler in *Happy Days* (1974–84)

According to a recent survey on the most popular performers in the
country, the top three are Carroll ("All in the Family") O'Connor,
Alan ("MASH") Alda and Henry ("Happy Days") Winkler. Movie
star Robert Redford has the fourth spot, one point below Winkler.
The great Redford can probably understand the first two choices,
since they're TV series stars. But Winkler must be a gag. Who is he?
Charles Witbeck, "Fonzie: Henry Winkler Adjusting
to New Popularity," November 1, 1974[1]

This profile of actor Henry Winkler appeared early during the second sea-
son of *Happy Days* (1974–84), when the series went from a relatively strong
showing of averaging sixteenth in the ratings to dropping significantly when
it was scheduled against the popular sitcom *Good Times* (1974–79).[2] The
survey reveals the dominance of television in popular culture by the 1970s,
illustrating how the medium eclipsed film. Carroll O'Connor, famous for
playing the middle-aged racist patriarch Archie Bunker on *All in the Family*
(1971–79), and Alan Alda, the wisecracking Korean War doctor Benjamin
"Hawkeye" Pierce on *MASH* (1972–83), emerged as figures more popular
than cinema's handsome leading men. Arguably, by 1974, O'Connor and
Alda could be viewed as male figures representing a cynical post–Vietnam
War, Watergate-era America. Their television shows marked a shift from
the harmless family sitcoms of the previous decades, addressing issues of

politics, race, sex, and war as opposed to just offering escapist entertainment. Perhaps that partly informs the surprise Witbeck expresses on seeing Winkler mentioned among these stars. Here is an actor playing a supporting character on a comparatively low-rated sitcom, a nostalgic throwback series aimed more toward adolescents. For an entertainment writer in 1974, it was a fair question to ask: who is this relatively obscure television actor and why is his broadly comic character making such an impact?

On Garry Marshall's 1950s-set series, Winkler's Arthur "Fonzie" Fonzarelli (or the Fonz), was originally presented as a secondary character—a motorcycle-riding high school dropout, a "greaser" from the wrong side of the tracks who served as a foil to the protagonist Richie Cunningham (Ron Howard), a teenager living a middle-class white existence commonly seen on television sitcoms since the 1950s. But by the second season, the character grew in popularity with viewers, especially with children, who responded by flooding the network with fan mail addressed to "Fonzie." Never before had such a clear identifier of "cool" been presented on network television, and children, especially male children, gravitated toward him. As the article explains to the uninitiated, the series "went on the air in January; and by July, Henry Winkler's Fonzie had become a folk hero to kids around the country. With his leather coat, long hair, street wisdom, and mechanical knack for fixing cars and motorcycles, Winkler's Fonzie struck a familiar chord with viewers."[3] Witbeck observes that the survey results show the birth of a pop culture icon, one whose popularity would be determined very much by children.[4] The character represented male rebellion in a sense but only in the safest way possible that made him "kid friendly." As the series continued, eventually making the character the star, it grew in the Neilson ratings, especially with children, who wore iron-on tee-shirts and carried lunchboxes adorned with Fonzie's image.

The 1974 profile of Winkler informs the readers that despite the growing adulation of kids, the actor should be taken seriously due to his credentials, including earning his masters in theater arts from the acclaimed Yale School of Drama. His legitimate training would be something often highlighted in publicity as the Fonz continued to grow in popularity throughout the decade. Two years later, as *Happy Days* cemented itself as a ratings hit and Fonzie-mania swept the nation, the Winkler-authored *The Other Side of Henry Winkler* covered his theatrical background with multiple accompanying

photos, while the less thorough *The Truth about Fonzie*, a slender volume of interviews by Peggy Herz, released the same year, also featured Winkler again touting his theatrical credentials.[5] In understanding the readership of such works to be, very likely, young television fans, Winkler tells Herz, about being most famous for playing a high school dropout: "I trained for nine years to become an actor. But I did not become a drop out by dropping out! I went to school. I have a masters degree in theater arts."[6]

Stella Adler was among the teachers who inspired Winkler to take acting seriously. He studied with her during Adler's time at Yale in the 1960s. The experience made a definite impression on him, with the actor writing in 1990, "As all of her students must, I carry Stella with me in my mind, in my heart and definitely in my ear. I'm still listening very carefully to see when she's going to tell me to sit down. Ms. Adler, you are one of the pillars that holds up my professional life. Thank you."[7] While Adler certainly influenced him, the nature of the program meant Winkler also studied with other teachers, including Mildred Dunnock, Liz Smith, Carmen DeLavallade, Robert Brustein, and Robert Lewis.[8] In general, though, it would be fair to view the Yale program as a counter to the Actors Studio in that it embraced approaches more relatable to Adler's original challenge of Strasberg in 1934 than to Strasberg's promotion of a psychologically focused Method in the 1950s and '60s. For example, the teacher most routinely associated with Yale, former Group Theatre member Robert Lewis, cofounded the Actors Studio in 1947 with Elia Kazan and Cheryl Crawford, only to leave it after internal conflicts. By the time Strasberg was firmly established as the artistic director of the Studio (and the public face of the Method), Lewis famously gave lectures that became the book *Method— or Madness?* in 1958, a work that embraced the spirit of Adler's original split by criticizing the overly psychological Method and, as a foldout, included a reproduction of Adler's hand-drawn chart of Stanislavski's System, which she originally presented to the Group Theatre in 1934.[9]

Henry Winkler's performance as the Fonz provides the opportunity to consider Adler's cultural significance beyond cinema, to see how performed maleness represents different medium-specific considerations and reception histories. While Brando and De Niro can be viewed as clear Method males, blazing the way in cinema with challenging depictions of masculinity, Winkler's performance as the Fonz demonstrates popular culture's consumption and commodification of such images. In relation to the stylistics of

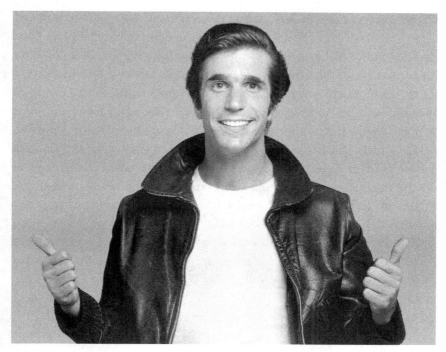

Henry Winkler as Arthur "Fonzie" Fonzarelli, publicity photo for *Happy Days* (1974–84).

sitcom acting, his performance embraces broadly comedic dimensions based in repetitious behavior, illustrating what Brett Mills identifies as a commedia dell'arte–derived style of comedy acting. With this genre-specific consideration, Adler's focus on long-standing theatrical traditions only aided the development of Fonzie over time, as he became more a slanted situation comedy stock character as opposed to a realistic social type. The on-screen history of Fonzie as he developed from social outsider to domesticated lead—moving into the Cunningham's garage apartment and integrating into their family— illustrates how the dynamics of Winkler's characterization considers the significance of audience response in determining the sitcom actor's choices.

Happy Days and its development of Fonzie also proves significant in its cultural specificity, gaining popularity at a time when nostalgia for the 1950s placed a new emphasis on the iconography of the then-recent past. While the series remains an exploration of families as they were seen on '50s television, the emergence of a "greaser" as its star opens questions concerning

the mythology of the Method male in relation to the most highly consumed of popular nostalgia. The greaser character, the motorcycle hoodlum donning a leather jacket, gained its foothold in popular culture in one of Marlon Brando's early roles as Johnny Strabler in *The Wild One* (1953). Fonzie serves not so much as a parody or homage of that performance, but as a post-Watergate culture's requalifying of pre-Vietnam-War-era icons of maleness. In approaching *Happy Days* as a clear representation of Fredric Jameson's reading of late capitalism's consumption of the remembered past, Winkler's performance can be deconstructed as a *pastiche* of the cultural undercurrents driving the Method males of the 1950s (and their cultural offspring in the 1960s and '70s). If dramatic cinema attempts to, at least on the surface, distance itself away from kitsch and pastiche, the television sitcom emerges as a gleeful disregard of realism. And actor performance, as seen with Winkler's Fonzie, serves as a fitting illustration of this phenomenon. By examining episodes from the third season of *Happy Days*, when the series took steps to domesticate Fonzie, Adler's methodology and its resulting depictions of maleness are shown to be repeated, recontextualized, and reconsumed.

The Sitcom Actor: Performance and Pastiche

While there are exceptions to the rule, especially in modern non-network television, as Larry Mintz outlines, *sitcom* as a genre denotes "a half-hour series focused on episodes involving recurrent characters within the same premise. That is, each week we encounter the same people essentially in the same setting." The episodes are "finite; what happens in a given episode is generally closed off, explained, reconciled, solved at the end of the half hour."[10] During the twentieth century, sitcoms were largely performed before a live audience or, at the very least, included the recorded laughter of viewers to simulate a live experience. For its first two seasons, *Happy Days* was filmed in bits and pieces without a live audience, but during a retooling when it was suffering in the ratings against *Good Times*, the series was reformatted into what cinematographer Karl Freund famously called the "three-headed monster" during his work on *I Love Lucy* (1951–57), consisting of a three-camera coverage: one to cover the actor speaking, one to catch reaction shots, and a wider shot for full coverage of all the actors.[11] This formal standard, which

was more cost effective than shooting like a film, would record the show like a stage performance, before a "live studio audience." *Happy Days* migrated to this structure for its third season, limiting the amount of location shooting and focusing more on standard sets with stage-like invisible "forth walls" facing the audience and cameras. Within this controlled space, dialogue and performances were crafted around audience reaction, usually laughs, which were given live (or heightened in postproduction) in response to well-understood character rhythms and joke structures.

The formal elements in this format exist in service to the genre itself—which, like all genres, enters a contract with the audience. Being a weekly broadcast defined by repetition and established comic rhythms, this contract serves a relationship even more clearly defined than many cinematic genres. With its diegetic motivations so clearly understood by all involved, the genre spent much of its height in popularity (the 1950s to the 1990s) not receiving much serious critical attention. In 1984, Paul Attallah questioned the genre's reputation as, essentially, an "unworthy discourse" as he analyzed one of the most "low-brow" of situation comedies, *The Beverly Hillbillies* (1962–71), suggesting, "As a rule, one does not talk about situation comedy."[12] Sitcoms, especially those offering no real ideological challenges to white viewership like *The Beverly Hillbillies* or *Happy Days*, are "generic" in most senses of the word—formulaic and highly consumable entertainment meant to confirm normalcy as opposed to disrupt or challenge mainstream mores. As Mintz summarizes, "The most important feature of sitcom structure is the cyclical nature of the normalcy of the premise, undergoing stress or threat of change and becoming restored."[13]

Beyond these generic confines, the success of *Happy Days* also reflected a return to "normalcy" on the larger television landscape. In the early 1970s, Norman Lear had broken new ground by bringing social issues to the genre with *All in the Family* and its spinoff *Good Times*, while Mary Tyler Moore (MTM) Studios produced less edgy shows, yet still ones focused on adult viewership, like *The Mary Tyler Moore Show* (1970–77) and *The Bob Newhart Show* (1972–78), which, in subtler ways, challenged the previous decades' gender depictions.[14] As Josh Ozersky relates, mid-decade, this trend changed after the Watergate hearings had dominated the broadcasting schedule: "After 1974, there was a broad retreat from controversy and 'relevant' programing: the Ford years enveloped television like cascading billows of cotton.

Television's second coming ended with Nixon's."[15] This change was actually enforced as policy by the networks when the National Association of Broadcasters (NAB) officially adopted the "Family Hour" in January 1975, in fear that the Federal Communication Commission (FCC) might step in and censor programs between the hours of 8:00 and 9:00 p.m. eastern time. With this change, ABC, once the perennial third-place network, excelled due to the accessibility of *Happy Days*, which appealed to kids oblivious to the 1950s nostalgia as well as to parents enjoying the show's throwback appeal. Rising to first place in the Nielsens, the popularity of the show spawned two spin-offs, also produced by Garry Marshall and equally "family friendly," *Laverne and Shirley* (1976–83) and *Mork and Mindy* (1978–82), which both eventually eclipsed *Happy Days* in the ratings.[16]

For this reason, *Happy Days* represents a cyclical return to "normalcy" in both form and narrative content, developing into what would exist as the ideal "family hour" sitcom. The "family hour" as an official NAB policy disappeared in 1977 after it was overturned in court, yet the concept continued to be employed by some networks and viewer advocacy groups who viewed the 8:00 p.m. eastern time slot as having an obligation to provide "safer" programming. Especially after its second season, *Happy Days* emerged as a prototypical "family hour" sitcom meant to appeal to the broadest spectrum of (white) viewership. Along with developing a more standardized "three-headed monster" shooting style, the clear fan-favorite Fonzie moved upstairs to the Cunningham's garage apartment. The point of this move was to centralize the character and allow him to ease smoothly into the established domestic interactions of the family. As Ozersky writes, "The housebreaking of Fonzie, along with his new place in the middle of nearly every episode, had its desired effect. *Happy Days* finished the season eleventh overall reaching a quarter of the nation's homes each episode." By the next year, it was number one, reaching a third of the nation's homes and 41 percent of kids between six and eleven, truly making it a "family hour" hit.[17]

This standardization of both form and content opens questions of how to approach sitcom acting in contrast to stage and screen. Since the genre is so dependent on established characters (even more so than established situations), actor performance proves critical to understanding sitcoms' appeal. As Brett Mills contends, to "understand the sitcom it is vital to explore the performances within it," giving three reasons for this claim:

First, this is because it conventionally employs styles of acting not used within other genres. . . . Second, it is within performance that the possible radical potential of sitcom is most obvious. . . . Third, we can explore performance for the pleasure it offers, particularly as these are often made so obvious in sitcom. Not taking account of acting in sitcoms means failing to get [to] grips with important aspects of it as a genre, a political text and a piece of entertainment.[18]

The sitcom highlights a manner of comic acting that remains different from motion picture or stage acting. The inherent repetitious and cyclical nature of the genre privileges performance choices viewed as familiar by viewers. In theory, another actor could have played Stanley Kowalski in Elia Kazan's film adaptation of *A Streetcar Named Desire* (1951), and some form of significant cultural currency might still exist for the audience.[19] On the other hand, by the third season, recasting Fonzie, after Winkler established the character's distinctive rhythms, would have been highly problematic for the established pleasures and cultural relevancy of *Happy Days*.

Mills provides a useful classification for most sitcom acting by relating it to the tradition of commedia dell'arte. Flourishing in markets across Europe from about the middle of the sixteenth century, these performances involved stock characters, performing in masks, with traditional stock narratives, on a stage in a crowded marketplace where performers competed with their surroundings for an audience. The commedia developed a coherent aesthetic that defined the masks, narratives, character interactions, and the actors' gestures. In terms of performance, commedia was viewed during its time as a skill set appropriate to each character, learned as a trade, and passed down through generations.[20] As Mills suggests, while classifying sitcom performance as relatable to commedia might seem "like a limiting constraint, it instead demonstrates that comedy has an aesthetic tradition with its own discrete and organised conventions and expectations."[21] This proves helpful in considering sitcom characters because they must not change too radically from episode to episode or, even, season to season. They eschew the psychological journey often central in discussions of "realistic" performance; sitcoms are a form of entertainment that, in Adler's terms, privilege characterizations definable as slanted types. Mills employs commedia's "use of recurring characters, and their characterization through masks" to understand

performance on sitcoms as not "intended to be read as psychologically complex beings."[22]

In relation, the most standardized "three-headed monster" format of sitcom is considerably different from shooting dramatic television, which can emulate cinematic styles. These genre constructs communicate to the viewer a distance from the characters. As Mills contends, through "adopting a different shooting style, comedy signals that it's not particularly interested in the psychology of its characters, or in them as realistic, believable, fully-formed human beings." As suggested by the "invisible forth wall," with a laugh-track-implied audience, "shooting and performance must combine to construct a diegesis which is understandable, but which also displays itself as fiction and doesn't allow the audience to become too emotionally involved in the characters."[23] This is not to say audiences cannot become invested in the lives of sitcom characters, since, in fact, they very much do, as Mills illustrates through the various romantic storylines of *Friends* (1994–2004). Yet this is a relationship defined by a communal experience with the audience as opposed to psychological identification: "The whole is filmed within the sitcom look, which while efficiently capturing the performance within a theatrical frame, emotionally distances the audience from the action." The three-camera format privileges comic performance as "a rigidly controlled aspect of acting, in which series' purposes are signaled clearly, audience responses are cued and responded to, and the whole maintains its distinction from seriousness as clearly as possible."[24]

One place where audience clearly affects the genre's performance style is "the catchphrase," or the repeated variation of a line (or gesture) meant to gain laughs through the audience's familiarity with characters. Henry Winkler's the Fonz developed over time into a repository of catchphrases—such as "Sit on it!," exclaimed in frustration to somebody, and a drawn-out, "Ayy!," (a variation on the originally scripted "Hey!"), given in agreement or excitement over something, often performed with a thumbs-up gesture. As Garry Marshall suggests, such moments were developed through the actor: "We gave Fonzie, 'Hey,' but Henry made it his own. We gave him the thumbs-up gesture—he made a life of that thumbs-up gesture!"[25] These moments illustrate the performer-centric nature of the genre as inherent to sitcom's appeals.[26] Mills contends, "the catchphrase, and the performer's delayed presentation of it, helps to bind the audience together as a common

group . . . all of whom are interested in the same pleasures and who recognise and understand the conventions of the programme they're watching."[27] The laugh track privileges this shared experience as well since it "tries to suggest to any individual viewer that their pleasures are the same as those of others, binding together an audience in a manner which discourages alternative readings of a text, at least if pleasure is to be gained."[28] The week-in, week-out grind of the sitcom only highlights this bonding, meaning performance itself dictates the development of a character on future installments. A well-performed comedic line can become standardized, part of the fabric of the series.[29]

While helpful as a baseline, as Mills himself suggests, sitcom performance as a style is not simply one born out of commedia dell'arte, but one "derived from other histories too, particularly as the history of acting in the twentieth century was a cross-pollination between theatre, film, radio, and television."[30] Generally, the genre's "cross-pollination" with other populist mediums means individual television shows are very much in conversation with the cultural moment of their popularity. As stated, *Happy Days* marked a move from the more adult-themed shows in the early 1970s to something "family friendly." Not coincidentally, the series also exists as, perhaps, the most widely consumed example of 1950s nostalgia to come out of the 1970s. The pilot, which did not include the Fonz character, was shot and eventually showed as a segment called "Love and the Happy Days" for the ABC anthology series *Love, American Style* (1969–74) in 1972. Eventual series regulars Ron Howard (as protagonist Richie Cunningham), Marion Ross (mother Marion Cunningham), and Anson Williams (best friend Potsie) appeared along with actors Howard Gould and Susan Neher as father Howard and little sister Joanie Cunningham, who were replaced by Tom Bosley and Erin Moran on the series.

The pilot was shelved, but eventually viewed by writer-director George Lucas when he started casting *American Graffiti* (1973). Lucas cast Howard as one of the male leads in a production that essentially birthed the "nostalgia film," a genre classification Fredric Jameson designates in "Postmodernism and Consumer Society"—suggesting it essentially started with Lucas's film, which "set-out to recapture all the atmosphere and stylistic peculiarities of the 1950s United States: the United States of the Eisenhower era."[31] While the film is actually set in September 1962, Jameson's classification remains valid

in that the film looks back at a supposedly "innocent" time as four white high school graduates spend one last night together. While set early in the proceeding decade, *American Graffiti* suggests the "1950s" as a concept— the pre–Vietnam War era as an idealized construct for white Americans. Despite its wandering narrative of youthful pleasantries, the film was meant to create a sense of longing for lost innocence among white Americans (especially males), even if the audience recognized the depiction as overly sanguine. As Vera Dika writes, "*American Graffiti* has the structure of irony, producing a feeling of nostalgia but also of pathos, and registering the historical events as the cause of an irretrievable loss."[32]

Due to the success of the film, ABC returned to Garry Marshall and asked him to retool the pilot and develop a 1950s nostalgia series as a vehicle for Howard, well known to the public ever since his childhood role as Opie Taylor on *The Andy Griffith Show* (1960–68). Marshall developed *Happy Days*, which would be perpetually set in a pleasant version of mid-1950s Milwaukee, Wisconsin—adding to the cast Winkler as Fonzie and Don Most as Ralph Malph, another of Richie's friends.[33] *Happy Days* was part of a larger wave of 1950s nostalgia that swept through the decade—including the band Sha Na Na, which performed classic '50s rock 'n' roll and had their own self-titled variety series (1977–81), and the hit musical *Grease*, which ran on Broadway from 1971 to 1980 and became a hit film in 1978. From a marketing standpoint, the rise of '50s nostalgia was not surprising since the first wave of baby boomers, born between the years 1946 and 1955, were now of the age where they would constitute an older market of consumers, now raising children who also happily consumed the "innocent" fun represented by the 1950s of *Happy Days*, Sha Na Na, and *Grease*.[34]

In his study of the 1950s and '60s as "politically charged public memories," Daniel Marcus examines "the marshaling of themes and symbols from the repository of popular culture" that emerged throughout the 1970s, '80s, and '90s.[35] As he suggests, the '50s nostalgia of the 1970s was a reorientation of cultural memory that was as much, if not more so, about reconsidering the culturally turbulent decade that came before: "The Fifties to be mined as nostalgia were an experience of white, middle-class teenagers. Their retrospective sense of personal innocence of the larger world in the 1950s becomes conflated ultimately with a sense that the nation as a whole lost its social innocence in the 1960s."[36] As the popularity of *American Graffiti*, *Happy*

Days, Sha Na Na, and *Grease* proves, this decade's '50s nostalgia was focused on youth culture, transferring the collective national memory onto the experiences of white teenagers as a representation of innocence.

Certain cultural markers were standardized as defining the 1950s, all of which were youth focused. For example, early rock 'n' roll, especially Elvis Presley, was deemed the dominant style of the era despite the fact more adult-focused music also dominated the airwaves during the decade. The fashion of the era was presented as blue jeans, chinos, crew cuts, white socks, pedal pushers, and black leather jackets—all markers of different variations of white adolescence. In terms of film stars, Marilyn Monroe became established as a clear icon of 1950s sexuality, while James Dean and Marlon Brando emerged as the epitomes of male coolness. With the male icons, their appeal was based on specific film roles, Dean as the tortured teenager Jim Stark in *Rebel without a Cause* (1955) and Brando in his leather-clad biker garb as Johnny Strabler in *The Wild One*. As Marcus suggests, the focus on these star images served as another commentary on the 1960s, as they all could retain a level of *cool*, something seen with the popularity of Brando's biker image in particular: "The insolence of Marlon Brando and James Dean gave the Fifties a veneer of hipness to compete with the culturally vibrant Sixties, while Brando's working-class, hypermasculine persona offered a contrast to the middle-class, somewhat feminized counterculture. As feminism began to challenge male prerogatives, the Fifties Brando presented a compelling figure as a rebel who was also insistently male."[37] The image could reestablish hetero-masculinity without embracing the patriarchal image of maleness seen in the nuclear family dominant during the 1950s.

With *Happy Days*, Marcus rightfully views the popular series as a largely conservative text in that it privileges a white male middle-class narrative as it "presages the revaluation of Fifties family life that would mark conservative rhetoric in ensuing decades."[38] The show is largely masculinist, reaffirming male authority figures through Richie Cunningham as a teen protagonist gaining knowledge from either his father, Howard Cunningham, or the cool greaser, the Fonz. Each figure exemplifies different forms of phallic dominance, respectively domestic and homosocial, "representing the two poles of experience around which the action revolves." Notably, women's voices are undervalued as "the female regulars on the show are never solicited for serious advice and make their desires known only by their occasional mild

mocking of the main, male leads."[39] As this suggest, the character of Fonzie and his evolving role on the series represent a reevaluation of the *greaser* image. With *Happy Day's* appropriation, the greaser could exist as hypermasculine and, in keeping with its "family hour" pedigree, harmless as a signifier of cool rather than subversion.

Also seen with Sha Na Na and *Grease*, this version of *greaser* exists as another reassessment of 1960s counterculture (especially white campus radicals and hippies) in that it negated the actual precursor to those social movements, the Beats. As Marcus writes, the "replacement of the Beat with the greaser as the emblematic 1950s rebel and arbiter of hip repositioned cultural authority in a number or ways."[40] After all, figures like Allen Ginsberg and Jack Kerouac represented middle-class, left-wing, intellectual, New York– or San Francisco–based figures, who often tied themselves to black culture through music and did not shy away from queer sexualities. In contrast:

> The greaser liked cars and girls and rock and roll, was working class, usually a non-Jewish "white ethnic," in the language of the time (such as Italian American . . .) and decidedly unintellectual and apolitical. The greaser's life was a physicalized one, in keeping with conceptions of working-class life as being centered on manual labor, industrial machinery, and simple pleasures. The greaser may have listened to black rock and roll, but did not emulate black social attitudes or behaviors. Almost the only commonality between the greaser and the Beat as avatars of the Fifties was their gender—the Fifties continues to be conceptualized as a predominantly male experience.[41]

Far from a subversive image, the greaser in this context tangentially denotes cool or rebellion as a hyper-masculine and hyper-heterosexual image and little else. In fact, Fonzie reinforces hegemonic ideas of not only gender but also social conservatism in general. Garry Marshall based the character on a composite of people he knew growing up, including aspects of himself, remembering one friend as "much meaner than Fonzie," but "despite his toughness, he had tremendous love of God, country, mother, father, his elders, and so on. I used that combination of qualities in the character of Fonzie. Fonzie respects all those things. He doesn't fool around with them."[42]

Happy Days is a series born out of the 1950s nostalgia of the 1970s, and Fonzie is a clear cultural reappropriation of the greaser as a type. While it is useful to see the characterization as a postmodern construct, it must be understood that Winker's Fonzie is a not a postmodern performance in a subversive parodic manner, as discussed with Brando's Robert E. Lee Clayton in *The Missouri Breaks* (1976). In contrast, while undeniably comedic, Winkler's performance is not a true parody of a young Marlon Brando or other youth icons of the 1950s such as Dean or Presley. In discussing nostalgia, Fredric Jameson uses *pastiche* as a classification sharing distinct characteristics with parody: "Both pastiche and parody involve the imitation or, better still, the mimicry of other styles and particularly of the mannerisms and stylistic twitches of other styles."[43] But while "pastiche is, like parody, the imitation of a peculiar or unique style, the wearing of a stylistic mask, speech in a dead language," it is "a neutral practice of such mimicry without parody's ulterior motive, without the satirical impulse."[44] Fonzie must be understood through this specific postmodern classification, meaning that Winkler's performance is not an act of subversion as much as an act of cultural reappropriation. There is no Fonzie without the biker image Brando helped cultivate in the 1950s. As it was retooled as pastiche, this image was reformulated to fit the highly consumable "family hour" sitcom style and speak to the decade's conservative 1950s nostalgia craze. To understand Winkler's the Fonz as an Adler performance, we must consider the development of the greaser in popular culture through Brando.

The Greaser as Icon: Marlon Brando in *The Wild One* (1953)

James Dean's reputation as an icon of youth is understandable, as his three films, *East of Eden* (1955), *Rebel without a Cause*, and *Giant* (1956), all feature the young actor clearly embodying restless youth, playing literal teenagers in two of the films, cementing him in that image after his death in 1955. In contrast, Brando remains a more complicated star image. He never played a teenager on screen, and his two most iconic roles of the decade were broken men—young but clearly defined adults expressing volatile misogyny, as

Stanley Kowalski in *A Streetcar Named Desire* (1951), or bittersweet regret, as Terry Malloy in *On the Waterfront* (1954). Within a decade defined by a wide variety of films far removed from the label of "teen-pic," only *The Wild One* has the actor clearly representing rebellion as a youthful enterprise.

Produced by Stanley Kramer and directed by László Benedek, *The Wild One* features characters in their twenties or older. This depiction reflects actual motorcycle gangs in the late 1940s since members were mostly World War II veterans struggling to adapt to civilian life.[45] As a product of the early 1950s film industry, *The Wild One* can be labeled a "social problem" movie, a drama examining rips in the social fabric. Such a production would have appealed to an Adler-trained actor like Brando, who was fascinated by social determinism. As he would later reflect, the movie posed a social question concerning "why young people tend to bunch into groups that seek expression in violence."[46] The film was loosely adapted from Frank Rooney's short story "Cyclist Raid," published in *Harper's Magazine* in 1951, which was based on an actual incident in Hollister, California, in 1947, where a gang drunkenly intimidated and brutalized the locals. Like many "social problem" films, the original screenplay, titled *The Cyclist Raid*, met with resistance from the Breen Office, who saw the hoodlums' violence as exploitive and possibly inspiring similar acts. In response, Kramer lightened the antisocial behavior and highlighted the redemption of Brando's Johnny Strabler, the leader of the Black Rebel biker gang. This change occurs through the love of a good woman, the young waitress Kathie (Mary Murphy), who, for narrative convenience, is also the daughter of a cowardly sheriff (Robert Keith). There also was the addition of a textual preface, warning the story "could never take place in most American towns—but it did in this one. It is a public challenge not to let it happen again."[47]

The Wild One represents a popular culture product that grew and changed in significance over time. In retrospect, it is a prototype of later biker movies, especially those produced in the 1960s for American International Pictures (AIP), such as *The Wild Angels* (1966), *Devil's Angels* (1967), *The Glory Stompers* (1967), and *Born Losers* (1968). As Bill Osgerby writes, "*The Wild One* established many of the codes that came to typify the archetypical biker movie," including "the volatile aura of the maverick bike gang; their gratuitous violation of social taboos; the parochial 'squares' terrorized by subcultural Others," and "the brooding introspection of the biker gang leader."[48]

Despite these early appearances of what would become the biker film's genre codes, the original production was not necessarily meant to appeal to teen audiences. In fact, motorcycles did not really constitute a marker of youth in popular culture until AIP's "cycle cycle" of the 1960s. As Thomas Doherty writes on teen films of the era, six cylinder "hotrods" were more regularly employed in films marketed for that demographic, since "motorcyclists still had too much of a deranged outlaw image to capture the sensibilities of suburban teenage Americans."[49] In terms of the youthful viewership of the decade, it was not the iconography of the motorcycle that had the most impact but the image of Brando as the rebellious but sensitive Johnny, donning his leather jacket and oozing sexual allure. The significance of Brando to the film's appeal can be seen in what emerged as its most iconic moment, which notably does not feature a motorcycle. As Brando slaps his hands on a jukebox, a flirty townie flippantly asks him, "Hey Johnny, what are you rebelling against?" The film cuts to a close shot of Brando as he responds, "What'd ya got?" The line proves iconic in its merging of star image and rebellion, fetishizing the act of rebellion as a marketable image. The moment is the foundation for generations of young (white) male stars whose sexual allure would be tied to apolitical rebellion—rebellion for rebellion's sake.[50]

The film immediately marks Brando as its central appeal, opening after the Breen-friendly preface with Johnny's voice-over promising a characterization not simply defined by delinquency but by open lament and sensitivity: "Maybe I could've stopped it early. But once the trouble was on its way, I was just going with it. Mostly, I remember the girl. I can't explain it, sad chick like that. But something changed in me. She got to me." The titles then read "Marlon Brando as" followed by "*The Wild One*," over the actor in a close medium shot, on his motorcycle decked in black leather, sunglasses, and riding cap. The image of the biker here is one directly related to the image of Brando as Method male, with an emotional sensitivity established along with the production's "social problem" dramatic focus. The relative complexity of Brando's characterization in contrast to the rest of the motorcycle gang is established early on, as other leather-clad bikers are shown as hyperactive hooligans laughing at every square they encounter. In contrast, Brando displays slower deliberately subdued gestures and behaviors. For example, as his gang loudly mock and laugh at the participants of a legitimate motorcycle race, Brando mostly stands by quietly, only erupting in expressions of frustration

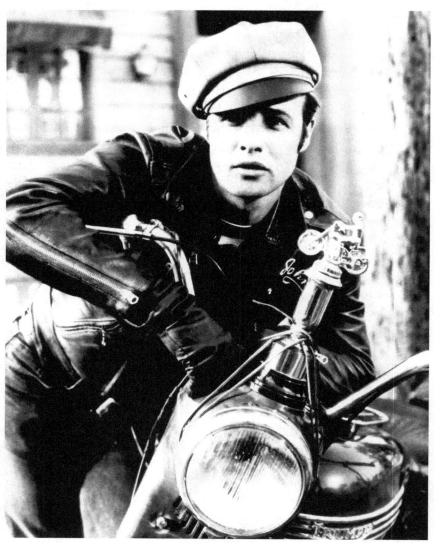

Marlon Brando as Johnny Strabler in *The Wild One* (1953).

and anger when protecting his gang—pointing his finger and roughing up a race official after he pushes one of the smaller bikers. When a police officer appears, Brando's piercing gaze denotes a true disgust toward authority. Later, the cop demands the gang leave town and, in response, Brando employs his sunglasses as an object to display his seething resentment, slowly placing them on his face without breaking his cold gaze.

Brando's Johnny is a realistic characterization very much defined by the manner of performance choices already discussed in *A Streetcar Named Desire*. Once again, the actor performs doable actions as stressed in Stella Adler's technique classes, choices in keeping with a unified characterization and the given circumstances of the screenplay. When Johnny first sees Kathie, he follows her as she enters the restaurant, letting his motorcycle racing trophy (stolen by his gang from the race) dangle off a string held in his left hand. Again, he stresses deliberately slow actions, removing his gloves and whistling. Passing the empty lunch counter, he extends his right hand and pushes the swivel chairs so they face the camera. Continuing to whistle, he walks to the end of the counter and looks off screen as if making sure they are alone. He then walks back to the counter, closer to Kathie as she nervously cleans the surface. Brando then makes direct eye contact and slowly raises his hand so she can wipe underneath. Kathie finally breaks the silence asking, "Do you want something?" "Yeah," he responds, pausing before stating, "I'd like a bottle of beer." As these actions illustrate, Brando stresses two key attributes in his characterization of Johnny, social disturbance and sexual dominance. In the quietness of the empty establishment, his whistling serves as an audible disruption, something Brando also provides in a visual sense as he disrupts the symmetry of the frame, turning each chair. Other actions highlight his sexual dominance—his slow removal of clothing (the gloves), his surveying of the empty space (implying possible sexual violence or, at the very least, active seduction), the moving of his hand above Kathie's as she cleans (stressing the close proximity of their bodies), and his pause after she asks, "Do you want something?" (once again implying sexual violence or seduction). Through this series of performance choices, Brando establishes fundamental aspects of the biker persona, a popular culture image representing social disturbance and sexual dominance.

Within the film, though, the Breen-friendly character arc of Johnny challenges some of the rougher aspects of this image as he adopts a level of social

responsibility. As his gang, the Black Rebels, and their rivals, the Beetles, take control of the town, they cut off the phone lines and go on a drunken rampage. In response, Johnny is made more sympathetic as he tries to get them to leave town. Wrongly accused of the death of a local, the character is captured and beaten by a group of merchants. Once he is proven innocent, the film's resolution features Johnny being lectured to by a reestablished patriarchal authority, in the form of a sheriff (Jay C. Flippen), who tells him, "I don't get your act at all and I don't think you do either. I don't think you know what you are trying to do or how to go about it. I think you're stupid." After Johnny is shown riding out of town with his gang, the film returns to the café, where Kathie sits with her father. Johnny enters alone, seemingly having left the gang, and orders a cup of coffee. Without saying a word, Brando leaves his stolen racing trophy on the counter and exchanges knowing smiles with Kathie. He then rides off alone as her father watches, suggesting the reestablished patriarchal power of the once powerless cop and the redemptive possibilities of heterosexual love on Johnny. The final image of Brando's rebel biker only goes so far though in rehabilitating him from the image of outlaw to upstanding citizen. The biker now appears as a solitary figure, divorced from the camaraderie of the gang and embodying a masculine individuality. The biker is still a sexualized rebel, a counterimage to the mainstream maleness of civilization represented by the cop/father, who watches him ride off.[51]

In popular culture, Brando's Johnny had an undeniable impact. This early image of the greaser marked a significant moment in the cultural history of the leather motorcycle jacket. Created by Irving Schott in 1928, the garment's cultural coding shifted throughout the twentieth century (and continues to shift) as it was embraced by GIs, bikers, juvenile delinquents, gay S/M, and punk rock. For *The Wild One*, Irving and Jack Schott provided all the leather jackets, with Brando wearing the then-new W-style One Star, which became a best seller after the film's release. As Marvin J. Taylor writes, the impact of Brando and his jacket on various subgroups of counterculture cannot be underestimated:

> Brando's mumbling, formidable loser, who even the sheriff's daughter calls a "fake," created a new kind of persona for American men. The outsider, antihero was born. From juvenile delinquents to bikers to leathermen to punks, the darker, more dangerous, more volatile hypermasculine

male found a common model, swathed in a black leather motorcycle jacket. This jacket, which is literally "another skin" that protects riders, became a metaphorical second skin that the vulnerable antihero wears for protection. From this point onward, the jacket began to take on different meanings in different cultural groups.[52]

As Taylor suggests, the image of Brando as the leather-clad Johnny consistently appeared in twentieth-century subcultures who embraced the jacket to designate themselves as Other to mainstream masculinity. Yet these appropriations did so in a manner still implying some form of hypermaleness—be it the outlaw biker, the queer S/M leather men, or the punk movement. The leather-jacketed Brando, as reproduced for decades on posters, could accordingly be embraced as an expression of rebellious hypermasculinity. The jacket, as a type of "second skin," emerged as, perhaps, the most potent signifier of masculine cool during the twentieth century (which, even when adopted by women, also denoted a rejection of gendered passivity).

Method Masculinity as Pastiche: Henry Winkler in *Happy Days* (1974–84)

By the time Garry Marshall created *Happy Days* in the early 1970s, the image of the leather-jacketed biker was ingrained in culture through the popularity of juvenile delinquency films, biker subculture, and, though less mainstreamed, queer appropriations like S/M leather men. These connotations were seemingly in the minds of ABC executives as Marshall pitched the idea of Fonzie. As Henry Winkler relates, the network originally placed limits on the extent of Fonzie's image as greaser, basing their stipulations on the previous two decades' association of the leather jacket with criminality and delinquency: "The network had made an early decision that Fonzie would not be allowed to wear any leather or to have grease in his hair. Reason? ABC did not want Arthur Fonzarelli to be associated with crime or violence and somehow the public would connect grease and leather to a criminal mentality."[53] As a result, for much of the first season, the iconic dark brown leather jacket did not appear, as the character wore a windbreaker. As Winkler explains, Marshall and he wanted the character in a leather jacket from the start and,

eventually, "sneaked it into a taping. When the roof didn't fall in on us, the jacket became part of Fonzie's permanent wardrobe."[54]

The Fonz was not Winkler's first attempt at playing a leather-clad greaser, as he appeared in the 1950s-set drama *The Lords of Flatbush* (1974). While the film follows the exploits of a group of bikers as they hang out, rumble, and ride, the characterization proves different from Fonzie in key ways. Firstly, as Butchey Weinstein, the character is Jewish as opposed to Italian, reflecting Winkler's actual ethnicity. Weinstein is a loner and an intellect who, when learning there is more to life, eventually drifts away from his gang—populated by more traditional Italian greaser types, played by Perry King, Sylvester Stallone, and Paul Mace. Yet it would be fair to surmise that Winkler's preparation for the dramatic film would have informed his preparation for the more comedic Fonzie.[55] In the fights over wardrobe, while the jacket and hair were sticking points with the network, Winkler took a stand on one issue, based on his experience on *Flatbush*: "The costume people had also arranged for the Fonz to wear penny loafers—can you believe that?—a motorcycle dude in penny loafers? I couldn't stand for that." The actor protested and, instead, wore the "engineer boots I had worn in *The Lords of Flatbush*." Winkler brought the actual boots from that film to Hollywood, and "they too became a permanent fixture."[56] These issues of wardrobe would be of foremost importance to an Adler-trained actor, especially footwear, which affects the way the performer walks and stands. In Adler's lessons on characterization, she often focused on wardrobe, relating the practice to her general philosophy that performance must develop the character away from "self." As related in *The Art of Acting*, "When a man puts on a costume he also gives up something of himself, sacrifices something."[57] The significance of costume also relates to the work of social observation, an awareness of cultural classifications. Adler suggests, "On stage you're nothing. You are what the clothes make of you. Clothes say something about your self-control, your self-awareness, your social-awareness." Winkler's desire to define the Fonz through exteriors, like his jacket and boots, relates to the character's sense of social standing.[58]

In Winkler's account of his performance choices on his first day of shooting *Happy Days*, the actor directly credits Stella Adler as influencing his approach to character building: "That day I also learned something that every television series actor has to know—that is, come to a day's shooting with

multiple choices prepared for your character." He then recalls the "first thing I ever wrote in my notebook at Yale was a quote from Stella Adler, a brilliant actress and teacher: 'In your choices is your talent. The bits of detail you pick to build your character are what is going to make you or break you.'"[59] Winkler thought ahead before the scenes to consider multiple ways that Fonzie might react, an approach he views as medium-specific, "I learned that one choice is never enough for television." Employing Adler's lessons, Winkler realized that his choices not only had to prove relevant to the character and situation but also to the textual contract of the sitcom genre—the deference to audience. Even though early episodes were filmed with laugh tracks as opposed to a "live studio audience," this relationship can be seen. As Winkler relates, in one moment a girl was supposed to ask Fonzie to hold her books, so the actor thought "it seemed a good bit for her to ask him to hold her books for a second, which is exactly what he would do—*one second*, look at his watch, then drop the books on the ground." While this choice was true to the character and situation, Winkler was surprised when the director disapproved, telling him, "No, the audience wouldn't like Fonzie for doing that." In response, Winkler had to adapt his lessons from Adler to fit the stylistics of sitcom acting, where audience response is central. As he states, "That was when I realized that the thinking that goes behind a television series is so complicated you can never figure out all the angles. The only way to keep control is to have at least two different choices ready in case the first one doesn't work out."[60]

Adopting this approach, Winkler made multiple choices early on that became staples of the Fonzie characterization, elements that grew so popular they developed into catchphrases. In another scene of the first episode, in the bathroom of the drive-in restaurant, Potsie and Ralph coach Richie for a date with a supposedly loose girl. The two bumbling friends have fastened a brassier around a radiator to teach Richie how to unsnap it with one hand, an endeavor at which they all fail. Fonzie then enters, which Winkler relates as existing in the script as simply "Fonzie reacts," leading the actor to naturally ask, "How *would* Fonzie react?" Winkler decided to embrace the coolness of the character to the fullest: "My choice for that moment was to blow on my fingers like a safe cracker, unsnap the brassier with just a sweep of my hand and then walk out without a word."[61] The director then asked Winkler to comb his hair in the scene, which the actor did not want to do since the

action "was such a cliché gesture for this type of character, and who the hell cared about my hair anyway?" Winkler then made a choice that would ultimately determine the character's gestures for the rest of the series: "I made my choice. I walked to the mirror, pulled out my comb and brought it to my hair. Then, as I recognized that my hair was perfect, I said 'He-e-ey' with satisfaction, put the comb away and walked out."[62]

This performance choice illustrates Winkler as adopting the lessons of Adler to build his slanted characterization around cool as an abstract though viable social type. As the actor conveys, "Fonzie and I are as opposite as two men can be. So when I began creating the character, I *started* with the concept of 'cool.' I decided that cool comes from the center, the core of a person."[63] His performance choices usually relate to this conception, an individual removed from the patriarchal social order yet also superior in expressing masculinity. All these choices would remain with Fonzie in future episodes and grow, suggesting Adler's approach to characterization as adaptable to Brett Mills's classification of sitcom acting as similar to commedia dell'arte—an approach particularly aware of audience response and based in repetition with only minor variations. As Winkler relates, many of the defining attributes of Fonzie came from his early choices as an actor, such as the cool gestures of confidence and the thumbs-up "He-e-ey." These were embraced and developed by the show's writers, due to audience response: "By the time Fonzie caught on with the public and was an integral part of more plots in more scripts, these sounds and gestures had become established as part of his personality."[64]

These established sounds and gestures are on full display by the time *Happy Days* entered its third season, which, as stated earlier, found the series going through multiple changes. Firstly, it was now largely filmed before a "live studio audience" with a three-camera setup. Secondly, the popularity of Fonzie resulted in Winkler becoming Ron Howard's colead. These changes can be seen in that season's opening credit sequence. With the theme song playing, the first character shown is now Fonzie, dressed in his leather jacket and riding his motorcycle down a sunny suburban street. Interspersed with idyllic images of 1950s life featuring the entire cast (playing baseball, having a family dinner, hula-hooping, riding in a hot rod), the Fonz now appears throughout the montage, often on his motorcycle. Listed as one of the two stars of the show, after Howard, Winkler's greaser is now given a privileged

Don Most, Henry Winkler, Anson Williams, and Ron Howard, publicity photo for
Happy Days (1974–84).

position in the credit sequence's nostalgic celebration of an idealized white
past. Notably, the images of Winkler bear a resemblance to the biker ico-
nography associated with *The Wild One*, sometimes with the collar on his
leather jacket up and donning aviator sunglasses like Brando. Yet any sense
of danger is nullified by a smile on the character's face much of the time. The
final image of the credits place Fonzie front and center, leaning on his motor-
cycle and laughing as his thumbs pop up—Potsie, Ralph, and Richie standing
behind him. By 1975, Winkler's performance choices are now ingrained into
the fabric of the series. The actor makes variations on the confident gestures
developed in the first season, especially the thumbs-up. In one shot, he faces
a mirror, moving to comb his hair, then stops and extends out his arms as
if to exclaim "he-e-ey." The performance choice established during the first
episode of the series has become a staple of the characterization (and a staple
of the pastiche defining the diegesis of *Happy Days*).

 With Fonzie moving into the Cunningham's garage apartment, the so-
cial significance of the greaser became a major theme by the show's third

season. Much like when originating the character, cool emerges as the core concept driving Winkler's performance choices in all seasons. But as the series developed and Fonzie's popularity grew, cool also had to define the plots of individual episodes. Through this narrative focus, cool emerges as something not at all subversive but now fully integrated into a whitewashed image of the 1950s. As *Happy Days* established itself as simultaneously a safe "family hour" hit and the epitome of Eisenhower-era pastiche, the edge originated with Brando's greaser in *The Wild One* dissipated to accommodate Winkler's greaser. The sitcom audience was now fully acclimated to Fonzie as a safe "white ethnic" type and, as such, episodes were fully formed around the apolitical motivations of the character. This understanding of the Fonz clearly emerges in a two-part episode, "Fearless Fonzarelli" (original airdates September 23 and 30, 1975), which contains a storyline dependent on the viewer's knowledge of cool as the character's defining attribute.

The two-parter finds Fonzie falling into a slump, worried that he has lost his cool as his usually confident actions do not result in the expected reactions that have been established by the series, most notably meaning women fail to respond with unadulterated adoration. On seeing an episode of *You Want to See It*, a fictional write-in TV show based on the actual *You Asked for It* (1950–59), Fonzie has Richie write in and ask to see him jump fourteen garbage cans on his motorcycle, breaking a previously held record. Figuring this stunt will reestablish his cool, Fonzie proceeds despite the danger, ultimately, as shown at the start of the second episode, breaking the record but injuring his knee. After reluctantly getting an operation, he recuperates on the Cunningham's living room sofa, overstaying his welcome since standing up might mean being in agonizing pain, a reaction he decides will make him look less cool. Finally, Richie inspires his friend to get onto his feet by inviting a group of girls over. Fonzie eventually stands and joins the girls, fully reestablishing his cool. As this synopsis shows, the narrative is dependent on the established knowledge of the television audience, who must know that, as Winkler suggests, cool constitutes Fonzie's core, the essence of his being. This is a coolness defined not by any antisocial behavior or threat to patriarchy but by primarily a reaffirmation of hetero-masculinity. Fonzie's long-established ability to easily consummate (or, for this "family hour" sitcom, maybe just "make-out") with the opposite sex exists as both the initiation of the first episode's conflict and the resolutions of the second's.

The Fonz's entrance during the two-parter creates its humor largely through the audience's foreknowledge of these character attributes. The camera pans across Arnold's drive-in to show Paula Petralunga (Melinda Naud) exit the restroom past Richie, Potsie, and Ralph, who all ogle her curves. To the sound of applause, Fonzie enters and snaps his fingers at her. While this action usually results in a woman rushing into his arms, Paula simply states, "Sorry Fonzie, I got something to do." Fonzie appears frustrated and declares, "Yeah, well, I got something to do too. I was just practicing." He eventually sits alone with Richie to voice his concern that, "Something's happening to the Fonz." After telling him some experiences of being disrespected at his garage, he informs Richie that he is worried about "losing my cool." While Richie tries to comfort him by telling him that he is just in a "slump," Fonzie reacts with genuine worry. Throughout the conversation, Winkler's gestures still very much keep within a sense of overriding confidence even as he expresses self-doubt. The dialogue has the character repeatedly refer to himself in the third person, to which the actor employs his hands to gesture to his body, implying self-awareness. As he tries to leave Arnold's, Potsie and Ralph ask Fonzie to give the jukebox "the old Fonze touch," which the audience knows means the character's near magical ability to hit it and start it playing. When he hits it this time, nothing happens. Winkler turns to Howard and says, "Hey, I'm in a slump," extending out his arms in a defeatist fashion and leaving the scene with his head slightly lowered, shaking it as if depressed.

While Winkler performs his actions more confidently than the lesser male figures of Richie, Potsie, and Ralph, they still constitute a comic divergence from the viewer's foreknowledge of Fonzie as alpha-male greaser. True to the rules of sitcom, the audience is never too worried the character has lost his cool, yet we recognize he is facing a crisis as he leaves the scene alone (with no women) and unable to magically play the jukebox (a type of impotency). Later in the episode, after it is announced he will jump the garbage cans, Fonzie's coolness is reconfirmed through Winkler performing these actions again with the appropriate effects. When Richie expresses his concern after learning of the multiple failed attempts by other motorcyclists, Fonzie declares he needs to go through with it "to get out of this slump." He then says, "Observe," snapping his fingers, only to have Paula now rush to his side. Placing his arm around her waist, Winkler returns to performing well-established gestures, reestablishing his cool with greater confidence. He

rolls his eyes upward and exclaims "whoa" in response to Paula's presence. Walking her over to the jukebox, he blows on his fist and strikes it, to which Elvis Presley's "Hound Dog" plays. Winkler and Naud then press their bodies close together and, despite the fast music, slow dance. Throughout these performed actions, Winkler acts as if the Fonz himself fully grasps the diegetic world of *Happy Days*, its narrative contract with the audience. By the third season, coolness exists as not only a core trait of the slanted characterization but as an impetus of narrative cause and effect—resulting in a pastiche image of 1950s heterosexual conquest, appropriately set to the music of the era's most sexualized music icon.

Even with these established gestures and actions, moments emerge on the series that demonstrate Winkler as an actor still making in-the-moment choices based on, in Adler's parlance, the given circumstances of the script. Since the character of Fonzie was developed as a pastiche, these choices often correspond with the Method male persona as it was established by young actors in the 1950s. While his look and demeanor correspond most with Brando's Johnny in *The Wild One*, the show employs another icon as Fonzie's pop culture hero. In his garage apartment, a poster of James Dean hangs inside his closet, an image that the character directly addresses in this episode by telling it, "They don't understand." In the second episode, while he lays on the Cunninghams' sofa, he declares, "Nobody understands cool but me and James Dean." In his actual movie roles, Dean never played a tough greaser and, as the sensitive middle-class teenager Jim Stark in *Rebel without a Cause*, resembles the youths Fonzie calls "nerds" on the series.[65] Yet this image of Dean is forgotten, and in its place appears the 1970s appropriation of the restless young Method male as cool.

Such a pastiche also materializes throughout Winkler's performance in scenes divorced from catchphrases and established running gags. For example, when Fonzie starts to realize the danger of his jump, he asks Richie to help him write his last will and testament since his square friend has "good penmanship." After writing for a bit, Richie protests and declares, "I'm not going to do this, Fonze," which Winkler responds to by holding up his fist and asking, "Hey, are you talking back?" To Richie's relief, his father enters the garage apartment to try to convince Fonzie not to make the jump. As Howard Cunningham stresses the danger and how "a lot of guys" already attempted and failed, Fonzie states, "I know about a lot of guys. They were

all nerds." The conversation is covered in a standard three-camera setup—a close medium shot of Winkler, a two-shot of Ron Howard and Tom Bosley for reactions, and a three-shot for coverage. For most of the scene, the three-shot is employed, allowing the audience to watch Winkler's comparatively animated movements in contrast to Howard and Bosley, who stand mostly motionless behind a table. Throughout the conversation, Winkler performs gestures and employs objects that stress his character as different from the middle-class and largely ineffectual maleness of Richie and his father. These gestures include placing his foot on one of the chairs to adopt a dominant stance, leaning forward to place his hands on the table and chair, and, while Bosley attempts to talk, picking up a grease gun and shooting it into part of a motorcycle engine that sits on the table. When Richie attempts to also talk him out of the jump, Winkler takes a toothbrush and cleans the machinery. These performance choices all illustrate Fonzie as distracted and defiant in the face of the arguments of the domestic males, a motivation very much aligned with the given circumstances of the scene.

Since this is the pastiche 1950s world of *Happy Days*, these circumstances actively engage the viewer's understanding of the greaser's significance in culture. Here, removed from the iconography of his motorcycle or even his leather jacket, Winkler wears simply a tight white tee-shirt. As such, Fonzie emerges as a pastiche of Method maleness as an abstract concept removed from the subversions inherent in the image during the actual 1950s. Just as the poster of James Dean that hangs in his closet feels divorced from the reality of the actor during his lifetime, Winkler's expressive movements and object work only constitute a vague semblance of the youthful masculinity as it appeared in that group of actors. At one point, Fonzie compares his defiant stance to *High Noon* (1952), where Grace Kelly "tried to convince Gary Cooper to go back on his word." Pausing for a second, Fonzie then says to himself, "Hey, you know, he should've belted her one." While the moment is played for a laugh, since the character is never shown being violent toward women on the series, it reminds the audience of the volatile Method maleness that serves as the foundation of the rebel male actor as icon. Adorned in his white tee-shirt, Winkler calls to mind the performances of Brando, who established his stardom also in a tight tee-shirt as the abusive Stanley in *A Streetcar Named Desire*. Such a performance, along with the sexually alluring Johnny in *The Wild One*, suggests a dangerous sexual dominance as part

of the established Brando star image. The actor represented a sexuality that countered the leading men of the previous generation, like Gary Cooper.[66] The script has Fonzie admiring Cooper's stance, his code of ethics, but dismissing his lack of volatility, which situates the sitcom greaser as rebellious on the surface but moralistic in his core. Despite this, the scene still positions him as different from the domesticated maleness of Richie and his father, who remain aware that Fonzie represents some form of (at least surface) rebellion. As Howard Cunningham says as he exits, "How can you reason with a man who'd punch Grace Kelly?"

To recognize Winkler's characterization of Fonzie as a pastiche performance is not to diminish Winkler's choices as a sitcom performer. During the two-part episode, some of the most entertaining moments occur when the actor challenges the character's established coolness through comic expressions and movements. For example, the second episode has Fonzie facing an operation on his knee, a situation allowing for broadly comic reactions. In the hospital, Richie and Howard visit him as he is under the effects of sodium pentothal. Throughout this sequence, Winkler performs Fonzie as chemically altered for broadly comic effect, giggling with a blissful smile on his face. At one moment, he asks Richie, "You know how I dress in my jacket and my tee-shirt and my jeans and my boots and everybody thinks I'm so cool?" Thinking the drug-fueled lack of inhibition might lead to some deep insights about Fonzie, Richie informs his father, "This is the truth serum." Fonzie then declares, "The truth is I am cool," and erupts with an uncharacteristic high-pitched laugh. By the scene's end, Fonzie is wheeled out of the room, declaring, "I ain't scared," reaching to grab his leather jacket off the coat rack and defiantly hold it up. As such moments show, while the series and Winkler's performance are based in repetition and audience foreknowledge, the situations and the actor's corresponding choices could challenge and tease these established protocols for the sake of humor.

But being the sitcom genre, the character can never be challenged too far as his apolitical rebelliousness and heterosexual dominance are always reestablished. The two-part episode ends with the Fonz on his way to reclaiming his position as idealized greaser. As Richie welcomes a group of Fonzie's regular dates to the house to see him resting on the sofa, dressed in pajamas, one girl states, "Oh look at the Fonz. Doesn't he look cute in his little jammies," essentially de-masculinizing him. Demanding the girls turn

around, Fonzie quickly has Richie hand him his leather jacket, which he zips up over his pajama top. Winkler folds his arms over his chest, as if holding the "second skin" of the jacket closer to his body as a defense mechanism. When Fonzie reasserts his inability to walk, the girls leave. Only then does the Fonz finally decide to attempt walking again. Winkler performs some broadly comic expressions of pain and lunges around the set. He finally states, "Alright now, I'm gonna try to get my cool into shape here." With that, stiff-legged, Winkler circles Howard gritting his teeth as the Fonz attempts to perform cool. He asks, "My face? How's my face?" Richie responds, "You look cool." Fonzie then thanks Richie and to the thunderous applause of the live studio audience exits the front door, arms out, yelling, "Alright, girls. He-e-ey!" As the episode ends, the greaser's social and sexual dominance have been properly restored. The Fonz remains "family hour" cool.

6

CGI Performance and Size

Mark Ruffalo in
Avengers: Age of Ultron (2015)

It took a whole squadron of superheroes, but *The Avengers* easily soared off with the record for the biggest movie opening of all time, hauling in $207.4 million to dethrone last year's *Harry Potter and the Deathly Hallows—Part 2*. And while he had plenty of help, certainly some of the credit must go to the scene-stealing Hulk—who, after two somewhat disappointing turns on the big screen, is indeed incredible this time around.

Entertainment Weekly, May 18, 2012,
cover story, "That's a Lot of Green."[1]

A s noted by *Entertainment Weekly*'s enthusiasm over Joss Whedon's *The Avengers* (2012), it took a few tries for a film version of Stan Lee and Jack Kirby's comic book creation the Hulk to find wide acclaim with critics and the public. The television series *The Incredible Hulk* (1978–82) was a popular hit.[2] Yet when the blockbuster era came beckoning, the prospect of bringing one (or two) of Marvel Comics most popular characters to the screen proved difficult. The first attempt was *Hulk* (2003) starring Eric Bana and directed by Ang Lee, his follow-up to the international hit *Crouching Tiger, Hidden Dragon* (2000). Five years later, Marvel Studios rebooted the property with *The Incredible Hulk* (2008), directed by Louis Leterrier and starring Edward Norton, which brought the character into what is today popularly referred

to as the Marvel Cinematic Universe (MCU), narratively connecting him to other popular superheroes such as Iron Man, Thor, and Captain America. Both films grossed over $200 million at the worldwide box office yet, by tentpole blockbuster standards, were considered disappointments. Both also received mixed responses from fans, with Lee's film finding many lamenting its overly serious tone while the reboot was unfavorably compared to the more popular *Iron Man* (2008), released just a month before.[3]

Partly, these responses had to do with the basic difference between the tortured Banner/Hulk in contrast to other more clearly heroic males seen in superhero films. As Stan Lee states concerning the character's creation in 1962, "I was getting tired of the normal superheroes. My publisher said, 'What kind of new hero can we come up with? And I said, 'How about a good monster?' and he thought I was crazy. But I remembered Jekyll and Hyde and the Frankenstein movie with Boris Karloff where it always seemed that the monster was really the good guy."[4] Whedon contends that, after finding acclaim placing the character into an ensemble superhero film, creating a stand-alone Hulk vehicle would prove difficult: "The Hulk is really hard to build a movie around. He's kind of a hero and kind of a Universal [Studios] monster, like he's a werewolf. It's the job of the hero to try and stop the reason you came to see the movie from showing up, and structurally that's a hard job."[5] In this sense, having Banner as a secondary character allows him to embrace this struggle without having to carry the film's more simplistic heroic activities, which are given to clearer alpha male heroes like Tony Stark (a.k.a. Iron Man) and Steve Rogers (Captain America).

Yet these were not the most cited reasons by critics and fans for the relative success of the Hulk (and Banner) as he appears in *The Avengers*. Instead, most enthusiastic responses cited something different in considering this re-reboot of the character—which, while technically a continuation of the 2008 reboot, was largely viewed as rebooting that reboot with a new actor and a new special effects design. The praise for this newest incarnation fell into two categories: (1) the performance of Mark Ruffalo, and (2) the improved computer-generated image (CGI) of the Hulk. Much like the split personality of the character itself, these two points are not to be viewed as mutually exclusive. While like the previous films, Banner is a live-action performance and the Hulk is a digital effect, developments in digital technology position the actor himself as contributing to the performances on screen in

both their photorealistic and digital incarnations. Developments in *motion capture* technology, which essentially graphs Ruffalo's movements onto the digital figure of the Hulk, warrants a consideration of the actor as directing a performance through both a corporeal and digital body.

Both *Hulk* and *The Incredible Hulk* also employed motion capture (or *mocap* for short) but through what was perceived as varying degrees of success. On its release, Ang Lee's film, which used both motion capture and key frame animation, received criticism for its animation that heavily relied on unreal animated movements over mocap. The *New York Times'* A. O. Scott, echoing the disappoint of some fans, called the digital character "more like clay animation" than CGI.[6] Leterrier's reboot addressed this issue head on by attempting to improve on the design problems of the character, centrally employing actors to motion capture larger movements and having leading man Norton record facial expressions. In total, though, the special effects privileged animation once again, with lead animator Amanda Dague stating, "Motion capture was done, but I only used it to place the characters and figure out the timing—and then it was mostly key frame [animation]. The mocap just didn't have the finesse, it didn't have the superhero poses, it didn't have the superhero quality."[7] The film's lack of success resulted in the studio scrapping plans for any solo sequels, and when *The Avengers* went into development a few years later, the technology for motion capture had improved greatly and the Hulk was redesigned once again. Also, unhappy with the first film, Edward Norton opted out and the studio hired Ruffalo.[8] This time, the actor's role in creating the Hulk was greater, with Ruffalo performing the Hulk's scenes for either captured movements or, at least, reference points for the animators. Also, before shooting began, Industrial Light and Magic (ILM) performed high resolution scans of Ruffalo's body, creating a greater sense of the actor as dictating both the look and movements of the giant creature.[9]

Mark Ruffalo is one of the most acclaimed of Stella Adler's late-career students. His performance as Bruce Banner and the Hulk brings this discussion of Adler and the male actor into the postcinematic realm of digital technology, which converges with the body in the creation of "performance." In this context, the physicality and externality of the Adler approach allows for new ways to consider technological developments in film acting—where, due to CGI technology, the body is removed but the movements remain.

In many ways, this can be viewed as another step in a long history of questioning the apparatus of cinema as diminishing the agency of the actor through its disjointed shooting and multiple takes. With motion capture's merging of the aesthetics of animation with the movements of live action, the audience's ability to create an associative temporal continuity provides us with a new way to understand on-screen performance as affect. Employing Sharon Marie Carnicke's discussion of Stanislavski's Active Analysis in directing and analyzing mocap performance, this chapter considers Adler's own promotion of an action-based methodology to recognize her impact on a new era of cinematic acting. In this regard, Ruffalo shows how this performance approach translates into the blockbuster era with his role as Dr. Bruce Banner in *Avengers: Age of Ultron* (2015)—the sequel to *The Avengers* where much of his performance is motion captured as the Incredible Hulk in a manner showing advancements in the technology that allow for more nuanced expression and gesture. The approaches promoted by Adler, especially in relation to understanding the character's *size*, extend beyond the twentieth century, proving adaptable to the advancing technological conditions inherent in presenting the body as both a photorealistic and fantastical CG image in twenty-first-century cinema. Through this, Ruffalo explores fantastical ways to perform the damaging effects of white male rage within the repressed male.

Cinematic and Digital Performance: Process and Reception

Although teaching in the era of cinema and television, Stella Adler never made much of a distinction between stage and screen acting. Her archived materials show no courses devoted to film or television acting at her mid-century studio. In transcripts and interviews, the topic of stage acting in contrast to screen never feels to be of particular concern to her. Even though many of her students were probably interested in a career in film or television rather than the stage, especially at her later Los Angeles studio, acting for the screen was not something she felt the need to discuss in her book *The Technique of Acting* (1988). In an interview with Edward Vilga, she was directly asked why film acting was not covered in her book and if "you feel that a

separate kind of training is needed" for the screen. Adler responds with, "It depends if you can act. I think if you can act, you can act anywhere. You can act on the street, in church. It's a very fluent craft. It can use any platform."[10] When pressed on the subject, she begins to acknowledge the differences in the production of plays and films: "It's [film] is another medium. I think the screen demands other things. It's not as collaborative as the theater. The theater collaborates very much with the author, and therefore the author and the actor are together in interpretation."[11] Primarily, Adler sees the differences between the mediums for the actor as based in how the performer employs "imagination," as, ideally, the film actor can use locations or realistic sets for inspiration while a stage actor can feed off the energies of the audience: "When acting in film the imagination creates an atmosphere. For instance, the girl is in the ballroom so she works from the actual ballroom. She gets the emotion from the place that she is in. . . . The theater actor needs the noise, the ensemble, the soul of the audience. I think the motion picture actor has learned to cut it down."[12]

While certainly valid observations, surprisingly, Adler never mentions in the interview what might be considered the primary difference between stage and film acting as processes. While spatial differences and the energy of the audience are key considerations, creating a film performance is a more fragmented and disjointed process than the stage. Unlike on stage, in making a film, the temporality of the actor and the temporality of the character rarely matches (at least not in a complete sense). After rehearsals, a stage actor usually takes a journey in a single performance from the start to the end of the narrative. In contrast, a film actor, dealing with the out-of-sequence shooting of the script and multiple takes, has a performance defined by fragmentation. As such, in contrast to discussing stage stars, scholarship on movie acting in film studies often focuses on small moments (or fragments) as opposed to unified character interpretation. When John O. Thompson created his "communication test" for screen acting in 1978, he saw cinematic star performance "as a bundle of distinctive features" as opposed to the creation of psychologically whole fictional characters. When examining Cary Grant's or James Stewart's gestures, he saw "each feature functions as a potential distinguisher both within the film itself and in the indefinitely extending space established by viewers' familiarity with cinema in general."[13] This analysis occurs with a full understanding that these fragmented moments are not only

inherent to the filmmaking process but also are used to sell a star persona from film to film, as conventionalized expressions materialize to suggest a persona to the consuming public.

As sequences are shot out of order and broken into different camera set-ups and multiple takes, the process of film production feels like it would be disruptive to the unified temporalities associated with performance discussed in Stanislavskian-based approaches. Both Strasberg's more psychologically introspective and Adler's more circumstantially exterior variations on the Russian System attempt to realize a character's emotional journey in a larger context than what would be suggested by multiple disjointed camera setups. When contemplating the realities of film production, especially during the Classical Hollywood era, it is useful to take into consideration the acting instruction of the pre-Modern (or pre-Stanislavskian) era, where standardized gestures were promoted by Parisian elocutionist François Delsarte and his disciples. Delsarte, whose work had an enormous impact on early American stage and screen acting, focused largely on the semiotic function of gesture in a manner resembling pantomime. James Naremore outlines how early twentieth-century America was influenced by Delsarte, as "a good many actors could be described as Delsartean whether or not they ever studied him."[14] While midcentury acting instruction, much of which was rooted in Stanislavski's System and a striving for "realism," would denounce the melodramatic gesturing of this generation, Naremore reminds us of the strong impact these older techniques could produce, especially in expressionistic silent cinema. For example, Lon Chaney's masterful portrayal of the titular *The Phantom of the Opera* (1925) "owes to Delsarte's vision of the theater."[15]

Even though Stanislavski and later Modern teachers' impact on acting would promote a less expressionistic form of performance, the history of cinema shows the long-ranging influence of these earlier theories. As Naremore posits: "In general, the manuals on nineteenth-century pantomime continue to have an ethnologic interest, and even though they have been abandoned by acting students, many of the positions and gestures they describe can be seen throughout the history of cinema. Leafing through these books, one quickly recognizes that at some level actors have always employed basic, culturally transmitted gestures to 'write' characters."[16] The creation of a perceived cinematic "performance"—for example, what the viewer registers as Lon Chaney as the Phantom or Marlon Brando as Stanley

Kowalski—reflects much of the spirit of Delsarte through the realities of production. As Naremore writes, in most films, "actors need to produce vivid expressions in brief shots which are photographed out of sequence" and such moments of production might consist of simply registering "'fear' or 'pain' in close up."[17]

While these fragmented moments might define the production process and even many academic analyses, it would be difficult to contend they define our actual reception of a film performance. Especially on our initial reception, cinema creates a codified system for the viewer that represents the illusion of unity. In terms of understanding film performance as part of a system of textual codes, some approaches take on many of the inclinations found in other semiotic considerations of the filmic image. Just like other elements discussed with shot composition, performed gestures and expressions do convey intratextual as well as narrative codes that register as part of a larger system of communication. As Cynthia Baron and Sharon Marie Carnicke write in *Reframing Screen Performance*:

> The dense array of connotatively rich gestures, postures, intonations, and inflections seen and heard in film are the material, intratextual elements that belong to filmic representation in the same way that lighting design and editing patterns do. Importantly, performance details contribute to the flow of narrative information; interpretations about characters' desires, their confrontations, and their choices depend in part on the sense that audience members make of actors' gestures and expressions. The selection and integration of performance elements in a film provide some of the most crucial information about what is happening, why, and what is at stake.[18]

As this suggests, the gestures and expressions that create our perception of most film performances—while admittedly fragmented in production and, to an extent, reception—do tend to relate to a unified sense of textual motivation that defines our sense of a film as narrative.[19]

As Cynthia Baron contends, many of the connotations we perceive from filmic gestures and expressions come from our perception of a *temporal continuity*. We can perceive a unity of personality through an actor's performance as we compare the gestures with "(a) gestures and expressions in a

portrayal that are presented to us earlier or later in the film, (b) gestures and expressions linked to other characters in the film, and often (c) culturally and historically specific recognizable social gestures and expressions."[20] Hence, the "elusive, continually changing, but still identifiable temporal aspects of physical and vocal expressions in films are an integral component of screen performance," and these "contribute greatly to audience interpretations of characters and film narratives."[21]

To take this a step further, as Baron suggests, the audience's ability to create associations and establish a perceivable temporal continuity for gestures and expressions defines the reason why we perceive a "performance" on screen even when an actor's physical body is not present. An audience sees animated characters, such as Bugs Bunny or Buzz Lightyear, as giving a "performance." Baron writes that "our interpretations of live action and animated films emerge from our attention to identifiable *actions* infused with connotations that are created by ephemeral, temporal qualities of the physical and vocal expressions."[22] This essentially means one can do a detailed analysis of the "choices" of both a human actor and an animated "actor" in a similar manner, which Baron herself does with Robert Mitchum in *Out of the Past* (1947) and the titular character in Pixar's *WALL-E* (2008). Despite "animated films' technological base, audience responses are grounded in the temporal aspects of the visual and vocal expressions that convey meaning by approximating recognizable actions. Thus, even illustrated external actions are evidence of characters' inner impulses."[23]

Audiences register the signs of cinematic performance through a willingness (conscious or unconscious) to disregard the temporal realities of production—be it the fragmentations defining film production or the hand-drawn, stop-motion, or CGI-created approximations of human behaviors found in animation. These factors for analyzing live-action performance and animated "performance" as process and reception are fascinatingly muddled with motion capture, where the line between live action and animation blurs. While later examined in discussions of acting, the actual technological process was originated as a tool for animators more than as a tool for actors or even live-action directors. As Tom Sito recounts, in their development of computer graphic (CG) animation, animators invented and perfected motion capture in a "quest to mimic natural human movement in CG creations." It was developed with an eye toward producing more realistic CG animation

as opposed to a new venue for expressive acting as, in the simplest terms, the "human actor is covered with sensors that record his or her movements in the computer, so that movement can become the basis for the movement of the CG figure."[24]

By the 1980s, artists trying to create realistic movement in animation employed new tools, most prominently the "Waldo suit" originally employed at Walt Disney World in the 1960s to record human movement to calibrate animatronics. The first use of what the industry now considers motion capture (with real time captured movement directing a CG figure as opposed to simply using movements as reference points for animation) began on various fronts in the mid- to late 1980s, with Carl Rosendahl and others perfecting the technique at Pacific Data Images (PDI) and Jim Henson hiring the team to create a free-floating mocap character, named Waldo C. Graphic (after the Waldo suit) performed by puppeteer Steve Whitmire, for the TV show *The Jim Henson Hour* (1989). During the 1990s, the film industry saw an influx of CGI technology being employed in popular film, with digital environments created in movies ranging from *The Lawnmower Man* (1992) to *Titanic* (1997). By the early 2000s, mocap started to be employed in a manner that moved the focus beyond its origins in animation and puppetry and into the realm of actor performance. When Andy Serkis portrayed Gollum in *The Lord of the Rings: The Two Towers* (2002), discussion of the technology began to shift as acclaimed live-action directors like Peter Jackson, Robert Zemeckis, and James Cameron spoke of mocap as another way to capture performance as opposed to being just a tool for animation.[25] As Cameron said about the process while making his blockbuster *Avatar* (2009), "I'm not interested in being an animator. . . . That's what Pixar does. What I do is talk to actors. . . . There may be a whole team of animators to make sure what we've done is preserved, but that's their problem. Their job is to use the actor's performance as an absolute template, without variance, for what comes out the other end."[26]

Such sentiments by filmmakers are problematic since the actual process of mocap does not too closely resemble cinematically preserving a live-action actor's performance "without variance." In mocap, the actor's movements are captured by a series of sensors and graphed onto a separate digital body. In the most acclaimed variations of the process—such as Serkis's Gollum, Kong in *King Kong* (2005), or Caesar the ape in *Rise of the Planet of the Apes* (2011) and its sequels *Dawn of the Planet of the Apes* (2014) and

War for the Planet of the Apes (2017)—animators still have a crucial role in crafting the figures on screen as they clean up, alter, or even throw out and reanimate many movements that were captured. And even with the rise of a "mocap star" like Serkis, as Lisa Purse writes, "these digital bodies are still emphatically promoted as *special* effects, and 'making of' featurettes and trade and popular press testimony from visual effects supervisors, actors and directors provide accounts of the construction of the digital body that work hard to appeal to moviegoer's curiosity and cinephilia."[27] It is therefore difficult to fully classify mocap as either special effects animation or live action (at least in the terms embraced by previous generations). As Sito suggests, from the animator's perspective, the process "raises the question of whether the final end of animation is to re-create reality in the first place."[28] In terms of the audience's reception of performance, such an observation suggests the debate itself might not be all that essential since, as Baron contends, an animated subject with realistic movements does suggest a temporal continuity that registers as "performance." In this sense, the action itself is what determines affect for the audience and whether it is performed or animated becomes largely inconsequential.

Suggesting action as unifying our perception of performance does not necessarily get us any closer to defining the role of the actor in the process and on-screen product of mocap. Notably, much of the popular press on the technology during its initial incorporation into more popular cinema mischaracterized the process. As I examined in an earlier study of Serkis, news stories on his performance as Gollum suggested the actor as "driving a 'pixilated skin' as if a type of digital prosthetic has been added to the body in post-production."[29] Yet when considering the actual process involved with motion capture, the analogy to screen makeup is highly problematic as audiences perceive prosthetics as still masking a physical body, while mocap "takes one essential externalized aspect of performance (realistic movement) separates it from the body, and uses it to guide the special effect." The audience never senses the reality of the corporeal body of the actor. In this regard, the "entire philosophy behind the technology is not about a digitisation of the human, but the humanisation of the digital through the addition of supposedly real movement. It is a process developed to make the special effect perform realistically as opposed to, as suggested by many, digitally enhance the actor."[30]

Despite this essential truth defining the process, mocap has been described as having a nearly transcendent quality for the performer—especially when considering how advanced the technology has become as Serkis now performs without wires attached to his body, free-form, with the camera capturing his movements as he interacts with other actors on a sound stage. As the camera captures movements and instantly applies them to a digital model (though not the sophisticated finished version seen on screen), the process can imply a literal form of what is often simply suggested when an actor develops a characterization—a transformation or translation from one identity to another. As Tanine Allison writes, "Motion capture can be understood as a form of translation, the word stemming from the Latin translates, to carry over. In addition to conversion from one language to another, translation was originally used to signify the conveyance of people or objects from one place to another, as well as the change in substance from one thing to another."[31] Mocap can be viewed as a tool embraced by the performer to aid in creating a characterization radically different from oneself. Although such a classification should not be carried too far since the actual process does remove the physical autonomy of the actor as it records what some animators call a "movement cloud," which could be graphed onto, conceivably, any digital figure the animator wishes. As Allison suggests about her classification of the process as "translation," mocap "should not be considered a transcription, connoting an exact copy, a rewriting. Motion capture in practice is a messy process, rife with illegible data, inconsistencies, and errors."[32] With its added layers of technological apparatus, motion capture as a process places the actor into a questionable position when we register the performance on screen.

But these observations concerning the process are not meant to dismiss mocap's relevance as a venue for performance. After all, as the previous chapters have illustrated, action remains a central component of film acting. Mocap simply poses the question, if movement itself, removed from the physicality of the body, can still suggest an actor's *presence*. As I have previously suggested in my analysis of Serkis's Kong, mocap brings us into a new era of cinematic performance as process and on-screen image:

> As a performer forced to emote in fragments, the film actor has always had less power in determining onscreen performance than what is promoted in the popular Stanislavski-influenced discourse on acting. With

mo-cap, we see this discrepancy widen as the actor is literally stripped of his physical body to exist as pure kinesis—a marker cloud to be employed as a tool by the filmmaker. . . . On one level, the technological process only continues to perpetuate the illusion of performance in film. But, more provocatively, mo-cap also illustrates how far this illusion can progress while still allowing the actor to have a presence onscreen, even if it is only spectral and kinetic in nature.[33]

Mocap is yet another tool to accentuate the temporal (as well as spatial) continuity of gestures and expressions that define Cynthia Baron's observations on performance in both live action and animated films. As the process entails the performer to create a "movement cloud," the illusion of temporal and spatial unity can help to erase the realities of a disjointed and complicated production process. Even without the presence of a physical body, this illusion is enforced by an actor's system of gestures and expressions—as well as (still significant to live action, animation, and mocap) vocal choices.

In some of the most exciting research concerning mocap, Sharon Marie Carnicke has employed University of Southern California student actors in her work with the National Science Foundation (NSF) to assemble a database of emotionally expressive behaviors through motion capture. Paired with Shrikanth Narayanan, a professor of electrical engineering, computer science, linguistics, and psychology, Carnicke employed a technique developed by Stanislavski during the final years of his life, while he was confined to his home (1934–38).[34] True to his late-career turn away from personal experience to craft performance, Stanislavski developed Active Analysis on "a theatrical model that links dramatic literature to embodied performance." As Carnicke summarizes the approach: "Stanislavsky saw a play as a *score of actions* with its words encoding performance in much the same way as musical notes encode sound. Moreover, dramatic *structure* can be determined by following *the chain of events* that occur as the play unfolds. Each event results when an *impelling action* meets a *counteraction.*" In this regard, "Stanislavsky conceives of performance as a dynamic interplay of impelling actions and counteractions that must be decoded by close reading of the play."[35] In her overview of Active Analysis, which is still employed in Russian acting schools, Carnicke writes that actors, before improvising in a studio space, map the interaction they wish to explore by asking three essential

questions: (1) "What is the main 'event' that should occur? . . . For a scripted play, the event must jibe with the text." (2) "What is the dynamic function of each actor in the interaction? Some play 'impelling actions' which move purposely toward the event; others play 'counteractions' which resist, delay, or seek to prevent the targeted event." (3) Actors now identify strong, active, and playable verbs that will embody the actions and counteractions they have identified and that might naturally produce the target event."[36]

As Carnicke suggests, "Active Analysis is not to be confused with the American Method which was launched by Lee Strasberg in the 1930s" and "famously depends upon the use of the actor's personal emotion to create psychologically realistic characters."[37] Historically, American artists "did not know, nor could they know of Active Analysis; Soviet politics had too skill-fully buried it. Moreover, Soviet propaganda was so persuasively successful, that Stanislavsky's actual work is still largely misunderstood in the West."[38] While this is certainly true, the timeline of Stanislavski's development of Active Analysis, which comes soon after Stella Adler's five-week training with him, does open up some provocative questions. Adler sees Stanislavski in the summer of 1934 in Paris, before he returns to Moscow, where he would spend the remainder of his life, as Carnicke writes, "in what was, for all intents and purposes, an internal exile, imposed by the state."[39] The question remains how much, if any, of his early conceptions of Active Analysis might have been conveyed to Adler? At least in spirit, if not complete appropriation, are there elements of its action-based methodology carried over to America?

As discussed throughout this book—as well as by Carnicke's own history of Stanislavski's influence in America[40]—Adler's experiences with the Russian teacher is clearly reflective of his late-career "Method of Physical Action." This general transition to a less introspective process can also be considered a gateway to his final experiments in Active Analysis—which, as Carnicke summarizes, were "based upon a theoretical model that links dramatic litera-ture to embodied performance."[41] Due to Stanislavski's state-imposed separa-tion from the international community during the last years of his life, Adler would not have known the extent of his final experiments. Nonetheless, as seen in previous chapters, her embracement of the general philosophy of late-career Stanislavski very much deals with an overall training of actors that privileges embodied action. The basic course sequence of her studio shows this general philosophy at play. The first year deals with courses in *technique*

(the development of action). The second year has students employ those techniques to consider a broader sense of *characterization*. The culmination would be *script analysis*, which asks students to fully understand the play text in a manner that develops one's embodied performance, created through the action-based techniques established in previous courses.[42]

More directly, variations of the three basic questions of Active Analysis do appear in Adler's instruction, especially in technique classes. As discussed earlier, doable actions are a primary concern of Adler in the studio, and she did discuss them as a series of improvisational exercises. In such classes, actions existed as a concept outside of the play text, a technique to be honed as a skill adaptable to different circumstances. As conveyed in lecture notes for a March 20, 1972, class, "To understand an action, take the action from the play and put it in one thousand other circumstances and be able to do it in all of those circumstances. Then you can go back to the play and do the action. This is so that you will know the anatomy of the <u>action</u> and not be so rigid in the <u>play</u>."[43] With such a directive in mind, Adler's archived exercises for technique classes often take on the process of analyzing the anatomy of different performed actions, though admittedly without the structure of Stanislavski's Active Analysis. "Impelling action" and "counteractions" are never explicitly discussed in those terms, yet archived exercises show a consistent focus on variations on actions, with students discussing them through strong active and playable verbs.

For example, on an archived note card from October 5, 1950, she provides a list of actions that students would have to develop on their own and bring to the next class as homework:

1; an action that grows and an action that doesn't grow.
2; Three irrelevant actions, tied together into one action.
3; Opposite character elements; ex; quiet person, impatient person.
4; action with two character elements.
5; action with three steps. Each step completely controlled. Another action of the same one which is not controlled.
 Illus[tration]; my setting table for my family is simple but to set the table for a priest presents a problem.
6; Short cuts to actions.
7; Action of solitude. (Being alone with the circumstances).[44]

As this list shows, developing variations on actions was a significant component of Adler's studio. The "illus[tration]" provided on the note card—which refers to the example she would employ in class—displays how variance would be circumstantial, based on the narrative of the script in acting but, here, based in improvisations as this was early studio work. As such, setting the table for one's family is an everyday occurrence, hence it "is simple" with a basic goal. Setting the table "for a priest" would be a "problem" since the nervousness of the character could complicate the completion of the action. These actions would be discussed in active and playable verbs. While Active Analysis is not directly employed by Adler, some of the spirit of the approach does manifest, since she remained, throughout her career, a teacher focused on the circumstantial and physical more than the introspective and internal.[45]

Be it in the detailed Active Analysis of Stanislavski or in the less structured classroom approach of Adler, fully understanding the action itself as central to expressive performance helps to locate the presence of the actor in what we see of motion capture on screen. In her research with the NSF, Carnicke found Stanislavski's Active Analysis useful for directing her group of motion captured student actors, writing, that by "focusing on the interpersonal dynamics and lines of *impelling actions and counteractions* within each scene or scenario, the actors readily produced emotionally expressive movements that could be successfully captured and digitized."[46] Understanding performance beyond the physicality of the body, Carnicke employs Active Analysis to analyze the movements themselves as defining a definite presence of performance within the digitally disembodied data: "If my direct experience with motion capture has taught me anything, it is that the work that actors do in a motion capture studio remains starkly present within the skeletal figures that dance on the computer screen." Regardless of the fact there are undeniable compromises between the performed actions and final image on screen, mocap performance "can be subjected to the same kind of analysis and assessment as any other screen performance."[47] Carnicke's conclusions become particularly important when considering Adler's influence within the digital age, since the famous teacher promoted her own variations of an action-based technique. To see how Adler's teaching influences a new era of technology and performance, we can examine the work of one of her most well-known late-career students.

Size and Masculine Rage: Mark Ruffalo
as Bruce Banner and the Hulk

When Mark Ruffalo was eight years old, his grandmother let him watch the television premiere of *A Streetcar Named Desire* (1951), which he states had a major impact on him: "It made me want to be an actor. . . . Brando's magnetism and that fearlessness and the vulnerability. His raw presence was slightly effeminate, balanced. It was more real, more honest. And I guess it became about looking for the things that seem honest to me, that really reflect life, that are the things that turn me on about movies."[48] Fittingly, with this formative experience, Ruffalo went on to become among the last of a generation to directly receive instruction from Brando's teacher. He came to Stella Adler's West Coast studio at eighteen years old and did her program twice over seven years, with many of the classes then taught by Adler's teaching staff of former students. Actresses Joanne Linville and Irene Gilbert brought the program to Los Angeles, and the course offerings had expanded greatly since the early days of the studio in New York City.[49] Due to advanced age, Adler's role diminished in the classroom, with her retiring from active teaching in 1990. Yet the structure of the course sequence still reflected her established directives. For example, the 1990–91 program outlines "The First Year" as "Principles of Technique . . . Fundamental Skills" and "The Second Year" as "Application of Technique . . . Rehearsal . . . Performance," in a manner like her earliest archived programs. Ruffalo's time at the studio also consisted of direct instruction from the teacher, which had an undeniable impact on him. During his episode of *Inside the Actors Studio* in 2007, he introduces Linville in the audience and proceeds to tell stories of Adler, launching into an impersonation of her theatrical manner of speaking. In his foreword to Sheana Ochoa's biography of Adler, Ruffalo also recounts his financial need to work-study at the program as a young man, where he assisted "Stella" from her car to her dressing room, meaning he had direct one-on-one contact with the teacher.[50]

With such a dedication to the craft fostered by his formative experiences with Adler, it is not surprising that Ruffalo found much of his initial acclaim outside of blockbuster cinema and in the world of theater and lower-budget dramatic film, coming to the attention of audiences through his work with writer-director Kenneth Lonergan.[51] In 1996, he starred as the dejected son

of an abusive lingerie tycoon in the Off-Broadway production of Lonergan's *This Is Our Youth*. When the playwright wrote and directed the film *You Can Count on Me* (2000), he cast the largely unknown Ruffalo as the colead, playing Laura Linney's drifter brother, Terry. As *Backstage* wrote in a 2001 profile, "the actor imbues his wonderfully messy character with just the right combination of sensitivity and roughness, sharp intelligence and boyish innocence. Like his work in *This Is Our Youth*, some reviewers [of *You Can Count on Me*] have compared Ruffalo to a young Marlon Brando for his 'rumpled, rebellious charm,' as one journalist aptly described him."[52] For most of the first decade of the 2000s, the actor remained noticed by audiences and critics mainly due to his appearances in acclaimed independent films, like *Eternal Sunshine of the Spotless Mind* (2004) and *The Kids Are Alright* (2010), the latter of which he received an Oscar nomination for Best Supporting Actor. In these films, he displayed a sensitive variation of white masculinity in indie roles that could be classified as clear realistic characterizations.

Ruffalo's respect for Adler and her instruction appears very much based in her understanding of the importance of the ideas behind a role. In his foreword to Ochoa's biography, he writes, "Although ultimately what she was after was an honest, naturalistic style of acting, her love of the big ideas of the playwrights and her keen sense of social justice drove that naturalism toward nobility." In this sense, Ruffalo acknowledges that naturalism could be a complicated concept for his former teacher: "She was always worried that the naturalistic style would lead an actor to believe that he or she could drag the material down to the humdrum personalities of 'stars' while missing the greater and deeper ideas of the plays."[53] This is something the actor also expressed when discussing his former teacher on *Inside the Actors Studio*, where he talks to a young student who asks what constitutes his most important lesson from Adler:

> What she was talking about was the playwrights were trying to convey ideas that were big ideas about humanity and that you had a responsibility as an artist to take these things and to use yourself to lift these ideas. In a dramatic way, she would scream at you, "Never be boring, darlings!" That was her main thing. It was like a death sentence to be boring. And so what you see what great exciting acting is lifting the ideas of the play, they are being taken by the ideas of the play and set afire. And the self goes away. The ego goes away. And now you're in service.

Here, Ruffalo references a central directive often repeated in Adler's studio, the charge that students give a role *size*. This call had profound implications for Adler, one that moves the actor from simple introspection toward embracing the ideas of the text.

On one level, as heard in many of her class exercises, the call for more size could simply be employed as a call for students to emerge from their shells, to lose their obsessions with introspection and not fear appearing theatrical. In a recording of an October 4, 1973, Technique class, she tells her students, "Give it [the performance] its size. Don't make it pedestrian. Now how many people feel they are pedestrian? Common? So you are. Raise your hand. Every one of you. You have to learn the sense of, 'I am not only what I know, but I am what I don't know I know. And what I don't know I know is the content inside of me that I haven't used. And there is no way of using it in life.'"[54] While such a call might sound frustratingly vague to a young student, Adler relates this seemingly abstract concept to concrete processes. Size means fully grasping the larger implications of the text—the ideas behind the role, not just the emotions. As she states in an October 1, 1972, class, while welcoming new students into the program, "You're going to learn the difference between the truth of life and the truth of the theatre. And you mustn't mix them up. You're going to learn how to express yourself in size, what we call the epic ideas. The reason for that is man is eternal. And he will eternally be struggling with ideas. Always. He always has and always will. So you are part of the eternal struggle with ideas."[55] The expression of an idea finds itself in the expression of action for the actor, and this ultimately gives performance size. As recorded in *The Art of Acting*, "Immense size comes from understanding your relationship to everything you come into contact with—ideas, people, objects, experiences." This belief is the core of her process, since performance aids the ideas of the text: "As an actor, your presentation of the idea must be as large as the idea itself. Don't be afraid to use your voice and your body. Give me your energy, give me an idea you'd fight for. Enrich the audience. Don't leave them empty-handed or with small ideas."[56]

With such an appreciation of Adler's promotion of big ideas in drama, Ruffalo's successful turn as Banner/Hulk might seem surprising. His casting in the tentpole superhero film *The Avengers* marked a change in direction for the actor, who was then in his forties. While the character might be classifiable as a slanted characterization due to its easily definable dualistic nature,

Mark Ruffalo as Bruce Banner in *The Avengers* (2012).

there are aspects of the role, especially on the Banner side, that could benefit from an actor skilled in playing realistic types. Marvel Studios had already cast unconventional leading men in their films, such as Robert Downey Jr. in *Iron Man* and Edward Norton in *The Incredible Hulk*.[57] The studio viewed Banner/Hulk as a complex individual(s). The concept of an "indie actor" as opposed to traditional leading man or action star had fueled their original casting of Norton, an actor more known for low-budget drama. When Norton dropped out, Ruffalo was their first choice as a replacement, though the actor was hesitant to accept due to the lack of a finished screenplay and the sheer scope of the blockbuster production, stating in an interview, "I was scared, a little bit." Ultimately, Ruffalo warmed to the idea of taking the role due to Downey Jr.'s approach to Tony Stark in the *Iron Man* films, which "opened the way for this kind of indie character-actor approach, totally off the radar of what you would consider to be your classic movie star."[58]

Portraying Banner/Hulk can be approached in a similar fashion as any characterization, especially since he has size in the sense that the dichotomous personality expresses universal ideas. On a psychological level, the character proves profoundly different from other superheroes who express different elements of their psyche through a split persona. Most famously, Bruce Wayne expresses a darker and angrier persona when he adopts the

costume of Batman—that is, a dark side or embracement of personal de-mons.[59] The Hulk as an alternate persona for Banner is based in something more primal in its emotional makeup—*rage*. Christopher and Sarah Patrick write, "The emotion of anger is central to the story of the [I]ncredible [H]ulk because intense emotional arousal (including anger) serves as the catalyst for the periodic transformations of scientist Bruce Banner into the [H]ulk."[60] The alternate persona here is not a rational nor a prosocial being. Thus, in "contrast with Bruce Banner, who is sophisticated, even-tempered, and responsible, the Green Hulk has the temperament and intellect of a child."[61] The Incredible Hulk's continuing narrative within the comics serves as an exploration of rage as unwanted emotional release within the white male subject. While this informs the dichotomous psychology of the char-acter, the idea also has profound societal implications. Although not dealt with in *The Avengers*, the comics deal heavily with the trauma in Banner's past, from an alcoholic father and the death of his parents, as a source of his rage. Banner's resulting personal demons are socially destructive, a concept with metaphorical implications.[62]

Robin J. Dugall writes that the Hulk "is a superhero whose myth prompts us to the attention of deeper questions related to our own psyche: questions about identity, anger, self-deception, and grace."[63] The character proves inter-esting in how it explores the individual's psychology as it relates to society:

> The Bruce Banner/Hulk transformation is a paradigm for the spiritual and psychological struggle that every person faces. The dilemma of Bruce Banner summarizes the struggle of humanity—just like the Hulk, every-one possesses in the inner child a primal rage, pent-up fury, egotism, and potential for destructive mayhem. . . . The same issues that haunt Dr. Banner as he wrestles with the green monster that lives inside of him are the issues we face—isolation, loneliness, breakdown of community, inner turmoil, and the inability to control our rage. Consequently, the soul desperately erupts. From the depth of every person emerges his or her own ability to "hulk out."[64]

The universal truth behind the character's fantastical transformations also speaks to his personal responsibility, his place in a functioning society. Un-like other comic book characters, narratives containing the Hulk confront a

significant question concerning social responsibility. What is the white male's responsibility for repressing or expressing the inner self when that inner self might be destructive?

The character exemplifies larger ideas and questions inherent in white masculinity, the potential for destructive rage even within the seemingly harmless male. In recognizing rage as expressible—or based in doable actions—Ruffalo remembers his studio work with Adler and the difficulty fellow students had expressing that particular emotion. In contrast, the actor could manage anger through personal identification: "I remember it was so hard for people to be angry onstage. But the frustration I was having with acting made me angry all the time."[65] His teacher also related the emotion beyond the personal and into a larger understanding of audience engagement, as the expression of anger automatically warrants a reaction from onlookers due to its raw power. Ruffalo states, "Stella Adler used to say, 'Start a scene with people screaming, yelling, angry, and you'll have the audience's attention immediately.'" The idea of rage as a societal concern with archetypical significance is not lost on Ruffalo, who directly relates his former teacher's insights into his approach. When asked about how Adler would respond to her student playing a role in the pulpy Marvel Cinematic Universe, Ruffalo responds, "Stella would have just said, 'Darling, no man is bigger than the time he lives in.' And she would have said, you know, 'Just don't be small, darling.'" The actor then jokes, "Literally and figuratively."[66] In this context, the "time he lives in" is the fantastical world of Marvel. The charge of "don't be small" means living up to the ideas of the text inherent in the character—the psychological, social, and metaphorical significance of masculine rage.

Bodily and Digital Performance: Mark Ruffalo in *Avengers: Age of Ultron* (2015)

While *The Avengers* impressed audiences and critics with its depiction of the Hulk, the sequel *Avengers: Age of Ultron* advances the characterization further by giving Banner/Hulk more of a dramatic arc, one that speaks to many of the universal themes inherent in the character. Having been assembled in the first film to form the titular team of superheroes, the Avengers return in the form of Tony Stark/Iron Man, Steve Rogers/Captain America (Chris

Evans), Thor (Chris Hemsworth), Clint Barton/Hawkeye (Jeremy Renner), Natasha Romanoff/Black Widow (Scarlett Johansson), and Banner/Hulk. Even though Banner expresses his concern over the idea, Stark creates Ultron (James Spader, via mocap CGI), a super intelligent defense system and robot who eventually turns evil and attempts to destroy the world. For Banner, subplots create a greater depth for the character than in the previous franchise entry. Firstly, he and Natasha emerge as a possible romantic couple, offering a change in the solitary lives of both characters as established in the previous film. Secondly, at a crucial point in the narrative, Wanda Maximoff/ Scarlett Witch (Elizabeth Olsen) hypnotizes Banner, turning him into the Hulk, where he rampages through Johannesburg, South Africa, until Stark defeats him in advanced new armor. This destruction causes a public backlash against the Avengers, forcing them into hiding. Natasha and Bruce decide they will leave the team and go into hiding together after they defeat Ultron. Eventually, she is kidnapped, and after much action, Banner as the Hulk is shown rescuing Black Widow and, ultimately, flying off on his own, leaving the Avengers behind. In the end, the character decides to live a lonely life, rejecting the love of Natasha, due to an inability to control the Hulk. Natasha is left training new members of the Avengers at their facility.

From a dramatic standpoint, the storyline for Banner in the sequel contains higher stakes, as his potential for unfurled rage as the Hulk has definite consequences seen on both a personal level, his growing love for Natasha, and social level, his rampage through Johannesburg. With this, Ruffalo finds thematic through lines for the dichotomy of Banner and the Hulk through his performing body. His acting choices promote a perceived temporal and spatial unity through gesture and expression. The size Ruffalo brings to the role, through his understanding of its themes, informs his doable actions, allowing for a sense of his presence on screen in both the photo-real and digital images. The actions defining his performance as flesh-and-blood Banner and CGI Hulk appear as potent examples of external expression. If Ruffalo's training from Adler taught him to express the ideas inherent in the text through physical action, his acting embraces this philosophy in both its physical and digital incarnations.

Throughout *The Avengers* and this sequel, Ruffalo's performance choices as Banner accentuate a different demeanor from his fellow superheroes. The films often pair Downey Jr. and Ruffalo in scenes together since, as scientists,

the narrative exposition necessary to advance the fantastical plot is conveyed through their dialogue. On the Blu-ray commentary track for *Ultron*, Joss Whedon affectionately calls the characters "the science brothers," a pairing that allows for interesting interactions since "they [Ruffalo and Downey Jr.] are very different in their energy as actors." Early in the film, when Stark conveys his plan to place an advanced artificial intelligence into a defense system called Ultron, he takes Banner into his confidence. As they walk about the state-of-the-art laboratory, Stark tries to convey the benefits of an artificial intelligence–based defense system as an option superior to the Avengers: "What if you were sipping margaritas on a sun-drenched beach turning brown instead of green?" Throughout the scene, the differences in body language in Banner in contrast to Downey Jr.'s cocksure Stark are performed through subtle gestures. As he enters, Ruffalo holds a small coffee- or teacup, which he sets on a table. Downey Jr. places his hand on his costar's shoulder, as if attempting to manipulate him. As Downey Jr. moves around the space with confidence, launching into complicated sci-fi tech dialogue, Ruffalo keeps his movements contained, awkwardly stepping out of one of the holographic images as it appears and then keeping his hands folded before him, nervously rubbing his wrists as Stark moves in closer to his face. When Downey Jr. walks around him and attempts to sell him on the idea of Ultron, Ruffalo removes his glasses and listens intensely, still performing doable actions conveying uncertainty—such as moving his hands to his mouth, crossing his arms over his body, and sinking his head to avoid eye contact.

During a party scene, where Natasha flirts with Bruce, she suggests her attraction to him is based in his difference from the alpha males of the group. As she makes a drink at the bar, he awkwardly jokes, "How did a nice girl like you end up working in a dump like this?" She flirts back, "A fella done me wrong." Banner removes his glasses and playfully says, "You got lousy taste in men, kid." Natasha informs him, "He's not so bad. He has a temper. Deep down he's all fluff. The fact is he's not like anybody I've ever known. All my friends are fighters. And here comes this guy, spends his life avoiding the fight because he knows he'll win." While the scene contains Banner responding to and even flattered by her flirting, Ruffalo displays body language notably different from the more confident (super) males seen elsewhere in the party scene. He avoids direct eye contact through much of the exchange, looking down at the bar and into his drink and, then, only

briefly glancing in her direction off screen, shifting his eyes as he looks toward Johansson, who keeps her eyes more focused on her costar. Clearly letting her attraction be known, Natasha leaves the frame and Ruffalo adopts a look of slight panic over his face, as if to wonder how such a relationship might work with his split personality. Steve Rogers enters and voices his approval of the pairing, which Banner is quick to reject, "Nah, Natasha, she likes to flirt." While the muscular Chris Evans as Rogers confidently leans on the bar and grabs a bottle of beer, Ruffalo fidgets—letting his hands wave in dismissal, then turning to pick up his eyeglasses off the bar, and looking nervously at the ground as Evans moves in closer to tell him he should pursue the relationship.

While the scene is largely humorous and sweet, Ruffalo explores the constant struggle of Banner as he must decide to either accept or reject personal connections. This uncertainty is expressed through subtle gestures, accentuating the interplay between the actor and his costars. As Downey Jr., Johansson, and Evans's performances are defined by confident actions— direct eye contact, directing the movement around a room, the making of a drink, leaning on a bar, reaching to grab a beer bottle, and so on—Ruffalo keeps Banner in an awkward and nervous state. As Natasha suggests, his gestures might imply uncertainty due to his position as the quitter outsider of the group. But on a more profound level, his shifting nature suggests that he does not fully believe Natasha's assessment of his innate harmlessness as he understands the danger of his deep-seated rage. When the relationship continues to grow, the loneliness and emotional damage of the two characters bring them closer. After the Hulk's rampage through Johannesburg, Banner is shown to be despondent and depressed. While hiding on Clint Barton's farm with the rest of the team, Natasha surprises him as he leaves the shower and attempts to convince him to run away with her. As he expresses that he is a threat to the world and to her, Natasha tells him of her experience being sterilized during her training as an assassin, a personal admission that brings them even closer. Throughout the scene, Ruffalo now looks Johansson directly in the eyes, using more emotionally open expressions—such as widening his eyes and gesturing to the surrounding room in the farmhouse, when expressing that he cannot have a family. His direct eye contact displays exhaustion and sadness over recognizing his true nature, which will eventually necessitate his self-removal from society.

In total, Ruffalo's performance as Banner expresses an uncertainty over the character's sense of self and his place in society. While a dichotomy exists in the characterization of Banner/Hulk, the acting choices as Banner stress a consistent thinking of his other self as a potentially dangerous social being. Ruffalo's performed doable actions are about either awkward avoidance or, in his eventual emotional growth with Natasha, pained rejection of social integration. The threat of unfurled masculine rage exists consistently throughout most of his interactions. The mocap performance as the Hulk serves as a contrast to these inhibited movements. Ruffalo sees the performance as the Hulk as a personality separate from Banner, stating in an interview, "My whole thing is how—it is literally playing two characters in the same movie that are so completely different to each other. It's really exciting."[67] Ruffalo sees the two as having a complicated and dependent relationship, something explored less in the films' storylines (at least up until *Ultron*) and more apparent in the comics, "I've been finding this relationship between Banner and the Hulk and Hulk and Banner is equally compelling—it's been explored in the comics, but never in the movies. It's always been Banner's relationship to this sort of lump, this unknowable very two-dimensional thing."[68]

With *Ultron*, unlike its predecessor, technological advancements developed with Industrial Light and Magic helped to add more dimension to the Hulk. Ruffalo states, "in the past it was more animation-driven and the actor was kind of a placeholder. Now we're talking about performance and now what I can do as the Hulk is new territory."[69] Through these technological advancements, actor autonomy is more apparent since there is relatively quick animation playback for the actor to watch on monitors as he performs. Ruffalo acknowledges that his movements graphed onto another body relates his acting to another art form—puppetry. "It becomes a kind of puppetry. Eventually, you internalize it. I know how the Hulk moves now. I know what it's like to have all that weight on my body and how that body moves with his huge lungs that are filling."[70] In a making-of featurette, this process is shown as Ruffalo is seen in his mocap suit (complete with large Hulk hands) both on soundstages and on location, with a crude animated representation of the Hulk shown on monitors. Inherent to the process, this aspect of production does show a fragmentation and removal of actor autonomy as there is an element of a performance "by committee" at play, with the animators proving crucial to the final image of the creature seen on screen. As Ruffalo

Design for the CGI Hulk for *Avengers: Age of Ultron* (2015).

clarifies, this awkward process requires him to embrace his imagination as he performs, a central tenet to Adler's approach: "I'm seeing the Hulk moving in front of me [on monitors]. But it's unruly and imprecise and so you're sort of projecting your imagination into the final project but you have no idea what it's going to be. . . . So, you're really projecting your imagination onto something that you won't know what the final outcome is until much later. Plus, I'm working with a great team of incredible animators as well. And we're doing a collaboration together and so their input is also unknowable."[71]

The technological advancements allow for more autonomy in the actor and a greater sense of temporal unity. This advancement especially appears in the most significant improvement from a performance standpoint, the capturing of facial expressions. As Ruffalo explains on the featurette, "The first time we did this the technology was at a place such as you could capture movement and then you had to do all the facial recognition separately. In that time, this technology has taken another major leap forward." Now, the

ability to capture facial expressions is coupled with performing larger movements at the same time. As the footage shows, dots are places on Ruffalo's face as he performs most of the sequences, helping to limit the fragmentation found initially in the process—that is, the separation of time between capturing larger movements and facial expressions. His captured performance now serves as a reference and direction for digital movements both large and small within a more unified temporality. The featurette shows him performing rage-filled action sequences with large expressive bodily movements and smaller intimate scenes with Johansson as Black Widow, which, like with Banner, defines the most significant personal relationship in the film for the giant green creature.

These advancements help create and maintain a relative subtlety in performance—especially in nonaction scenes, which, for the Hulk, became a new performance challenge in *Ultron*. The first *Avengers* had the character raging mostly in audacious action sequences, very much employing Ruffalo as a placeholder or, at best, an inspiration as animators moved the digital body as it leaped through the air and onto the sides of buildings. The sequel continues this tradition, especially in the battle between the Hulk and Iron Man through the streets of Johannesburg. Yet there is also more self-awareness in the creature, which allows for actions displaying an underlying cognizing of and grappling with its nature. As Ruffalo states, "Hulk is doing some acting. He's not just raging. He's transitioning in and out of Banner, and that has its own inner life to it. We haven't even started to get into who he the Hulk really is, what makes him tick. What is he fighting? What is he struggling against? What is he afraid of? We're only scratching the surface of it."[72]

The film opens in a mid-action sequence with all the Avengers assembled and battling armies in a snowy forest in Eastern Europe in a raid on a compound. The Hulk is introduced in the film before Banner in the middle of a full rage-filled rampage—throwing jeeps and soldiers, leaping in the air, and crashing through a concrete machine-gun nest. These are shots that, most likely, are the domain of the animator using Ruffalo as a reference more than based closely on the actor's choices. As the sequence ends, Black Widow searches out the Hulk in the woods only to find him still rampaging by himself. Alone with no threat, the violent actions of the creature are now those of an angry child as he throws scrap metal out of frame and to the ground. When Johansson enters and cautiously states, "Hey, big guy," the Hulk turns

quickly and snarls only to adopt a confused expression. Johansson states, "The sun's getting really low," to which the Hulk snarls again and defensively flexes his muscles as he crouches slightly back. Black Widow kneels to the ground, to show she is not a danger, and lifts her hand. The Hulk moves toward her with slight uncertainty yet a recognition and extends his hand outward, which she soothingly caresses. Throughout the sequence, Ruffalo's motion captured movements accentuate one of the defining physical markers of rage—heavy breathing. On first seeing his costar, he continues deep breathing as a physical sign of his anger only to have it dissipate during his interaction with Johansson. The expressions on the digital face of the Hulk are a combination of confusion and, perhaps, guilt over his previous snarling at Natasha. The creature then stumbles off away from Black Widow and painfully transforms back into Banner.

During the Hulk's rampage through Johannesburg, where he battles with Iron Man in his massive "Hulk Buster" armor, the mind control caused by the Scarlett Witch results in behavior for the creature that is near manic. As Whedon explains on the commentary track, the choices to create these actions were very much determined by a team of animators as much as if not more than Ruffalo himself—though the actor did have a voice in the process, most likely creating reference points. In discussing the sequence, the director states, "We looked at some point-of-view shots [for the Hulk] but nothing we created really did as much as just showing how bonkers the Hulk was being, because ultimately it didn't matter. What I said to the animators and to Mark was he feels like the world is attacking him. It's like he's in the middle of a wasp nest all the time." The animated and acted movements in the scene are about quick stimulus response: "One of the most difficult things about animating the Hulk is trying to figure out what he is pissed about and how. When he is there for a long time, he has to keep this very specific energy."

The director then references various actions in the scene that produce quick reactions of anger from the creature—such as being shot or the appearance of Iron Man. Of course, it is near impossible as a viewer to determine in such moments what, if anything, is mocap as opposed to animation. The sequence, though, ends on a note stressing subtle performance within the CGI monster, one seemingly based in an actor's choices. After a building collapses, the Hulk bursts through the rubble in anger, breaths heavily, and looks out at the disturbing scene of frightened and despondent civilians. The

creature's breathing slows and a look of pained grief comes across his face as some part of him registers guilt. As Whedon tells on the commentary, the filmmakers originally showed Banner, now in his human form, emerge from the rubble to experience this emotion. But they ultimately reshot the footage with a motion captured Ruffalo instead: "We originally shot it that he changed back to Banner . . . but thought late in the game it'd be more effective if the Hulk himself was able to register." The previously shot performance by Ruffalo in this moment as the human Banner informs his mocap performance as the expressions of the CG Hulk are also about what he "registers," sharing a guilt similar to Banner over his actions.

For Banner/Hulk's final moments in the film, a photo-realistic version of Ruffalo no longer appears. Instead, the Hulk comes to represent the physical form taking the emotional journey—one involving self-recognition and self-sacrifice. After much spectacular action as the assembled Avengers, along with new allies, take on an army of Ultrons, the film presents a scene recalling the earlier moment of Black Widow calming the Hulk in the forest. She again searches out the creature in hopes of completing his transformation back into Banner. As she places her hand up for him to touch, Ruffalo again has his breathing slow down as he starts to awkwardly move toward her, raising his eyebrows. This resolve is quickly interrupted as Ultron fires at them from a plane, resulting in the Hulk roaring in anger. After the creature rescues Black Widow and places her in a safe spot, he jumps to the plane and throws Ultron out the rear. The final image of the Hulk is aboard the plane as Natasha appears on the video monitor, pleading, "Hey big guy. We did it. The job's finished. Now I need you to turn this bird around, OK? We can't track you in stealth mode. So help me out, I need you . . ." During her message, the Hulk moves through the cabin at a slow pace, no longer defined by the heavy breathing usually distinguishing his rage-filled body. Instead, the movements are slow and humanlike, lumbering because his huge size makes him feel awkward in the confined space. As he sits and watches her image, he reaches to the console slowly as she speaks and then switches the picture off. During the scene, the realistic facial expressions on the creature are startling in how much they feel intricate and human, reminding us of the expressions found in the scenes featuring the photo-realistic Ruffalo. On the commentary track, Whedon discusses the moment as an example of the potential of motion capture as a performance venue: "This is another really beautiful performance.

I shot Mark on a mocap stage doing this. But, again, ILM has to bring their own integrity to what his face is doing. And what was great was, you know, we kept saying, 'less.' "

The final image of the Hulk is of the large creature hunching over as he flies the plane, a body language like much of Banner's awkward physicality seen in other parts of the film. The sequence shows the actor exploring the self-isolation and self-sacrifice of the Hulk as he rejects society in general and Natasha in particular. The consequences of male rage are now fully displayed in the creature as opposed to just Banner, opening up potential to grow the CG character for future installments in the Marvel Cinematic Universe.[73] In an interview for the film's release, Ruffalo discusses this potential to complicate the Hulk. True to his Adler training, he contemplates the character as defined by circumstances, especially the fact that the creature must deal with another version of self in the form of the weaker Banner: "But there's also something really interesting about Hulk's relationship with Banner. The only thing that scares Hulk is Banner. It's not some bigger, scarier, huger thing— it's this frail man. And it terrifies him and it angers him."[74] The physicality and psychology of Banner fuels the Hulk's anger and fear. It is in these moments, such as on the plane where the subtlety of expressive performance still appears, that the presence of the actor materializes as he explores the ideas of the text. Here, the most advanced digital techniques in capturing movement find a fitting performer in Ruffalo, an actor who studied with a teacher who stressed expression over introspection. Adler's lessons find their way into twenty-first-century cinema, where the physical body of the actor might be less important but the presence of performance remains.

Conclusion

Stella Adler and the Female Actor

People will say Ms. Adler likes to study with boys more than girls. Rumor. People say Ms. Adler loves everybody. Rumor. People say Ms. Adler is conceited. Rumor. The only time you can understand from what people say is from an authority you respect and that happens very seldom.

Stella Adler[1]

This statement comes from an October 1, 1972, class, the first meeting of Technique I. Most of the students would have just started the program, likely aware of Stella Adler's reputation in the acting community. The statement is not one made simply out of personal defense by the teacher but expressed in an effort to have the young students understand that their currently held beliefs could be defined by bias and false information. In turn, these limitations impede actors as artists, feeding their inhibitions. She tells the class, "How many people see that most of us live by these rumors given to us by ignorant people? . . . Everything you're afraid of, you're afraid of the outside world because you have filled yourself with respect for opinions that deserve no respect." She then employs persistent rumors against her as examples of this limited worldview that breeds selfish, unengaged performances: "You will act if you won't be bastards, if you won't be stupid, if you won't be idiots, if you won't hold onto the idiocy in which we're surrounded."[2]

Significantly, the "rumors" Adler mentions reference her reputation as a teacher of acting through a sexist lens. Her theatrical personality and her expressions of exuberant love or dislike toward a student's performance

in the classroom are related to her status as a woman, supposedly irratio-
nal and fueled by emotion. Her gender identity feeds the most persistent
rumor that Stella Adler favored male students or, as sometimes conveyed,
was tougher on female students. Her supposed gender bias is something that
persists through recollections, often of men. Peter Bogdanovich remem-
bers, "She was kinder, generally speaking, to men than to women, but she
could be brutal to either sex."[3] James Coburn also repeated such a sentiment,
though thought her toughness served a purpose: "She was especially tough
on women because she wanted them to be more. She wanted them to stand
up and be strong. Those women that came through Stella were always really
strong ladies and really standup people who went for the work, who did the
work, who understood the work."[4] Robert Brustein, who hired Adler to teach
at Yale, writes, "She was famously tough on female students, some of whom
she bullied and cowed into near paralysis. (By contrast, she bewitched the
men in her class . . .) That is not to say that women didn't adore her, but they
usually felt intimidated by her powerful theatricalism."[5]

The question remains if this characterization is fair. After all, as Coburn
suggests, Stella Adler trained many respected actresses, including Nina Foch,
Elaine Strich, Margaret Barker, Lauren Hutton, Terri Garr, Sally Kellerman,
Jayne Meadows, Cybill Shepherd, Candice Bergen, Melanie Griffith, Kate
Mulgrew, and Salma Hayek. While none of these names reached the iconic
status of such Method stars as Marlon Brando or Robert De Niro, it can be
argued that few women perceived as Method by the public reached the same
level of icon status as these pupils or the Strasberg-trained James Dean, Al
Pacino, and Dustin Hoffman. In the 1950s, Marilyn Monroe gained head-
lines when she studied with Lee Strasberg at the Actors Studio, but her repu-
tation as movie star was firmly established beforehand.[6] The one exception is
Meryl Streep, who grew in popularity in the 1980s. In many ways, she gained
and continues to have a reputation as a star who challenges the introspective
psychological approach of Strasberg through a masterful expression of craft
as the ability to alter "self"—via accents, gestures, and other technical consid-
erations.[7] Consequently, part of the reason for the perception of Adler being
gender biased is due to the fact that, for much of her lifetime, male actors
simply received more public recognition for their craft than women.

This "rumor" of favoritism toward men was also likely facilitated by
Adler's association with famous males throughout her lifetime: Jacob Adler

and Constantin Stanislavski as her teachers; Harold Clurman as ex-husband and director at the Group Theatre; Lee Strasberg as her rejected teacher and later professional rival; Marlon Brando as star pupil; and other major stars like Robert De Niro and Warren Beatty as former students. Even when the press did correctly credit her contributions to acting—especially after the death of Strasberg in 1982—the names of these males routinely appear to give context for the uninformed reader. A celebratory December 10, 1984, profile relates this history to her exuberant personality, slyly highlighting her more theatrical quirks in clearly gendered terms as that of the female monarch: "Daughter of Jacob Adler, teacher of Marlon Brando, student and disciple of Konstantin Stanislavski, Stella Adler in her eightieth year is the queen of acting theory. And she carries herself accordingly, with furs and attendants and, next to her reading glasses at a table at home, a finger bowl filled with rose petals."[8] This association with a type of feminine regality was a genuine expression of Adler's theatrical background, where she witnessed her mother Sara Adler's role as a grand dame of the Yiddish stage. In a 1989 episode of *American Masters*, viewers get a glimpse of Stella's opulent New York City Fifth Avenue apartment, adorned with chandeliers and statues of cherubs, which the narrator characterizes as "part Venetian, part Madam Pompadour. It also resembles the opulent dressing rooms of a bygone era, in which an actress received her public." The tour focuses on displayed photos of Adler's two major influences as a teacher, Constantin Stanislavski and Jacob Adler, as well as a third figure perhaps more influential on her as an actress and theatrical personality—Sarah Bernhardt, who, by Stella's lifetime, would have been viewed as the true grand dame of the world stage.[9]

While usually recalled warmly by students, as in the *American Masters* episode, Adler's theatrical personality sometimes was employed to dismiss her contributions to acting. The Adler-Strasberg feud could suggest an image of Adler as a preening diva coasting on personality more than substance in the studio—an aging has-been actress out to dismiss the actual father of the American Method, like a kind of spurned lover. It was a reputation Strasberg himself did not dissuade, as noted in an October 7, 1979, *New York Times* article that covers the feud and visits both teachers, giving them equal space to state their cases.[10] Throughout the piece, Strasberg characterizes Adler as the young actress he knew in the 1930s rather than the accomplished teacher of the 1970s. He defines her rejection of his Method in 1934 as based in her

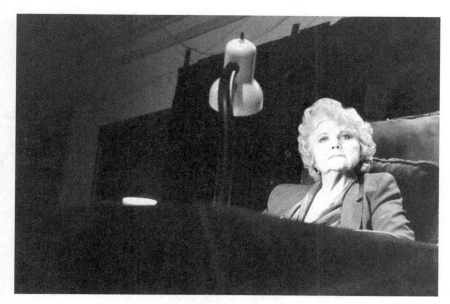

Stella Adler. Harry Ransom Center, the University of Texas at Austin.

emotional personality more than her intellectualism: "She was always over emotional. In a scene she would start to cry. I'd say, 'If you cry, I'm going to punch you with my fist.' Then she went off to Stanislavsky. *Of course*, he said that was a misuse of the Method and that was all she wanted to hear. She came back and told the Group we were misinterpreting. But the results are right. You can't be doing it wrong if the results are right."[11] Strasberg dismisses her contribution to American acting as minor compared to his Actors Studio and appears insulted to be even mentioned in the same breath: "There's no comparison between the people who have come out of my school and the people who have come out of her school."[12] With such a powerful narrative presented by the media darling of the Method, it should be of no surprise that Stella Adler would be rumored to be overly emotional and biased against women, a cartoonish personality prone to jealousy toward her own female students.

The sexist reality of the industry and the mythology surrounding the Method must be considered when examining Adler's reputation. In her feminist assessment, Rosemary Malague questions if such characterizations, such as Robert Brustein's blunt declaration of gender inequality, are fair: "I do

not dispute Adler's toughness—or the possibility that she may have favored her male students. Such gender biases *do* enter the classroom and cannot be excused. But Brustein's suggestion that the female students found Adler more threatening than the men seems to be its own slightly sexist (and unsupported) assertion."[13] In considering remembrances of the Adler studio, we cannot disregard the inherent sexism possible in male perspectives on a female teacher. It is difficult to consider such stories without thinking the possibility exists that Adler held male and female students to, at the very least, standards that were more equal than found in the classrooms of male teachers of the era. When perceived by students unaccustomed to such an approach, mischaracterizations might occur. As Malague points out, "In sharp contrast to Lee Strasberg, however, there is virtually no evidence of Stella Adler coaching female students in the portrayal of 'sex kittens,' nor does she ever seem intent on breaking them down (or making them cry). When she was tough on her actors, her stated purpose was to build them up—to challenge them to find their own strength."[14]

While the specific gender dynamics of countless class meetings would be difficult to analyze, listening to her studio recordings in researching this book, I never found anything to suggest gender bias as defining her overall classroom manner. Adler harshly criticized poor scene work from both male and female students, only to turn around and compliment strong work from the same. Minor typically mid-twentieth-century gender bias does appear in the language, such as the privileging of the male pronoun in defining the "actor" as ideal. But, despite this, a surprising aspect of listening to her class recordings as artifacts of the era is how little gender plays a role in her responses to students' scene work. Regardless of the individual, an interesting performance choice is celebrated, a poor choice is criticized, and laziness is demonized. Dated views toward gender usually come into play when discussing the play text, the characterizations, and the society that produced them. But the actor as a gendered subject is rarely discussed outside of the ability to interpret these elements.

In some of the few instances where Adler addresses the topic of the actress as a gendered subject, there is an expressed recognition of the different social role women face in contrast to men. For example, in a circa 1960 transcript of an opening session of a technique class, Adler tells the female students: "You come from a very busy world. You didn't have your coffee, or you grabbed it

at the cafeteria, if the baby is home crying, or your husband doesn't love you, or your boyfriend didn't call you, and you've got mail to answer—everybody has troubles."[15] Adler continues with this characterization of the female student in a manner that, at first, might suggest she sees them as more emotional and less responsible than males: "And then there's that other scattered person, doesn't know where she is, and she's going to come in anyway, and she's late for no reason. She's just late, that's her way of life." But as she continues, it becomes apparent her message to young actresses is not to paint them as less reliable but to make them feel more comfortable with removing themselves from the patriarchal confines of society. She states, "You've got to understand that these four-and-a-half [studio] hours, and this is the principle, you leave the outside world, why, because for this you need all of yourself here. You don't need your father, you don't need your mother, you don't need your husband, and you don't need your child, and you don't need the money, and you don't need the papers, and you don't care what happens in the *New York Times*."[16] She tells female students in particular to be comfortable focusing on themselves rather than others in their pursuit of the craft: "You need one hundred percent selfishness, honorable selfishness toward you. You come in quietly to be with yourself and the next problem for you."[17] In this call for honorable selfishness, Adler tells women to feel comfortable challenging and empowering themselves, especially within the studio space, where the outside world and its gendered confines should to be dismissed.

While honorable selfishness could be considered a general empowering philosophy of Adler's studio,[18] moments do occur that could be perceived as targeting a female actor by those present. As evidenced by hours of recordings, Adler could be blunt and frustrated when dealing with students, regardless of gender. Young students witnessed something they might not see in other classrooms, a strong older woman directly engaging and challenging the beliefs of a younger female student. For example, it is common in recordings to hear male and female students express a desire to embrace their perception of "reality" and dismiss Adler's call for closer engagement with the text and, in a larger sense, the society that produced it. In her frustration, Adler's responses can sound like personal attacks. For example, in an April 3, 1974, Technique II class, a female student is persistent in calling for a "mediocre" (or dispassionate) approach to her performance because that color would make it more "realistic" and "lifelike." Adler erupts with

frustration, "You have to know your limitations. You have to know what your contribution is. And it is never going to be in the middle because you're not strong enough to understand how much has to be done in the middle. And that is not your fault. Your personality has to be whipped into shape so you have something to say when you work. And what you say in the middle is boring. It's boring."[19] Adler continues this charge in language that could be perceived as insulting to the student, "Your language is boring. Your society is boring. The way you're brought up is boring. And the theater, an art form, is the only thing that'll give you some of this excitement of a living human being." The student voices her frustration with Adler's approach, understandably expressing confusion over how the teacher can ask for "realism" in gesture and object work one day and then criticize "realism" as a general concept when expressed by students. As they debate this point, displaying the mental fatigue that can accompany endless hours of teaching, Adler finally has enough and shuts down the conversation, suggesting the student "doesn't get anything" and mumbling, to the amusement of the class, she would like to hit the student: "I'll give you a show. A crack."[20]

These sorts of moments illustrate how, to some, Adler's personality in class could be perceived as that of a tyrant. Angry outbursts occurred regularly as the result of the daily grind of studio work, personality conflicts, and students directly challenging Adler in language coded in the psychological "realism" of Strasberg. Yet these moments are often followed by her regaining composure and attempting to explain the reasons for her frustration, working toward the goal of empowering the actor. After the above exchange, Adler clarifies that the lessons of the technique class have a larger purpose, to develop an appreciation of serving the play text, which, due to the course sequence, cannot be fully taught until technique is covered. Regaining her composure, Adler says to the student, "I wish to God I got to where you had enough so I could put you into a scene. I can't do that this year because you have to know what a scene is about and how to work together and what your actions are and your interactions."[21] Such moments do not suggest Adler held a gender bias against female students or was, in general, tyrannical. Instead, she held a bias against all students misappropriating or, in her eyes, lazily ignoring her instruction. Variations on this sort of conflict commonly appear in recordings with male and female students who are persistent in embracing their view of "realism" over textual and/or social engagement. This occurs

particularly in classroom debates where students wish to get overtly psycho-logical in their approach. For example, in an October 20, 1961, class, Adler passionately dismisses a male student's attempt to explore his character in overtly Freudian terms: "Never do that in acting. Let somebody else do that. Usually the audience because they don't know anything. Or some psychia-trist, some scientist will come. . . . So don't say what he's [the character is] doing subconsciously."[22]

Recognizing Adler's approach to teaching as relatively gender inclusive, of course, means notable female performers can also be read as illustrating her methodologies. For example, this influence can still be seen today in Kate Mulgrew's acclaimed performance as Galina "Red" Reznikov, an inmate and chef in a minimum-security prison, on the Netflix original series *Orange Is the New Black* (2013–present). In discussing the role, Mulgrew suggests that the producers wanted her to do "just a light Russian" accent, but, true to her Adler training, the actress engaged the character more fully as a *slanted type*, whose identity was initially considered through a predetermined social context: "I said, 'That's an oxymoron. Have you ever met a light Russian?! . . . And it [the accent] fits her. It's her signature. It's who she is. She's come from Russia."[23] But Mulgrew never caricatures a Russian, suggesting even the heavy accent as facilitated by the *given circumstance* of a character in a minimum-security prison: "In the prison, that [the accent] is not only her stamp, but her cloak. It's a guard. It protects her. There's something very good about that, that can make other people stand away from her. I've loved using it, as a tool." Mulgrew discusses the role in the context of the prison setting as a distinct *social situa-tion*, a very particular manner of confinement that allows for more freedom than maximum security: "You can breathe in this prison, but only just, which is why you have to find your own way to survive. That's why Red has to have the kitchen. She must have the kitchen. It is her spine." Mulgrew suggests her character's protective relationship with the kitchen is expressing a larger uni-versal theme of survival: "As long as she can keep that part of herself alive, she has triumphed over this system, which will try to deaden you. That's what's great about having the kitchen, and the kitchen must never be taken away from her."[24]

In her memoir, Mulgrew recalls Adler as a stern taskmaster and some-body who "regarded herself as royalty, and, so, as a consequence, did we. . . . Stella did not suffer fools—not lightly, not briefly, not ever."[25] While this

characterization mirrors many often-told stories of Adler's theatrical person-
ality, Mulgrew goes further than many male students' remembrances to dis-
cuss her as a more complex figure, one that made her leave college and focus
her energies full time at Adler's studio:

> Stella wanted nothing more from me than to deliver and I wanted nothing
> more than to deliver. There was no time for anything else and little need
> for courses in modern philosophy or English lit when I spent my days
> under the tutelage of a woman who freely quoted Goethe and Rilke, a
> mentor who, in the course of an afternoon, could open our imaginations
> to the life and times of Harold Clurman and the Group Theatre, what it
> meant to be the daughter of the great Jacob Adler, and how she trans-
> formed the Stanislavski method into a style of acting that was inimitably
> her own. We didn't have to ask how; she told us. "I found Stanislavski in
> Paris and I sat at his feet and I listened, until I understood."[26]

Mulgrew's recognition of her mentor's personal interpretations of
Stanislavski—to make his theories "inimitably her own"—recognizes Adler
as a thinker as opposed to just a personality. She not only becomes a cul-
mination and continuation of these malecentric traditions of acting but a
new narrative that recontextualizes that which came before through Adler's
position as an intellectual.[27]

Recognizing Adler as a thinker allows us to view her as something be-
yond simply a trainer of important actors. She also was a trainer of teachers—
figures who would spread her message of a more textually and socially en-
gaged approach to performance. In perhaps the greatest illustration of her
lack of preference toward men, the people she entrusted to continue her
legacy were often women. Adler relied on former female students to teach at
her New York studio and, later, at its Los Angeles location, especially as she
grew older and found it more difficult to teach on a regular basis. The West
Coast studio itself was cofounded by Adler alumni Joanne Linville and Irene
Gilbert in 1985. A look at the 1990–91 program for her New York studio dis-
plays the trust she placed in her female mentees to continue her mission on
the East Coast, listing former student Elizabeth Parrish as the artistic direc-
tor as well as former pupil Alice Winston as the "Master Technique Teacher"
(essentially meaning she oversaw the course that served as the foundation of

all the other required lessons in Adler's program). Even early in the studio's history, class recordings show Adler directly mentoring young women as teachers, having them come to class sessions to give instruction to new students. In an October 28, 1958, class, Adler welcomes a young former student, Jenny Eagan, to give a demonstration on stage makeup. She speaks highly of Eagan and tells the students to listen closely and show her respect. Adler then turns the class over to Eagan to demonstrate her skills at stage makeup to display how to add color to characterizations, such as "shyness" or "flirtatious" through externals like eyelashes. In incorporating her own skills to demonstrate Adler's points, Eagan then compliments Adler's approach to building characterization, telling the students that the studio is the "only place you'll learn this."[28]

Beyond just the presence of empowered women (both teachers and students) in the studio, the approaches themselves can be considered as, if not feminist, more adaptable to a feminist worldview. Malague suggests, "Adler has a sharp, critical understanding that 'woman' is not a straightforward category. She understands complexity: there are different *kinds* of women, and they are the products of their circumstances."[29] Just as seen in discussions of technique and characterizations with males, a similar complexity arises as Adler teaches women. The gendered dynamics of the studio, which were relatively more inclusive, only aided in empowering women and productively challenging men. As Malague contends, "Adler pushes female actors to be strong and *forceful*—not weak or victim-like. Women are subjects, not objects in her world view. From a feminist perspective, one of the things I find most compelling is Adler's invitation to thought and action."[30]

Malague's feminist interpretation of Adler is confirmed in some of the passionate devotion of her female students, often based in an appreciation of her technique more than her personality. For example, in a September 12, 1970, letter to her teacher, Oklahoma-born actress Pamela Tiffin expresses an excitement over playing a character very different from herself, a "Napolitano," brought up in Naples's poorer districts. The young actress writes, "I could never even approach the character if it wasn't for your 'Character Class.'"[31] Tiffin then goes on to describe her process of developing the character through an understanding of circumstances, setting, and social situation: "Anger, bitterness, flare-ups, hunger, poverty are a daily part of Neapolitan life. Everybody lives in these six and eight story apartment buildings. You

can see into everybody's house, hear everyone's arguments, see love affairs, deaths, and probably births and abortions." Through her examination of circumstance, Tiffin writes she not only locates a strength but, more importantly, a complexity of character defined by social forces: "So you act proud and hold your head high, one second showing the 'world' you are independent 'above it all,' showing you can hold your own, that you've got balls and guts and are nobody's fool. The next second you look around to see if your act is working—that's when the sneaky looking eyes come in—you're really insecure and frightened because you're poor and badly dressed and can't speak well in a society that has a vicious bourgeoisie and upper class."[32] In such a breakdown of character, the actress displays the lessons of Adler's characterization and script analysis classes as a way to complicate what could be a simplistic gendered type if considered through another methodology. In the words of Malague, Tiffin approaches the character through "thought and action" and, as such, appears to have found empowerment as a performer.[33]

Often in the classroom, Adler's discussions of character traits found fascinating gendered connotations in their expressions of thought and action. In another example of Adler mentoring future teachers, a young Elizabeth Parrish appears on a December 9, 1966, recording of a character class. The two teachers oversee a discussion of a trait usually associated with masculinity in popular culture, "toughness," in a manner promoting a fluidity of gendered characteristics. The two engage, in particular, female students who seem hesitant to embrace a callous manner of toughness. They go over different tough types, asking the students to perform. Adler states, "The difference between the cop, the difference between the moll, the difference between the executive that is tough, and the teacher. Now the general type is given to you."[34] When some of the female students still appear too timid or uncertain to perform the character trait, Adler moves onto a female tough type they would have more experience witnessing: "What's the teacher tough about? Absences, postures, kids. Supposing the kid comes in and has to go to the bathroom. . . . What does she do?" After some exercises physicalizing these traits into doable actions, Adler asks the young women, "All the girls, how do you feel now? Better?" They respond with an appreciative "yes." Later in the same class, a young woman tries to grasp the difference between "self-assured" and "tough" as traits. Parrish employs Adler herself as an example: "But the kind of callous toughness we're working on now is not Stella's, for

example, self-assuredness. The self-assuredness that makes her give a bunch of coats to somebody who said, 'No, we don't take coats.'"[35] Here, the personality of Alder is ingrained into the lesson, illustrating how the gender of Adler cannot be removed from her significance as a teacher. This component could especially be seen in the training of women who, like Parrish, might look up to her as a role model of "self-assuredness."

This studio environment only reinforced the socially engaged lessons of Adler's teaching, which examined societal constructions of gender more than perceived psychological truisms. Nowhere do these dynamics become more pronounced than Adler's lessons in script analysis, where she treats female characters with as similar an eye toward social complexity as male characters. In many of these lectures, Adler emerges as a thinker acutely aware of the gendered constructs of society and their limitations. In published lectures on playwright August Strindberg, she focuses on the image of women in his works as problematized by the patriarchy.[36] She states, "Strindberg is the psychological dramatist. He is an antifeminist."[37] In positioning the work in a gender history, she suggests, "Strindberg gives you the woman who hasn't had enough time to equal the man in development but still says, 'I'm smarter than you.' She has the lower-class mentality even though she is middle-class. She does not have the man's aristocratic point of view." While this suggestion might sound insulting to the female characters, Adler places it into its proper cultural context as she conveys how sexism affects self-definition: "She is in that moment of 'I want something, even though I don't know what it is'—compelled by the historical moment to want more than her capabilities permit her."[38]

While fascinated by Strindberg, Adler explains to the students how his own fractured sense of masculinity feeds these depictions of women: "Strindberg was an atheist and a moralist. He was highly neurotic and had two nervous breakdowns. . . . He had a desire to live like a married man and have children, but he didn't want to be disturbed." Through this understanding of the limitations of the male artist, Adler explains how this influences the female characters created for his plays, "He saw the woman as a madonna/virgin but also as a corrupted prostitute. He wanted his wife to be sensuous and virginal, motherly and submissive, housekeeper and soul mate, all at the same time."[39] With this psychological profile, Adler positions the playwright as responding to the changing gender dynamics of

the late nineteenth and early twentieth century, writing, "Strindberg's historical moment was also the historical moment of transition for women."[40] The playwright's conflicted resentment toward his female characters serves as a precursor to the gendered conflicts throughout the twentieth century and the birth of modern feminism: "Strindberg was a prophet about what would happen in society between men and women. He questioned the balance between men and women."[41] In Adler's reading, Strindberg creates a limited dichotomy of female characters that still exists in popular culture: "(1) the older, more motherly women—kind and compassionate—and (2) the emancipated females, whom he calls 'the third sex.'" As Adler tells her students, "Strindberg developed this theory of the third sex—the woman who wants to be liberated from her womanly side, reverse the roles of authority and take over. She has a strong masculine streak."[42] In this lecture, Adler warns her female students that the strength of the characters must not be divorced from the patriarchy that created the art, one with a negative view of this "third sex": "Strindberg attacks the institutions and emphasizes that in the women's revolt against the tyrannical men, the men are tyrannical because of their weakness, not strength. His position is that society is trying to undervalue and deprive men of their masculinity and transfer it to women. The male position has gone from aggressiveness to possessiveness."[43]

As this example proves, Adler was an intellectual aware of both the complexities of gendered categorizations and the societal limitations placed on women. Despite the remembrances of many actors, the most progressive aspect of this studio environment was not just the centrality of Adler herself as a grand dame of theatrical training. The real power was more intangible, something found in the space's discussions and deconstructions of gender. The classroom celebrated and criticized performances without simple gendered divisions, promoting a plurality of gendered types. As a mid-twentieth-century environment, individual ideas toward women as types that are now passé or even offensive did appear. For example, a January 5, 1966, lesson plan on characterization asks the class to consider the type of the "<u>Airline</u> Stewardess-(surpy [sp], cupiedoll, she ozzes [sp], pouts, uses baby talk, big, big eyes, walk as if she walks on daisies, sit down on two daises, really built)." Then it asks students to consider the "secretary thru the eyes of the housewife—ozzes [sp] sex, playful, does little work, is stupid, dresses sexy, avid, giggles, lazy."[44] Yet these lessons are more about

reflecting and even deconstructing societal definitions than representing truths about gender. In the next class meeting, January 7, Adler has students performing variations of female types based on shifting situations and differing viewpoints: "When doing heightened characters heighten not only the character but also the environment, attitude. Make partner heightened. Do waitress—see her through the boss's eye, then add you're serving Dukes and Duchesses, then add you are serving explosive pancakes."[45] While this example proves extreme, the point is clear. There might be a social categorization in approaching the performance of a waitress, but the situational context and controlling viewpoint changes everything. The patriarchal viewpoint (the boss) changes context. The addition of class dynamics (serving dukes and duchesses) does the same. Most importantly, changing the narrative significance of the waitress (serving explosive pancakes) challenges her original conception as a type, giving the character a centrality unseen in other storylines.

As this suggests, Adler can be considered a progressive and even feminist presence in the history of acting. But it must be noted this is progressive principally through the viewpoint of white feminism. Undeniably, Adler focuses primarily on white playwrights and the white subject as the ideal representative "actor" in most of her discussions, representing a Eurocentric worldview. This is not surprising since, while Adler did train actors of color, her students were most often white—a fact that reflects the racial dynamics of American theater throughout the twentieth century. As Malague writes, the major programs in the latter half of the century "appear to take for granted that 'the actor' is white, middle-class, American-born, and able-bodied." When looking at video recordings of most popular acting programs, including Adler's, "with only a few exceptions, the students appear to conform to that description."[46] While Adler, a progressive liberal, certainly displayed an awareness and sensitivity toward issues of civil rights in studio recordings, she could universalize discussions in a manner dissuading diverse voices. For example, in a 1980 recording of a script analysis class, Adler hears two students perform a scene from *Wedding Band: A Love/Hate Relationship in Black and White* (1962), a play by an African American playwright, Alice Childress, about an interracial relationship between a white man and black woman. Unhappy with the performance, Adler addresses the racial dynamics in the analysis but frames them more in the context of gender relationships

than racial: "Here is a play that says what every play says between a man and a woman together. . . . There is only one thing. There's trouble in the family. There's trouble because she's black and he's white. There's trouble because the children don't go to temple. . . . Because the man spends too much time in the factory. It's always trouble."[47] Adler does recognize the social conflict inherent in the racial differences involved in analyzing the scene, yet feels more interested in universalizing the issue than recognizing the black character's agency: "The author is saying something about his society. He is saying the white man is a louse. And the black people in relation to a black woman, you have treated her like a louse. The author is saying how depraved you are in your manhood to have done that to a human being. That's what has to come out. A big play about social injustice. That's what plays are about. The social injustice of keeping a woman and making her stay at home."[48]

Recognizing this limitation is not to diminish Adler's contribution to screen acting nor to the history of on-screen maleness. By promoting a socially insightful understanding of gender, many of her actors gave us challenging depictions of manhood on screen. These performances range from Marlon Brando's deconstruction of misogyny as based in masculine anxiety in *A Streetcar Named Desire* (1951) to his subversively postmodern role-playing in *The Missouri Breaks* (1976). They gave us cinema's most frightening depiction of post-Vietnam-War-era white male rage with Robert De Niro in *Taxi Driver* (1976) and an absurd pastiche reflection on rebellious maleness through Henry Winkler's Fonzie on television's *Happy Days* (1974–84). Adler's influence even extends into this century as Mark Ruffalo explores repressed rage and challenges the definitions of the performing body as the CGI Hulk in *Avengers: Age of Ultron* (2015). Despite this wider-ranging impact, Adler should not be seen as a singular feminine influence altering the direction of masculinity on screen. Instead, she is representative of schools of acting that challenged the psychologically based approaches of Lee Strasberg—the Method as based in the rigidly defined parameters of a gendered "self." While her original 1934 challenge of his Method at the Group Theatre cemented her reputation as, perhaps, the most prominent counternarrative, it is best to see her as reflective of various countervoices, found in the influence of teachers like Robert Lewis, Sanford Meisner, Uta Hagen, and many others. Similar analyses of on-screen performance and gender could be performed with their students

employing their recorded instruction and theories. Hopefully, this book has laid some groundwork to explore these other teachers' wide-ranging influence beyond the label of Method.

While she would selectively use the term in some interviews, Adler knew the connotations of "Method" were problematic and limiting. In a 1977 interview, when asked about the "American style" and the Method, she responded with a focus on the male actor: "What Method? It's not related to Strasberg and it's something bigger and deeper than that. The American young man has a lack of energy in this particular creative field. . . . We're still in the Puritan tradition and have to work very hard for him to understand that he can express something emotionally or even poetically."[49] To Adler, the beauty and complexity of a male performance is available not through some mysterious psychological insight into "self," but "a certain sense of craft, which he's able to get because the craft is available to him. And it's not the Method, and it's not by Strasberg, or Stella Adler, or Sanford Meisner." This craft is not *the* Method but *a* method resulting in a multitude of approaches, and "it doesn't belong to any one individual and every individual is responsible for his own interpretation. Nobody is Stanislavski."[50] While the centrality of Constantin Stanislavski could be challenged in her proclamation, the point remains that there is a multiplicity of approaches that resulted in new depictions of maleness. Modern masculinities and femininities exist on screen beyond the singular influence of Strasberg or Adler. They exist beyond the psychological "self," embracing complex engagements with society's gendered discourses. They exist beyond Method.

Notes

Abbreviation Guide

The Stella Adler and Harold Clurman Papers are currently archived in the Performing Arts Collection of the Harry Ransom Center at the University of Texas at Austin. Archived materials from these sources will be marked in endnotes as HRC. Materials from the Robert De Niro Papers, also housed at the Ransom Center, are designated with RDP. NP means the document had no page numbers. ND means the document or recording was not dated.

Notes to Introduction

1. Mel Gussow, "Demystifying the Method: The Once-Exclusive Actors Studio Reaches Out to the Public," *New York Times*, May 20, 1997, C11+.

2. In Russian, Константи́н Станисла́вский. In English, his name has been translated as Konstantin Stanislavsky and Constantin Stanislavski. For this book, keeping with the most common way it appears in Stella Adler's classroom transcripts and notes, I will be using the translation Constantin Stanislavski, though other cited scholars might employ an alternate spelling.

3. Gussow, "Demystifying the Method," C14.

4. Arthur Gleb, "Behind the Scenes at the Actors Studio," *New York Times*, April 29, 1951, X1. For articles referencing Brando learning his trade via Strasberg and/or the Studio see, for starters, Linda Gross, "Lee Strasberg: Merlin of Method," *New York Times*, August 4, 1968, C1; Joyce Harper, "Strasberg Talks, People Listen," *Los Angeles Times*, October 17, 1967, C16; Margaret Hartford, "Pessimistic Less Strasberg Halves Cultural Rebirth," *New York Times*, December 12, 1966, D1; Robert Jennings, "The Method Goes to College," *Los Angeles Times*, October 20, 1968, A32+; Walter Kerr, "Actors Studio Gives Virile Approach to Craft," *Los Angeles Times*, June 17, 1956, D4; Seymour Peck, "The Temple of the 'Method': Many of Tomorrow's Stars—and

Quite a Few . . . ," *New York Times*, May 6, 1956, 220+; Philip Scheuer, "Strasberg: A Man and His Method," *Los Angeles Times*, June 25, 1978, T1+; Sandra Schmidt, "Lee Strasberg Starts His Second Acting Life," *Los Angeles Times*, January 25, 1970, P1; and Cecil Smith, "Actors Studio: Tonic for Tired Stage Blood," *Los Angeles Times*, July 8, 1962, M15.

5. Patt Morrison. "Lee Strasberg, Mentor of Method Actors Dies," *Los Angeles Times*, February 17, 1982, A1.

6. Marlon Brando, with Robert Lindsey, *Brando: Songs My Mother Taught Me* (Toronto: Random House of Canada, 1994), 85.

7. Brando, *Brando: Songs*, 79–81. This is a sentiment Brando stresses also in his foreword to the only book on acting Adler released in her lifetime, *The Technique of Acting*, writing, "Almost all filmmakers anywhere in the world have felt the effects of American films, which have been in turn influenced by Stella Adler's teachings." Stella Adler, *The Technique of Acting* (New York: Bantam Books, 1988), 1.

8. Brando, *Brando: Songs*, 81.

9. Cynthia Baron, *Modern Acting: The Lost Chapter of American Film and Theatre* (London: Palgrave Macmillan, 2016), 6.

10. Marlon Brando, Remembrance for Stella Adler memorial, ND, HRC.

11. Suzanne Finstad, *Warren Beatty: A Private Man* (New York: Harmony Books, 2005), 133.

12. Finstad, *Warren Beatty*, 139, 133.

13. Brando, *Brando: Songs*, 79.

14. Gwendolyn Aubrey Foster, *Performing Whiteness: Postmodern Re/constructions in the Cinema* (Albany: State University of New York Press, 2003), 2.

15. See, among others, Gail Bederman, *Manliness and Civilization: A Cultural History of Gender and Race in the United States, 1880–1917* (Chicago: University of Chicago Press, 1995); Joe. L. Dubbert, "Progressivism and the Masculinity Crisis," in *The American Man*, ed. Elizabeth H. Pleck and Joseph H. Pleck, (Englewood Cliffs, NJ: Prentice-Hall, 1980), 303–20; Peter G. Filene; *Him/Her/Self: Sex Roles in Modern America* (Baltimore: Johns Hopkins University Press, 1986), 69–93; John Higham, "The Reorientation of American Culture in the 1890s," in *Writing American History: Essays on Modern Scholarship*, ed. John Higham (Bloomington: Indiana University Press, 1978), 73–103. Like most long-standing terms used by historians, "masculinity crisis" has been challenged. Rightfully, some, most notably Bederman, have pointed out that despite the rhetoric of the period, most middle-class men did not challenge their comfortable domestic situations.

16. For more on this cultural history, see E. Anthony Rotundo, *American Manhood: Transformations in Masculinity from the Revolution to the Modern Era* (New York: Basic Books, 1993), and Michael Kimmel, Manhood in America: A Cultural History, 4th ed. (New York: Oxford University Press, 2017).

17. James Gilbert, *Men in the Middle: Searching for Masculinity in the 1950s* (Chicago: University of Chicago Press, 2005), 16–17.

18. See Miriam G. Reumann, *American Sexual Character: Sex, Gender, and*

National Identity in the Kinsey Reports (Berkeley: University of California Press, 2005), and Paul Rutherford, *A World Made Sexy: Freud to Madonna* (Toronto: University of Toronto Press, 2007).

19. Dennis Bingham, *Acting Male: Masculinities in the Films of James Stewart, Jack Nicholson, and Clint Eastwood* (New Brunswick, NJ: Rutgers University Press, 1994), 4.

20. Susan Jeffords, *Hard Bodies: Masculinity in the Reagan Era* (New Brunswick, NJ: Rutgers University Press, 1994); Gaylyn Studlar, *This Mad Masquerade: Stardom and Masculinity in the Jazz Age* (New York: Columbia University Press, 1996); Steven Cohan, *Masked Men: Masculinity and the Movies in the Fifties* (Bloomington: Indiana University Press, 1997); Scott Balcerzak, *Buffoon Men: Classic Hollywood Comedians and Queered Masculinity* (Detroit: Wayne State University Press, 2013). Other less era-specific film masculinity studies of note, which examine some major stars, include Peter Lehman, *Running Scarred: Masculinity and the Representation of the Male Body* (Philadelphia: Temple University Press, 1993); Chris Holmlund, *Impossible Bodies: Femininity and Masculinity at the Movies* (London: Routledge, 2002); David A. Gerstner, *Manly Arts: Masculinity and Nation in Early American Cinema* (Durham, NC: Duke University Press, 2006); and Barry Keith Grant, *Shadows of Doubt: Negotiations of Masculinity in American Genre Film* (Detroit: Wayne State University Press, 2011). Star studies are also featured in masculinity-focused collections, including Steven Cohan and Ina Rae Hark, eds., *Screening the Male: Exploring Masculinities in Hollywood Cinema* (London: Routledge, 1993); Sharon Willis and Constance Penley, eds., *Male Trouble* (Minneapolis: University of Minnesota Press, 1993); and Phil Powrie, Ann Davies, and Bruce Babington, eds., *The Trouble with Men: Masculinities in European and Hollywood Cinema* (London: Wallflower, 2004).

21. Cohan, *Masked Men*, xvii.

22. Judith Butler, *Gender Trouble: Feminism and the Subversion of Identity*, 2nd ed. (New York: Routledge, 1999), 173. In this work, Butler applies Michel Foucault's discussion of "juridical systems" from *The History of Sex: Volume 1* to determining gender boundaries and, eventually, the conception of performative gender, writing, "Juridical power inevitably 'produces' what it claims merely to represent." Butler, *Gender Trouble*, 5.

23. R. W. Connell, *Masculinities*, 2nd ed. (Berkeley: University of California Press, 2005), 71.

24. Christine Geraghty, "Re-examining Stardom: Questions of Texts, Bodies, and Performance," in *Reinventing Film Studies*, ed. Christine Gledhill and Linda Williams (Oxford: Oxford University Press, 2001), 192.

25. James Naremore, *Acting in the Cinema* (Berkeley: University of California Press, 1988); Cynthia Baron and Sharon Marie Carnicke, *Reframing Screen Performance* (Ann Arbor: University of Michigan Press, 2008). See also Andrew Klevan, *Film Performance: From Achievement to Appreciation* (London: Wallflower, 2005). The following collections also contain scholarship of note: Jeremy Butler, ed., *Star Texts: Image and Performance in Film and Television* (Detroit: Wayne State University

Press, 1991); Alan Lovell and Peter Krämer, eds., *Screen Acting* (London: Routledge, 1999); Cynthia Baron, Diane Carson, and Frank P. Tomasulo, eds., *More Than a Method: Trends and Traditions in Contemporary Film Performance* (Detroit: Wayne State University Press, 2004); and Alan Taylor, ed., *Theorizing Film Acting* (New York: Routledge, 2012).

26. Donna Peberdy, *Masculinity and Film Performance: Male Angst in Contemporary American Cinema* (London: Palgrave Macmillan, 2011), 9.

27. Peberdy, *Masculinity and Film Performance*, 10.

28. Stella Adler, letter to Arnold Dolin, February 22, 1980, HRC.

29. Adler, *Technique of Acting*.

30. Stella Adler, *The Art of Acting*, ed. Howard Kissel (New York: Applause, 2000); Joanna Rotté, *Acting with Adler* (New York: Limelight, 2000).

31. Stella Adler, *Stella Adler on Ibsen, Strindberg, and Chekhov*, ed. Barry Paris (New York: Vintage Books, 1999); Stella Adler, *Stella Adler on America's Master Playwrights: Eugene O'Neill, Thornton Wilder, Clifford Odets, William Saroyan, Tennessee Williams, William Inge, Arthur Miller, Edward Albee*, ed. Barry Paris (New York: Alfred A. Knopf, 2012).

Notes to Chapter 1

1. For more on the archetype of the prankish "bad boy" in film and literature, see Peter Krämer, "Bad Boy: Notes on a Popular Figure in American Cinema, Culture and Society, 1895–1905," in *Celebrating 1895: The Centenary of Cinema*, ed. John Fullerton (Sidney: Libbey, 1998), 117–130. For more on *Rebecca of Sunnybrook Farm* as coming-of-age work, see Joe Sutliff Sanders, *Disciplining Girls: Understanding the Origins of the Classic Orphan Girl Story* (Baltimore: Johns Hopkins University Press, 2011), 65–77.

2. Weales, "Crazy Mixed-Up Kids Take Over." Weales's piece is typical of entertainment articles from the period that focused on the "boyishness" of a new generation of male movie star. See chapter 6, pages 201–63, of Steven Cohan, *Masked Men: Masculinity and the Movies in the Fifties* (Bloomington: Indiana University Press, 1997), for a discussion of how these descriptions appear in the fan discourse. In particular, Cohan focuses on a 1957 *Photoplay* feature story that contends the "current movie heroes are boys trying to do a man's work. Most of them are adolescent, and this applies regardless of age." Sidney Skolsky, "The New Look in Hollywood Men," *Photoplay*, May 1957, 41.

3. Weales, "Crazy Mixed-Up Kids Take Over."

4. The piece critiques a widespread embracing of the masculine immature—from Presley to Dean to J. D. Salinger's *The Catcher in the Rye* (1951) to even comedian Jerry Lewis, who is described as changing the "comic hero" into a "lubberly, rebellious baby." Weales, "Crazy Mixed-Up Kids Take Over," 41.

5. Weales, "Crazy Mixed-Up Kids Take Over," 41.

6. Cohan, *Masked Men*, 202.

7. Cohan, *Masked Men*, 260.

8. Weales, "Crazy Mixed-Up Kids Take Over," 40.

9. Maurice Zolotow, "The Stars Rise Here," *Saturday Evening Post*, May 18, 1957, 83.

10. Zolotow, "Stars Rise Here."

11. "Cary Grant, Kicks Shin-Kicking Boys of 'The Method,'" *Variety*, May 8, 1957, 2.

12. "Not All Actors Studio Alumni Wear Dungarees; Steiger Gives Lowdown," *Variety*, August 21, 1957, 24.

13. Cynthia Baron, *Modern Acting: The Lost Chapter of American Film and Theatre* (London: Palgrave Macmillan, 2016), 61.

14. James Naremore, *Acting in the Cinema* (Berkeley: University of California Press, 1988), 197.

15. It is important to know that "affective" memory and "sense" memory were just two of many techniques explored in the First Studio by Stanislavski and his disciples. From 1914, archived lectures show "Affective action, memory, and feeling" as just one topic of Part One of the Study Program, which also included muscular relaxation, concentration, belief, naïveté, circle of attention, task, and rhythm, increased or restricted energy. Parts Two and Three of the program focused on the relationship to the other actors and analysis of plays and characters. Jean Benedetti, *The Art of the Actor: The Essential History of Acting from Classical Times to the Present Day* (New York: Routledge, 2007), 128–36.

16. These definitions are adapted from Sharon Marie Carnicke, *Stanislavsky in Focus* (Amsterdam: Harwood-Academic Publishers, 1998), 170–71, 179. See also chapters 1 and 2 of Rose Whyman, *Stanislavski: The Basics* (London: Routledge, 2013), 22–85.

17. Carnicke, *Stanislavsky in Focus*, 57.

18. Naremore, *Acting in the Cinema*, 199. Emphasis added.

19. This is not to say Strasberg did not still employ more traditional formulations of Stanislavskian sense memory in his studio. As outlined in his writings, he did promote exercises "exploring the real objects from our immediate environment." This sort of practice can lead to a sense memory onstage employed to realistically perform actions. But even this variation of sense memory developed into a psychological activity for Strasberg and was meant to unblock the repressed actor. His *private moment* exercise used sense memory to make students comfortable performing usually private actions, tapping into "whole areas of experience" within "many people who seem repressed or who have difficulty in responding." In total, to Strasberg, sense memory was used to facilitate the goal of emotional memory onstage, with the actor employing "a past event with the strength of emotional response that is pertinent to the monologue or scene." To the teacher, sense memory and emotional memory were very similar because "the emotions and the senses work exactly alike. There's only one difference. The emotion is sensation at a point of high intensity." Lee Strasberg, *The Lee Strasberg Notes*, ed. Lola Cohen (London: Routledge, 2010), 16, 25, 29, 33.

20. Lee Strasberg, *A Dream of Passion: The Development of the Method* (New York: Plume, 1987), 149.

21. First discussed in the famous "Wolf Man" case (1914), to Freud, the "primal scene" would be the occasion where a child becomes aware of the sex act, usually through witnessing his parents having intercourse, misconceiving it as violence. The timing of this witness, in Freudian developmental psychology, would be crucial in determining a predisposition to future neuroses. Edward Erwin, ed., *The Freud Encyclopedia: Theory, Therapy, and Culture* (New York: Routledge, 2002), 424–25.

22. Shonni Enelow, *Method Acting and Its Discontents: On American Psycho-Drama* (Evanston, IL: Northwestern University Press, 2015), 41.

23. Strasberg, *Dream of Passion*, 138.

24. Strasberg, *Dream of Passion*, 148.

25. Seymour Peck, "The Temple of the 'Method': Many of Tomorrow's Stars—and Quite a Few . . . ," *New York Times*, May 6, 1956, 27.

26. Peck, "Temple of the 'Method,'" 42.

27. Peck, 44.

28. Peck, 44, 47.

29. Christine Geraghty, "Re-examining Stardom: Questions of Texts, Bodies, and Performance," in *Reinventing Film Studies*, ed. Christine Gledhill and Linda Williams (Oxford: Oxford University Press, 2001), 193.

30. Geraghty, "Re-examining Stardom," 193–94.

31. Barry King, "Articulating Stardom," in *Stardom: Industry of Desire*, ed. Jeremy G. Butler (Detroit: Wayne State University Press, 1991), 127.

32. Cynthia Baron and Beckett Warren, "The Actors Studio in the Cold War Era," in *The Wiley-Blackwell History of American Film*, vol. *1946–1975*, ed. Cynthia Lucia, Roy Grundmann, Art Simon (Malden, MA: Blackwell, 2012), 138.

33. Richard Dyer, "Charisma," in *Stardom: Industry of Desire*, ed. Christine Glenhill (London: Routledge, 1991), 58.

34. Dyer makes the case that Monroe can be analyzed as a product and response to the period, yet this does not dismiss her innate appeal because "one can also see her 'charisma' as being the apparent condensation of all that within her." So, the personal elements of the star, or more precisely what defines their appeal beyond the acting talent, exist in direct dialogue with the cultural appeals defining their popularity. Dyer, "Charisma," 59.

35. Richard Dyer, *Stars*, 2nd ed. (London: British Film Institute, 1998), 134.

36. In terms of a collective analysis of the filmic text, such signs are part of a larger semiotic system defining popular cinema, existing as a form of communication with the viewer. See John O. Thompson, "Communication Test," in *Stardom: Industry of Desire*, ed. Christine Glenhill (London: Routledge, 1991), 186–200.

37. Naremore, *Acting in the Cinema*, 200–201.

38. Lee Strasberg, "Acting," *Encyclopedia Britannica*, 14th ed., vol. 1, 1957. More to the point, as actress Kim Hunter noted, "No matter what you do in a film, it is, after all, bit and pieces for the director, and that is marvelous for the director, but it doesn't

allow the actor to learn to mould the part." Quoted in Lillian Ross and Helen Ross, *The Player* (New York: Limelight, 1984), 15.

39. Cynthia Baron and Sharon Marie Carnicke, *Reframing Screen Performance* (Ann Arbor: University of Michigan Press, 2008), 17.

40. Sharon Marie Carnicke, "Lee Strasberg's Paradox of the Actor," in *Screen Acting*, ed. Alan Lovell and Peter Krämer (London: Routledge, 1999), 78.

41. Quoted in Carnicke, "Lee Strasberg's Paradox of the Actor," 78.

42. Carnicke, "Lee Strasberg's Paradox of the Actor," 84.

43. Carnicke, *Stanislavsky in Focus*, 1.

44. Carnicke, *Stanislavsky in Focus*, 5.

45. In many ways, the Jewishness of both her and Strasberg would figure heavily into their public images, especially in later years as their rivalry became more popularly known. In 1984, in *A Method to Their Madness*, Foster Hirsh characterizes each teacher in decidedly Jewish terms: "If Strasberg was the remote Jewish father, withholding approval behind a stolid mask, Adler is the domineering Jewish mother, forever tisking and scolding." Foster Hirsh, *A Method to Their Madness: The History of the Actors Studio* (New York: Da Capo Press, 1986), 19.

46. For more on Jacob Adler and the American Yiddish Theatre, see Jacob P. Adler, *A Life on the Stage: A Memoir*, trans. and ed. Lulla Rosenfeld (New York: Knopf, 1999); Lulla Rosenfeld, *Bright Star of Exile: Jacob Adler and The Yiddish Theatre* (New York: Crowell, 1977); Lulla Rosenfeld, *The Yiddish Theatre and Jacob P. Adler* (New York: Shapolsky Publishers, 1988); Maxine Seller, ed., *Ethnic Theatre in the United States* (Westport, CT: Greenwood Press, 1983); and Nahma Sandrow, *Vagabond Stars: A World History of Yiddish Theater* (New York: Harper and Row, 1977). Chapter 3 of this book will consider the influence of Yiddish theater tradition on Stella Adler's teaching and Marlon Brando's acting.

47. Sheana Ochoa, *Stella! Mother of Modern Acting* (Milwaukee: Applause Theatre and Cinema Books, 2014), 21.

48. Ochoa, *Stella!*, 42. In total, the tradition of the Yiddish stage greatly informed Stella Adler's artistic and intellectual growth throughout her lifetime. During her final interview in 1992 with Barry Paris, she spends a great deal of time discussing her family, stressing a sadness over how the Yiddish theater had been largely forgotten: "But the Yiddish theatre was, I think, not what most people think it was. It was a great theatre." Adler's identity as a Jewish woman was something she held in great reverence, proving politically active especially during the post–World War II period when she smuggled Jewish refugees out of Europe. Stella Adler, audio recording of interview with Barry Paris, October 15, 1992, HRC.

49. Stella Adler, *The Technique of Acting* (New York: Bantam, 1988), 122.

50. Adler, interview with Barry Paris.

51. Quoted in Ochoa, *Stella!*, 99.

52. Adler, interview with Barry Paris.

53. Adler, *Technique of Acting*, 120.

54. Adler, interview with Barry Paris.

55. Quoted in Ochoa, *Stella!*, 101.

56. Carnicke, *Stanislavsky in Focus*, 60.

57. Robert Lewis, *Slings and Arrows: Theater in My Life* (New York: Stein and Day Publishers, 1984), 71.

58. Carnicke, *Stanislavsky in Focus*, 60.

59. Undated letter quoted in Ochoa, *Stella!*, 129.

60. See Sanford Meisner, *Sanford Meisner on Acting* (New York: Vintage Books, 1987). Along with Adler, Meisner emerged as the most famous American acting teacher to reject Strasberg's approach. Meisner's technique develops externally, as opposed to Method acting, which develops from an internal source such as emotional recall or sense memory. In this regard, his approach corresponds more with Adler than Strasberg. Meisner had the actor "get out of his head," so to behave instinctively to the surrounding environment. For example, some exercises for the Meisner technique are based on repetition so that the words are deemed insignificant compared to the reactions. In the Meisner technique, there is also more of an instinctual focus on the scene partner. Meisner was influential in his own way on male stardom, training such actors as Robert Duval, Peter Falk, and Jeff Bridges.

61. Robert Lewis, *Method—or Madness?* (1958; New York: Samuel French, 1986), 23. The book is a printing of a collection of lectures Lewis gave in 1957 to a standing-room-only audience of professional actors, directors, and writers in New York City.

62. Constantin Stanislavski, *Creating a Role*, trans. Elizabeth Hapgood (New York: Theatre Art Books, 1961). The other two books in the trilogy are *An Actor Prepares*, trans. Elizabeth Hapgood (New York: Theatre Art Books, 1936), and *Building a Character*, trans. Elizabeth Hapgood (New York: Theatre Art Books, 1949).

63. Stanislavski, *Creating a Role*, 150.

64. Carnicke, *Stanislavsky in Focus*, 61.

65. Baron, *Modern Acting*, xv.

66. Baron, *Modern Acting*, xvii.

67. Sophie Rosenstein with Larrae A. Haydon and Wilbur Sparrow, *Modern Acting: A Manual* (New York: Samuel French, 1936); Josephine Dillion, *Modern Acting: A Guide for Stage, Screen, and Radio* (New York: Prentice-Hall, 1940); Lillian Albertson, *Motion Picture Acting* (New York: Funk and Wagnalls, 1947). In *Modern Acting*, Baron provides a detailed examination of the lessons covered in these texts along with what is known of the instruction from the listed acting programs as well as individual tutors found on studio backlots. Many of these records show that the era's Modern techniques—especially when discussing script analysis, the focus of this book's fourth chapter—were continued by Adler at her studio.

68. Baron, *Modern Acting*, 248.

69. Baron, *Modern Acting*, 248.

70. Ochoa, *Stella!*, 238–41.

71. Transcript of Stanislavski Seminar, 1964, HRC.

72. Transcript of Stanislavski Seminar.

73. Transcript of Stanislavski Seminar.

74. Naremore, *Acting in the Cinema*, 199.

75. Transcript of Stanislavski Seminar, 1964, HRC.

76. With the Group Theatre, Adler appeared in hit plays, including Clifford Odets's *Awake and Sing!* (1935) and *Paradise Lost* (1935) and directed the touring company of Odets's *Golden Boy* (1937). In 1937, she went to Hollywood and acted in two films, *Love on Toast* (1937) and *Shadow of the Thin Man* (1941), occasionally returning to the Group Theater until it dissolved in 1941. She also appeared in a supporting role in the film *My Girl Tisa* (1948). See Ochoa's biography for more detail on Adler's acting career.

77. See Ochoa's biography for details on the various incarnations of her programs, studios, and conservatories. Throughout her lifetime, Adler's studio would exist under different names, referred to at times as the Stella Adler Theatre Studio, the Stella Adler School for Acting, the Stella Adler Conservatory of Acting, and variations on these. Today, the New York City location is known as the Stella Adler Studio of Acting while the Los Angeles location is called the Stella Adler Academy of Acting. Since her archived materials show a consistency of instruction through all these incarnations, as well as in her guest teaching at different programs, throughout this book, I will refer to all these spaces simply as Adler's *studio* or *classroom*.

78. Suzanne O'Malley, "Can the Method Survive the Madness?" *New York Times*, October 7, 1979, SM8+. For more of the increased press coverage on Adler, see also La Wrence Christon, "Stella Adler Sums Up a Life in Theatre," *Los Angeles Times*, September 6, 1988, I1; Rue Faris Drew, "The Truth of Your Art Is in Your Imagination," *New York Times*, August 15, 1976, 65+; Phillip Rosenfield, "Stella Adler: Teaching Actors How to Imagine," *Los Angeles Times*, August 15, 1982, L15; Mervyn Rosenstein, "Stella Adler in Her Latest Role: Author," *New York Times*, September 4, 1988, H3; Dan Sullivan, "Stella's Green Thumb in a Hothouse of Actor Training," *Los Angeles Times*, June 21, 1970, Q34. Also, in 1989, Adler was the subject of an episode of PBS's *American Masters* titled *Stella Adler: Awake and Dream!*

79. Brochure Draft, 1958, Stella Adler Theatre Studio, HRC.

80. Brochure Draft.

81. Baron, *Modern Acting*, 53.

82. Carnicke, *Stanislavsky in Focus*, 173.

83. Adler, *Technique of Acting*, 35.

84. This approach is external in that it privileges the characterization and circumstances as dictated by the script over any deeply rooted personal memory or emotion in the actor, which would be interior. Adler writes in *Technique*, "the circumstances that the playwright gives you will make you aware of such important elements." As such an approach suggests, she was not simply interested in "the Method of Physical Action" to discount emotional memory, a technique she found limiting and even harmful to students. In her approach, the external privileges a movement away from the personal psychological interior of the actor—a way to encourage an engagement with something larger than "self." Adler, *Technique of Acting*, 67.

85. Stanislavski, *Creating a Role*, 152.

86. Adler, *Technique of Acting*, 106.

87. Adler, *Technique of Acting*,

88. Rosemary Malague, *An Actress Prepares: Women and "the Method"* (London: Routledge, 2012), 93. While her classrooms were relatively gender inclusive, Adler was a product of her time and often reflected the period's gender biases when speaking. A clear indication is found in her privileging of masculine pronouns. The "actor" as an ideal subject is routinely referred to as a male unless she is directly addressing a female student.

89. Stella Adler, *The Art of Acting*, ed. Howard Kissel (New York: Applause, 2000), 24.

Notes to Chapter 2

1. "Beefcake for Cheesecake," *Vogue*, May 15, 1953, 52.

2. "Beefcake for Cheesecake," 52, 53.

3. Laura Mulvey, "Visual Pleasure and Narrative Cinema," in *Issues in Feminist Film Criticism*, ed. Patricia Erens (Bloomington: Indiana University Press, 1990), 33.

4. The photo spread can be read as conforming to the essential dichotomies found in depicting male bodies that was established in 1970s film theory. When scholars first considered cinematic masculinity through the foundations of Mulvey, who suggested, the "male figure cannot bear the burden of sexual identification," the concept of negating desirability, often through some form of physical "action," proved central to their proclamations—with Steve Neale writing in 1983, "the erotic elements involved in the relations between the spectator and the male image have constantly to be repressed and disavowed." Mulvey, "Visual Pleasure," 34. Steve Neale, "Masculinity as Spectacle: Reflections on Men in Mainstream Cinema," in *Screening the Male: Exploring Masculinities in Hollywood Cinema*, ed. Steven Cohan and Ina Rae Hark (London: Routledge, 1993), 19.

5. Miriam Hansen, "Pleasure, Ambivalence, Identification: Valentino and Female Spectatorship," in *Star Texts*, ed. Jeremy G. Butler (Detroit: Wayne State University Press, 1991), 284.

6. Peter Lehman, *Running Scared: Masculinity and the Representation of the Male Body* (Detroit: Wayne State University Press, 2007), 22. Foundationally, since cinema generally is based in objectifying bodies, males can obtain a power in the active display of bodily desirability. As Lehman suggests, even if we contend to Mulvey's basic dichotomy of male activeness and female passivity on screen, that does not necessarily negate the erotic nature of male bodies since "while watching a movie everyone is looking at representations of bodies in ways that include, but are not limited to, objectification. The cultural phenomenon surrounding the star system, for example, clearly illustrates this." Lehman, *Running Scared*, 7.

7. Ernest Jacobi, "A Character—But Still Brando," *Photoplay*, June, 1955, 91.

8. Kenneth Krauss, *Male Beauty: Postwar Masculinity in Theater, Film, and Physique Magazines* (Albany: State University of New York Press, 2014), 168.

9. "Beefcake for Cheesecake," 53.

10. Grady Johnson, "Marlon Brando: Actor on Impulse," *Coronet*, July 1952, 78.

11. Krauss, *Male Beauty*, 167–68.

12. Steven Cohan, *Masked Men: Masculinity and the Movies in the Fifties* (Bloomington: Indiana University Press, 1997), 252.

13. Pete Martin, "The Actor Who Sneers at Hollywood," *Saturday Evening Post*, June 6, 1953, 32.

14. Martin, "Actor Who Sneers,"

15. Martin, 85.

16. Susan L. Mizruchi, *Brando's Smile: His Life, Thought, and Work* (New York: W. W. Norton, 2014), xv.

17. Mizruchi, *Brando's Smile*, xxx.

18. Raised in Omaha, Nebraska, and Libertyville, Illinois, Brando had many reasons to find himself fascinated by the cosmopolitan Adler and everything she represented in terms of a stage history. His early experiences with her and her family, including a romantic relationship with Stella's daughter Ellen, meant he spent much time with the Adlers, including matriarch Sara Adler during the last years of her life. Marlon Brando, with Robert Lindsey, *Brando: Songs My Mother Taught Me* (New York: Random House, 1994), 81.

19. Mizruchi, *Brando's Smile*, 44–45.

20. Brando, *Brando: Songs*, 83.

21. Transcript of "Introduction to Techniques I," ND, HRC. While the transcript is undated, it is most likely from 1960, as Adler references *The World of Suzie Wong* (1960) as a contemporary film.

22. Transcript of "Introduction to Techniques I."

23. Typed notecard, "Technique I," April 1950–December 1951 classes, ND, HRC.

24. Typed notecard.

25. Typed notecard.

26. As director Elia Kazan suggests, the moment was at least partly improvised. He uses the moment to discuss Method acting and subtext in an interview: "The glove was his way of holding her. Furthermore, whereas he couldn't, because of this tension about her brother being killed, demonstrate any sexual or loving feeling towards her, he could toward the glove." Quoted in James Naremore, *Acting in the Cinema* (Berkeley: University of California Press, 1988), 193.

27. James Naremore, *Acting in the Cinema* (Berkeley: University of California Press, 1988), 203–4.

28. Naremore, *Acting*, 204.

29. Stella Adler, *The Technique of Acting* (New York: Bantam, 1988), 41.

30. Typed notecard, "Technique, 1963, Nature of Experience, Talk—Effective Memory + Nature of Experience," ND, HRC.

31. Typed notecard, "Technique, 1963, Talk: Effective Memory," ND, HRC, emphasis added.

32. Recording of "Techniques II: Discuss, Argue, Talk," NYU, March 21, 1973, HRC.

33. Recording of "Techniques II: Discuss, Argue, Talk."

34. Stella Adler, *The Art of Acting*, ed. Howard Kissel (New York: Applause Books, 2000), 35.

35. Adler, *Technique of Acting*, 17.

36. Adler, *Technique of Acting*, 24.

37. Adler, *Technique of Acting*, 18.

38. Recording of "Techniques II: Discuss, Argue, Talk," NYU, March 21, 1973, HRC.

39. Recording of "Techniques II: Discuss, Argue, Talk."

40. Joanna Rotté, *Acting with Adler* (New York: Limelight, 2000), 100.

41. Rotté, *Acting with Adler*, 101.

42. Rotté, 102.

43. As explained in *The Technique of Acting*, justification can come in various forms, since, much like in life, actions onstage have differing levels of significance. "Instant Justification" defines an immediate need, for example: "Why are you closing the window? The shade was rattling." "Justification in the Circumstances" would be related to a larger narrative purpose: "Why are you locking the door? To test the alarm system." Adler, *Technique of Acting*, 48.

44. Adler, *Technique of Acting*, 56.

45. Rotté, *Acting with Adler*, 103.

46. Recording of "Technique II: Attitude to Partner," NYU, February 15, 1973, HRC.

47. Recording of "Technique II: Attitude to Partner."

48. Typed class notes, "Beginner's class, ATTITUDE ... JUSTIFICAITON / ELEMENTS IN ENVIROMENT," April 3, 1950, HRC.

49. Recording of "Technique I: 2nd Class," NYU, October 16, 1972, HRC.

50. Recording of "Technique I: 2nd Class."

51. Rotté, *Acting with Adler*, 53. Adler's class recordings and transcripts are filled with such exercises, where students report back on trips to museums or library research. These all contribute to her overall philosophy of privileging the imagination as a vehicle to understanding the given circumstances of the play. In a March 9, 1972, class, she states, "In approaching a play, you must first find out the class of your character and the social background or environment of the play's setting. These are the larger circumstances of the play in which your character lives and is therefore real. You must know the costumes, the social customs, the morals and ethics of that time, the music, the architecture, the shops, in effect, everything you can about the time and the people from which you can build a background and fill the outline of the play. Knowing all this will help fire your imagination and create the truth of your character in his situation." Transcript, "TECHNIQUE II: FEB–MAY 1972," HRC.

52. Rotté, *Acting with Adler*, 52–53.

53. Rotté, 53.

54. Recording of "Technique 2," NYU, October 15, 1973, HRC.

55. Mizruchi, *Brando's Smile*, xxvi.

56. Mizruchi, *Brando's Smile*, xxvii.

57. Brando, *Brando: Songs*, 84.

58. Judith Butler, *Bodies That Matter: On the Discursive Limits of Sex* (London: Routledge, 1993), 2.

59. Butler, *Bodies That Matter*, 7. It is important to recognize that while Butler is certainly not proposing a view of gender promoting "essentialism" (gender as biologically determined), she is also not proposing gender as "constructivist," behaviors imposed by familial or cultural determinants. Butler dismisses such a binary framework when considering gender, writing that the debate between constructivism and essentialism "misses the point of deconstruction altogether" since for "there is an 'outside' to what is constructed by discourse, but this is not an absolute 'outside,' an ontological there-ness that exceeds or counters the boundaries of discourse." Butler, *Bodies That Matter*, 8.

60. Butler, *Bodies That Matter*, 2.

61. Butler, 3.

62. Rosemary Malague, *An Actress Prepares* (London: Routledge, 2012), 75.

63. R. W. Connell, *Masculinities*, 2nd ed. (Berkeley: University of California Press, 2005), 56.

64. When approaching his characters, Williams can be read as an ironist, providing a queer commentary on social definitions of gender in such plays as *Streetcar*, *Cat on a Hot Tin Roof* (1955), and *Sweet Bird of Youth* (1959). The characters in such works welcome a deconstruction of gender performativity by actors since, thematically, the historical relativities of gender definitions were a central concern to Williams. For a reading of his work through a queer lens, see John Bak, *Homo Americanus: Ernest Hemingway, Tennessee Williams, and Queer Masculinities* (Madison, NJ: Fairleigh Dickinson University Press, 2010); Annette J. Saddik, *Tennessee Williams and the Theatre of Excess: The Strange, the Crazed, the Queer* (Cambridge: Cambridge University Press, 2015); and David Savran, *Communists, Cowboys, and Queers: The Politics of Masculinity in the Work of Arthur Miller and Tennessee Williams* (Minneapolis: University of Minnesota Press, 1992).

65. Savran, *Communists, Cowboys, and Queers*, 80.

66. Savran, 80–81.

67. Tennessee Williams, *A Streetcar Named Desire* (New York: New Directions Publishing, 1947, 2004), 24–25.

68. Williams, *Streetcar*, 179.

69. Philip C. Kolin, *Williams: A Streetcar Named Desire* (Cambridge: Cambridge University Press, 2000), 9.

70. Kolin, *Williams*, 9–10.

71. Tennessee Williams, April 19, 1947, quoted by Kazan in Elia Kazan, *Kazan on Directing* (New York: Alfred A. Knopf, 2009), 62.

72. Quoted in Savran, *Communists, Cowboys, and Queers*, 25.

73. Brando's youthful appeal found many responding to Stanley with more sympathy than warranted, as the character would be described in youthful terms like "bully" rather than the more mature "brute." Harold Clurman responded to the performance believing Brando provided a "combination of an intense, introspective, and almost lyrical personality under the mask of a bully," suggesting the actor "endows [Stanley] with something almost touchingly painful." Quoted in Savran, *Communists, Cowboys, and Queers*, 29.

74. Kolin, *Williams*, 27.

75. Brando, *Brando: Songs*, 121–22.

76. Charles Higham, *Brando* (New York: New Amsterdam Library, 1987), 82.

77. Mizruchi, *Brando's Smile*, 70.

78. Williams, *Streetcar*, 25.

79. Williams, 26–28.

80. Williams, 27.

81. Carla J. McDonough, *Staging Masculinity: Male Identity in Contemporary American Drama* (Jefferson, NC: McFarland, 1997), 29.

82. Krauss, *Male Beauty*, 143.

83. Steven Cohan, *Masked Men*, 248.

84. Some of Brando's gestures in the scene could be considered *stage business*, movements performed more for overall dramatic effect and less directly related to interactions with his costar. It would be logical to conclude that some of these gestures were developed during Brando's many performances of Kowalski on Broadway, where he registered audience response. While stage business can sometimes be ascribed to "scene stealing" with a partner, its successful employment is still related to careful preparation by the actor. As Jean Sabatine writes, "*Which* gesture one uses and when one uses it are stage business concerns, best handled by the actor and director in rehearsal. . . . Of course the primary *how* is answered by these principles: precision, sequence, and clarity." Working with Adler, Brando would have had training in breaking down scenes and considering precision, sequence, and clarity. Especially in early performances, stage business feels motivated by narrative considerations of the play. In later performances, Brando's gestures sometimes feel less clearly motivated by the script, as seen in his postmodern performance in *The Missouri Breaks* (1976), discussed in the next chapter. Jean Sabatine, *Movement Training for the Stage and Screen: The Organic Connection between Mind, Spirit, and Body* (New York: Back Stage Books, 1995), 119.

85. Brando, *Brando: Songs*, 124, 121.

86. Brando, 121.

87. Brando, 124, 122.

88. Brando, 124.

89. Williams, *Streetcar*, 33–35.

90. Brando, *Brando: Songs*, 121.

91. Williams, *Streetcar*, 29.

92. Williams, 30.

93. Williams.

94. Williams, 32.

95. Williams, 33.

96. In the play, this line reads, "You're damn tootin' I'm going to stay here." Williams, 36.

97. Brando, *Brando: Songs*, 121.

98. Rotté, *Acting with Adler*, 103.

99. Mizruchi, *Brando's Smile*, 74.

100. Mizruchi, 74.

101. Transcript of lecture, "Script Interpretation—Social Situation—Tennessee Williams," April 5, 1982, p. 1, HRC.

102. Transcript of lecture, "Script Interpretation—Social Situation," p. 2.

103. Transcript of lecture, "Script Interpretation—Intro to Williams," March 29, 1982, p. 19, HRC.

104. Transcript of lecture, "Script Interpretation—Intro to Williams," p. 20.

105. Letter reproduced in Brando, *Brando: Songs*, 119.

106. Kaja Silverman, *Male Subjectivity at the Margins* (London: Routledge, 1992), 55.

107. Silverman, *Male Subjectivity*, 120–21.

108. Removed from the generic classification of the Hollywood melodrama, as a play, *Streetcar* examines the returning veteran in a different manner than the films considered by Silverman. Yet it remains acutely aware of trauma as an agent exposing male lack. As Larry T. Blades writes, the play takes a "much bleaker, less 'Hollywood' view of the reintegration of the returning vet" than found in the cinema discussed by Silverman. Williams inverts the conventional Hollywood plot: "Instead of the familiar pattern in which the confused and bitter vet finds meaning in commitment of community, we are given a plot in which an aggressive and brutal vet finds meaning in a violent assertion of his individual self and his antisocial urges." Larry T. Blades, "The Returning Vet's Experience in *A Streetcar Named Desire*: Stanley as the Decommissioned Warrior Under Stress," *Tennessee Williams Annual Review* 10 (2009): 17–18.

109. John L. Gronbeck-Tedesco, "Absence and the Actor's Body: Marlon Brando's Performance in *A Streetcar Named Desire* on Stage and in Film," *Studies in American Drama, 1945–Present* 8, no. 2 (1993): 118.

110. Williams, *Streetcar*, 154.

111. Williams, 160.

112. Butler, *Bodies That Matter*, 3.

Notes to Chapter 3

1. Blake Eskin, "Ste-lla! Brando's Geshrei for Yiddish Theater," *The Forward*, July 30, 1999, 12.

2. Eskin, "Ste-lla!," 1. The article takes some of these overly dramatic proclamations with a grain of salt since the call was made somewhat as a desperate plea to save the location of the studio and, afterward, a deal was worked out to give the school a two-year reprieve. The piece appeared at an interesting time as the actor had run into controversy just three years earlier for telling CNN's Larry King, in discussing Hollywood's history of negative stereotypes on screen, that "Hollywood is run by Jews. It's owned by Jews and they should have a greater sensitivity about the issue of people who are suffering." Ironically, the problematic statement was born out of Brando's own idealization of Jewish creatives as more socially sensitive individuals than other groups. Brando later tearfully apologized to a group of Los Angeles rabbis, proclaiming his long support of civil rights and Jewish causes. "Weeping Brando Apologises to Jews," *Independent*, April 13, 1996), http://www.independent.co.uk/news/world/weeping-brando-apologises-to-jews-1304594.html.

3. Eskin, "Ste-lla!," 12.

4. Eskin.

5. See Sheana Ochoa, *Stella! Mother of Modern Acting* (Milwaukee: Applause Theatre and Cinema Books, 2014), 191–95.

6. Eskin, "Ste-lla!," 12.

7. Susan L. Mizruchi, *Brando's Smile: His Life, Thought, and Work* (New York: W. W. Norton, 2014), 56–67.

8. Marlon Brando with Robert Lindsey, *Brando: Songs My Mother Taught Me* (New York: Random House, 1994), 81.

9. Valleri J. Hohman, *Russian Culture and Theatrical Performance in America, 1891–1933* (New York: Palgrave Macmillan, 2011), 12.

10. Hostile attitudes toward Jews continued in Russia well into the Revolution, a period that initiated the final wave of pogroms from 1918 to 1922. For more on the history of the attacks on Russian Jewish culture during the years of the Revolution see Jonathan Frankel, *Crisis, Revolution, and Russian Jews* (Cambridge: Cambridge University Press, 2009), 57–156.

11. While Stanislavski and the Moscow Art Theatre rose in popularity post-Revolution on the world stage as representing a Soviet theatrical style of realism, there was the establishment of the Moscow Yiddish State Art Theatre (1919–49), which means the tradition did not completely die in the USSR during this time. See Nahma Sandrow, *Vagabond Stars: A World History of Yiddish Theater* (New York: Harper and Row, 1977), 222–50.

12. In America, acting programs did exist from the late nineteenth century onward in greater New York City, Boston, and Philadelphia. These schools often embraced the premodern taxonomy of facial and gestural expressions associated with François Delsarte, methods that would be denounced by followers of Stanislavski. Yet also, as Cynthia Baron notes, "In general, the schools established in the late nineteenth century rejected the older conservative method in which master teachers demonstrated how scenes should be played." As James McTeague shows, many of the teachers "believed that the actor must identify with the character, think and

feel *as* the character." Some of these programs could be considered as precursory to later acting programs, even if the central tenets of Delsarte were rejected by Modern teachers. Cynthia Baron, *Modern Acting: The Lost Chapter of American Film and Theatre* (London: Palgrave Macmillan, 2016), 94. James McTeague, *Before Stanislavsky: American Professional Acting Schools and Acting Theory, 1875–1925* (Metuchen, NJ: Scarecrow Press, 1993), 243.

13. Ochoa, *Stella!*, 50.

14. Hohman, *Russian Culture*, 4.

15. Hohman, *Russian Culture*, 46.

16. Stella Adler, Introduction to *A Life on the Stage*, by Jacob Adler, trans and ed. Lulla Rosenfeld (New York: Knopf, 1999), xiv.

17. Jacob Gordin (1853–1909) was a Russian-born American playwright best known for introducing realism and naturalism into Yiddish theater, earning the title "Reformer of the Yiddish Stage." Upon his arrival in America, he found the Yiddish theater vulgar and focused mainly on historical operettas. Gordin's first great success, *The Yiddish King Lear* (1892), made his reputation and featured Jacob Adler in the title role. Gordin went on to create lead roles for Adler in *The Wild Man* (1893) and *Elisha ben Abuye* (1906). As in other works of Yiddish theater, dancing and songs unrelated to the plot still appeared as well as expressionistic melodrama. Yet Gordin's plots and style were largely viewed as more naturalistic. For example, the characters speak colloquial Yiddish rather than the affected Germanized Yiddish favored by the bombastic theater style of the day. Due to Gordin's output, many Jewish actors, Jacob Adler among them, began to regard their profession with more earnest conviction. See Beth Kaplan, *Finding the Jewish Shakespeare: The Life and Legacy of Jacob Gordin* (Syracuse, NY: Syracuse University Press, 2007).

18. Hohman, *Russian Culture*, 22.

19. Adler, Introduction, xv.

20. Adler, Introduction, xviii.

21. Adler, Introduction, xvii.

22. Ochoa, *Stella!*, 185.

23. Mizruchi, *Brando's Smile*, 38.

24. Mizruchi, *Brando's Smile*, 39. These approaches would be consistent with both the New York Yiddish and modern theater's preoccupations with social realism and sympathy for the downtrodden. As such, a major element of their styles would consist of culling observations from the outside world in crafting performance. As Mizruchi observes, "Jacob Adler's empathy, like Brando's, was bolstered by their shared habit of social observation. Adler loved watching people, especially in the courtroom." Tellingly, observing people at the courthouse was also a favorite activity of Brando during his New York City days. Mizruchi, *Brando's Smile*, 39–40.

25. For more on the life and career of Paul Muni, see Jerome Lawrence, *The Life and Times of Paul Muni* (New York: Putnam, 1974), and Michael Druxman, *Paul Muni: His Life and His Films*, rev. ed. (Albany, GA: BearManor Media, 2016).

26. Mizruchi, *Brando's Smile*, 57.

27. Mizruchi, 64.

28. Nahma Sandrow, "Romanticism and the Yiddish Theatre," in *Yiddish Theatre: New Approaches*, ed. Joel Berkowitz (Oxford: Littman Library of Jewish Civilization, 2003), 47.

29. Sandrow, "Romanticism."

30. Sandrow, 53.

31. Stella Adler, *The Art of Acting* ed. Howard Kissel, (New York: Applause, 2000), 29.

32. Video interview with Bob Crane, "Stella Adler and the Actor," KTLA 1964, HRC.

33. Stella Adler, *The Technique of Acting* (New York: Bantam, 1988), 105. See chapter 6 for more on *size* as significant to Adler's philosophies of acting.

34. Adler, *Technique of Acting*, 66

35. Recording of "Character Class," November 6, 1958, HRC.

36. As examples in class, Adler would include the fairies in Shakespeare's *A Midsummer Night's Dream* and Mephistopheles in Marlowe's *Doctor Faustus*.

37. Adler, *Technique of Acting*, 67.

38. Joanna Rotté, *Acting with Adler* (New York: Limelight, 2000), 136.

39. Rotté, *Acting with Adler*, 137–38.

40. Rotté, 100.

41. Recording of "Character Class," January 5, 1959, HRC. In Adler's characterization classes, she often employs the adjective "social" in discussing characters that would appear in modern drama or, here, generally modern media. When considering the *social situation* as defining a characterization, she would often refer to a character as a "social character," "social type," or another variation on this phrasing. As this suggests, Adler saw social determinism as a fundamental consideration in crafting modern characterization.

42. Recording of "Character Class."

43. Recording of "Character Class."

44. Recording of "Character Class."

45. Nahma Sandrow, *Vagabond Stars: A World History of Yiddish Theater* (New York: Harper and Row, 1977), 158.

46. Sandrow, *Vagabond Stars*, 141.

47. Sandrow, 129.

48. Hohman, *Russian Culture*, 23.

49. Typed notes of "BEGINNING LESSON TWENTY SIX: CHARACTERIZATION," May 1, 1950, HRC.

50. Typed notes of "Characterization Notes, First Class," 1958, ND, HRC.

51. The final thirty-five years of Pavlov's research were devoted to the investigation of the conditioned reflex and the study of the human brain. His conditioning model had an enormous influence on behavioral psychology. For Pavlov, the unconscious processes were reflexes that could be conditioned to affect behavioral change. In a broader sense, outside of the laboratory, this could be understood as a social

conditioning. For more information, see Daniel Todes, *Ivan Pavlov: A Russian Life in Science* (Oxford: Oxford University Press, 2014).

52. Rose Whyman, *Stanislavski: The Basics* (London: Routledge, 2013), 151–52.

53. First outlined in his 1898 publication *The Psychology of the Emotions*, Ribot defined affective memory as a type of memory that causes the rememberer to re-experience emotions from a past event. This consists of more than simply recalling being, for example, happy or sad. This experience would mean physically and mentally experiencing those emotions once again. Théodule-Armand Ribot, *The Psychology of Emotions* (London: Walter Scott, 1898).

54. Sharon M. Carnicke, *Stanislavsky in Focus* (Amsterdam: Harwood Academic Publishers, 1998), 150.

55. Recording of "Character Class," December 1958, HRC.

56. Recording of "Character Class," December 1958.

57. Recording of "Character Class," October 30, 1958, HRC.

58. Recording of "Character Class," October 30, 1958.

59. Hohman, *Russian Culture*, 38–39.

60. Susan White, "Marlon Brando: Actor, Star, Liar," in *Larger Than Life: Movie Stars of the 1950s*, ed. R. Barton Palmer (New Brunswick, NJ: Rutgers University Press, 2010), 169.

61. White, "Marlon Brando," 169–70.

62. White, 179–80.

63. White, 180.

64. Mizruchi, *Brando's Smile*, 235. Similar exercises with makeup are heard in Adler's characterization classes, as her former student Jenny Egan would show students how adding makeup alters the body in a way that is more for the performer than the audience. In these lessons, Egan and Adler discuss how physical deterrents to seeing (like false eyelashes) or talking (like false teeth) might change one's physical manner in a way that adds to the performance choices. Recording of "Character Class," October 28, 1958, HRC.

65. Mizruchi, *Brando's Smile*, 244.

66. The dialogue represents an amalgam of Brando's real-life biography and film roles. He was both an actor and did play bongo drums as a hobby. In *On the Waterfront*, Brando played a boxer and racketeer. He plays a revolutionary in *Viva Zapata!*; *Mutiny on the Bounty* (1962) is set in Tahiti, a location the real-life Brando grew to love.

67. Linda Williams, *Screening Sex* (Durham, NC: Duke University Press, 2008), 114.

68. Pauline Kael, "Tango," *New Yorker*, October 28, 1972, 130, 134.

69. Mizruchi, *Brando's Smile*, 230.

70. Mizruchi, *Brando's Smile*, 232.

71. Quoted in David Thompson, *The Last Tango in Paris* (London: British Film Institute, 1998), 68.

72. Brando, *Brando: Songs*, 426–28.

73. Adler, *Technique of Acting*, 9.

74. R.W. Connell, *Masculinities*, 2nd ed. (Berkeley: University of California Press, 2005), 76.

75. Connell, *Masculinities*, 77.

76. Connell, *Masculinities*, 78. While Connell employs homosexuality as a modern example of subordination, she makes a point to state that some "heterosexual men and boys are expelled from the circle of legitimacy," with labels like "wimp" or "nerd" denoting a symbolic "blurring with femininity." Connell, *Masculinities*, 79.

77. Connell, *Masculinities*.

78. Connell, 80.

79. Connell, 81.

80. The shooting of the "butter scene" represents one of the most controversial moments in Modern cinematic acting. Schneider was only nineteen during production and felt unable to refuse to perform the sequence. In a 2007 interview, she described the shooting as emotionally traumatic: "Marlon said to me: 'Maria, don't worry, it's just a movie,' but during the scene, even though what Marlon was doing wasn't real, I was crying real tears. I felt humiliated and to be honest, I felt a little raped, both by Marlon and by Bertolucci." While Schneider later maintained a friendship with Brando, she characterized Bertolucci as "fat and sweaty and very manipulative, both of Marlon and myself.... Marlon later said that he felt manipulated, and he was Marlon Brando, so you can imagine how I felt." Questions remain if the rape existed at all in the original shooting script. Schneider maintained, "That scene wasn't in the original script. The truth is it was Marlon who came up with the idea. They only told me about it before we had to film the scene and I was so angry." In 2016, Bertolucci suggested otherwise, "Maria knew everything because she had read the script, where it was all described. The only novelty was the idea of the butter." Lina Das, "I Felt Raped by Marlon Brando," *DailyMail.com*, July 29, 2007, http://www.dailymail.co.uk/tvshowbiz/article-469646/I-felt-raped-Brando.html; Nick Vivarelli, "Bernardo Bertolucci Responds to 'Last Tango in Paris' Backlash over Rape Scene," *Variety.com*, December 5, 2016, http://variety.com/2016/film/global/bernardo-bertolucci-responds-to-last-tango-in-paris-backlash-1201933605/.

81. Williams, *Screening Sex*, 117.

82. Some reviewers saw the performance as actor vanity at its worse. Vincent Canby, in his *New York Times* review upon its release, criticized the performance as "out-of-control" since Brando "behaves like an actor in armed revolt." Vincent Canby, "'Missouri Breaks' Offbeat Western," *New York Times*, May 20, 1976, www.nytimes.com/1976/05/20/archives/missouri-breaks.

83. Mizruchi, *Brando's Smile*, 257.

84. Nick Kaye, *Postmodernism and Performance* (New York: St. Martin's Press, 1994), 2.

85. Linda Hutcheon, *A Poetics of Postmodernism: History, Theory, Fiction* (New York: Routledge, 1988), 22.

86. Kaye, *Postmodernism and Performance*, 22.

87. Kaye, *Postmodernism and Performance*, 23.

88. These groups of men would be standard western archetypes, with one group representing a civilizing order (the barons) and the other a rugged individuality (the rustlers). For more on these classifications of maleness in the genre, see Lee Clark Mitchell, *Westerns: Making the Man in Fiction and Film* (Chicago: University of Chicago Press, 1996).

89. Mizruchi, *Brando's Smile*, 259.

90. Other such broad performances include his bloated oil tycoon in *The Formula* (1980) and his walrus-like Swedish prison warden in *Free Money* (1998). Yet some late-career performances still display his ability to craft subtle and effective screen characterizations in supporting roles, such as in *A Dry White Season* (1989), *Don Juan DeMarco* (1995), and his final completed film, *The Score* (2001), where his scenes with Robert De Niro are the highlights of an otherwise routine heist film.

91. Benjamin Svetkey, "Marlon Brando's Real Last Tango: The Never-Told Story of His Secret A-List Acting School," *Hollywood Reporter*, June 11, 2015, http://www.hollywoodreporter.com/news/marlon-brandos-real-last-tango-801232.

92. Mizruchi, *Brando's Smile*, 355.

93. Svetkey, "Marlon Brando's Real Last Tango."

Notes to Chapter 4

1. Typed document, "I'm a Capitalist," RDP, ND, HRC. The archived document has a post-it note attached labeling it as "Stella Adler," i.e., from her class. While possibly from a play, the document does not credit the speech from any playwright or work.

2. Typed document, "I'm a Capitalist."

3. Stella Adler, *The Technique of Acting* (New York: Bantam Books, 1988), 114.

4. For more on the life and career of Robert De Niro, see John Baxter, *De Niro: A Biography* (London: Harper Collins, 2002); Andy Dougan, *Untouchable: A Biography of Robert De Niro* (New York: Thunder's Mouth Press, 2002); and Shawn Levy, *De Niro: A Life* (New York: Crown Archetype, 2014).

5. Sheana Ochoa, *Stella! Mother of Modern Acting* (Milwaukee, WI: Applause Theatre and Cinema Books, 2014), 227.

6. Ochoa, *Stella!*. De Niro's opinion of Adler appears to be defined by a respect of her ideas and approach, even if her theatrical personality was off-putting to the young actor. As he stated in 2012, "I always gave her credit for script analysis and her approach towards acting. Just for the record, I wanted to do that. How she behaved, her affectation, that whole side of her . . . I never cared for personally. But she made a lot of sense as a teacher. She had a very healthy approach toward acting and technique, although she was a little at odds with the Studio and Strasberg and all that, but then she had a great actor, Brando, with her." Sheana Ochoa, "Robert De Niro: I Am Prone to Overanalysis," *Salon*, March 16, 2012, http://www.salon.com/2012/03/16/robert_de_niro_im_prone_to_overanalysis/.

7. Baxter, *De Niro: A Biography*, 5–6.

8. Ochoa, "Robert De Niro."

9. Rosemary Malague, *An Actress Prepares* (London: Routledge, 2012), 91.

10. The lectures went beyond what is found in her only publication during her lifetime, *The Technique of Acting* (1988), which only has one chapter focused on analyzing the script. Recognizing this oversight, during the final months of her life, she gave permission to publish a collection of her lectures on playwrights to Barry Paris, who edited them as *Stella Adler on Ibsen, Strindberg, and Chekhov* (1999) and *Stella Adler on America's Master Playwrights* (2012). Stella Adler, *Stella Adler on Ibsen, Strindberg, and Chekhov*, ed. Barry Paris (New York: Vintage Books, 1999); Stella Adler, *Stella Adler on America's Master Playwrights: Eugene O'Neill, Thornton Wilder, Clifford Odets, William Saroyan, Tennessee Williams, William Inge, Arthur Miller, Edward Albee*, ed. Barry Paris (New York: Alfred A. Knopf, 2012).

11. John Randolph, "STELLA ADLER: 'Acting Should be a Joy,' " *New York Times*, January 24, 1993, http://www.nytimes.com/1993/01/24/theater/l-stella-adler-acting-should-be-a-joy-464293.html.

12. R. Colin Tait, "When Marty Met Bobby: Collaborative Authorship in *Mean Streets* and *Taxi Driver*," in *A Companion to Martin Scorsese*, ed. Aaron Baker (Malden, MA: Wiley-Blackwell, 2015), 294.

13. Brochure Draft, 1958, Stella Adler Studio, HRC.

14. Adler, *Stella Adler on America's Master Playwrights*, 3. In a footnote, Barry Paris dates this lecture, here reproduced in a chapter titled "Actor vs. Interpreter," from 1983. As confirmed in archived materials at the HRC, this was a variation of a lecture she often used to start the term on script interpretation.

15. Adler, *Stella Adler on America's Master Playwrights*, 4.

16. Adler, 5. Emphasis added.

17. Recording of "Summer 1980—Scene Interpretation," Los Angeles, ND, HRC.

18. Recording of "Summer 1980—Scene Interpretation."

19. Recording of "Summer 1980—Scene Interpretation."

20. Adler, *Stella Adler on America's Master Playwrights*, 11.

21. Many exercises of previous courses are conceived as preparation for script analysis as they were designed to expand intellectual curiosity. For example, Adler promotes discussion of topical issues in her courses not so much for students to express their own opinions but to have them generally practice expressing complex and uncomfortable topics. In *The Technique of Acting*, before outlining such exercises on issues such as abortion, capital punishment, and marriage, she writes, "The discussion of ideas is at the center of the modern theatre. . . . In discussion, one must recognize the difference between issues of varying weight and importance, and judge between the larger and the smaller ones." Adler, *Technique of Acting*, 106.

22. Malague, *An Actress Prepares*, 92.

23. Malague, *An Actress Prepares*, 94.

24. Joanna Rotté, *Acting with Adler* (New York: Limelight, 2000), 175. In many

ways, these questions are similar to the questions asked when building a characterization, a process also referred to as considering the *social situation*, as discussed in the previous chapter. Since the script would be the primary tool for considering how to create a character, it makes sense that the same phrase, social situation, would be employed for analyzing the culture surrounding the play and the culture surrounding the specific character within the play.

25. Rotté, *Acting with Adler*.

26. Rotté, 175–76.

27. Rotté, 176.

28. Transcript, "Analysis of Scripts," February 27, 1961, HRC.

29. Transcript, "Analysis of Scripts."

30. Transcript, "Analysis of Scripts."

31. Notecard, "Scene Analysis: Facts," ND, HRC.

32. Notecard, "Scene Analysis: Facts."

33. Notecard, "Scene Analysis: Facts."

34. Adler, *Stella Adler on America's Master Playwrights*, 328.

35. Adler, *Stella Adler on America's Master Playwrights*, 330.

36. A "crisis of masculinity" for white manhood, a privileged position in society, is, of course, a problematic concept. See the introduction for more on the debates surrounding this classification.

37. Adler, *Stella Adler on America's Master Playwrights*, 331.

38. Recording of "Summer 1980-Scene Interpretation," Los Angeles, ND, HRC.

39. Recording of "Summer 1980-Scene Interpretation."

40. Recording of "Summer 1980-Scene Interpretation."

41. Adler, *Stella Adler on America's Master Playwrights*, 297–98.

42. Adler, *Stella Adler on America's Master Playwrights*, 299–300.

43. Adler, 300.

44. Adler, 301.

45. Transcript of "Come Back, Little Sheba," January 14, 1980, HRC.

46. *Sexual Behavior in the Human Male* and *Sexual Behavior in the Human Female*, studies based upon sex surveys directed by Alfred C. Kinsey, astounded the public and were immediately controversial upon their releases in 1948 and 1953. See Miriam G. Reumann, *American Sexual Character: Sex, Gender, and National Identity in the Kinsey Reports* (Berkeley: University of California Press, 2005).

47. Transcript of "Come Back, Little Sheba."

48. Transcript of "Come Back, Little Sheba."

49. Kevin Alexander Boon writes that screenplays "occupy a space somewhere between literary studies and film studies." On one level, "The dramatic principles at work in screenplays are the same as those in fiction and stage plays, thus they share a common literary heritage tracing back to Hellenistic theater, and are amendable to the earliest literary criticism—Aristotle's *Poetics*." Yet screenplays still exist as part of a process, something filmmakers often view as just blueprints that can be tweaked or reconsidered completely, existing as significant to our understanding of

film production. Kevin Alexander Boon, *Script Culture and the American Screenplay* (Detroit: Wayne State University Press, 2008), ix.

50. Boon, *Script Culture*, ix–x.

51. Boon, *Script Culture*, 26.

52. Adler, *Stella Adler on America's Master Playwrights*, 10.

53. At the time of writing this book, Scorsese and De Niro began collaborating on the film *The Irishman,* with a planned 2019 release date. For more on this history of collaboration, see Andrew J. Rausch, *The Films of Martin Scorsese and Robert De Niro* (Lanham, MD: Scarecrow Press, 2010).

54. Gretchen Schwartz, "'You Talkin' to Me?': De Niro's Interrogative Fidelity and Subversion of Masculine Norms," *Journal of Popular Culture* 41, no. 3 (June 2008): 444.

55. *Mean Streets* is a more developed variation on Scorsese's first feature film, the low-budget black and white *Who's That at My Door?* (1969), featuring the first lead performance of Harvey Keitel as a sexually repressed Italian American youth, J. R.— obsessed with the versions of masculinity in films like *The Searchers* (1956) and *The Man Who Shot Liberty Valance* (1961), more comfortable with his male counterparts in the neighborhood than with women, and riddled with Catholic guilt. For more on the early film career of Scorsese, see Vincent LoBrutto, *Martin Scorsese: A Biography* (Westport, CT: Praeger, 2008), and Marie Katheryn Connelly, *Martin Scorsese: An Analysis of His Feature Films, with a Filmography of His Entire Directorial Career* (Jefferson, NC: McFarland, 1993).

56. Robert De Niro, notebook paper, *Mean Streets*, NP, RDP, HRC. Unlike previously discussed archival material from recordings, transcripts, or typed notes, Robert De Niro's notes are quickly hand written and meant originally for personal reference. As such, typical to handwritten notes, underlining (to stress importance) and symbols (such as "+" for "and") commonly appear.

57. Tait, "When Marty Met Bobby," 296.

58. Robert De Niro, notebook paper, *Mean Streets*, NP, RDP, HRC.

59. Robert De Niro, archived screenplay, *Mean Streets*, p. 15, RDP, HRC.

60. De Niro, archived screenplay, *Mean Streets*, back of p. 26, RDP, HRC.

61. It would be difficult to contend De Niro's script notes here reflect personal homophobia as much as reflect the language of the social setting. Although, the actor admittedly has a complicated and personal relationship with the issue of sexual identity and social stigmatization due to the fact his father, expressionistic painter Robert De Niro Sr., was gay. In 2014, De Niro Jr. contributed to the HBO documentary *Remembering the Artist: Robert De Niro, Sr.,* directed by Perri Peltz, where he tearfully read letters from his father that recounted his personal conflicts over his sexuality.

62. Tait, "When Marty Met Bobby," 303.

63. Tait, "When Marty Met Bobby."

64. Tait, 302.

65. Tait, 304. In some ways, this process is similar to Marlon Brando's contribution to *The Missouri Breaks* (1976), where, due to heavy improvisation, the actor could be

seen as contributing to the "writing" of the character of Robert E. Lee Clayton. But while that performance produces a characterization that feels subversive to the rest of the film, De Niro's characterization is clearly a collaboration and more so fits the motivations of the script's narrative. The improvisations and rewritings by the actor, as will be discussed, contain clear motivations aligned with Schrader and Scorsese's overall vision.

66. Kevin Jackson, ed., *Schrader on Schrader* (London: Faber and Faber, 1990), 119. Schrader's version of De Niro's inspiration for the famous lines is not the only one. In his autobiography, saxophonist Clarence Clemons suggests De Niro told him he got the idea from seeing Bruce Springsteen work the cheering crowd at a concert, where he yelled, "You talking to me?" Clarence Clemons and Don Reo, *Big Man: Real Life & Tall Tales*, (New York: Grand Central, 2009), 102-03. A bootleg recording confirms Springsteen did call this out at a concert De Niro and Scorsese supposedly attended.

67. These portraits were direct counters to the rise of the empowered black males seen in the popular blaxploitation genre of the era with films such as *Shaft* (1971) and *Superfly* (1972), narratives that also embraced violence as a form of idealized justice. See Novotny Lawrence, *Blaxploitation Films of the 1970s: Blackness and Genre* (New York: Routledge, 2008).

68. Jonathan Rosenbaum, "New Hollywood and the Sixties Melting Pot," in *The Last Great American Picture Show: New Hollywood Cinema in the 1970s*, ed. Thomas Elsaesser, Alexander Horwath, and Noel King (Amsterdam: Amsterdam University Press, 2004), 151.

69. Jackson, *Schrader on Schrader*, 117.

70. With this basic attribute of the character established early on, the writer's original screenplay was even more overt in its depiction of Travis's rage as a specifically white rage. As Schrader clarifies, "In fact, in the draft of the script that I sold, at the end all the people he [Travis] kills are black. Marty [Scorsese] and the Phillipses [producers Michael and Julia Phillips] and everybody said, no, we just can't do this, it's an incitement to riot; but it was true to the character." Jackson, *Schrader on Schrader*.

71. Jackson, *Schrader on Schrader*. Philosopher Jean-Paul Sartre's *Nausea* was published in 1938 and is a canonical work of existentialism. The novel tells the story of Antoine Roquentin, a French writer horrified at his own existence. In impressionistic diary entries, he ruthlessly catalogs his every feeling and sensation. In his own less sophisticated way, Bickle's ramblings also represent an existential narrative, since the meaning of his existence is a question at the center of *Taxi Driver*. Alistair Rolls and Elizabeth Rechniewski, eds., *Sartre's Nausea: Text, Context, Intertext* (Amsterdam: Rodopi, 2005).

72. Amy Taubin, *Taxi Driver* (London: British Film Institute, 2000), 37.

73. *The Searchers*, like *Taxi Driver*, features a protagonist whose motives are meant to be consistently questioned by the audience, as Ethan is motivated by ugly racism and bitter vengeance over the murder of his family. Challenging typical

western motifs, the film has resulted in a myriad of different readings. See Arthur Eckstein and Peter Lehman, eds., *The Searchers: Essays and Reflections on John Ford's Classic Western* (Detroit: Wayne State University Press, 2004).

74. Lawrence S. Friedman, *The Cinema of Martin Scorsese* (New York: Continuum, 1998), 69.

75. David Greven, *Psycho-Sexual: Male Desire in Hitchcock, De Palma, Scorsese, and Friedkin* (Austin: University of Texas Press, 2013), 145–46.

76. Glenn Kenny, *Robert De Niro: Anatomy of an Actor* (Paris: Cahiers du Cinema, 2014), 59–60.

77. Adler, *Technique of Acting*, 16.

78. Type note cards, "characterization elements," Characterization, May 1950, HRC.

79. Notebook page, "Wolves," *Taxi Driver*, RDP, HRC.

80. Robert De Niro, archived screenplay, *Taxi Driver*, insert opposite p. 10, RDP, HRC.

81. Greven, *Psycho-Sexual*, 151.

82. Greven, *Psycho-Sexual*, 150.

83. Greven.

84. De Niro, *Taxi Driver*, p. 62, RDP, HRC.

85. De Niro, *Taxi Driver*.

86. De Niro, *Taxi Driver*. Emphasis added.

87. Paul Schrader, *Taxi Driver*, p. 2, RDP, HRC.

88. With its distinctive Bernard Herman score and stylized camerawork, *Taxi Driver* calls to mind Hitchcock films that similarly explore castration anxiety and the male gaze. In particular, the film parallels *Vertigo* (1958), with its own psychologically disturbed protagonist, played by James Stewart, with obsessive drives toward an idealized vision of blond femininity (Kim Novak).

89. Greven, *Psycho-Sexual*, 147.

90. Greven, 148.

91. Jackson, *Schrader on Schrader*, 119.

92. De Niro, archived screenplay, *Taxi Driver*, insert opposite p. 11, RDP, HRC.

93. De Niro, archived screenplay, *Taxi Driver*, insert opposite p. 11.

94. De Niro, archived screenplay, *Taxi Driver*, insert opposite p. 21, RDP, HRC.

95. De Niro, archived screenplay, *Taxi Driver*, insert opposite p. 21.

96. De Niro, archived screenplay, *Taxi Driver*, insert opposite p. 21.

97. De Niro, archived screenplay, *Taxi Driver*, p. 23.

98. De Niro, archived screenplay, *Taxi Driver*, p. 24.

99. De Niro, archived screenplay, *Taxi Driver*, p. 28B.

100. De Niro, archived screenplay, *Taxi Driver*, p. 28B.

101. De Niro, archived screenplay, *Taxi Driver*, p. 37.

102. De Niro, archived screenplay, *Taxi Driver*, p. 38.

103. De Niro, archived screenplay, *Taxi Driver*, p. 40.

104. De Niro, archived screenplay, *Taxi Driver*, p. 74.

105. Like De Niro, Keitel studied with Stella Adler. Costar Cybill Shepherd also was an alumna. See Marshal Fine, *Harvey Keitel: The Art of Darkness* (New York: Fromm International, 1998), and Cybill Shepherd, *Cybill Disobedience* (London: Ebury, 2000).

106. De Niro, archived screenplay, *Taxi Driver*, p. 75.

107. De Niro, archived screenplay, *Taxi Driver*, p. 78.

108. De Niro, archived screenplay, *Taxi Driver*, p. 80.

109. De Niro, archived screenplay, *Taxi Driver*, p. 78.

110. De Niro, archived screenplay, *Taxi Driver*, p. 78.

111. De Niro, archived screenplay, *Taxi Driver*, p. 80.

112. De Niro, archived screenplay, *Taxi Driver*, insert opposite 84.

113. De Niro, archived screenplay, *Taxi Driver*, p. 84.

114. De Niro, archived screenplay, *Taxi Driver*, p. 84.

115. De Niro, archived screenplay, *Taxi Driver*, p. 84. In the film, De Niro continues to alter the dialogue, addressing her directly as an individual: "You're a young girl. You should be at home now. You should be dressed up. You should be going out with boys. You should be going to school."

116. De Niro, archived screenplay, *Taxi Driver*, pp. 85–86.

117. De Niro, archived screenplay, *Taxi Driver*, p. 105.

Notes to Chapter 5

1. This article, appearing with different titles, was syndicated to multiple newspapers in late October and early November 1974.

2. Peggy Herz, *The Truth about Fonzie* (New York: Scholastic Books, 1976), 27–28.

3. Charles Witbeck, "Fonzie: Henry Winkler Adjusting to New Popularity," *Boca Raton News*, November 1, 1974, 11.

4. This is documented by television historian Josh Ozersky, who writes, "'The Fonz' was a James Dean for the grade school set: tough, irresistible to women, and most of all ultra-cool. The ambiguities and tensions of the vulnerable-hood type, which had been played at various times by Dean, Brando, and many lesser lights, were smoothed over, and Fonzie made a kind of semidivine figure." Josh Ozersky, *Archie Bunker's America: TV in an Era of Change, 1968–1978* (Carbondale: Southern Illinois University Press, 2003), 112.

5. Henry Winkler, *The Other Side of Henry Winkler* (New York: Warner Books, 1976); Herz, *Truth about Fonzie*.

6. Herz, *Truth about Fonzie*, 16.

7. Henry Winkler, "Letter for 50th Anniversary," August 21, 1990, HRC.

8. Winkler, *Other Side of Henry Winkler*, 67.

9. Robert Lewis, *Method—or Madness?* (1958; New York: Samuel French, 1986). Lewis was another powerful force in the history of American acting who, at Yale, trained such actors as Meryl Streep, Sigourney Weaver, and Frank Langella. See

Robert Lewis, *Slings and Arrows: Theater in My Life* (New York: Stein and Day Publishers, 1984), for more on Lewis's life and influence.

10. Larry Mintz, "Situation Comedy," in *TV Genres: A Handbook and Reference Guide*, ed. Brian G. Rose (Westport, CT: Greenwood Press, 1985), 114.

11. Patricia Mellencamp, *High Anxiety: Catastrophe, Scandal, Age, and Comedy* (Bloomington: Indiana University Press, 1992), 322.

12. Paul Attallah, "The Unworthy Discourse: Situation Comedy in Television," in *Critiquing the Sitcom: A Reader*, ed. Joanne Morreale (Syracuse, NY: Syracuse University Press, 2003), 96. In examining this oversight, Attallah sees television genre in general as "something with which we feel comfortable and that helps us organize the output of television. It also has certain institutional and industrial resonance. Shows self-consciously offer themselves as belonging to specific genres, and production is organized around them." For viewers, television "genres seem also to have a life of their own; they exercise a determinate and clearly visible pleasure." Attallah, "Unworthy Discourse."

13. Mintz, "Situation Comedy," 115.

14. By portraying a single working woman as its protagonist during the rise of second wave feminism, *The Mary Tyler Moore Show* is an important benchmark in popular culture. As such, it has often been examined through that lens. To a lesser extent, *The Bob Newhart Show*, with its depiction of a two-income household with no children, also challenged previously seen gender dynamics on sitcoms. See Susan Crozier, "Making It after All: A Reparative Reading of *The Mary Tyler Moore Show*," *International Journal of Cultural Studies* 11, no. 1 (2008): 51–67; Bonnie J. Dow, "Feminist Criticism and *The Mary Tyler Moore Show*" and "Hegemony, Feminist Criticism, and *The Mary Tyler Moore Show*," in *Critical Questions: Invention, Creativity, and the Criticism of Discourse and Media*, ed. Gary A Copeland, William L Nothstine, and Carole Blair (New York: St. Martin's Press, 1994), 97–101, 102–17.

15. Ozersky, *Archie Bunker's America*, 107.

16. Ozersky, *Archie Bunker's America*, 108–14.

17. Ozersky, 113.

18. Brett Mills, *Television Sitcom* (London: British Film Institute, 2005), 68–69.

19. In fact, other actors have found acclaim playing the role on stage and screen, including Treat Williams and Alec Baldwin in the 1984 and 1995 television productions. While Brando might be held as the most iconic Stanley, the role is consistently performed by different actors who must differentiate the character from the cultural legacy of that performance.

20. *Commedia dell'arte* translates into "comedy of art." This form of theater had a long life in Italy, spanning from the fourteenth to the eighteenth century, flourishing especially in the sixteenth and seventeenth centuries. The label implies a manner of performance more than the subject matter of the plays. While technically "unwritten" or "improvised," in practice, the play was not the result of a moment's inspiration. Beforehand, the subject was chosen, the characters and relationships largely conceived, and the situations clearly outlined. The material was divided into acts and scenes with

a prologue. The performances were very much tailored to audience foreknowledge in that the characters had stock masks, costumes, gestures, and stage business. See Christopher J. Gossip and David J. George, eds., *Studies in the Commedia Dell'arte* (Cardiff: University of Wales Press, 1993), and Judith Chaffee and Olly Crick, eds., *The Routledge Companion to Commedia Dell'Arte* (London: Routledge, 2015).

21. Mills, *Television Sitcom*, 80.

22. Mills, *Television Sitcom*, 81. In the sitcom genre, as Mills writes, "a tension exists in how such types are realised within specific narratives and by particular performers." While characters on the popular sitcom *Friends* (1994–2004) can perform actions read as "stupid" by the audience, "the exact ways in which these function and are performed relies on individual responses to similar 'masks.'" Joey Tribbiani (Matt Le Blanc) displays a lack of education and understanding while Phoebe Buffay (Lisa Kudrow) displays "simply a novel, emotive response to events." These two "masks" cannot be challenged too much or it could hurt the structure of the comedy, and often the whole narrative of episodes, which are dependent on the audience's established knowledge of characters. Mills, *Television Sitcom*, 81.

23. Mills, *Television Sitcom*, 85.

24. Mills, 88.

25. Herz, *Truth about Fonzie*, 23.

26. As Mills contends, these sorts of moments also show the genre's collaborative nature, something akin to commedia dell'arte, in how that tradition's "commercial and industrial nature" was based in collaboration, both within the performance and as an industrial business venture. With the sitcom in America, a similar process materializes in that most popular programs result from collaboration with teams of writers, producers, and executive producers, and the development of material by performers during rehearsals and throughout a series' long run. Mills, *Television Sitcom*, 82.

27. Mills, *Television Sitcom*, 89.

28. Mills, *Television Sitcom*, 89.

29. This is once again similar to commedia dell'arte, as Mills suggests, performers "respond to the ways in which audiences react to the comedy which is performed for them, and this is more than simply allowing them time to laugh." The sitcom is a tradition where the "kind of jokes, characters and performance which get the most positive responses are likely to be more common in future episodes of any longrunning series." Mills, *Television Sitcom*, 88.

30. Mills, *Television Sitcom*, 82. This "cross-pollination" can be seen in the earliest versions of situation comedy on radio. Previously a vaudevillian, Jack Benny developed a form of character-based comedy that was a prototype for American situation comedy with *The Jack Benny Program* (1932–55). Recognizing the "intimacy of the [broadcast] medium," this was a groundbreaking program in how it focused on the interactions of regular cast members every week as opposed to simply providing gags. With Benny's own relatively diverse radio cast, the performance traditions of vaudeville can be seen in styles more associated with minority groups displaying, for example, Jewish, Italian, or black comedic voices. Scott Balcerzak, *Buffoon Men:*

Classic Hollywood Comedians and Queered Masculinity (Detroit: Wayne State University Press, 2013), 117.

31. Fredric Jameson, "Postmodernism and Consumer Society," in *The Cultural Turn: Selected Writings on the Postmodern, 1983–1998*, by Fredric Jameson (London: Verso, 1998), 7–8.

32. Vera Dika, *Recycled Culture in Contemporary Art and Film: The Uses of Nostalgia* (Cambridge: Cambridge University Press, 2003), 91. This inherent sadness in the film is clearly seen by the conclusion, where the viewers learn the fates of the four lead characters in the proceeding ten years—including being killed by a drunk driver, missing in action in Vietnam, dodging the draft in Canada, and, with Howard's character, living the bland life of the white "silent majority" as an insurance agent.

33. The series also included Gavan O'Herlihy (1974)/Randolph Roberts (1974/75) as Chuck Cunningham, the oldest brother of Richie, who was written out after the second season. This character was also in the pilot, portrayed by Ric Carrott.

34. See Daniel Marcus, *Happy Days and Wonder Years: The Fifties and the Sixties in Contemporary Cultural Politics* (New Brunswick, NJ: Rutgers University Press, 2004), 9–35.

35. Marcus, *Happy Days*, 2.

36. Marcus, *Happy Days*, 19. It is important not to simply conflate the 1950s nostalgia of the 1970s with the employment of the Eisenhower era in later decades as political rhetoric, especially during the presidency of Ronald Reagan. For example, as Marcus observes, "The quality of family life in the Fifties has become a staple of conservative rhetoric since the 1980s, but most articles on the revival in the 1970s paid little attention to the issue." Yet this idealization of the 1950s only sets the stage for more overtly politicized rhetoric against the 1960s employed by Reagan-era conservatism, which was a movement consisting of many of the white Baby Boomers who consumed this less overtly politicized nostalgia in the 1970s. Marcus, *Happy Days*, 20.

37. Marcus, *Happy Days*, 18.

38. Marcus, 25.

39. Marcus, 24.

40. Marcus, 31.

41. Marcus, 31–32.

42. Herz, *Truth about Fonzie*, 22.

43. Jameson, "Postmodernism and Consumer Society," 4.

44. Jameson, 5.

45. See Dave Nichols, *One Percenter: The Legend of the Outlaw Biker* (Saint Paul, MN: Motorbooks, 2007), and Daniel R. Wolf, *The Rebels: A Brotherhood of Outlaw Bikers* (Toronto: University of Toronto Press, 1992).

46. Gary Carey, *Marlon Brando: The Only Contender* (New York: St. Martin's Press, 1985), 90–91.

47. Despite all these changes, the film still was deemed shocking and dangerous to impressionable young minds, with the British Board of Film Censors implementing

an outright ban, not approving it for general release until 1967. For more on the reception history of the film, see Jerald Simmons, "Violent Youth: The Censoring and Public Reception of *The Wild One* and *The Blackboard Jungle*," *Film History: An International Journal* 20, no. 3 (2008): 381–91.

48. Bill Osgerby, "Sleazy Riders: Exploitation, 'Otherness,' and Transgression," *Journal of Popular Film and Television* 31, no. 3 (2003): 99.

49. Thomas Doherty, *Teenagers and Teenpics: The Juvenilization of American Movies in the 1950s* (Philadelphia: Temple University Press, 2002), 108.

50. In later decades, "rebel" is the term most often associated with young male actors of the 1950s identified as Method. See Graham McCann, *Rebel Males: Clift, Brando, and Dean* (London: Hamish Hamilton, 1991).

51. This final image of Brando in the film conforms to rugged individualistic maleness that actively eschews domestication. This idealized male image often appears in westerns, which suggests the lone biker as adopting the social significance of the lone cowboy character. This image of maleness was identified as fetishized on screen by Steve Neale's "Masculinity as Spectacle: Reflections on Men in Mainstream Cinema," in *Screening the Male: Exploring Masculinities in Hollywood Cinema*, ed. Steven Cohan and Ina Rae Hark (London: Routledge, 1993), 9–22.

52. Marvin J. Taylor, "Looking for Mr. Benson: The Black Leather Motorcycle Jacket and Narratives of Masculinities," in *Fashion in Popular Culture: Literature, Media and Contemporary Studies*, ed. Joseph H. Hancock II, Toni Johnson-Woods, and Vicki Karaminas (Bristol, England: Intellect, 2013), 125.

53. Winkler, *Other Side of Henry Winkler*, 101.

54. Winkler, *Other Side of Henry Winkler*, 101. The color of the jacket does seem to have changed at points in the series, with it appearing black for later episodes and photo shoots. For the most part, though, the jacket most routinely worn in early seasons is a dark brown bomber jacket. In terms of his hair, the production took pains to avoid actual hair grease to please the network, appropriating the look through other means, as Winkler writes: "First it was wetted and combed, then sprayed and styled into the ducktail shape. It took about half an hour to dry, then it was recombed into the ducktail and sprayed again." In this manner, Marshall appeased the network by making it look like grease with no actual grease. Winkler, *Other Side of Henry Winkler*, 101.

55. The film speaks to the 1950s nostalgia of the decade even though it certainly did not make as much of a splash as *American Graffiti*, which inspired ABC to pursue *Happy Days*. As Winkler conveys, Marshall and the producers were not even aware of the film when creating the series and Fonzie, explaining about the audition, when "the director explained to me what and who Fonzie was, I silently wished that they could all see *The Lords of Flatbush*, where I at least *physically* looked the part. But this was October and *The Lords* wouldn't be released until the following May. No help there." Winkler, *Other Side of Henry Winkler*, 101.

56. Winkler, *Other Side of Henry Winkler*, 101.

57. Stella Adler, *The Art of Acting*, ed. Howard Kissel (New York: Applause, 2000), 193.

58. Adler, *Art of Acting*, 192. As Alder contends, wardrobe often serves as the first step toward character building since it moves a performer away from "self." "Clothes say something about your ability to be restrained, your ability to be respectful. When you wear your own clothes, you're limited to your own mind, your own memory. It's hard to act. You can be only yourself." Adler, *Art of Acting*, 192.

59. Winkler, *Other Side of Henry Winkler*, 103.

60. Winkler, *Other Side of Henry Winkler*, 103.

61. Winkler, 103.

62. Winkler, 103.

63. Winkler, 113.

64. Winkler, 103. In correlation to Mills's conception of sitcom acting as comparable to commedia dell'arte, this moment also exemplifies the collaborative nature of sitcom performance. In discussing the above scene, Winkler states, "I liked my choice. It solved the comb and hair problem in a way that pleased both the director and me. It also seemed consistent with the 'cool' concept of the Fonz." Winkler, *Other Side of Henry Winkler*, 103.

65. For more on the gendered image of Dean in *Rebel*, see Will Scheibel, "Rebel Masculinities of Star/Director/Text: James Dean, Nicholas Ray, and *Rebel without a Cause*," *Journal of Gender Studies* 25, no. 2 (2016): 125–40.

66. For more on the star image of Cooper, see Corey Creekmur, "Gary Cooper: Rugged Elegance," in *Glamour in a Golden Age: Movie Stars of the 1930s*, ed. Adrienne McLean (New Brunswick, NJ: Rutgers University Press, 2011), 66–83.

Notes on Chapter 6

1. Anthony Breznican, "That's a Lot of Green! (cover story)," *Entertainment Weekly*, no. 1207, May 18, 2012, 15–16, MasterFILE Premier, Web, NP.

2. The television series starred Bill Bixby as David Banner (as opposed to Bruce Banner, as he is named in the comics) and a painted green Lou Ferrigno as the titular Hulk.

3. *The Hulk* and *The Incredible Hulk* received mixed reviews, with the website *Rotten Tomatoes* concluding that only 51 percent of top critics responded positively to Lee's film and 59 percent to Leterrier's. See www.rottentomatoes.com for critical summaries.

4. Brian Hiatt, "The Last Angry Man (cover story)," *Rolling Stone*, no. 1234, May 7, 2015, 40+, MasterFILE Premier, EBSCOhost, NP.

5. Hiatt, "Last Angry Man."

6. Quoted in Lisa Purse, *Digital Imaging in Popular Cinema* (Edinburgh: Edinburgh University Press, 2013), 57.

7. Tom McLean, "SFX Whizzes Make the Incredible Hulk a Credible Hulk," Newsarama.com, October 9, 2008, http://www.newsarama.com/1248-sfx-whizzes-make-the-incredible-hulk-a-credible-hulk.html.

8. See Breznican, "That's a Lot of Green!"

9. Breznican.

10. Edward Vilga, *Acting Now: Conversations on Craft and Career* (New Brunswick, NJ: Rutgers University Press, 1997), 4.

11. Vilga, *Acting Now*. When asked if the director would be more important in film than stage, Adler simply states, "I think the director has another job in film. He has to illuminate it and light it and make the background interesting." Vilga, *Acting Now*.

12. Vilga, *Acting Now*, 7.

13. John O. Thompson, "Screening Acting and the Communication Test," in *Stardom: Industry of Desire*, ed. Christine Gledhill (London: Routledge, 1991), 186.

14. James Naremore, *Acting in the Cinema* (Berkeley: University of California Press, 1988), 53. Stanislavski's System is often viewed as a rejection of the melodramatic posing that developed on the nineteenth century stage due to the influence of François Delsarte (1811-71). Despite this, Delsarte is still regarded as influential in world of modern dance where overt expressive movements are necessary – influencing Isadora Duncan, among others. See Carrie J. Preston, *Modernism's Mythic Pose: Gender, Genre, Solo Performance,* (New York: Oxford University Press, 2011), 58-81.

15. Naremore, *Acting in the Cinema*. While Delsarte can certainly be seen as influencing many of the foundational performances of silent cinema, it is important to know that by the 1930s and '40s, studio era stars were trained with Modern techniques. As Cynthia Baron covers in *Modern Acting*, the acting manuals, theater programs, acting schools, and studio backlot "acting experts" of the period employed many techniques later endorsed by Adler and other midcentury teachers—like close script analysis and action-based exercises. Cynthia Baron, *Modern Acting: The Lost Chapter of American Film and Theatre* (London: Palgrave Macmillan, 2016).

16. Naremore, *Acting in the Cinema*, 63.

17. Naremore, *Acting in the Cinema*, 63.

18. Cynthia Baron and Sharon Marie Carnicke, *Reframing Screen Performance* (Ann Arbor: University of Michigan Press, 2008), 62.

19. Of course, extratextual elements can shape our reception of these performances as well—such as, for example, Marlon Brando's off-screen reputation affecting our reception of *Last Tango in Paris* (1972). Yet such extra knowledge does not necessarily mean it creates an experience that feels fragmented for the viewer or even the film analyst. As Baron and Carnicke write, "analyses of screen acting are complicated by the fact that extratextual information colors audience responses to performances. Even so, viewers do reckon with the performance details that help to create and sustain their impressions about characters and star images." Baron and Carnicke, *Reframing Screen Performance*, 67.

20. Cynthia Baron, "The Temporal Dimensions of Screen Performance: Exploring Expressive Movement in Live Action and Animated Film," in *Acting and Performance in Moving Image Cultures: Bodies, Screens, and Renderings*, ed. Jörg Sternagel, Deborah Levitt, and Dieter Mersch, (New Brunswick, NJ: Transaction, 2012), 304.

21. Baron, "Temporal Dimensions," 304.

22. Baron, 306–7.

23. Baron, 318.

24. Tom Sito, *Moving Innovation: A History of Computer Animation* (Cambridge, MA: MIT Press, 2013), 199. As Sito posits, the original experiments in mocap can be viewed as an attempt to create a more sophisticated variation in CG animation of the rotoscope technique found in hand-drawn animation. Invented by animation legends Max and Dave Fleischer in 1917, rotoscoping consisted of the brothers filming a live action subject and projecting the film frame by frame into a light box so a piece of paper could be placed over the still frame and traced. The result was a smooth-flowing character movement in animation, appearing in their Koko the Clown, Betty Boop, and Popeye cartoons and finding its most impressive employments in their feature *Gulliver's Travels* (1939) and series of *Superman* shorts (1941–43). Sito, *Moving Innovation*, 201.

25. See Sito, *Moving Innovation*, 199–216, for a fuller history of motion capture.

26. Sito, *Moving Innovation*, 212.

27. Purse, *Digital Imaging*, 53. This is seen especially with Serkis's mocap performances, such as Caesar and Kong, where detailed footage of the process, often showing the actor in the form-fitting mocap suit, were widely disseminated as online and DVD extras.

28. Sito, *Moving Innovation*, 215.

29. Scott Balcerzak, "Andy Serkis as Actor, Body, and Gorilla: Motion Capture and the Presence of Performance," in *Cinephilia in the Age of Digital Reproduction: Film, Pleasure, and Digital Culture*, ed. Scott Balcerzak and Jason Sperb (London: Wallflower Press, 2009), 196. With the release of *Lord of the Rings: The Two Towers*, New Line Cinema launched an Oscar campaign to have Serkis nominated as a supporting actor. Jackson also supported the idea, stating in an interview that he believed the dramatics to be "as relevant an acting performance as *The Elephant Man* (1980) with John Hurt [who was nominated as best actor in 1981]." The director's comparison of the two actors was based in Hurt's heavy prosthetic makeup in David Lynch's film, made of inches of thick rubber and how he had "to use his acting skills to push this prosthetic around and fuel the character." To Jackson, Serkis is simply using a similar technique, but this time as "the driver manipulating this pixilated skin that we see in the film." Andy Stout, "Motion Capture Comes of Age," *IBE Magazine*, March 2003, 12.

30. Balcerzak, "Andy Serkis as Actor," 196.

31. Tanine Allison, "More Than a Man in a Monkey Suit: Andy Serkis, Motion Capture, and Digital Realism," *Quarterly Review of Film and Video* 28, no. 4 (2011): 329. This concept seems to be how Serkis himself views the process, as the actor meticulously worked to alter his own physicality in creating the characterizations of Kong and Caesar by closely studying the movements of primates.

32. Allison, "More Than a Man," 329.

33. Balcerzak, "Andy Serkis as Actor," 210–11.

34. While indeed ill at the time, Stanislavski was also housebound as a form of

house arrest largely because aspects of his continually evolving System (adapted from the spiritual practice of yoga and his commitment to aspects of nonrealist drama) were viewed as subversive to Soviet policies of art, as Marxist materialism replaced forms of spiritualism and socialist realism replaced other artistic styles by 1934. As Carnicke writes, "Ironically, while Stalinist propaganda turned Stanislavsky into a public icon for theatrical realism, he privately worked out the tenets of Active Analysis in secret on plays that were unsanctioned with actors who could not speak publicly about the work." Sharon Marie Carnicke, "Emotional Expressivity in Motion Picture Capture Technology," in *Acting and Performance in Moving Image Cultures: Bodies, Screens, and Renderings*, ed. Jörg Sternagel, Deborah Levitt, and Dieter Mersch (New Brunswick, NJ: Transaction, 2012), 323.

35. Carnicke, "Emotional Expressivity," 324.

36. Sharon Marie Carnicke, "Stanislavsky and Politics: Active Analysis and the American Legacy of Soviet Oppression," in *The Politics of American Actor Training*, ed. Ellen Margolis and Lissa Tyler Renaud (London: Routledge, 2010), 18.

37. Carnicke, "Emotional Expressivity," 323.

38. Carnicke, "Emotional Expressivity," 324.

39. Carnicke, "Stanislavsky and Politics," 16.

40. Sharon M. Carnicke, *Stanislavski in Focus* (Amsterdam: Hapwood Academic Publishers, 1998), 53–70.

41. Carnicke, "Emotional Expressivity," 324.

42. See chapter 1 for more on the basic course sequence of Alder's studio.

43. Typed notes, TECHNIQUE 2, March 20, 1972, NP, HRC.

44. Typed class notes on notecard, Technique 2, Intermediate Class-Second Lesson, Oct. 5, 1950, HRC.

45. In a sense, she breaks this approach down, once again, into stressing the do-able, her central mantra to technique, yet in a manner that declares there are endless variants in considering what is doable. In an April 8, 1974, class, as she coaches a student on the action of escaping, she states, "You can draw the action from something you observed in life. Have you ever seen a cockroach try to escape? What does it try to do?" As she continues to work with the student, she stresses experimenting with different variations on the action based upon circumstances: "Now you worked it out. To get away from the danger. That's the nature of the action. Whether it's a cockroach or you in the car or whether it's a convict. Now get out of jail." Adler stresses that developing actions is about fully exploring a wide range of what is doable. Recording of "Techniques II," NYU, April 8, 1974, HRC.

46. Carnicke, "Emotional Expressivity," 325.

47. Carnicke, "Emotional Expressivity," 332.

48. Thelma Adams, "We Called It: Mark Ruffalo, Observer Cover Star, Gets Globe, SAG, Critics Award Noms," *The Observer*, December 14, 2015, http://observer.com/2015/12/mark-ruffalo-the-man-in-the-movies/.

49. The studio now featured classes in movement, voice, and speech offered along with Shakespeare and a class called "The Actor's World," where students learned "to

breakdown other art forms from an acting point of view." Brochure, 1990–91, the Stella Adler Conservatory, Los Angeles, HRC.

50. Much like Brando before him, Ruffalo celebrates his former teacher as "one of the most influential acting teachers and theater personalities of modern times." He also credits her as "the only American teacher to work with Stanislavski to gain a deeper and more articulate understanding of his 'method.'" He also considers his autographed copy of *The Technique of Acting* (1988) as a prized possession. Sheana Ochoa, *Stella! Mother of Modern Acting* (Milwaukee: Applause Theatre and Cinema Books, 2014), ix.

51. Ruffalo stated in 2001 that he feared a focus on just film and television would hurt his craft, something Adler warned about in her classes: "She would tear them [film and television] apart. . . . She would say, 'It destroys your craft,' and that is kind of a fear of mine. That's why I always want to go back [to the stage]. . . . I want to exercise that muscle—keep it agile." Jamie Painter Young, "You Can Count on Him," *Backstage*, February 21, 2001, http://www.backstage.com/interview/count-on-him/.

52. Young, "You Can Count on Him."

53. Ochoa *Stella!*, ix.

54. Recording of "Technique I," NYU, October 4, 1973, HRC.

55. Recording of "Technique I," NYU, October 1, 1972, HRC.

56. Stella Adler, *The Art of Acting*, ed. Howard Kissel (New York: Applause Books, 2000), 166.

57. Son of famed filmmaker Robert Downey Sr., Robert Downey Jr.'s troubled history with drug addiction made him a risky investment upon his initial casting as Stark. His career originally was launched in the Brat Pack era of the 1980s, in such films as *Weird Science* (1985) and *Johnny Be Good* (1988), only to transition to independent productions and quirkier roles in the 1990s and early 2000s, in such films as *Restoration* (1995), *The Gingerbread Man* (1998), and *Kiss Kiss Bang Bang* (2005). Edward Norton grew to prominence in intense dramatic performances in such films as *American History X* (1998) and *Fight Club* (1999). His reputation as a new generation of Method male is accentuated by the fact he appears representing a third generation of male actor opposite Robert De Niro and Marlon Brando (in his final full performance) in *The Score* (2001). See Dominic Lennard, "Wonder Boys: Matt Damon, Johnny Depp, and Robert Downey Jr.," in *Shining in Shadows: Movie Stars of the 2000s*, ed. Murray Pomerance (New Brunswick, NJ: Rutgers University Press, 2011), 12–31; and Graham Fuller, "Getting out of My Head: An Interview with Edward Norton," *Cineaste: America's Leading Magazine on the Art and Politics of the Cinema* 25, no. 1 (1999): 6–13.

58. Hiatt, "Last Angry Man."

59. For more on Batman as archetype, see Will Brooker, *Hunting the Dark Knight: Twenty-First Century Batman* (London: Tauris, 2012); Matt Yockey, *Batman* (Detroit: Wayne State University Press, 2014); and Alex Wainer, *Soul of the Dark Knight: Batman as Mythic Figure in Comics and Film* (Jefferson, NC: McFarland, 2014).

60. Christopher J. Patrick and Sarah K. Patrick, "The Incredible Hulk: The Origins

of Rage," in *The Psychology of Superheroes: An Unauthorized Exploration*, ed. Robin S. Rosenberg and Jennifer Canzoneri, (Dallas: Smart Pop, 2008), 214.

61. Patrick and Patrick, "Incredible Hulk," 218.

62. As the Patricks write, the character speaks to the larger goal in psychology of helping patients manage rage as it speaks to seeing "individuals among us who exhibit repeated, extreme acts of aggression, we need to understand the basic instinctual motivation that drives aggressive behavior in humankind as a whole, and also the distinctive constitutional and environmental influences that contribute to enhanced aggressiveness in particular individuals." Patrick and Patrick, "Incredible Hulk," 225–26.

63. Robin J. Dugall, "Running from or Embracing the Truth Inside You? Bruce Banner and the Hulk as a Paradigm for the Inner Self," in *The Gospel According to Superheroes: Religion and Popular Culture*, ed. B. J. Oropeza (New York: Peter Lang, 2005), 145.

64. Dugall, "Running," 147.

65. Hiatt, "Last Angry Man."

66. Hiatt, "Last Angry Man."

67. Nigel M. Smith, "Why Mark Ruffalo Wants to Lead the Charge on Motion Capture Performance and Where He Wants to Take the Hulk," *Indiewire*, July 1, 2014, http://www.indiewire.com/2014/07/why-mark-ruffalo-wants-to-lead-the-charge-on-motion-capture-performance-and-where-he-wants-to-take-the-hulk-24729/.

68. Smith, "Why Mark Ruffalo Wants."

69. Smith, "Why Mark Ruffalo Wants."

70. Hiatt, "Last Angry Man."

71. Smith, "Why Mark Ruffalo Wants."

72. Hiatt, "Last Angry Man."

73. At the time of writing this book, these installments would include *Thor: Ragnarok* (2017), *Avengers: Infinity War* (2018), and its untitled sequel (2019).

74. Smith, "Why Mark Ruffalo Wants."

Notes to Conclusion

1. Recording of "Technique, 1st class," October 1, 1972, HRC.

2. Recording of "Technique, 1st class," October 1, 1972.

3. Peter Bogdanovich, *Who the Hell's in It: Portraits and Conversations* (New York: Alfred A. Knopf, 2004), 84.

4. Quoted in Sheana Ochoa, *Stella! Mother of Modern Acting* (Milwaukee: Applause Theatre and Cinema Books, 2014), 222.

5. Robert Brustein, "Stella for Star," *New Republic*, February 1, 1993, 52.

6. Monroe's relationship with Strasberg and the Studio is controversial since it can be argued that the teacher exploited the star to build his reputation and, eventually, even have himself named as the primary benefactor of her estate after her death.

During her final interview in 1992, Adler tells Barry Paris of her disappointment that Monroe's husband, playwright Arthur Miller, would let Strasberg exploit Monroe: "I don't understand Miller permitting Strasberg and Paula [Strasberg, Lee's wife and a teacher at the Studio] to direct the girl. . . . I don't understand Arthur Miller, who was brilliant and understanding of the theatre and everything and he fell for it. Well, that was a period when the authors didn't have the sense of the actor interprets the author. He let it happen. And Arthur was a smart Jew—a brilliant, brilliant author." Stella Adler, audio recording of interview with Barry Paris, October 17, 1992, HRC.

7. This reputation is far from surprising as Streep was trained by Group Theatre alum Robert Lewis, who cofounded the Actors Studio only to reject much of the approach of Strasberg. Lewis most famously headed up the Drama Department at Yale, where he taught Streep. See Michael Schulman, *Her Again: Becoming Meryl Streep* (New York: HarperCollins, 2016).

8. Samuel Freedman, "Adler: Queen of the Method," *New York Times*, December 10, 1984, C13.

9. While Bernhardt did her famous "farewell tours" of the United States between 1905 and 1914, the young Stella Adler probably did not see a performance during her formative years. The appreciation she had for Bernhardt most likely stemmed from seeing her as a career role model more than as a direct influence on her acting style. For more on Bernhardt, see Carol Ockmann and Kenneth E. Silver, *Sarah Bernhardt: The Art of High Drama* (New York: Yale University Press, 2005).

10. Suzanne O'Malley, "Can the Method Survive the Madness?" *New York Times*, October 7, 1979, SM8+, ProQuest Historical Newspapers, *New York Times*, NP.

11. O'Malley, "Can the Method Survive the Madness?" At least not here, Strasberg does not mention the large contingency within the Group that also found his Method problematic and welcomed Adler's challenge to his authority. See this book's first chapter for on more of this history.

12. O'Malley, "Can the Method Survive the Madness?"

13. Rosemary Malague, *An Actress Prepares* (London: Routledge, 2012), 88.

14. Malague, *An Actress Prepares*, 88. In her book, Malague provides a feminist critique of many recorded classroom practices by Strasberg, including promoting a dictatorial position for the director or acting coach (both implied as male). The two practices mentioned here, forcing women to perform demeaning roles and pushing for emotional "breakthroughs" through what could be perceived as emotional abuse, are outlined in her book. She is particularly critical of Marilyn Monroe's experiences with Strasberg, which she sees as a cautionary tale of a male acting teacher exploiting a female student. See Malague, *An Actress Prepares*, 30–71.

15. Transcript of lecture, "Techniques 1, 1950–1990," ND, NP, HRC. While no date is given on this transcript, Adler references *The World of Suzie Wong* (1960) as a contemporary film.

16. Transcript of lecture, "Techniques 1, 1950–1990."

17. Transcript of lecture, "Techniques 1, 1950–1990."

18. "Honorable selfishness" was not necessarily a gender-specific charge for Adler.

In fact, *Art of Acting* features Adler making a similar statement to, apparently, all her students, "You need 100 percent honorable selfishness toward *you*." Stella Adler, *The Art of Acting*, ed. Howard Kissel (New York: Applause, 2000), 1.

19. Recording of "Technique 2," NYU, April 3, 1974, HRC.

20. Recording of "Technique 2," NYU.

21. Recording of "Technique 2," NYU.

22. Recording of "Characterization," October 20, 1961, HRC.

23. Christina Radish, "Kate Mulgrew Talks Netflix Series *ORANGE IS THE NEW BLACK*, Working with Creator Jenji Kohan, Finding the Right Russia Accent, and More," *Collider*, July 5, 2013, http://collider.com/kate-mulgrew-orange-is-the-new-black-interview/.

24. Radish, "Kate Mulgrew."

25. Kate Mulgrew, *Born with Teeth: A Memoir* (New York: Little, Brown, 2015), 38.

26. Mulgrew, *Born with Teeth*, 40–41.

27. With this deeper appreciation, Mulgrew positions Adler as a figure counter to a literal patriarch, her own father, who disapproved of her decision to pursue acting, writing "choosing between my father and Stella represented the proverbial fork in the road." With this contrast, Mulgrew remembers the lessons of Adler as countering the masculinist philosophy of her father: "Where my father feared disappointment, Stella embraced it. . . . Stella lifted me up and filled me with the desire to throw away all the baggage I didn't need, to become the actress I was meant to be." Mulgrew, *Born with Teeth*, 41.

28. Recording of "Characterization Class," October 28, 1958, HRC.

29. Malague, *An Actress Prepares*, 110.

30. Malague, *An Actress Prepares*, 110.

31. Pamela Tiffin, letter to Stella Adler, September 12, 1970, HRC.

32. Pamela Tiffin, letter to Stella Adler, September 12, 1970.

33. Malague, *An Actress Prepares*, 110.

34. Recording of "Character Class," December 9, 1966, HRC.

35. Recording of "Character Class."

36. Swedish playwright August Strindberg (1849–1912) combined psychology and naturalism to emerge as a master of early modern drama. His chief works include *The Father* (1887), *Miss Julie* (1888), *Creditors* (1888), *A Dream Play* (1902), and *The Ghost Sonata* (1907). Adler's gender-focused reading of the playwright speaks to the cultural emergence of the "New Woman" at the time of the plays' original productions. See Mararetha Fahlgren, "Strindberg and the Woman Question," in *The Cambridge Companion to August Strindberg*, ed. Michael Robinson (Cambridge: Cambridge University Press, 2009), 20–34; and Helena Forsås-Scott, "August Strindberg, the New Woman, and Elin Wägner," *Women: A Cultural Review* 10, no. 1 (1999): 78–86.

37. Stella Adler, *Stella Adler on Ibsen, Strindberg, and Chekhov*, ed. Barry Paris (New York: Vintage Books, 1999), 120.

38. Adler, *Stella Adler on Ibsen, Strindberg, and Chekhov*, 120.

39. Adler, *Stella Adler on Ibsen, Strindberg, and Chekhov,* 121.

40. Adler, *Stella Adler on Ibsen, Strindberg, and Chekhov,* 125.

41. Adler, *Stella Adler on Ibsen, Strindberg, and Chekhov,* 125–26.

42. Adler, *Stella Adler on Ibsen, Strindberg, and Chekhov,* 126.

43. Adler, *Stella Adler on Ibsen, Strindberg, and Chekhov,* 130.

44. Typed notecard for "Teaching Materials—1965–67," January 5, 1966, HRC.

45. Typed notecard for "Teaching Materials—1965–67," January 7, 1966, HRC.

46. Malague, *An Actress Prepares,* 190.

47. Recording of "Scene Interpretation," Los Angeles, Summer 1980, HRC.

48. Recording of "Scene Interpretation." Adler's misidentification of Childress as a "he" shows how she did not employ many female playwrights (or playwrights of color) in her studio work. In fact, it is possible the students selected this scene to workshop. A playwright, actress, and novelist, Alice Childress (1916–1994) was a continual presence on the American theater scene from the 1950s to the 1970s, with her most famous work being the backstage comedy-drama *Trouble in Mind* (1955), about racism in the theater world. See La Vinia Delois Jennings, *Alice Childress* (New York: Twayne Publishers, 1995).

49. Stella Adler, interview with Russell Vandenbroucke, *Yale/Theatre* 8, no. 2 (1977): 31.

50. Adler, interview with Russell Vandenbroucke.

Bibliography

Adler, Jacob P. *A Life on the Stage: A Memoir*. Translated and edited by Lulla Rosenfeld. New York: Knopf, 1999.

Adler, Stella. *The Art of Acting*. Edited by Howard Kissel. New York: Applause, 2000.

———. Introduction to *A Life on the Stage: A Memoir*, by Jacob Adler, xiii–xx. Translated and edited by Lulla Rosenfeld. New York: Knopf, 1999.

———. *Stella Adler on America's Master Playwrights: Eugene O'Neill, Thornton Wilder, Clifford Odets, William Saroyan, Tennessee Williams, William Inge, Arthur Miller, Edward Albee*. Edited by Barry Paris. New York: Alfred A. Knopf, 2012.

———. *Stella Adler on Ibsen, Strindberg, and Chekhov*. Edited by Barry Paris. New York: Vintage Books, 1999.

———. *The Technique of Acting*. New York: Bantam Books, 1988.

Albertson, Lillian. *Motion Picture Acting*. New York: Funk and Wagnalls, 1947.

Allison, Tanine. "More Than a Man in a Monkey Suit: Andy Serkis, Motion Capture, and Digital Realism." *Quarterly Review of Film and Video* 28, no. 4 (2011): 325–41.

Attallah, Paul. "The Unworthy Discourse: Situation Comedy in Television." In *Critiquing the Sitcom: A Reader*, edited by Joanne Morreale, 91–116. Syracuse, NY: Syracuse University Press, 2003.

Bak, John. *Homo Americanus: Ernest Hemingway, Tennessee Williams, and Queer Masculinities*. Madison, NJ: Fairleigh Dickinson University Press, 2010.

Balcerzak, Scott. "Andy Serkis as Actor, Body, and Gorilla: Motion Capture and the Presence of Performance." In *Cinephilia in the Age of Digital Reproduction: Film, Pleasure, and Digital Culture*, edited by Scott Balcerzak and Jason Sperb, 195–213. London: Wallflower Press, 2009.

———. *Buffoon Men: Classic Hollywood Comedians and Queered Masculinity*. Detroit: Wayne State University Press, 2013.

Baron, Cynthia. *Modern Acting: The Lost Chapter of American Film and Theatre*. London: Palgrave Macmillan, 2016.

———. "The Temporal Dimensions of Screen Performance: Exploring Expressive Movement in Live Action and Animated Film." In *Acting and Performance in Moving Image Cultures: Bodies, Screens, and Renderings*, edited by Jörg Sternagel,

Deborah Levitt, and Dieter Mersch, 303–20. New Brunswick, NJ: Transaction, 2012.

Baron, Cynthia, and Sharon Marie Carnicke. *Reframing Screen Performance*. Ann Arbor: University of Michigan Press, 2008.

Baron, Cynthia, Diane Carson, and Frank P. Tomasulo, eds. *More Than a Method: Trends and Traditions in Contemporary Film Performance*. Detroit: Wayne State University Press, 2004.

Baron, Cynthia, and Beckett Warren. "The Actors Studio in the Cold War Era." In *The Wiley-Blackwell History of American Film*. Vol. 3, *1946–1975*, edited by Cynthia Lucia, Roy Grundmann, and Art Simon, 137–57. Malden, MA: Blackwell, 2012.

Baxter, John. *De Niro: A Biography*. London: Harper Collins, 2002.

Bederman, Gail. *Manliness and Civilization: A Cultural History of Gender and Race in the United States, 1880–1917*. Chicago: University of Chicago Press, 1995.

Benedetti, Jean. *The Art of the Actor: The Essential History of Acting from Classical Times to the Present Day*. New York: Routledge, 2007.

Bingham, Dennis. *Acting Male: Masculinities in the Films of James Stewart, Jack Nicholson, and Clint Eastwood*. New Brunswick, NJ: Rutgers University Press, 1994.

Blades, Larry T. "The Returning Vet's Experience in *A Streetcar Named Desire*: Stanley as the Decommissioned Warrior under Stress." *Tennessee Williams Annual Review* 10 (2009): 17–29.

Bogdanovich, Peter. *Who the Hell's in It: Portraits and Conversations*. New York: Alfred A. Knopf, 2004.

Boon, Kevin Alexander. *Script Culture and the American Screenplay*. Detroit: Wayne State University Press, 2008.

Brando, Marlon, with Robert Lindsey. *Brando: Songs My Mother Taught Me*. Toronto: Random House of Canada, 1994.

Brooker, Will. *Hunting the Dark Knight: Twenty-First Century Batman*. London: Tauris, 2012.

Butler, Jeremy, ed. *Star Texts: Image and Performance in Film and Television*. Detroit: Wayne State University Press, 1991.

Butler, Judith. *Bodies That Matter: On the Discursive Limits of Sex*. London: Routledge, 1993.

———. *Gender Trouble: Feminism and the Subversion of Identity*. Rev. ed. New York: Routledge. 1999.

Carey, Gary. *Marlon Brando: The Only Contender*. New York: St. Martin's Press, 1985.

Carnicke, Sharon Marie. "Emotional Expressivity in Motion Picture Capture Technology." In *Acting and Performance in Moving Image Cultures*, edited by Jörg Sternagel, Deborah Levitt, and Dieter Mersch, 321–38. New Brunswick, NJ: Transaction, 2012.

———. "Lee Strasberg's Paradox of the Actor." In *Screen Acting*, edited by Alan Lovell and Peter Krämer, 75–87. London: Routledge, 1999.

———. "Stanislavsky and Politics: Active Analysis and the American Legacy of Soviet

Oppression." In *The Politics of American Actor Training*, edited by Ellen Margolis and Lissa Tyler Renaud, 15–30. London: Routledge, 2010.

———. *Stanislavsky in Focus*. Amsterdam: Harwood-Academic Publishers, 1998.

Chaffee, Judith, and Olly Crick, eds. *The Routledge Companion to Commedia Dell'Arte*. London: Routledge, 2015.

Clemons, Clarence, and Don Reo. *Big Man: Real Life & Tall Tales*. New York: Grand Central, 2009.

Cohan, Steven. *Masked Men: Masculinity and the Movies in the Fifties*. Bloomington: Indiana University Press, 1997.

Cohan, Steven, and Ina Rae Hark, eds. *Screening the Male: Exploring Masculinities in Hollywood Cinema*. London: Routledge, 1993.

Connell, R. W. *Masculinities*. 2nd ed. Berkeley: University of California Press, 2005.

Connelly, Marie Katheryn. *Martin Scorsese: An Analysis of His Feature Films, with a Filmography of His Entire Directorial Career*. Jefferson, NC: McFarland, 1993.

Creekmur, Corey. "Gary Cooper: Rugged Elegance." In *Glamour in a Golden Age: Movie Stars of the 1930s*, edited by Adrienne McLean, 66–83. New Brunswick, NJ: Rutgers University Press, 2011.

Crozier, Susan. "Making It after All: A Reparative Reading of *The Mary Tyler Moore Show*." *International Journal of Cultural Studies* 11, no. 1 (2008): 51–67.

Dika, Vera. *Recycled Culture in Contemporary Art and Film: The Uses of Nostalgia*. Cambridge: Cambridge University Press, 2003.

Dillon, Josephine. *Modern Acting: A Guide for Stage, Screen, and Radio*. New York: Prentice-Hall, 1940.

Doherty, Thomas. *Teenagers and Teenpics: The Juvenilization of American Movies in the 1950s*. Philadelphia: Temple University Press, 2002.

Dougan, Andy. *Untouchable: A Biography of Robert De Niro*. New York: Thunder's Mouth Press, 2002.

Dow, Bonnie J. "Feminist Criticism and *The Mary Tyler Moore Show*." In *Critical Questions: Invention, Creativity, and the Criticism of Discourse and Media*, edited by Gary A. Copeland, William L. Nothstine, and Carole Blair, 97–101. New York: St. Martin's Press, 1994.

———. "Hegemony, Feminist Criticism, and *The Mary Tyler Moore Show*." In *Critical Questions: Invention, Creativity, and the Criticism of Discourse and Media*, edited by Gary A. Copeland, William L. Nothstine, and Carole Blair, 102–17. New York: St. Martin's Press, 1994.

Druxman, Michael. *Paul Muni: His Life and His Films*. Rev. ed. Albany, GA: Bear-Manor Media, 2016.

Dubbert, Joe L. "Progressivism and the Masculinity Crisis." In *The American Man*, edited by Elizabeth H. Pleck and Joseph H. Pleck, 303–20. Englewood Cliffs, NJ: Prentice-Hall, 1980.

Dugall, Robin J. "Running from or Embracing the Truth inside You? Bruce Banner and the Hulk as a Paradigm for the Inner Self." In *The Gospel According to Superheroes:*

Religion and Popular Culture, edited by B. J. Oropeza, 145–54. New York: Peter Lang, 2005.

Dyer, Richard. "Charisma." In *Stardom: Industry of Desire*, edited by Christine Glenhill, 57–60. London: Routledge, 1991.

——. *Stars*. 2nd ed. London: British Film Institute, 1998.

Eckstein, Arthur, and Peter Lehman, eds. *The Searchers: Essays and Reflections on John Ford's Classic Western*. Detroit: Wayne State University Press, 2004.

Enelow, Shonni. *Method Acting and Its Discontents: On American Psycho-Drama*. Evanston, IL: Northwestern University Press, 2015.

Erwin, Edward, ed. *The Freud Encyclopedia: Theory, Therapy, and Culture*. New York: Routledge, 2002.

Fahlgren, Mararetha. "Strindberg and the Woman Question." In *The Cambridge Companion to August Strindberg*, edited by Michael Robinson, 20–34. Cambridge: Cambridge University Press, 2009.

Filene, Peter G., *Him/Her/Self: Sex Roles in Modern America*. Baltimore: Johns Hopkins University Press, 1986.

Fine, Marshal. *Harvey Keitel: The Art of Darkness*. New York: Fromm International, 1998.

Finstad, Suzanne. *Warren Beatty: A Private Man*. New York: Harmony Books, 2005.

Forsås-Scott, Helena. "August Strindberg, the New Woman, and Elin Wägner." *Women: A Cultural Review* 10, no. 1 (1999): 78–86.

Foster, Gwendolyn Aubrey. *Performing Whiteness: Postmodern Re/constructions in the Cinema*. Albany: State University of New York Press, 2003.

Frankel, Jonathan. *Crisis, Revolution, and Russian Jews*. Cambridge: Cambridge University Press, 2009.

Friedman, Lawrence S. *The Cinema of Martin Scorsese*. New York: Continuum, 1998.

Geraghty, Christine. "Re-examining Stardom: Questions of Texts, Bodies, and Performance." In *Reinventing Film Studies*, edited by Christine Gledhill and Linda Williams, 183–201. Oxford: Oxford University Press, 2001.

Gerstner, David A. *Manly Arts: Masculinity and Nation in Early American Cinema*. Durham, NC: Duke University Press, 2006.

Gilbert, James. *Men in the Middle: Searching for Masculinity in the 1950s*. Chicago: University of Chicago Press, 2005.

Gossip, Christopher J., and David J. George, eds. *Studies in the Commedia Dell'arte*. Cardiff: University of Wales Press, 1993.

Grant, Barry Keith. *Shadows of Doubt: Negotiations of Masculinity in American Genre Film*. Detroit: Wayne State University Press, 2011.

Greven, David. *Psycho-Sexual: Male Desire in Hitchcock, De Palma, Scorsese, and Friedkin*. Austin: University of Texas Press, 2013.

Gronbeck-Tedesco, John L. "Absence and the Actor's Body: Marlon Brando's Performance in *A Streetcar Named Desire* on Stage and in Film." *Studies in American Drama, 1945–Present* 8, no. 2 (1993): 115–26.

Hansen, Miriam. "Pleasure, Ambivalence, Identification: Valentino and Female

Spectatorship." In *Star Texts*, edited by Jeremy G. Butler, 259–82. Detroit: Wayne State University Press, 1991.

Herz, Peggy. *The Truth about Fonzie*. New York: Scholastic Books, 1976.

Higham, Charles. *Brando*. New York: New Amsterdam Library, 1987.

Higham, John. "The Reorientation of American Culture in the 1890s." In *Writing American History: Essays on Modern Scholarship*, edited by John Higham, 73–103. Bloomington: Indiana University Press, 1978

Hirsch, Foster. *A Method to Their Madness: The History of the Actors Studio*. New York: Da Capo Press, 1986.

Hohman Valleri J. *Russian Culture and Theatrical Performance in America, 1891–1933*. New York: Palgrave Macmillan, 2011.

Holmlund, Chris. *Impossible Bodies: Femininity and Masculinity at the Movies*. London: Routledge, 2002.

Hutcheon, Linda. *A Poetics of Postmodernism: History, Theory, Fiction*. New York: Routledge, 1988.

Jackson, Kevin, ed. *Schrader on Schrader*. London: Faber and Faber, 1990.

Jameson, Fredric. "Postmodernism and Consumer Society." In *The Cultural Turn: Selected Writings on the Postmodern, 1983–1998*, by Fredric Jameson, 1–20. London: Verso, 1998.

Jeffords, Susan. *Hard Bodies: Masculinity in the Reagan Era*. Brunswick, NJ: Rutgers University Press, 1994.

Jennings, La Vinia Delois. *Alice Childress*. New York: Twayne Publishers, 1995.

Kaplan, Beth. *Finding the Jewish Shakespeare: The Life and Legacy of Jacob Gordin*. Syracuse, NY: Syracuse University Press, 2007.

Kaye, Nick. *Postmodernism and Performance*. New York: St. Martin's Press, 1994.

Kazan, Elia. *Kazan on Directing*. New York: Alfred A. Knopf, 2009.

Kenny, Glenn. *Robert De Niro: Anatomy of an Actor*. Paris: Cahiers du Cinema, 2014.

King, Barry. "Articulating Stardom." In *Stardom: Industry of Desire*, edited by Jeremy G. Butler, 167–82. Detroit: Wayne State University Press, 1991.

Klevan, Andrew. *Film Performance: From Achievement to Appreciation*. London: Wallflower, 2005.

Kolin, Philip C. *Williams: A Streetcar Named Desire*. Cambridge: Cambridge University Press, 2000.

Krämer, Peter. "Bad Boy: Notes on a Popular Figure in American Cinema, Culture, and Society, 1895–1905." In *Celebrating 1895: The Centenary of Cinema*, edited by John Fullerton, 117–30. Sidney: Libbey, 1998.

Krauss, Kenneth. *Male Beauty: Postwar Masculinity in Theater, Film, and Physique Magazines*. Albany: State University of New York Press, 2014.

Lawrence, Jerome. *The Life and Times of Paul Muni*. New York: Putnam, 1974.

Lawrence, Novotny. *Blaxploitation Films of the 1970s: Blackness and Genre*. New York: Routledge, 2008.

Lehman, Peter. *Running Scared: Masculinity and the Representation of the Male Body*. Detroit: Wayne State University Press, 2007.

Lennard, Dominic. "Wonder Boys: Matt Damon, Johnny Depp, and Robert Downey Jr." In *Shining in Shadows: Movie Stars of the 2000s*, edited by Murray Pomerance, 12–31. New Brunswick, NJ: Rutgers University Press, 2011.

Levy, Shawn. *De Niro: A Life*. New York: Crown Archetype, 2014.

Lewis, Robert. *Method—or Madness?* New York: Samuel French, 1986. First published 1958.

———. *Slings and Arrows: Theater in My Life*. New York: Stein and Day Publishers, 1984.

LoBrutto, Vincent. *Martin Scorsese: A Biography*. Westport, CT: Praeger, 2008.

Lovell, Alan, and Peter Krämer, eds. *Screen Acting*. London: Routledge, 1999.

Malague, Rosemary. *An Actress Prepares: Women and "the Method."* London: Routledge, 2012.

Marcus, Daniel. *Happy Days and Wonder Years: The Fifties and the Sixties in Contemporary Cultural Politics*. New Brunswick, NJ: Rutgers University Press, 2004.

McCann, Graham. *Rebel Males: Clift, Brando, and Dean*. London: Hamish Hamilton, 1991.

McDonough, Carla J. *Staging Masculinity: Male Identity in Contemporary American Drama*. Jefferson, NC: McFarland, 1997.

McTeague, James. *Before Stanislavsky: American Professional Acting Schools and Acting Theory, 1875–1925*. Metuchen, NJ: Scarecrow Press, 1993.

Meisner, Sanford. *Sanford Meisner on Acting*. New York: Vintage Books, 1987.

Mellencamp, Patricia. *High Anxiety: Catastrophe, Scandal, Age, and Comedy*. Bloomington: Indiana University Press, 1992.

Mills, Brett. *Television Sitcom*. London: British Film Institute, 2005.

Mintz, Larry. "Situation Comedy." In *TV Genres: A Handbook and Reference Guide*, edited by Brian G. Rose. Westport, CT: Greenwood Press, 1985.

Mitchell, Lee Clark. *Westerns: Making the Man in Fiction and Film*. Chicago: University of Chicago Press, 1996.

Mizruchi, Susan L. *Brando's Smile: His Life, Thought, and Work*. New York: W. W. Norton, 2014.

Mulgrew, Kate. *Born with Teeth: A Memoir*. New York: Little, Brown, 2015.

Mulvey, Laura. "Visual Pleasure and Narrative Cinema." In *Issues in Feminist Film Criticism*, edited by Patricia Erens, 28–40. Bloomington: Indiana University Press, 1990.

Naremore, James. *Acting in the Cinema*. Berkeley: University of California Press, 1988.

Neale, Steve. "Masculinity as Spectacle: Reflections on Men in Mainstream Cinema." In *Screening the Male: Exploring Masculinities in Hollywood Cinema.*, edited by Steven Cohan and Ina Rae Hark, 9–22. London: Routledge, 1993.

Nichols, Dave. *One Percenter: The Legend of the Outlaw Biker*. Saint Paul, MN: Motorbooks, 2007.

Ochoa, Sheana. *Stella! Mother of Modern Acting*. Milwaukee: Applause Theatre and Cinema Books, 2014.

Ockman, Carol, and Kenneth E. Silver. *Sarah Bernhardt: The Art of High Drama*. New Haven, CT: Yale University Press, 2005.

Osgerby, Bill. "Sleazy Riders: Exploitation, 'Otherness,' and Transgression in the 1960s Biker Movie." *Journal of Popular Film and Television* 31, no. 3 (2003): 98–108.

Ozersky, Josh. *Archie Bunker's America: TV in an Era of Change, 1968–1978*. Carbondale: Southern Illinois University Press, 2003.

Patrick Christopher J., and Sarah K. Patrick. "The Incredible Hulk: The Origins of Rage." In *The Psychology of Superheroes: An Unauthorized Exploration*, edited by Robin S. Rosenberg and Jennifer Canzoneri, 213–28. Dallas: Smart Pop, 2008.

Peberdy, Donna. *Masculinity and Film Performance: Male Angst in Contemporary American Cinema*. London: Palgrave Macmillan, 2011.

Powrie, Phil, Ann Davies, and Bruce Babington, eds. *The Trouble with Men: Masculinities in European and Hollywood Cinema*. London: Wallflower, 2004.

Preston, Carrie J. *Modernism's Mythic Pose: Gender, Genre, Solo Performance*. New York: Oxford University Press, 2011.

Purse, Lisa. *Digital Imaging in Popular Cinema*. Edinburgh: Edinburgh University Press, 2013.

Rausch, Andrew J. *The Films of Martin Scorsese and Robert De Niro*. Lanham, MD: Scarecrow Press, 2010.

Reumann, Miriam G. *American Sexual Character: Sex, Gender, and National Identity in the Kinsey Reports*. Berkeley: University of California Press, 2005.

Ribot, Théodule-Armand. *The Psychology of the Emotions*. London: Walter Scott, 1898.

Rolls, Alistair, and Elizabeth Rechniewski, eds. *Sartre's Nausea: Text, Context, Intertext*. Amsterdam: Rodopi, 2005.

Rosenbaum, Jonathan. "New Hollywood and the Sixties Melting Pot." In *The Last Great American Picture Show: New Hollywood Cinema in the 1970s*, edited by Thomas Elsaesser, Alexander Horwath, and Noel King, 131–54. Amsterdam: Amsterdam University Press, 2004.

Rosenfeld, Lulla. *Bright Star of Exile: Jacob Adler and the Yiddish Theatre*. New York: Crowell, 1977.

———. *The Yiddish Theatre and Jacob P. Adler*. New York: Shapolsky Publishers, 1988.

Rosenstein, Sophie, with Larrae A. Haydon and Wilbur Sparrow. *Modern Acting: A Manual*. New York: Samuel French, 1936.

Ross, Lillian, and Helen Ross. *The Player*. New York: Limelight, 1984.

Rotté, Joanna. *Acting with Adler*. New York: Limelight, 2000.

Rotundo, Anthony E. *American Manhood: Transformations in Masculinity from the Revolution to the Modern Era*. New York: Basic Books, 1993.

Rutherford, Paul. *A World Made Sexy: Freud to Madonna*. Toronto: University of Toronto Press, 2007.

Sabatine, Jean. *Movement Training for the Stage and Screen: The Organic Connection between Mind, Spirit, and Body*. New York: Back Stage Books, 1995.

Saddik, Annette J. *Tennessee Williams and the Theatre of Excess: The Strange, the Crazed, the Queer*. Cambridge: Cambridge University Press, 2015.

Sanders, Joe Stuliff. *Disciplining Girls: Understanding the Origins of the Classic Orphan Girl Story*. Baltimore: Johns Hopkins University Press, 2011.

Sandrow, Nahma. "Romanticism and the Yiddish Theatre." In *Yiddish Theatre: New Approaches*, edited by Joel Berkowitz, 47–59. Oxford: Littman Library of Jewish Civilization, 2003.

———. *Vagabond Stars: A World History of Yiddish Theater*. New York: Harper and Row, 1977.

Savran, David. *Communists, Cowboys, and Queers: The Politics of Masculinity in the Work of Arthur Miller and Tennessee Williams*. Minneapolis: University of Minnesota Press, 1992.

Scheibel, Will. "Rebel Masculinities of Star/Director/Text: James Dean, Nicholas Ray, and *Rebel without a Cause*." *Journal of Gender Studies* 25, no. 2 (2016): 125–40.

Schulman, Michael. *Her Again: Becoming Meryl Streep*. New York: HarperCollins, 2016.

Schwartz, Gretchen. "'You Talkin' to Me?': De Niro's Interrogative Fidelity and Subversion of Masculine Norms." *Journal of Popular Culture* 41, no. 3 (2008): 443–66.

Seller, Maxine, ed. *Ethnic Theatre in the United States*. Westport, CT: Greenwood Press, 1983.

Shepherd, Cybill. *Cybill Disobedience*. London: Ebury, 2000.

Silverman, Kaja. *Male Subjectivity at the Margins*. London: Routledge, 1992.

Simmons, Jean. "Violent Youth: The Censoring and Public Reception of *The Wild One* and *The Blackboard Jungle*." *Film History: An International Journal* 20, no. 3 (2008): 381–91.

Sito, Tom. *Moving Innovation: A History of Computer Animation*. Cambridge, MA: MIT Press, 2013.

Stanislavski, Constantin. *An Actor Prepares*. Translated by Elizabeth Hapgood. New York: Theatre Art Books, 1936.

———. *Building a Character*. Translated by Elizabeth Hapgood. New York: Theatre Art Books, 1949.

———. *Creating a Role*. Translated by Elizabeth Hapgood. New York: Theatre Art Books, 1961.

Strasberg, Lee. *A Dream of Passion: The Development of the Method*. New York: Plume, 1987.

———. *The Lee Strasberg Notes*. Edited by Lola Cohen. London: Routledge, 2010.

Studlar, Gaylyn. *This Mad Masquerade: Stardom and Masculinity in the Jazz Age*. New York: Columbia University Press, 1996.

Tait, R. Colin. "When Marty Met Bobby: Collaborative Authorship in *Mean Streets* and *Taxi Driver*." In *A Companion to Martin Scorsese*, edited by Aaron Baker, 292–311. Malden, MA: Wiley-Blackwell, 2015.

Taylor, Alan, ed. *Theorizing Film Acting*. New York: Routledge, 2012.

Taylor, Marvin J. "Looking for Mr. Benson: The Black Leather Motorcycle Jacket and Narratives of Masculinities." In *Fashion in Popular Culture: Literature, Media, and Contemporary Studies*, edited by Joseph H. Hancock II, Toni Johnson-Woods, and Vicki Karaminas, 121–34. Bristol, England: Intellect, 2013.

Taubin, Amy. *Taxi Driver*. London: British Film Institute, 2000.

Thompson, David. *The Last Tango in Paris*. London: British Film Institute, 1998.

Thompson, John O. "Communication Test." In *Stardom: Industry of Desire*, edited by Christine Glenhill, 183–97. London: Routledge, 1991.

Todes, Daniel. *Ivan Pavlov: A Russian Life in Science*. Oxford: Oxford University Press, 2014.

Vilga, Edward. *Acting Now: Conversations on Craft and Career*. New Brunswick, NJ: Rutgers University Press, 1997.

Wainer, Alex. *Soul of the Dark Knight: Batman as Mythic Figure in Comics and Film*. Jefferson, NC: McFarland, 2014.

White, Susan. "Marlon Brando: Actor, Star, Liar." In *Larger Than Life: Movie Stars of the 1950s*, edited by R. Barton Palmer, 165–83. New Brunswick, NJ: Rutgers University Press, 2010.

Whyman, Rose. *Stanislavski: The Basics*. London: Routledge, 2013.

Williams, Linda. *Screening Sex*. Durham, NC: Duke University Press, 2008.

Williams, Tennessee. *A Streetcar Named Desire*. New York: New Directions Publishing, 2004. Originally published 1947.

Willis, Sharon, and Constance Penley, eds. *Male Trouble*. Minneapolis: University of Minnesota Press, 1993.

Winkler, Henry. *The Other Side of Henry Winkler*. New York: Warner Books, 1976.

Wolf, Daniel R. *The Rebels: A Brotherhood of Outlaw Bikers*. Toronto: University of Toronto Press, 1992.

Yockey, Matt. *Batman*. Detroit: Wayne State University Press, 2014.

Index